Comics for Film, Games, and Animation

Using Comics to Construct Your Transmedia Storyworld

Tyler Weaver

Focal Press
Taylor & Francis Group

NEW YORK AND LONDON

First published 2013
by Focal Press
70 Blanchard Road, Suite 402, Burlington, MA 01803

Simultaneously published in the UK
by Focal Press
2 Park Square, Milton Park, Abingdon, Oxon OX14 4RN

Focal Press is an imprint of the Taylor & Francis Group, an informa business

Library of Congress Cataloging in Publication Data
Weaver, Tyler, 1981–
 Comics for film, games, and animation: using comics to construct your transmedia storyworld/Tyler Weaver.
 pages cm
 Includes index.
 1. Narration (Rhetoric) 2. Arts. 3. Popular culture. 4. Comic books, strips, etc.—History and criticism. I. Title.
 NX650.N37W43 2012
 741.5'9—dc23 2012017803

ISBN: 978-0-240-82378-2 (pbk)
ISBN: 978-0-240-82405-5 (ebk)

Cover art by Blair Campbell

Typeset in Myriad Pro
by Florence Production Ltd, Stoodleigh, Devon, UK

Printed in Canada

Comics for Film, Games, and Animation

Contents

Figures

Introduction

Comic books are more than storyboards. Unfortunately, in today's media-making world, comics are viewed as something worse than storyboards; they are viewed as stepping stones, a niche medium to be mined for ideas that are then transferred to a medium with a wider audience for a bigger payday.

This "hunt/gather/adapt" train of thought has also moved into screenwriting discussions. Take a script that you can't sell, transform it into a comic book in the hopes that someone will buy the rights and turn it into the movie of your dreams. Monetarily, it makes unfortunate sense. Creatively, it's a daydream that limits the world-building potential of your writing and turns it into nothing more than another transparent means to an end. This book seeks to end that by showing you the limitless storytelling potential of comics and how to use them as part of an irresistibly immersive transmedia world that will entice your audience to dig deeper.

I've been lucky enough to make films, run a company, and collaborate with some of the most astounding creatives around. I've also been a comic book reader for more than twenty years, and as part of my current project, *Whiz!Bam!Pow!*, I collaborated with Blair Campbell—who provided the art for this book's cover as well as features throughout—to create a comic book that would be at the center of the storyworld that my writing partner and I were building. I will never forget the day that the first page of art came through email, the first time I had ever seen a script of mine turned into comic book form.

On the other hand, ask me what it was like seeing my movie on a big screen for the first time . . . I really can't remember. I'm sure it was nice. But I'll never forget the first time that first page of comic art came through.

I want you to have that same feeling.

* * *

Comics is rich in three areas*: storytelling potential, the building of dedicated fan bases, and the deep collaboration between writer and artist in a manner not seen in other media forms. If you can tell the story visually, you can make

* Note that I will use "comics" in the singular when discussing the medium throughout this book. This usage comes from Scott McCloud in his seminal work on the medium, *Understanding Comics*.

it a comic book; a superhero story, a noir tale, abstract, surrealism, epics, fantasy, espionage, autobiographical, non-fiction "how-to" manuals. The list is endless. It takes the best movies can offer and the freedom of a novelist, mixes it together with a marvelous thing called the "gutter"—that space between panels where one's imagination takes over, creating the connections and movement that spur the story onward.

You would be hard-pressed to find a group as dedicated (both positively and negatively) as the comic book fan base. Message boards, fan fiction, cos-play, you name it. These are the people—the absorbers—who will dig deep into your work, into your storyworld. Comics can help you get there, while at the same time, giving your main audience a whole new world that they may be looking at for the first time. Every comic book could be someone's first—or their last.

In the beginning of this piece, I relayed the personal story of how I was awash with joy the first time I saw a script I had written become a fully drawn and realized page of comic book art. The collaboration with my artist, Blair Campbell, has been one of the most fruitful and rewarding experiences of my creative life, combining our passion of the comics medium with a desire to build something cool. If it weren't for comics, I would never have had that collaboration.

* * *

This book is divided into three parts. In Part 1, we will explore the history and practice of immersive transmedia storytelling as well as content creation in the 21st century. Just what exactly is "transmedia storytelling"? How has content creation become democratized? What is the ultimate form of immersion? Why take the time to construct a deeply immersive world when you can just write a script and hope for the best?

Part 2, "Comics: The Creation and Evolution of a Medium," will dig deep into the history of comics as a reflection of the times in which they were created. It will also give you a look at the stylistic evolution of comics. How did comics look in the 1930s and 1940s? What types of stories were told? How did characters that were created as popular entertainment become icons of pop culture and our modern mythology? What lessons can transmedia creators take from the vast storytelling history of comics and apply to their own projects?

The point of this deep exploration of comics history is that I believe in order to create within a medium, you must understand it. The path to understanding lies in the history of the medium. History gives you a foundation on which to

build and gives you a sense of your place in its evolution. Let's not mince words here: by adding comics to the storyworld of your project, you are part of comics history, part of the next evolution of comics storytelling—an evolution that must take place in order for the medium to survive.

But that evolution is not without peril. Many times, explorations into other media by creatives focused in one particular medium have resulted in less than stellar results. It's my fear that as comics become more and more appealing to creatives as a low-cost way to spread the word about their work (low-cost, but highly involved and difficult to do well) we will drown in a sea of subpar tie-in comics that do nothing for either the medium of focus or the comic book medium itself. I want this book to stop that trend in its tracks.

Part 3, "Comics and Convergence," will examine the mixture of comics with the titular film, games, and animation. What are the strengths of each medium and how can the particular storytelling conventions of the comics medium augment those strengths and fill in where they are lacking? We'll also look at case studies for each medium; what worked, what didn't. Finally, I'll offer a series of thought experiments: how can we add a comic book to an already-existing property that both deepens a storyworld and is capable of standing on its own—without denigrating the story in the focus medium?

Comics is one of the most powerful communication and storytelling tools ever created. It's time to treat it with the love and respect it deserves. And there's no way to better respect a medium than to create great works within it; works that inspire, expand, and tantalize your dedicated audience.

* * *

Acknowledgments

Before we dive in, I want to take a moment and thank a few people who have saved my sanity during the writing of this tome:

To my family, for teaching me how to think—not what to think—and always encouraging me to follow my bliss.

To Orson, the (anything but) standard poodle who is my constant companion and best friend.

To Max, for his enthusiasm in unpacking every box I had lying around and finding the exact books I needed to research this behemoth.

To my *Whiz!Bam!Pow!* collaborators—Paul Klein, Kate Dawson-Cohen, Paul Montgomery, and Blair Campbell—you guys are the best creative partners I could ask for.

To Mike Elrod—we started our writing careers reviewing television shows. Now he's checking my facts and making sure this book is all it should be (and pointing out when I ramble too much in parenthesis [like now]). I owe you buddy.

And lastly, thank you to those who stayed with me throughout this leap of faith, to those who turned away when I leapt, and to the amazing new people that were there when I landed. You all inspired me in one way or another.

Transmedia Storytelling

What is Transmedia?

A man holding a gun plummets into the bubbly waters below. Never mind that the gun is made of plastic and fits into his carefully molded hand grip. Sometimes his hand falls off. Never mind that he is a mere 5.75 inches tall. Or that he, like his weapon, is made of plastic. Or that his voice is the voice of a kid imitating that very character's animated voice in a mock attempt at being a vicious, mercurial killer.

The hand that pushed him in: the same hand controlling the voice. Let's call this kid . . . um . . . Tyler. He's just watched his favorite television show, *GI Joe*, and is creating his own stories with his collection of plastic avatars, sending them into the watery abyss of Mr. Bubble "lava." He's expanding the narrative he's just seen because he's been moved to do so by the irresistible pull of the *GI Joe* world. In human terms, he's playing. He loves it. The world. The perils that await beloved characters. The mythological battle between good and evil.

This is the fan fiction I created, inspired by the action, excitement, and connection I formed to the *GI Joe* storyworld. I was the god—the merciless, sudsy hand of fate in my expanded *GI Joe* universe, a universe that I created using all forms of media available to my Reagan-baby playtime-mind.

I'll never forget the change between seasons about midway through the *GI Joe* run. Before it, we had the hooded Cobra Commander, his pre-pubescent vulture voice squawking out orders and beguiling the Joe team. Then the next thing I knew, he was in armor, still squawking like that pre-pubescent vulture. What had happened? What changed?

Until I saw the movie, I created my own scenario. That he had plummeted into the murky waters of a bathtub and reemerged an armored badass. It seemed perfectly feasible to me. After all, that's what people did in my mom's soap operas.

Then I finally saw the *GI Joe* animated film. It continued the narrative, expanded what came before it and revitalized a (kinda) staid universe. I learned what had happened, and it brought a new level of meaning* to the elements that preceded and followed it. Did it live up to the scenarios I had created in my young mind? I don't really remember. But from that moment

*He was transformed into a giant cobra thanks to the machinations of Golobulous and the world of Cobra-La. He then becomes the pet snake of Serpentor before getting hooked up with the aforementioned battle armor and becoming inexplicably human again. Never said it was good meaning.

on, I had a love of transmedia in my blood. Even if I didn't know what, exactly, it was.

So What Is It?

Transmedia. Deep media. Cross media. All of the above. At the end of this transitional period from the one-way, massmedia, one-size fits all, suit-driven, pre-packaged entertainment to an always-on, always-connected, dialog and engagement-driven media landscape (probably another five to six years), it will just be what it is: storytelling. But until that time, and before we can fully dive into a book about transmedia (and particularly the place comics holds in it), it's best to come up with a working definition so we're all on the same page.*

TRANSMEDIA STORYTELLING
The crafting of stories that unfold across multiple media platforms, in which each piece interacts with the others to deepen the whole—but is capable of standing on its own—giving the audience the choice as to how deep into the experience they go.

Now, let's break that up into some component parts.

"Crafting of Stories that Unfold Across Multiple Media Platforms . . . "

There are two approaches to transmedia storytelling: you either create a story that can only be told across multiple platforms or you take a story from one medium and add other media to it to deepen the world created in the focus medium. My own *Whiz!Bam!Pow!* project could only be told across multiple platforms: a comic book from 1938, a radio show from 1946, a novella, a short film.

Implied and essential in this first section is the notion of fragmentation, the first of four linchpins in transmedia storytelling. As your story fragments across multiple platforms, you must construct each piece so that it both builds upon what has come before (by adding meaning and subtext) and stands on its own—but more on that in a moment.

* While a definition is needed for the purposes of this book, I do not believe that "transmedia storytelling" should be defined at this point. It's so new, so filled with possibility, that confining it to one definition goes against the very nature of this new storytelling paradigm. To define transmedia at this point is like defining the iPad as a "multi-touch device for the consumption of media." The beauty of the iPad and transmedia is that both are tabulae rasae—blank slates—on which we can create whatever we wish, changing from person to person, practitioner to practitioner, story to story. It must be allowed to evolve, to grow, and to adapt.

Transmedia Storytelling and ABC's *Castle*

ABC's *Castle,* the tale of mystery writer Richard Castle (Nathan Fillion) doing research with the NYPD, solving mysteries, and falling in love with his muse, Detective Kate Beckett (Stana Katic), has proven one of the most successful uses of transmedia storytelling—even though most audiences don't realize that that's what it is. It's irresistible transmedia. Castle has his own Twitter account (@WriteRCastle), offering more insight into his thought process, and providing little winks to the show's past and future. And, as is logical with a series about a mystery writer, Hyperion Press has published Castle's books including *Heat Wave, Naked Heat,* and *Heat Rising.* Each of these books lay bare Castle's infatuation with and love for Beckett (by fantasizing about their relationship and idealizing her as the bad-ass lead protagonist Nikki Heat) as well as character layers beyond the capabilities of a television show (after all, the true feelings of a writer are most often revealed in their work). *Castle* is a perfect example of transmedia flowing from character. All of these elements make character sense and are organic to the rules of the world set forth by the writers of the show.

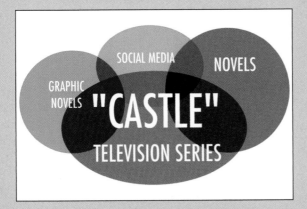

FIG 1.1 ABC's *Castle* represented as a nodal transmedia project.

Most recently, Marvel Comics released *Richard Castle's Deadly Storm: A Derrick Storm Mystery*, a graphic novel written by *Ultimate Spider-Man, Halo: Uprising* and *Avengers* writer Brian Michael Bendis. To further blur the lines between fiction and reality, the graphic novel (or "OGN"—Original Graphic Novel—in comic book parlance) features an introduction by "Richard Castle," where he mentions his concerns about adaptation but how thrilled he is that Brian Michael Bendis is the man adapting the work, and how happy he is that Marvel Comics is the publisher. The graphic novel was then featured in a recent episode of the television show, about a murderous, sword-wielding, comic-inspired vigilante.

Transmedia storytelling is like playing with building blocks—construct a solid foundation and build your story skyscraper. But be careful—the more clever you try to be, the more perilous your game of Jenga.

" . . . in which Each Piece Interacts with the Others to Deepen the Whole . . . "

Transmedia does not simply mean breaking up a movie or game into multiple pieces. We're letting these story pieces play with one another. The interplay of various story pieces is what makes transmedia such a fascinating means of storytelling (and distinguishes it from a franchise). Interplay and depth are the second and third linchpins of transmedia storytelling.

Think of the whole as a Wikipedia page. Think of the transmedia elements as the other articles you link to. Now take that page and deepen it from there. How can you deepen the lives of characters in a film through a web series? Or through a blog? A short film?

" . . . But is Capable of Standing on Its Own . . . "

Each and every piece of your transmedia building blocks must be a complete story in its own right. There's an old adage in comics, "every comic book is somebody's first" (as well as someone's last). This applies to transmedia storytelling as well.

Your objective is to create multiple gateways into your storyworld, and disperse those gateways to the devices they use to consume media. It doesn't matter if that's a movie theater, a smartphone, a comic book, or a television show. Every piece has the chance to be somebody's first (or last) and we have to give them a complete narrative that not only enthralls with its own story, but entices the viewer/consumer to become engrossed in the world and dig deeper.

However, we must keep in mind that the last thing we want is for our audience to feel lost or overwhelmed. Remember—Jenga. Many people will consume your project in a non-linear fashion (not in the release schedule you have laid out—this is a key element of giving up a degree of control, and a true realization of Jean-Luc Godard's line that a story must have a beginning, middle, and end, but not necessarily in that order). There's a fine line between curiosity and complete frustration, and we have to walk that tightrope carefully because we want our audience to be pulled into our world, not buried alive.

Confusing them with half-stories and boring them with less-than-involving characters isn't the way to do that. So, how do we prevent it?

" . . . Giving the Audience the Choice as to How Deep into the Story Experience They Go"

Choice is the fourth linchpin of transmedia storytelling. Your audience won't be filled exclusively with obsessive fans who want to consume every piece of your project. Some may want to consume only one piece. They just want a simple distraction and good time. What both categories desire is choice; the choice of casual consumption or obsessive immersion and participation. We have to make sure we satisfy both by giving them pieces that will move, inspire, and invite them to grab a shovel and dig as deep as they please. Audiences love being rewarded for their expertise. Play to that need and your chances of success will increase exponentially.

How to Avoid Playing Jenga

With every new technology and tool comes the inevitable over-proliferation of the innovation created by that tech or tool. Transmedia storytelling is no exception, with "gurus" and the like proclaiming the necessity of transmedia-fying everything.

Let me make something crystal clear: you should only do it if it makes story sense. Our job as media-makers is not to give people what they want (or what marketeers and the legion of their books in the business section think they want), but to give them something they never knew they wanted, and make it irresistible to them.

Here are three quick pieces of advice for those considering a transmedia approach to their projects:

1. Say "no" more than "yes." Unless, of course, it makes the work done in the focus medium (the term I use for the central medium of an additive transmedia project) better and more well rounded. There are several stories that work best in a single medium, in spite of a push on the part of marketeers and the undisciplined to transmedia-fy everything.

2. We've got to think of ourselves like fine dining chefs in the Midwest. I live near Cleveland, so the proliferation of amazing restaurants continues to astound me. What's the secret of their success? Meet people halfway. Give them mac and cheese, but make it with goat cheese, white truffles, and grilled chicken. Ask a lot, intrigue, but don't ask too much . . . ahem *Matrix*. Don't expect people to dig deep into your world. Make it irresistible for them to do so.

3. Don't make a bad comic book. Or a bad ARG. Or a bad video game. Or a bad web series. The crap list goes on and on. If you're going to expand outside your focus medium, you have to know how to create within that

The Three Types of Transmedia

- **Native transmedia**—stories conceived to be transmedia from the start. My own *Whiz!Bam!Pow!* project is a native transmedia project. *Pokemon. The Matrix. Avatar.* These stories are crafted from the very beginning to be spread across multiple media forms.

- **Additive transmedia**—stories that began life in another medium and had transmedia elements added to them: ABC's *Lost* with *The Lost Experience* ARG*; *Castle* with the "Nikki Heat" novel series, the @WriteRCastle Twitter feed, and the *Derrick Storm* graphic novel; *Twin Peaks* (a very early form of televised additive transmedia) with the book *The Secret Diary of Laura Palmer*; NBC's *Heroes* with graphic novels and webisodes; *The Office* with Dundler Mifflin Infinity. For the most part, these are not . . .

- **Crap transmedia**—what we're trying to avoid: transmedia just for the sake of it or solely for marketing purposes because it's "in." If it comes from the wallet instead of from the story, it's crap transmedia—which can be native or additive, though usually additive.

* ARG: Alternate Reality Game.

medium. You have to learn the medium (or media) and *love* it. You have to know what makes it different. You have to know how it can best suit your story.

The Secret Handshake

In *Manhood for Amateurs,* his second collection of non-fiction pieces, Michael Chabon, author of the brilliant *The Adventures of Kavalier and Clay*, says, "Every work of art is one half of a secret handshake, a challenge that seeks a password . . . Art, like fandom, asserts the possibility of fellowship in a world built entirely from the materials of solitude."[1]

With this quote, Chabon sums up transmedia perfectly: we are creating the handshake, and it gives an audience the chance to return that handshake by consuming one piece, then deciding if they want to continue the conversation by seeing what else you've got cooking for dinner.

All great stories envelop the audience in their narrative grasp. Stories are a communication tool for understanding, entertainment, and persuasion. It doesn't matter if the story is told orally, in a piece of media—film, novel, comic book, television, web series—to achieve maximum impact and longevity, the story you tell must speak to your audience.

The focus in transmedia storytelling cannot be the media or the "cool tech" aspect of it. It has to be the storytelling. You have to tell a story that is so irresistible to an audience that it pushes them to dig deep, to immerse themselves in the world of your creation, the world of your story. The media and tech aspect will grow organically as the needs of the story dictate.

This brings up a question that, on the surface, seems to have an easy answer (although, throughout your studies into transmedia and storytelling, you will learn there's no such thing): "What is a story?"

Glad you asked.

You Must Remember This . . .

■ Transmedia storytelling is the crafting of stories that unfold across multiple media platforms, in which each piece interacts with the others to deepen the whole—but is capable of standing on its own—giving the audience the choice as to how deep into the experience they go.

■ While I provide a definition of transmedia in this book (like above), I don't believe transmedia should be defined at this point. It's a blank slate, like the iPad, and an opportunity for experimentation, exploration, and excitement.

- Don't transmedia-fy everything. There are some stories that work best in a single medium. Resist the urge to listen to the prevailing winds of popularity and do what makes sense for your story.

- The four linchpins of transmedia storytelling are: fragmentation, interplay, depth, and choice.

- The most important element of transmedia storytelling is not the multiple media platforms or the technology behind it. It's the storytelling. We must create great stories that prove irresistible to audiences, pushing them to dig deeper into the storyworld of our creation. And the only way to do that is to know and remember the key tenets of great storytelling.

Note

1. Michael Chabon, *Manhood for Amateurs: The Pleasures and Regrets of a Husband, Father, and Son* (New York: HarperCollins, 2009), p. 5.

Once Upon a Time . . .

What is a Story?

Story: a narrative or sequence of events featuring characters moving towards a goal in conflict. Right? That's part of it. That's "story."

But what about "a story"? What is the point of these things that have so infected and inspired our lives? Why do we have such a deep-rooted need to be told a story, to engage with a story experience? Why do we want to immerse ourselves in a fictional (or not) world?

In any society, the extent to which people seek to escape into entertainment are determined by the times in which they live. The stories and themes must be of their times, their themes relevant, and their values commensurate with the values of those who will hear those stories.

All stories have a singular point: to communicate truth. Shamans and storytellers would regale their communities with tales of adventure, with universal themes that resonate to this day. Come to think of it, that sounds quite a bit like where we are today, doesn't it? We're a worldwide community, sitting around a digital campfire of Twitter, Facebook, mobile technology, and all of the other techno-advancements that are waiting just down the road to give us the power to engage, deepen, and experience a story in expansive ways.

With all that, what are stories? For this book, I define them as:

STORY
A narrative construction in which ideas and themes are communicated in entertaining, persuasive, or educational ways.

Why Do We Tell Stories?

There are four reasons for telling stories:

- To entertain—Any number of stories and properties from *The Odyssey* and *Beowulf* to *Batman*, the James Bond film series, the *Pirates of the Caribbean* franchise, *Star Wars*, and *War of the Worlds*. In a perfect world, all stories should, at the very least, be entertaining—no matter the intent.

- To persuade—Any number of stories in the political spectrum, from the McCain 2008 presidential campaign "Joe the Plumber" story to Richard Nixon's 1952 "Checkers" speech. Marketing campaigns, from *Old Spice* to

Geico to those Folgers Coffee ads of soldiers coming home. All of these stories have a goal of bringing you over to their side, be it Democrat or Republican, cologne or coffee.

- To educate—One notable example in the comics medium is *The Amazing Spider-Man* #96–98, the so-called "Drug Issues," in which Peter Parker's friend (and son of Norman Osborn, The Green Goblin), Harry Osborn, succumbs to his pill-popping addiction.

- To understand/to foster understanding—At their heart, all stories are about some sort of understanding, some sort of truth-telling. As a society, we have an innate desire to know where we came from and who we are. From the first tales ever told to the biggest blockbuster, all have some form of theme or truth that they're trying to express. As Anne Lamott says in *Bird by Bird*, "all good writing is about telling the truth."[1]

Problems arise when the intent is blurred for purposes not organic to the stories themselves. For example, stories meant to persuade are used as education—news stories with a blatant political bias over an objective educational stance (or worse, stories used to educate children that are actually persuasive, to make them believe instead of accumulate knowledge and seek their own critical viewpoint).

When used with proper intent, all four of these reasons speak to basic human values. We wish to forget ourselves and be entertained. We wish to entertain others and be liked. We strive to bring others to our points of view. We know that we must fill the heads of our kids with knowledge—in an entertaining manner. And lastly, we strive to understand the unanswered questions, those universal themes, metaphors, and stories that are constant in the religions and cultures of the world: Christian to Mayan, Buddhist to Native American, Hindu to Eskimo.

The Elements of Story

Character

Think about your favorite television shows. Why do you watch them? First, you watch them (partake in the storytelling experience) because you wish to be entertained. But what makes it entertaining? What makes you watch from week to week?

Is it the formulaic storytelling, a reassuring presence that will guide you by the hand through the plot twists and turns? Not really.

Is it the promise of wild and crazy mysteries that will confound you? Maybe. They're certainly fun. But that's not the reason you watch each and every week.

You watch your favorite television show because watching that show is a similar experience to having old friends over for dinner. You watch it because of the characters. Week after week, you welcome these characters into your home, and, by extension, when dramatic things happen, it amplifies our natural tendency towards empathy—we care when bad things happen to characters we love, and root for them to overcome the obstacles they must endure.

One of my favorite recent viewing experiences was watching *Lost* in its entirety over the course of two months. At the time, I had no idea I was going to be writing this book, but the idea of character as everything was at the top of my head without fail, as I had spent a year prior reviewing television shows like *Fringe*, *House*, *Human Target*, and *Leverage*, extolling the importance of character.

Lost represents something special in 21st-century media consumption: a work that is so labyrinthine and dense, with branching narratives, perceived interactivity, and plot twists that it couldn't be contained by a single medium. But all of that doesn't matter when it comes to the key reason for its status as a television phenomenon. What does matter is that it was filled with characters you loved and cared about.

Look at, for example, any number of the *Lost* imitators that sprang out in the wake of the show's sixth and final season. *The Event. Flash Forward. V.* These shows tried to replicate the *Lost* formula. The problem was, and the reason they failed, was that they replicated the wrong formula.

It's not the mysteries that draw people back and made *Lost* arguably the greatest television experience of the 21st century—it was the characters. People you genuinely cared about. People whose loss—Jin and Sun, anyone?—left a void in your life that you're still recovering from.

I always push myself to develop characters and stories where the "inciting incident," or the bit that causes the story to take off, comes from a deep character flaw or need that must be fulfilled. Additionally, it's important to remember that "well developed and engaging" does not always mean "likeable." Look at Doctor Gregory House in *House* or Louie De Palma in *Taxi*.

There is nothing worse than a story filled with passive people you don't care about who agree on everything. I call that the "Midwest" story. Infer what you will.

Character is everything. But we're surrounded everyday by "characters." What do we have to do to them to make it a story?

I suggest cornering them in a tree and firing machine guns at them.
Ah, drama.

Conflict and Risk

Conflict only matters when you have two characters whom you care about stuck in a struggle with two opposing viewpoints and methods for getting unstuck from the situation. This creates tension, that beautiful thing that creates all drama.

The Survivors of Oceanic 815 versus The Others. Jack versus John Locke. Batman versus The Joker. Superman versus Lex Luthor. Luke versus Anakin. Rick versus Victor Lazlo for the affections of Ilsa. Beowulf versus Grendel. These are just some of the great protagonist–antagonist relationships in storytelling, relationships where both characters believe they are right and are willing to fight for that belief.

No conflict can come without its best friend, risk. The machine gun I mentioned earlier? The risk is that the hero we caught up in a tree will be shot. Perhaps multiple times. The conflict is that he's in the tree, trying to attain his goal of getting out with guns being fired at him.

Risk is when Superman fights Doomsday, even though he knows he'll probably die. Risk is when Batman faces down Darkseid, a man versus a god. Risk is when you, with *Halo*'s Master Chief as your in-game avatar, take a dive from a ship on top of a bomb to save a space station, plunging to the Covenant's spaceship below. It's very likely you won't make it. But, you're the Master Chief. He rides bombs before, during, and after breakfast.

Risk doesn't apply only to alpha male power fantasies. It can also be as simple as the potential for a broken heart when that potentially special someone hangs up the phone on you. You took the risk with someone you're in conflict with (all love stories are a protagonist–antagonist relationship; as Billy Wilder said, a love story is about what keeps them apart) and it may or may not pay off.

Welcome to life.

Place

Speaking of the Midwest, place is almost as important to a story as character and conflict. From the Island on *Lost* to Batman's Gotham City, to Liberty City, Vice City, and San Andreas in the *Grand Theft Auto* series, to *Bioshock*'s Rapture, a well-defined and detailed sense of place can suck an audience in, encouraging them to explore and engage, to learn, and to seek.

The old adage that Gotham City is as much a character in *Batman* as Batman? It's true (*Batman* and *Nightwing* writers Scott Snyder and Kyle Higgins, respectively, are adding to the backstory of Gotham City, further fleshing out

the "character" of the city, in their 2011 mini-series, *Gates of Gotham*, as well as their current monthly "New 52" relaunch titles). The Island is its own character in *Lost*, with its own backstory, wants, needs, and goals (its own survival). The Liberty City of *Grand Theft Auto IV* is a richly detailed and designed world, with its own neighborhoods and stories, more stories begging to be told (as the expansion packs, *The Lost and the Damned* and *The Ballad of Gay Tony* have proven).

Take your audience to a place, transport them, make it irresistible for them to engage with your world, and your transmedia story experience already has more legs than most.

Theme

Theme is a tricky one, because it's both the most simple and complicated part of describing a story. It's one of those things that you either know right away or never figure out, leaving it to your audience to find their own meaning.

While your methods may differ, all of my transmedia storytelling is connected by theme and character, not by narrative threads (though there's some of that as well, especially if you bind media by theme and character; they tend to appear naturally, without feeling artificial or forced). Why do I operate this way?

Theme and character are universal. They are recognizable. They're easy to swallow (though sometimes not to describe). An audience will follow a character they love—even though you say they're following your plot twists. They're not. They're following a character they love through the trials and tribulations of reaching their goal.

The value of connecting by theme is best stated in a practical manner by director Francis Ford Coppola in a fantastic interview with The 99*u*:

> When you make a movie, always try to discover what the theme of the movie is in one or two words. Every time I made a film, I always knew what I thought the theme was, the core, in one word. In *The Godfather*, it was succession. In *The Conversation*, it was privacy. In *Apocalypse [Now]*, it was morality.

> The reason it's important to have this is because most of the time what a director really does is make decisions. All day long: Do you want it to be long hair or short hair? Do you want a dress or pants? Do you want a beard or no beard? There are many times when you don't know the answer. Knowing what the theme is always helps you.[2]

Not only does knowing the theme in one or two words help in the practical, day-to-day decisions facing visual storytellers on set, it also provides a connective tissue between transmedia elements and pieces. Look at any collection of short stories. For instance, in my own project, *Whiz!Bam!Pow!*, the stories are connected by character and by the theme of secret identities, of becoming the hero you need to be. This gives the audience the choice of following. They don't *need* to follow every piece. They *choose* to. Or not.

Theme is the underlying dramatic question that we must answer. It's the one element that satisfies all of the reasons we tell a story: to entertain, to persuade, to educate, and to understand. And it's because of that universality that theme will always be omnipresent and important.

But What About Plot?

Even worse than a story filled with passive people you don't care about who agree on everything in a boring place is the same story with those same characters jammed into a plot that they don't fit in. So not only are these boring, passive characters in a place that makes boiling water exciting, but *they* don't even want to be in your plot.

Stephen King has a marvelous quote about plot: "Plot is, I think, the good writer's last resort and the dullard's first choice. The story which results from it is apt to feel artificial and labored."[3] All great stories emerge from characters in conflict with goals. While I don't believe in plot, I do believe in goals. A character should have something that they're going after. And someone else should want the same thing but for different reasons, or want to stop that protagonist from achieving the goal.

Plot, to be truly effective, must flow organically from character, conflict, and theme. If plot comes first, your story is sunk. Every story has already been told. It's up to you to fill it with your experiences, values, and ideas, and those are best represented by character, conflict, place, and theme.

Stick your characters in a tree and fire machine guns at them. Trust me, they'll figure a way out of it. All you have to do is keep firing and watch what they do. And then write it down.

The Future of Storytelling

We have a limitless supply of technology at our fingertips. With each technological innovation comes a transitional period, which we're experiencing at this writing, a transition from mass, homogenized media with one-way communication to a democratized, independent, engagement-media economy. But, no matter the technology we have, great storytelling

must reign supreme. It doesn't matter if you create something that utilizes all forms of media. Format can never trump story.

We live in a hyper-connected world. In every single person carrying a Blackberry or iPhone, a Kindle or iPad, you have a person just looking to be immersed in a story. It's our job to give them what they don't even know they want—and by doing so, usher in a new age of storytelling.

The thing of it is, we've already seen an age like this. History has a funny way of being a cyclical phenomenon with newer, shinier toys.

You Must Remember This . . .

- A **story** is a narrative construction in which ideas and themes are communicated in entertaining, persuasive, or educational ways.

- We tell stories to entertain, to persuade, to educate, and to understand. All great stories are about telling truths and fostering understanding of themes.

- The five elements of story are **Character**, **Conflict**, **Risk**, **Place**, and **Theme**. Plot should flow organically from all of these.

- Format can *never* trump story.

Notes

1. Anne Lamott, *Bird by Bird: Some Instructions on Writing and Life* (New York: Anchor Books, 2004), p. 3.
2. Ariston Anderson, *Francis Ford Coppola: On Risk, Money, and Collaboration. The 99u.* Available online at: www.the99percent.com/articles/6973/Francis-Ford-Coppola-On-Risk-Money-Craft-Collaboration.
3. Stephen King, *On Writing: A Memoir of the Craft* (New York: Pocket Books, 1999), p. 160.

A Bucket of LEGO®s
Fragmentation and Interplay

The detective sits at his desk, looking out over the San Francisco night.
He lights a cigarette from the desk lighter. He draws in a breath, exhales.
His door opens, a man with a gun enters. "You will clasp your hands behind
your head . . . "

TO BE CONTINUED . . .

Welcome to the world of serialized narratives (paraphrased from the first version of Dashiell Hammett's *The Maltese Falcon,* serialized in *Black Mask* magazine between 1929 and 1930), an early form of fragmenting narratives. A response to the needs and monetary capabilities of the times, serialized narratives, from penny dreadfuls to soap operas, have held audiences in their grasp for more than 200 years.

So what separates fragmented and serialized storytelling from transmedia?

First of all, "multiple media platforms." And secondly . . . *play.*

Ever play with LEGO®s? You did? Great. You're about to make a career out of it. Only instead of plastic building blocks in an assortment of primary colors, you're going to assemble a story experience crafted from a careful selection of any type of media you can get your hands on.

Shattering the Black Box

In his seminal book on transmedia and the collision of old and new media, *Convergence Culture: Where Old and New Media Collide*, Henry Jenkins, former Director of the Comparative Media Studies Program at MIT, talks of the "Black Box Fallacy." He describes the argument of those in favor of "The Black Box" as: "All media content is going to flow through a single black box into our living rooms . . . figure out which black box will reign supreme, then everyone can make reasonable investments for the future."[1]

Yeah. Right.

We have XBoxes. Playstations. Television. Comic Books. Graphic Novels. Feature Films. Short Films. Web serials. Smart phones. Tablets. And yes, some people still read books. (Ahem). The list of media forms at our fingertips is endless—and it's going to keep growing.

Jenkins also states that "Part of what makes the black box concept a fallacy is that it reduces media change to technological change and strips aside the cultural levels . . ."[2]

And indeed, we are witnessing not only the technological changes listed above and in numerous other sources, but a significant cultural shift—forwards, with technology and connectivity, and backwards, with a return to a more collective creativity and consumption habits. We are creating stories for a generation, the Millennials (and their eventual progeny), for whom a world without Internet is akin to the days before electricity. It's a world where people can play out an epic battle for humanity with others all over the world, or download the latest television episode to their phone. Everyone is connected; rather, everyone is hyper-connected. People want their media when they want it, where they want it. To have any sort of relevance and resonance, we have to be both great storytellers with a formidable command of media, and, as Woody Allen said, "fifteen minutes ahead."

People of my generation are kind of used to this "when you want it where you want it" consumption (or, to appropriate a term I love from Lawrence Lessig's *Remix: Making Art and Commerce Thrive in the Hybrid Economy,* "absorption"). We had *GI Joe, Transformers,* all of that; a cartoon series, a movie, and those awesome action figures. But then again, a cordless home telephone was a remarkable technological innovation where I grew up. It was training wheels for riding the bike of 21st-century media.

But today? That level of fragmentation has exponentially grown. Today's new generation? Those Internet-babies? They're conditioned for fragmentation. Twitter. Facebook. A comic. A message board to discuss the comic. The latest video game trailer on IGN. The digital comic of the show they just downloaded that tells the story between the episode they're watching and the episode they'll download next. And then tweeting about it.

As Frank Rose, author of *The Art of Immersion: How The Digital Generation is Remaking Hollywood, Madison Avenue, and the Way We Tell Stories* said in an interview with me, they're truly "the people formerly known as the audience."[3]

A Brief History of Fragmentation

In a post on his Deep Media blog, Frank Rose says . . .

> The historical precedent shows us that the impulse to tell stories across different media isn't new. But it's the proliferation of devices that deliver a variety of different media—audio, video, text—that makes it feel increasingly natural.[4]

If you look at the history of storytelling and branded entertainment, we're living in a hyper-connected version of the mid-19th century up through the advent of mass media (or "frozen dinner" media, as I call it). Frozen dinner media is only a byproduct of the 20th century, much like the tasteless frozen treats I reference. With the end of the 20th century, we're getting back on pace with an organic media that corresponds to the needs and wants of the culture it finds itself being consumed (and created) by.

The culture of the 1830s was urbanized, crowded, living in squalor, over-worked, and seeking an escape. Mass urbanization in the 1830s in numerous cities created often horrific conditions that made fictionalized escape a refuge for many. As most people couldn't afford novels, many works were serialized.

Any storytelling innovation and transition does not happen in a vacuum. Historian Mary Noel, talking to Ron Goulart, author of the book, *Cheap Thrills: The Amazing! Thrilling! Astonishing! History of Pulp Fiction* says it best: "Popular literature on the scale marketed today is as much a product of the Industrial Revolution as is large-scale manufacture of any sort."[5]

The cultural significance and importance of serialization and fragmentation cannot be underestimated. It was a reaction to the needs and wants of the working class, without whom true success in anything is elusive (just look at politics). These media consumers wanted to be immersed in a world of cheap excitement, escape, sex, and action—because their lives were anything but an escape—and they wanted it cheaply and quickly.

The working class couldn't afford novels, then primarily the leisure activity of the elite, but they could shell out a shilling or a dime for monthly or weekly serialized fictions and adventures. Charles Dickens, now regarded as a literary master, was reviled in his time by the English elite, and the serialization of his novels stirred up particular controversy, such as in this passage from the *North British Review* (quoted in Frank Rose's *Art of Immersion*):

> The form of publication of Mr. Dickens's works must be attended with bad consequences. The reading of a novel is not now the undertaking it once was, a thing to be done occasionally on holiday and almost by stealth . . . It throws us into a state of unreal excitement, a trance, a dream.[6]

But for the "working class heroes," the virtues of whom Dickens extolled in his work, even the publications in which Dickens was published were too costly. They turned instead to the lurid penny dreadfuls, which, as their name suggested, cost a single penny. Their blood-soaked pages bore such pop culture figures as Sweeney Todd, and ignited the imaginations and tastes of a British youth and working class beset by the hells that were their day-to-day lives.

Thought Balloon: Frank Rose

Frank Rose, a Wired contributor, is the author of The Art of Immersion: How the Digital Generation is Remaking Hollywood, Madison Avenue, and The Way We Tell Stories, *published by Norton in 2011. In this interview, we discuss the roots of fragmented storytelling and how the past shaped our current media landscape.*

Tyler Weaver (TW): I loved the quote you included in your section on Charles Dickens, the serialized novel, and the resultant rise of immersion from the *North British Review*, that "it must be attended with bad consequences."

Frank Rose (FR): Right! Exactly. I became increasingly fascinated with that as I was working on the book. What started off as about two pages ended up as eight or ten. I realized that serialization really did involve a level of participation in terms of readers that in many ways anticipates what we're seeing now.

The idea of serialization is purely a product of technology. A whole series of different and seemingly unrelated technological developments came together to create this. There were improvements in paper manufacturing, so suddenly it was possible to make much cheaper paper that was still good. Improvements in printing presses. Railroads came, which meant you could deliver things, which had never been the case before. The whole process of industrialization meant that large numbers of people moved to the city. That meant that there were many more people, because once they moved to the cities, they started to learn to read and write, which in many cases had never been the case before.

The percentage of the population that was literate was very small a hundred years earlier. By the 1830s, it was starting to grow quite dramatically and now, of course, it's about 98 or 99 percent. But it wasn't anywhere near that then. There were a lot more people who could read, but most of this new reading population didn't have much money. They were poor because they weren't being paid very well and they didn't have much free time because they worked very hard hours. But they also didn't have much else to do—there was no television obviously. Suddenly, there was a much bigger market for novels, for fiction, and even though most people in this market couldn't afford to buy a whole book, they could afford to buy a book in weekly or monthly installments. Almost every novel Dickens wrote was published in monthly installments.

What that meant was that there was a whole way of interacting with the author that really hadn't existed before because when you publish a

book whole it's like a movie—that you write the thing in isolation, then you publish it, it's out, it's done, and you move on to the next one. But the fact that these novels were published in installments meant that readers could write in—and they did. They had very vocal opinions.

Dickens was, in addition to being quite young and taking advantage of the latest technology, not received well by the literary establishment. Frankly, it had only been relatively recently that fiction had been accepted at all. Fiction in the sense of novels as opposed to theatre or something like that. That novels had been accepted at all in sort of polite society . . . throughout the 18th century they were considered a pretty disreputable form of entertainment, hard as that is to believe now.

With Dickens, they became quite disreputable again for a couple of different reasons. First off, there's that quote that you mentioned in the *North British Review* that says the idea that these things kept coming one installment at a time—a couple of chapters at a time—the idea that you could lose yourself in fiction, which has always been, I've found, something that people have both wanted to do and feared the consequences of.

I think that the reviewer there makes a remark that if you're reading a book, you can lose yourself in it for awhile and put it away and go back to normal pursuits . . .

TW: Right. I love that it says basically by stealth, that you hide in the corner and read your book.

FR: Exactly, exactly! What I found totally fascinating about that quote was the implication being that what was much better than fiction, what was much better than reading novels, was something like playing backgammon or tennis or badminton or simply conversing with one another. Which, in other words, is games and social media. Games and social media were considered respectable, and fiction was not.

I think it definitely puts things into perspective.*

On the Air

In America, the outbreak of the Civil War led to a heightened literacy, and dime novels brought the penny dreadful *raison-d'être* to soldiers fighting brother against brother for the long, horrifying years of the American Civil

* The full interview, conducted by the author, was originally published on Focal Press' "Mastering Film" website at http://masteringfilm.com/digging-deep-an-interview-with-frank-rose/.

War. It was from these pages of wartime that the American pulps would evolve not more than 30 years later.

In 1896, Frank Munsey released the first pulp magazine, *Argosy*, made of rough, coarse, and unforgiving wood-pulp paper.* The combination of genre fiction, low price, and lurid material brought the once-deeply indebted Munsey millions. By the early 1900s, Munsey was pulling in over $9 million profit.[7]

Although serialized fiction eventually lost favor as a prose form (moving instead to the then-new medium of film, most notably in the crime-saga serials of French *auteur* Louis Feuillade, such as the *Fantômas* series and my personal favorite, *Les Vampires,* and giving way in the pulp pages to short stories and novellas), the pulps (much as the serialized magazines that published Dickens and his contemporary, the father of the "sensation novel," Wilkie Collins in the 19th century did) churned out literary luminaries such as James M. Cain (*Double Indemnity*, *Mildred Pierce*), Raymond Chandler (*The Big Sleep*), and Dashiell Hammett (of the aforementioned *Maltese Falcon*).

It wasn't just a public disinterest in serialized storytelling that caused the pulps to switch gears to a more self-contained form of storytelling. It was the rise of another technological innovation that brought serialized storytelling into the home in a more immediate and visceral way. It brought stories of drama, suspense, adventure, and comedy into the ears of families crowded around that magical device known as radio.

It wouldn't be long before the two entertainment forms started to bleed together.

"Who Knows What Evil Lurks in the Hearts of Men?"

With that ominous query, The Shadow burst into pop culture consciousness, thanks to Orson Welles and his Mercury Theater in 1937. The Welles Shadow and subsequent portrayals have cemented that familiar vocal sneer into the national consciousness, including his lovely assistant, Margot Lane, and that mocking, from-hell laugh.

But the Shadow that we know (well, some of us) today didn't start off that way. He began life on July 31, 1930 as the narrator of *Detective Story Hour*. So popular would the character prove that The Shadow would become the star of his very own pulp magazine less than a year later. *The Shadow*

* 1896 was also the same year that the first comic strip, *The Yellow Kid*, created by Richard F. Outcault, appeared in newspaper magnate (and *Citizen Kane* inspiration) William Randolph Hearst's *New York Journal*.

Magazine debuted in 1931, written by Walter B. Gibson, an accomplished magician and workhorse of a writer (in fact, over The Shadow's 20+ year pulp history, Gibson, under the pen name Maxwell Grant, would pen 282 of The Shadow's 325 adventures between 1931 and their cancellation in 1949).[8] Gibson, it's also worth noting, functioned as a ghost writer for Harry Houdini's books on magic and spiritualism.

Although forgotten by The Shadow's own radio show in 1937,* *The Shadow Magazine* pulp and the *Detective Story Hour* radio show were a crude, early form of transmedia storytelling (a shrewd—as most everything was at that time in the publishing world—blurring of the line between entertainment, branding, and franchising) with the same character existing in two different media. In The Shadow's first prose adventure, *The Living Shadow*, Gibson (AKA Grant) makes it clear that The Shadow of the pulps and the narrator of the radio show were the same person:

> But at the broadcasting studio, The Shadow's true identity had been carefully guarded. He was said to have been allotted a special room, hung with curtains of heavy, black velvet, along a twisting corridor. There he faced the unseeing microphone, masked and robed.[9]

While the stories didn't necessarily interact, the character existed in two different media and it was clear that The Shadows were in the same universe. By filling *The Shadow Magazine* with details such as a secret identity and a vast network of agents for a supporting cast, Gibson deepened the world of that narrator, so much so that one could imagine The Shadow narrating a radio episode between plot beats in the book, or before calling in one of his numerous agents to infiltrate a secret gang lair.

This was crude, early transmedia, a form of branded entertainment, grabbing fans of *Detective Story Hour* on the radio and pulling them towards the monthly, book-length adventures of the dark avenger of the night. Gibson and Street & Smith were offering the audience a bucket of LEGO®s.

Playing with LEGO®s

Let's pretend each piece of a story, each fragment of a different media, is one of those nifty building blocks. What separates transmedia from a franchise is how the pieces in a transmedia project play with one another. A book leads to a comic. A movie to a game. Characters pop out of one story into another. The pieces play with one another, locking together brick by brick (sometimes

* Also forgotten was the large supporting cast of agents working for The Shadow and his true identity, that of World War I aviator Kent Allard (the Lamont Cranston identity was merely one that Allard used).

the audiences will create their own bricks), and the final construction is your collective version of how everything goes together. Sometimes we "transmedia producers" (now a fancy title with the Producer's Guild of America) give you an instruction manual to make your castle or LEGO® TIE Fighter™.

This distinguishes a transmedia property from a franchise—not to be confused with "film series." A film series is the James Bond series; multiple sequels planned out in advance across a single medium. A franchise could contain a film series, a theme park, novels, video games—like the *Pirates of the Caribbean* franchise—but that doesn't make it transmedia as the story pieces don't fit together: like LEGO®s franchises (generally) are driven by the needs and wants of a conglomeration and the dollar. And, in spite of my apparent "stick it to the Man" declaration in the previous sentence, I won't deny that transmedia storytelling can make monetary sense. Grab the audience where they already are and exploit the devices they already use. Answer the cultural shift with a new storytelling culture. See? It makes sense.

But dollars and cents aren't what make transmedia storytelling so cool. What's fun about transmedia storytelling is figuring out new ways to make pieces of media play with one another. It's in that play that surprise and magic can happen—both for you as a creative, and for the audience who partake in the story experience into which you've invited them.

Transmedia and Tone Color

I have a bit of an unusual background. I majored in music composition, not writing or filmmaking. And I've always said that the most important lessons I learned about transmedia, I learned from twenty years of reading comic books (hence the next 200 pages of this book) and being a composer.

Orchestration courses were the bane of my existence. Not that I didn't enjoy it, I did. But I was the lone percussionist in a roomful of guitar players, and by default, I always had to teach the percussion section (which, like comic books, is viewed as the red-headed bastard stepchild of the orchestra—but, also like comics, we had the most fun). It all came back to the same lesson: tone color! Sure, there may be an infinite number of instruments in the percussion family (clap your hands, bang on a tabletop), but you need to know the sound you want in order to build the musical amalgam you wish to create. You need to know tone color.

Tone color is the specific sound capabilities of each instrument. You must know the strengths and weaknesses of each instrument to write them in such a way that produces the best blend of sound and color. Blend poorly, and you get a cacophony of crap. Blend them well, and you get Ravel.

And so it is with transmedia. Instead of violins or violas, drums, or marimbas, we're composing with media. Feature films and short films. Webisodes and blogs. Twitter. Facebook. Comic Books. Music. ARGs. Prose. Novels. Short stories and novellas. Cocktail napkins. It's all a vehicle for telling a story that grabs people and makes it irresistible for them to dive deeper into your story experience. In order to be relevant and have your work stand out, you have to know the defining characteristics of each media form you want to use.

The Defining Characteristics of Media Forms

Like any musical instrument, each media form has its own strengths and weaknesses. What works in one medium may not work in another. As I always used to say, I wouldn't write a piece for orchestra to be played in a dive bar. With that in mind, let me be very clear about something: I don't intend for these listed items to be the end-all, be-all statement of "this is what this medium is good for." I view these as the best practices, a foundation on which you can build. It is not meant to limit you, though many times, the most creative stuff comes from working within chains. Use them to your advantage!

Let's take a quick look at what a few select media do best:

Film—You can't beat the cinematic experience. But from a storytelling perspective, films are primarily based in action. What does a character do? Many films take the popular "two people talking" method, which goes against the very grain of what makes film film. As Alfred Hitchcock said of the advent of the "talkies," "these things are just pictures of people talking."

Games—You are the protagonist. You are sucked into a world that you must make better by your own actions. The world created by the developers may be massively immersive, letting you peer through newspapers, audio recordings, or all sorts of things. The time you spend in that world is greatly increased too as exploration is the key here. Or, they can be simple, casual affairs. There's a wide range of uses and types of games, and you have to pick the one that's right for the story, or stay away.

Novels and prose—What people think. Freedom of structure. Zero budget considerations (in the storytelling part of it anyhow). A personal connection and experience for the reader, as your work is being held in their hands.

Television—The heir apparent to serialized novels and immersion. Character-driven with ample time for the audience to get to know these characters. One welcomes your characters into their homes each and every

week. Long-form serialized stories can mix with episodic, "done-in-one" tales with an overarching theme/mystery.

Web series—the low-budget, immediate, consume-when-you want cousin to television. If television is the heir apparent to Dickensian serialization, web serials are the penny dreadful heir apparent. They're accessible anywhere with an Internet connection, and can foster extreme audience interaction and devotion thanks to the comment fields.

Comic books—Well, we're going to spend about 200 pages talking about their strengths. Needless to say, they can do a lot more than reveal backstory.

Social media—Immediacy, back and forth dialog. Engagement.

Playing Nice

If we know a few of the basic defining characteristics of media, we need to look at how to mix them together. It's only through careful selection and honest insight into the wants and needs of your project that you'll find how to mix the media forms into your cocktail. In other words, go with some trial and error.

I advocate irresistible transmedia. And the way to do that is to make the most of branching narratives, or a form of nodal narrative, separate stories connected by place or character that may not interact directly, but occur within the same world. A wonderful example of this in a single medium is Kar-Wai Wong's brilliant film, *Chungking Express*—two love stories that centered around a food stand in Hong Kong.

My own *Whiz!Bam!Pow!* is an example of nodal storytelling, taking the example from *Chungking Express* (and others), and using instead of a food stand, a comic book from 1939. Every single story spins out of that particular comic book—both in the pages of the comic book, *Whiz!Bam!Pow! Comics* #7, and from the fictional hands that both create and hold the book.

There are three ways that I like to combine media. The first is through character. Does a media form represent a character? What would they read? How would they consume media? Would my character be flattered by a comic book being done of their life? If I were doing *Mad Men*, I would do a comic book in the style of 1950s romance comics to relay the inner thoughts and fantasies of Betty Draper.

Would the character shudder at a home-video web series reality show? Would he keep a blog? Would he Tweet? Would he have a thousand Facebook friends, or a dozen?

The second is through place or object. *Whiz!Bam!Pow!* is connected by a comic book, and all of the media surrounding it comes from character. The lead character in the feature film always wanted to be in the pictures, so he gets the feature, which features the comic. In the novella, the lead character is a reader and artist, possessing the comic book, so he goes to prose. A supporting character in the feature (with the comic book) loves to talk, so they get a blog. Maybe a Twitter account.

And lastly, through theme. The stories don't continue and twist and turn through separate media. Each piece stands on its own (more on that in the next chapter). They are connected by a theme, by "secret identities," that feeling that not everyone is who they say they are. Even the radio show, which features The Sentinel, the character from the comic book, deals with his secret identity possibly being revealed, and him ultimately becoming the hero he needs to be.

Because I connect these fragments through natural means—character, theme, object within the world—a narrative thread emerges. Not one that is artificial or forced, but rather one that flows organically from piece to piece, deepening the project as it goes, and giving those who choose to absorb the project the choice of how deep they go—which is the central point of our next chapter.

Construct your LEGO® pieces through character, object, or theme, and you're on your way to making a transmedia project that will entice and excite an audience to dig deeper.

How Deep Will You Go?

From the penny dreadfuls to the most advanced transmedia tale possible, from words to images, moving pictures to games, the fragmented tale you craft is just part of the transmedia picture. Your media fragments must play with one another in fascinating and surprising ways. You must make it irresistible for your audience to pick at more pieces of your storyworld.

But there's one defining element, which, when coupled with the interplay of mixed media fragments makes transmedia transmedia—*choice*. Your audience won't be filled only with dedicated cos-players who will consume every single piece of your story with an obsession to rival Ahab. Your audience wants their media where and when they want it. They won't make appointments, and they won't appreciate having to go outside their comfort level to get every piece of your story (unless it's absolutely irresistible for them to do so!). They want to consume your story on their own terms.

You Must Remember This . . .

- The idea that we will consume all media in a single black box isn't just a fallacy, it goes against the very nature of our historical media consumption habits and the cultural implications of those habits.

- What we're seeing now is a readjustment to a 19th-century model of fragmentation, serialization, and democratization of media.

- What separates transmedia from a franchise is how the media fragments play with one another. While all transmedia is a franchise, not all franchises are transmedia.

- The fun in transmedia is in creating surprising and exciting connections between media forms.

- To craft an enduring and relevant transmedia story experience, you must know the strengths and defining characteristics of each media form you use and how to tell stories within that form.

Notes

1. Henry Jenkins, *Convergence Culture: Where Old and New Media Collide* (New York: New York University Press, 2006), pp. 14–15.
2. Ibid., 15.
3. Tyler Weaver, *Digging Deep: An Interview with Frank Rose,* Mastering Film. Available online at: http://masteringfilm.com/digging-deep-an-interview-with-frank-rose/.
4. Frank Rose, *Deep Media Online*. Available online at: www.deepmediaonline.com/deepmedia/2011/08/why-transmedia-is-like-a-walk-in-patagonia.html.
5. Ron Goulart, *Cheap Thrills: The Amazing! Thrilling! Astonishing! History of Pulp Fiction* (New Rochelle: Arlington House, 1972), p. 10.
6. Frank Rose, *The Art of Immersion: How the Digital Generation is Remaking Hollywood, Madison Avenue, and the Way We Tell Stories* (New York: Norton, 2011), pp. 92–93.
7. Ron Goulart, *Cheap Thrills: The Amazing! Thrilling! Astonishing! History of Pulp Fiction* (New Rochelle, Arlington House, 1972), p. 12.
8. Anthony Tollin, "Spotlight on The Shadow," *The Shadow: Two Complete Novels, #1.* (Encinitas: Nostalgia Ventures, 2006), p. 5.
9. Ibid., p. 4.

Into the Rabbit Hole
Depth and Choice

You stand in an art-deco underwater dystopia (formerly utopia), a gun in your right hand, a crackling ball of electricity flowing from your left. Spliced up former humans throw firebombs, shoot you, and scream in manic agony as their bodies are decimated by the drill of the paternally protective Big Daddy. After dodging the fireballs, screams, and sobs, you look at the walls, read the writing on them. You pick up an audio recording from a long-dead citizen, their last testament to the fall of a city of beauty, the undersea libertarian ideal of Rapture. You are immersed in the world of *Bioshock*.

Just as beautiful, just as powerful as the city of Rapture, as the story written by Ken Levine, is that ability to choose. You can choose to pick up an audio recording to hear the inner thoughts of the dead, the living, and the in-between. You can choose to look in deep, dark recesses, to see what's there. But you don't have to. You can follow the shiny gold arrow to the next objective, obliterating Splicers to your heart's content, electrocuting them with your electro-bolt, and proceeding to a linear resolution of the story.

Bioshock is irresistibly deep.

That inner desire to dig deeper, that choice to peel back the layers, to track down pieces of story, of character, is the beating heart of great transmedia storytelling. Only instead of living inside the four walls of a next-gen video game console and a spinning plastic disc (or digital download), it's spread across all of the media forms at our disposal in "the real world."

Transmedia is digital (and analog) archaeology. You place the artifacts, and give your audience the chance to put on their fedoras, whips, and well-worn leather jackets and embark on a journey of narrative discovery. In what order will they discover the pieces? How will they make sense of them? What new meaning will your audience ascribe to your work; meaning that you never saw but adds excitement to the work? Will your project stand up to the scrutiny of the collective consciousness, the community that surrounds your work?

Or will your audience be passive? Some will only wish to admire the pieces in the museum (hopefully not the *Raiders of the Lost Art* storage locker, where "top men" are studying it). The trick with transmedia is to make sure you satisfy and engage both the seekers and the seers.

Branching Narrative and Non-Linearity

Life isn't linear (in the sense that it has a defined three-act structure where A–B–C happens in order), so why do so many stories go down that road? By our nature, we function non-linearly. Multiple things happen at once, so instead of A–B–C, it's more like CA–B–D–AB, and so on. But it depends on the person. And so too does switching your thinking to a transmedia storytelling approach. Your audience won't absorb all of your story pieces in the same order. They will absorb them in an order that they decide from any number of external circumstances.

A character may appear in a feature film, but have something happen to them in a short film as soon as they walk out the door. In mono-media terms, we can look at things from multiple perspectives (Kurosawa's *Rashomon* being a prime example). We can split the narrative and throw it up in the air, piecing it together in new and exciting ways.

Nowhere is the branching narrative (and harnessing the power of your community) more well represented than on Wikipedia. I call this Wikipedia storytelling—with the overarching narrative or the project name as the top article, filled with links, giving you the option to dive deep into the world, or just pick one or two things to dive into.

FIG 4.1 The transmedia spiral.

To those who ask if this is really the way people want to hear stories, I have only one question: When you read a Wikipedia page, do you read the entire article before clicking on a link?

Click on one, and it takes you to another article that ties into and informs your understanding of the main article. Imagine that instead of linking to another

Wikipedia page, it links to a short film, to a comic book, or to a game. Whatever it is, it draws your audience in further to your world.

For me, the transmedia story experience looks like the spiral in Figure 4.1 above (with each node representing a different story piece).

Alternatively, a transmedia experience may be represented by a nodal structure:

FIG 4.2 **Nodal transmedia structure.**

The lines represent tenuous ties—not everything has to be deeply tied into the other. These tenuous ties also leave gaps for the audience (hopefully by now, an absorber, and an active part of a community) to create their own stories within your world—if you want to open your world up to audience-based co-creation.

The above two structures and representations run in stark contrast to how most media has been produced and crafted in the 20th century: a mono-media based, linear story, which is more like this:

We are creating story experiences in an environment where our audience wants to consume media on their terms. And their terms don't mean linearly.

FIG 4.3 **Mono-media linear structure.**

They want to pick it apart. To consume it on any device in any place: the subway, in bed, on an airplane, throwing back a pint.

While we may release our projects in a certain order (indeed, my own project, *Whiz!Bam!Pow!* was released on a set schedule playing out over ten weeks), our audience doesn't necessarily consume them in that order. It's up to us to make sure they work, however the audience may put things together.

In the ARG world, they're called rabbit holes, or trail heads. I like to call them Gateways. Gateways into a story, and they can be anywhere. Maybe the first experience your audience has with your work is the second episode of your web-series or a digital comic download. Maybe it's a podcast of your third episode of a radio show. Maybe they've been with you since day one. Maybe they find you after the release, when your project lives in some form of archive.

It doesn't matter. Whichever way they come to you, you have to give them something that frozen food media (my term for the 20th-century mass media) doesn't: choice. And, of course, great storytelling.

Standing on Their Own

The Matrix is a noble failure. Sure, it ignited a whole culture, sure it made endless shots of slomo bullet time cool, and it absolutely made use of nearly every single type of media available to it. But for all of its achievements, it has nearly condemned transmedia storytelling to a tool of the geek. *The Matrix* failed (forget the crappy second and third flicks) because it *expected* its audience to seek out every single piece. To the person who only wanted to watch the movies (the second and third specifically), they were lost in a sea of unexplained things that boggled the mind. You had to play the (crappy) video game (*Enter the Matrix*) to find out how Jada Pinkett's character got to the highway in *The Matrix Reloaded,* and if you didn't consume every piece of the puzzle, the third film, *The Matrix Revolutions*, was an incoherent mess. It was bold, it had some cool moments, but *The Matrix* (all-too-often discussed in transmedia studies, so my apologies for going into it again) failed. Its reliance on continuing plot lines in multiple media forms relegated it to noble failure. It was *expectantly* transmedia.

To be irresistible, your project has to offer choice. It has to give people the chance to consume any piece in any order, get a complete story, and then decide to continue to dive in.

The pieces of *Whiz!Bam!Pow!* can be consumed in any order. The audience doesn't even need to buy the comic book, the linchpin of *Whiz!Bam!Pow!*, to get the story. If they do, they will obviously deepen their experience, but it's not necessary. They could just enjoy the serialized novella, the radio show, or just the short film. But every piece is linked together through a character, an object or a theme (as mentioned in the previous chapter). It's up to the audience to decide on their own how deep they want to go into it.

So how do you build that element of choice into a transmedia project? Not by making something expectantly transmedia with "to be continued in a media device you don't own" slapped on its forehead.

It's deceptively simple. You tell complete stories. With a beginning, middle, and end. You can leave endings ambiguous, but the story has to be a complete character journey. It doesn't matter the length, the medium, for a story to stand on its own the character must complete their journey within the confines you've set up.

And remember, the fun of transmedia storytelling is in finding and creating fascinating and fun connections between media forms. Telling a complete story gives you ample opportunity to do so.

A journey can be long, or short. It can be an instant realization of a wrong, or an ongoing process of awakening. Whichever it is, make sure you make it irresistible for your audience to keep going deeper.

Passive vs. Absorptive Audiences

Great transmedia should not be *expectantly* transmedia. It should be *irresistibly* so. It's a lot like exposition, doled out when the audience craves it, not in blocks of voice-over narration and clunky scenes (or relegating pieces of story essential to the understanding of the story to media that not every member of your audience partakes in). There's a technique to it, a technique that has yet to be honed.

This goes back to my definition of transmedia as storytelling where the story is fragmented, but each piece should stand on its own. As I said earlier, transmedia (when done right) can give the audience what they crave, something they haven't had (the remote control notwithstanding) since frozen food media took over in the mid-20th century: choice (and two-way communication, either with characters or with the creators of the project).

There will be absorbers who will seek out each and every piece of your story. But they will only do so if they have an emotional connection to your world; if you've constructed a place where they want to immerse themselves, a place where they want to be.

And there will be passive viewers; those who want to watch a film, read a comic, play a video game, or read a book. There will also be audiences that meet you partway (like the chefs in the Midwest) by consuming a few pieces; maybe they want to get their toes wet.

It's through creating stories that work both as a whole and separately that we will engage and stimulate both audiences.

Time, Culture, and Story Absorption

As an audience and media-absorbing public, we're constantly bombarded with new content, all at the click of a mouse or swipe of a finger. And not only that, there are the day-to-day realities of life: jobs, families, fighting the old grouch at the supermarket for the last carton of milk.

Rising above the noise is the single greatest challenge media makers face— doesn't matter if we're talking transmedia or working in a single medium. All of those distractions function as the right-hand men of arch-nemeses *and* the primary transaction of the transmedia storytelling experience: time.

In a wholly unscientific poll on my website, tyler-weaver.com, I asked my readers three questions:

1. Do you consider yourself a Passive (watch the movie, watch a TV show, read a comic) or Absorptive (consume all the parts of a project, actively seeking them out) media consumer?

2. If you consider yourself Absorptive, what is it about the project or intellectual property that makes you seek out each story piece and become an active member of the project community? This can be anything, from the story, to the characters to the creators.

3. If you consider yourself Passive, what would make you lean towards being Absorptive? Anything? How many pieces of story do you consume?

Here are a few responses:

I'm both depending on the media. I have some shows I like, but forget about until a new episode pops up on my Hulu queue. Yet, ask me about Harry Potter sometime . . . my quest for people to talk to about it literally lead to a sequence of events that changed my life.[1]

Passive. I really, really want to be Absorptive, but I just never seem to manage it.[2]

I'm definitely Passive, although that is more because of lack of time, as opposed to lack of desire. I can be a bit OCD, and thus try to avoid getting sucked down the various rabbit holes. *Lost* was the only one that snagged me badly the past few years, and thankfully there wasn't that much extra material.[3]

Definitely Absorptive if the property warrants it. Perhaps I date myself, but I remember reading and re-reading the Lloyd Alexander fantasy series as a child and just wishing there was more to it than the five—albeit wonderful—books. I suppose I created my own brand extensions by writing to the author, asking for name pronunciation guides, dressing as

one of the characters every Halloween, and even scripting my own (no doubt dreadful, thank goodness lost) original script based on the storyworld and coercing my 5th grade "pals" to perform it, under my direction, for our teachers![4]

I'm Passive, but I wish I was more Absorptive. It's only because of lack of time. When I do seek out a project, it's because something about it jazzes me. I had to have heard about it somewhere to make me want to take the time out of my schedule to find out more about it. Sad, I know . . . but it's honest.[5]

Passive, but it's a time constraint thing. Once in a while I will visit a site for a TV show I really like to learn a little about the planning and sets, but it's a value added, use once in a while, not a necessary, feature for me.[6]

It's fascinating, but not surprising, that the number one issue in all of these responses is lack of time. This is worth exploring a bit. I've always believed that when film-makers release a film, it's not money that's the primary transaction. Money is a secondary transaction brought on by the primary transaction of giving two hours of your life to a project. Transmedia projects ask even more. They ask for dedication to get the whole picture (though, if done right, will give an engaging and fun experience with just one piece of your project).

One has to bear that in mind that when crafting a transmedia experience; we are asking a lot of our deepest absorbers, and we must make it irresistible and staggeringly powerful to get them to really dig deep.

On Question 3, "If you consider yourself Passive, what would make you lean towards being Absorptive? Anything? How many pieces of story do you consume?", this argument was really driven home:

As far as what would make me turn towards being Absorptive about all media, it won't happen. Sometimes I just need a little surface entertainment.[7]

I think for me it's about ease of finding things. I know that I don't normally "seek out" parts of a story. I don't often seek out anything; my blogs are delivered by RSS, my TV is series-linked on Sky+ (kind of like British TiVo). For me, if I were to be deeply involved in a story it would have to be a) automatically delivered to me or b) unbelievably strong and engrossing. And I mean unbelievably. I'm terrible at even taking in all parts of my friends' transmedia projects, let alone one I just come across via recommendation etc.[8]

It's hard to pinpoint. I know it's a piece of media that after consuming it my first thought is, "*I have to talk to someone about this*!", but why? I think

it's media that has mystery and calls for interpretation or prediction. *Harry Potter*, *Lost*, *Dr. Who* all have rabid fanbases that seem to form in order to say "What next?" and then obsessively collect and dissect clues. I think, for me at least, that's key. Simply enjoying something may get me to proclaim my love once or twice, but mystery and points of discussion are what make me want more, more, more!

For the things I'm passive about . . . I love *Modern Family*. It's one of my favorite new comedies and if anyone brings it up I will laugh and laugh with them. But I have two episodes sitting in my queue I wasn't aware of till this morning, and I'm certainly not on any *Modern Family* boards or websites. It's funny and enjoyable, but not engaging. It's a show you consume and then it's over. There's no "What does this mean?" or even "Will they or won't they?" which is the sitcom or dramas answer way or including mystery or suspense. It just is.[9]

If you want to build community, and make immersive experiences worth your community's time (the biggest and most important transaction in all media creation), you'd better make it exciting . . . and irresistible.

Questions in this case, are infinitely more exciting than answers.

Community over Consumers

I've grown to love the term "absorbers" and loathe the term "consumers." While that term may have rung true at one point, it has given (or should give) way to "community."

I remember my grandfather and mother watching *Twin Peaks*. After each episode would air on Saturday night, my grandfather would be up at the house the next morning to discuss the surreal narratives and mysteries that populated the world of Twin Peaks, USA. What were the secrets behind Laura Palmer's death? What does the Log Lady know? What does the log represent? It was a version of the "Water Cooler," the first social network and community surrounding a media work, only instead of a "Water Cooler," discussion revolved around a cup of (damn fine) coffee in a log cabin near Wooster, Ohio.

Today, community is different. But not really—they've just moved into the digital space.

Communities can become active collaborators (even if they don't necessarily effect the main narrative; the production process of a television show makes this extremely difficult). Turning again to *Lost*, look at things like the Lostpedia, a customized Wiki for the *Lost* community, where fans from the

world over came together to solve the mysteries of the show, character profiles, and more. It was, according to Frank Rose in *Art of Immersion*, "Such an important knowledge base that even writers for the show turned to it when their script coordinator wasn't available."[10]

As I mentioned before about *Lost*, where *Lost* succeeded—and its imitators failed—was in the importance it placed in its characters. The only reason the mysteries in the show (4 8 15 16 23 42, the Hatch, the Others, the Island itself) were the topic of such fervent debate and Lostpedia collective intelligence was that those mysteries both came from and affected the characters the audience had grown to love and welcome into their homes.

The mysteries in *Lost* created a desire to forage, to hunt for the truth, to discuss the truth, and to debate it. Fostering that desire to forage is among the greatest challenges facing the creative today. As Kevin Croy (the guy who started the Lostpedia) told Frank Rose, "Lost may not be interactive directly . . . but it creates an environment where people need to talk to each other to get the whole story."[11]

Building that desire is akin to creating "viral videos." You can't do it if you try. It's up to the audience to decide if they want to share; as Aaron Sorkin wrote in *The Social Network*, "It's not who I send it to, it's who they send it to." All we can do is create stories with compelling characters, a fascinating place, loads of conflict, and a theme that resonates with a vast number of people who will spread the word and build a community around those stories. Once that takes place, we have to be ready to harness that collective intelligence and energy to make an even better experience.

If foraging and hunting is a key, what is the highest form of community and audience engagement?

The Audience as Creative Collaborator

During the heyday of the pulps (1920s–1930s, basically before comics came along in the late 1930s), there was one that stood out among others in the hearts and minds of readers: Hugo Gernsback's *Amazing Stories*. In those cheap, wood-pulp pages, Gernsback introduced the world to the term "scientifiction," later to be known as science-fiction.

Among Gernsback's greatest contributions to "scientifiction" was the publishing not only of the letters of his readers, but their complete addresses as well. He created his own version of a social network, inspiring kids in the 1920s to come together over their mutual love of this new, fantastic medium.

He inspired them to create their own stories, and the first fan magazine too—*Cosmic Stories*, of which only ten copies were made at a school in Cleveland, Ohio, and all the stories were written by one author using pen names to make his magazine seem as grand as the one that inspired him.

His name was Jerry Siegel and, about ten years later, he would co-create one of the most enduring pop culture icons of all time.[12]

In the 21st century, the deepest form of immersion and flattery is not imitation, but fan fiction and dedicated fans of your property using your property to express themselves creatively, as well as learn essential skills, such as overcoming the fear of criticism and gaining a knack for informed conversation and discourse through the peer-editing of their works in a public forum.

While transmedia properties generally function as a storytelling expression of a single creative or team of creatives (*Lost*, *Avatar*, *The Matrix*), we're creating stories in the YouTube generation. While not every single person watching your story on their phone will turn the cameras on themselves and create their own fan video or remix, the urge and capability is there. Why do they have the desire to do this?

They'll desire to do so if they're emotionally connected to your story and your characters. They will want to insert themselves into the world you've created, be it because of the themes, the characters, the vibrancy of the world (think *Star Wars* and the legion of fan-fiction, videos, parodies, and homages it's inspired).

This brings up the issue of control. Who is in control of a transmedia property? How do you balance canon-based creation with the creations of those who are moved to create their own works because of the work you've done?

Creativity in the Digital World: Decentralized and Democratized

In spite of their political connotation, the terms "decentralized" and "democratized," don't imply politics here. By "decentralized" I mean that we are loosening the grip of corporate and conglomerate-controlled media, of "leaving it to the professionals," and embracing our own natural creativity. "Democratized" implies that the tools of content creation across multiple media are at our fingertips—movie editing software comes with nearly every computer today. Even telephones, those things that once astounded my Midwestern upbringing with their new-fangled cordless technology have video cameras in them, marking the rise of the "Citizen Journalist," and new, on-the-spot, unfiltered visions of social uprising (the Arab Spring) as well as

lighter fare, such as skateboarding bulldogs, surprised kitties, or wiener dog races. Anyone can create, write, be published, and be visible to the world with the touch of a button.

What's more remarkable is the relatively short period of time it's taken for this to happen (most of these changes have happened in the last decade). What's even more remarkable than that remarkable fact is that it's not anything new. It's the way creativity has been done since the beginning of time. It's only in the 20th century that we heard that shudder-inspiring phrase, "leave it to the professionals."

Again, turning to Lessig's *Remix*: "The twentieth century was the first time in the history of human culture when popular culture had become professionalized, and when the people were taught to defer to the professional."[13]

How many times have we heard "leave it to the professionals"? In my career, one too many times. Even in music school, and as an ardent student of cultural history, I was turned off by the feeling that we couldn't aspire to be as great as the greats we studied. That they were put on some form of pedestal, that even Batman with a grapnel boost couldn't reach.

But all that's changing (finally), and getting back in line with a popular culture that leans towards the folk and amateur (not used condescendingly, but from embracing everyone's urge to create cool stuff) from the 19th century.

When absorbers of your story experience or franchise or film or book or comic want to create their own stories using your characters, I have one piece of advice to impart on the matter: Don't stop them.

Warner Brothers learned that lesson the hard way with *Harry Potter* (check out Henry Jenkins' *Convergence Culture: Where Old and New Media Collide* for a detailed story of how exactly the "PotterWars" debacle went down) with public relations and legal departments unaccustomed to the wants and needs of its new breed of consumer—as well as a desire to maintain control over their copyright—the absorber, empowered and emboldened by the democratization of creativity and their own love of the *Harry Potter* property.

Copyright law is out of touch with the realities of the present day. We're in a brand new creative (or hybrid, as Lessig points out) economy, and the copyright laws designed during the heyday of frozen food media a generation ago are not up to the task of this decentralized, democratized, and creatively empowered digital culture. To deny the absorbers of our work the opportunity to use that as a springboard for exploring their own creativity runs in stark contrast to the clear needs and wants of our culture.

I advocate a happy medium between closed doors and high barriers of entry and glass houses, almost a Firefox/open-source model of creative, audience collaborative storytelling. While there are official releases from Mozilla of Firefox, and the software is completely open, and they do take suggestions and help from the Firefox community in official releases, there is no doubt of the Firefox brand of browser. It's not a hodgepodge of ideas (they do allow user-generated and designed extensions and tools), but a cohesive brand that allows user-generated content and non-branded uses of its code.

I don't advocate allowing creators of fan-generated content to profit from your work, and 90 percent of the time, they don't have any intention to do so (in spite of what we may hear in the media). They want to create because they've formed an emotional connection to your world and want to be a part of it in any way possible. It should be considered a testament to your work that you've engrossed and excited an audience in the way that would inspire them to explore their own creativity. Harness it.

The Choice Is Theirs

Transmedia is not about the media. Transmedia is about immersing audiences in story experiences so compelling that they will form vibrant communities around it—and giving that community the chance and tools to thrive. It's about being where your audience is, allying yourself and your work with their absorption and consumption habits, and taking that knowledge and giving them not what they wanted, but what they didn't know they wanted in the first place.

Transmedia is about discovery, and the choice of how much the audience is willing to discover. You cannot make things so convoluted and complex that they will be overwhelmed, with stories concluding in one medium then jumping to another, with little to no regard for choice. We are as much in the hands of the audience as they could be in ours.

As a composer, I held strong to the belief that my work was only 50 percent of the act of composition and creation. The other 50 percent lay in the hands of the audience and those performing the work. In transmedia storytelling, as in music, it's what they bring to the work, the new meanings they find, the embellishments and deeper layers they'll peel, that brings the magic to the method.

Once our work is complete, it's up to the "people formerly known as the audience" to make it grow and prosper. And to allow them the freedom to do so, we must be aware of the culture in which we're creating. While it's highly unlikely that any copyright change will affect already existing franchises and works, it creates a window of opportunity for independent projects to harness

that innate desire among absorbers of media to immerse themselves in stories and in the worlds we create, and in doing so, thrive. It's through a collaboration between fan and producer that the future of storytelling will be paved.

You Must Remember This . . .

■ Choice (along with fragmentation, interplay, and depth) is the fourth linchpin of transmedia storytelling.

■ Great transmedia storytelling must be *irrestistibly* transmedia, not *expectantly* so.

■ All media fragments of a transmedia story experience must be able to stand on their own, and be part of the larger experience, deepening the world you've created.

■ Your audience will be filled not only with those deep absorbers, those who want to engage with every single piece of your story experience. There will be passive viewers who only wish to consume one piece. We must satisfy both. And the way to do that is by creating stories that not only operate on their own, but deepen the whole.

■ Time is the number one issue preventing people from digging deeper into a transmedia world. And in all media creations, time is the primary transaction between producer and absorber. Never forget that no one owes you their time.

■ Current copyright law is anathema to today's creative economy and digital reality. It was designed a generation ago during the heyday of mass ("professional") media, and must be amended to suit the needs of a decentralized, democratized, and creatively empowered 21st-century digital culture.

■ The ultimate form of commitment to, and immersion in, your story is when the audience begins creating their own works (fan fiction) using your characters. Don't be afraid of this. Harness it.

Notes

1. Tyler Weaver, *POLL: Passive or Immersive Audience*. Available online at: www.tyler-weaver.com/2011/09/23/poll-passive-or-immersive-audience/(comments).
2. Ibid.
3. Ibid.
4. Ibid.
5. Ibid.

6. Ibid.
7. Ibid.
8. Ibid.
9. Ibid.
10. Frank Rose, *Art of Immersion: How the Digital Generation is Remaking Hollywood, Madison Avenue, and the Way We Tell Stories* (New York: Norton, 2011), p. 156.
11. Ibid., p. 153.
12. Gerard Jones, *Men of Tomorrow: Geeks, Gangsters, and the Birth of the Comic Book* (New York: Basic Books, 2004), pp. 29–37.
13. Lawrence Lessig, *Remix: Making Art and Commerce Survive In the Hybrid Economy.* (New York: Penguin, 2008), p. 29.

Building Gotham City
The Transmedia Story Experience

We've got strong characters. Fascinating stories that weave in and out of each other, giving our absorbers (and passive viewers) the choice of how deep into the story they go. But what's the final element? What do all of these pieces add up to?

The last piece of the puzzle is the massive realization of "place." We must create vibrant worlds in which our stories take place. The Island on *Lost*. Batman's Gotham City. *Twin Peaks*. Pandora in *Avatar*. Hyrule in *Legend of Zelda*. We have to make our audience want to visit this place through story, and simultaneously give ourselves, as creatives, a sandbox in which to play.

Details, Details, Details . . .

When I explained transmedia to my grandfather (now 85), I used the example of the small town he lives in. I told him to look at the neighborhood. You have multiple houses, a park, a school, and a town just down the hill. Inside each and every one of those structures is people—characters—with stories to tell and to be heard. Now imagine that we tell one of their stories as a web series. Maybe one of the characters crosses over into the short film of another. Maybe a supporting character in the web series shows up in a comic book that is spawned from the mind of one of the kids in the neighborhood. Maybe that same kid has created a new playground game that becomes a small, casual video game. Or maybe there's a deep, dark mystery hidden inside the small town that must be found, resulting in an ARG, or the overall arc of the story.

Nadia Boulanger, the great music composition teacher said, "all great art is created within chains." What are the rules of your world? It doesn't matter if it's a far-off planet with crazed tentacled aliens or the harsh realities of an inner-city ghetto. Every world has its rules, and you need to define them.

It's these things that make the world you create go round. You have to make the transmedia exploration of your storyworld irresistible, not expected. Surprising, not required. Fun, not work. And if you fill your world with details and chains (like *Bioshock,* like *Grand Theft Auto IV)* being irresistible follows quickly.

The Sandbox

Grand Theft Auto IV was one of the biggest influences on my own *Whiz!Bam!Pow!* project. I'm sure that comes as a surprise, but there was something about it that appealed to me (other than the total freedom to do whatever you wanted). Its open-world sandbox fulfills multiple functions for me—one day, it can be a chance to drive around a city. Another, an engaging narrative through-line with compelling characters. And yes, it can be great stress relief after a bad day.

Characters weave in and out of the narrative. A character you first meet on the boat coming to Liberty City shows up as a small side mission in Algonquin. A man whose life you spare (if you choose to spare it) shows up near the end of the game in Alderney. *GTA IV* even has its own Internet that fleshes out the world even more, through FOX News-inspired reportage, adding layers to stories, even setting up tales that will be explored in an expansion pack. A character briefly shown in a bank robbery becomes the lead character in a whole other game set in Liberty City that intersects and connects with the main narrative of *GTA IV*.

Now, imagine that taken out of the sandbox world of the game and brought into real life. Imagine if instead of another game, the character from the bank robbery had his own web series. Or if he were tweeting from the scene of the robbery. Imagine if those news stories were text messages delivered to your cell phone. Welcome to transmedia—a sandbox on top of reality.

That was what we set out to do with *Whiz!Bam!Pow!*—to create a sandbox of the Golden Age of Comics, a sandbox where both the creators and readers of the comics and the superheroes that populate their pages intermingle around a theme of secret identities. Newspaper articles inspire things in the feature film, which ties back to the comic book presented in the novella. We managed to lay the foundations for an unlimited chance to play, a sandbox we can revisit any time—and invite others to play in as well.

Really, all storytelling is about playing with action figures. And now, my action figures are different media forms.

Thought Balloon: Dr. Christy Dena

Dr. Christy Dena is the director of the Director of Universe Creation 101, a company where she develops her own creative projects and entertainment services, as well as consults on cross-/transmedia projects. She has written a dissertation on transmedia practice and blogs war stories at YouSuckat Transmedia.com. In this interview, we discuss the basics of transmedia storytelling and lessons for creatives considering making the jump to a transmedia project.

Tyler Weaver (**TW**): What storytelling possibilities does transmedia story-telling offer? In what ways (other than the obvious) does the storytelling differ from a mono-media approach?

Christy Dena (**CD**): What I love about transmedia is that I can combine artforms that I love through a beautiful creative challenge. It is hard to make different artforms work together in an elegant way, and I love that both digital and traditional media can work together. Another thing I love about transmedia is the ability to play with the variety of story (and game) approaches. Episodic storytelling in mono-media (a film trilogy, TV or book series for instance) enables the writer to delve deep into the characters lives. You can do this with transmedia, but you also have the restriction/opportunity of delving into those lives with different artforms. That changes what you can do and allows you to play with your world more.

TW: For anyone considering a transmedia approach to their story, what is the one piece of advice that you'd give them?

CD: Use artforms that you love. Painters, film-makers, and game developers all work with the artforms they love. For some reason when people are exploring transmedia for the first time, they often choose media that is popular. I understand many projects are created to target a particular market. But if you're serious about exploring transmedia as an artform, then create with media that you already work with, love, or are genuinely curious about. These drives will give your project a starting point that comes from sincere expression, not cheap mimicry.

TW: How open do you recommend content creators be to allowing the audience to expand and create their own stories within a universe?

CD: Frankly, I do not recommend creators be open if they're not already inclined that way. Creating projects that encourage, acknowledge and utilise audience-created content have different design requirements. It is a different project, and it is hard. If you're not interested in seriously doing it, then I don't recommend they go there.

But it should also be noted that you can't stop your audience doing anything. So while your project may not be designed for audience expansion to be a part of the main project, there are other options. Acknowledgement of their self-driven efforts would be ideal!

TW: What is the biggest mistake you see creatives making when shifting to a transmedia aesthetic? How do you recommend they fix it? There are a few that I see happen over and over again, and so I'll quickly mention them.

CD: As I explained earlier, creatives rarely choose media platforms according to what they have skill in, love, or are curious about. Ask if the artforms you choose have a function other targeting a certain market (or perhaps even cost), if not, then choose again.

I've seen many creatives not consider points-of-entry (POE)—the different paths through your entire project. If you have spread your narrative across different artforms, then your audience will be able to access your story in any order. Some may read the comic first, and then the webisode, and vice versa. So I always recommend creatives do a POE check. If there is a particular order they want to encourage, there are various techniques they can institute to control the direction of access. However, if you have no control over POE, then make sure the plot works no matter what order.

Newcomers often create or commission content in another medium that is insubstantial. This is another symptom of not seeing the collection of artforms as being an equal part of the meaning-making process. While there is nothing wrong with having small pieces of content spread across your different artforms, there needs to be a conscious decision about the degree of depth. Consider how much effort it takes to access or use the artform. If a moderate to high amount of effort, then make sure there is enough content there to justify the activity. There are other reasons for providing substantial content, but this is one that crucial.

TW: Is transmedia really anything new? Or has it always been around and we just now have a name for it?

CD: I have presented and published on this topic many times, because it is an important one. If we classify transmedia as the employment of multiple media platforms (artforms, environments, whatever), then there have been artists doing this throughout time. However, if you view transmedia as the latest development in franchise practice, then it is new. I personally think the urge to combine media that have been artificially separated will always happen. It is an artistic urge that will keep inspiring generations of practitioners.

TRANSMEDIA TOOLS: The Story Bible

You've no doubt heard of this. But what is a story bible? First, let's take a look at the first word: *story*. As I discussed in Chapter 2, story consists of five elements: character, conflict, risk, place, and theme. In your story bible, you should aim to include all of these elements in varying degrees of detail. And

for the "bible" portion, well, that's pretty self-explanatory. This is where you lay out the rules of your world.

Questions

The first question you must ask when creating your story bible is "Will this be useful and readable by my team?" The second one is "Will this give my team the room to add their own creative voice to it?" No project is created in a vacuum, and you must be willing to leave room for interpretation, creativity, and, of course, room for your audience to create their own works.

All great projects are based around questions, and your story bible should be no different. Who are your main characters? What are their relationships and conflicts with each other? It doesn't matter if your project is a romantic comedy or *Halo*. All great stories have characters in conflict with one another. What are those conflicts?

A story bible consists of questions you wish to answer by telling stories in different media. You need to lay out the key basics of each character prior to the start of the story that will feature them. This story bible is the place that backstory lives—some may show up in the work, others will inform the work itself, as well as (if you're doing a film, web series, or other visual storytelling means involving players) the actors who will bring these characters to life.

When laying out a character there is no such thing as too much information. Just because you won't use it in the story proper doesn't mean that it doesn't exist. And for that matter, your characters will shine and come to life in ways they wouldn't otherwise. Remember, as people, all we are is the sum of our experiences, and our reactions to the obstacles we face come from those.

As important in transmedia storytelling as character is place. Often, the "Fifth Beatle" of storytelling. What is the town or planet or house like? How is the furniture arranged? Where do your characters meet? What's the Internet connectivity like (characters that have a Twitter feed but no Internet access in the story don't work)? Are the roads paved? Gravel? Is it a *Twin Peaks* type small town? A neon nightmare like *Blade Runner*? A deep ecosystem like Pandora in *Avatar*? All of these details should be spelled out in your story bible. They will make the experience of absorbing your story that much more vibrant and alive. You will create a place that people want to visit (or avoid, but still find themselves sucked in).

Theme

You should lay out the defining theme of your story, ideally in one or two words right up front. Is the story experience about secret identities? Finding

love where you least expect it? These are the guiding principles of your story and a key element in building interest.

If your setting is an elevator, for example, that's not very interesting. But if you add a fascinating guiding principle or theme, like finding love where you least expect it, and place the elevator in an unusual place, like the JFK Conspiracy Convention, you've got the building blocks for a fascinating world of conflict, drama, and engaging characters, all revolving around that core principle.

Genre

While some stories may have a defined genre, like sci-fi, other projects don't. For instance, *Whiz!Bam!Pow!*, has a guiding principle of "secret identites," but the genres in which that theme is extrapolated change from media to media. In the comic book, it's superhero action. In the film, it's family dramedy. In the novella, it's a hybrid of drama, hero's journey, and 1950s crime novels. Never be beholden to one genre—and remember, just as media choice can be defined by the wants and needs of a character, so too can genre.

Other Considerations

I view a stark line between an internal story bible and one used to fund the project or attract investment. In a later "Transmedia Tools" section (pp. 238–239), I will explore what goes into the transmedia pitch (still an evolving art form in and of itself), but for now, stick to the key tenets of describing the world of your story experience to your internal team.

Living Document

You have to think of a transmedia project like a product launch with a story at its core. In keeping with that theme, you have to accept that your story bible will not be static. Indeed, it may be more like a Wikipedia page, ever-evolving and adapting as you move forward. Think of it less as a full-fledged orchestra score and more of a jazz chart: the melody's there, the chords are there, and you (or your audience) can improvise based on those melodies and chords. When it gets off track, or you get lost, you always have a road map to return to the tune.

Never close yourself off to ideas just because it's not written in "the bible." Write it, add it, and let your sandbox grow.

Go Your Own Way . . .

We've picked apart my definition of transmedia, explored it in all of its implications and ideas. We know that in any transmedia project, format can never trump story. This is the single most important lesson you can learn about transmedia storytelling. I don't care about the technology behind it. I care that the story gets across in the most exciting and engaging way possible.

Let me reiterate one of my words of warning about transmedia storytelling: not everything should be transmedia. Just because it's "in," or the prevailing winds of popularity are shifting towards it, doesn't mean that it's the end-all-be-all option for every single story.

Let's take an example to prove my point. I mentioned that Dashiell Hammett's *The Maltese Falcon* originated as a serialized story in the pages of *Black Mask* magazine. It was then released as a book, with more than 2,000 textual differences between the novel and serialized version, many of which assumed to have been made by Hammett himself.[1] So, the *Falcon* has been serialized, then transformed for the novel. It was adapted as a film three times in ten years, from 1931 to 1941 (the second time as a comedy), and as a radio show. But it was that final version, the 1941 version starring Humphrey Bogart that crystalized *The Maltese Falcon* as an icon. Would *The Maltese Falcon* be as highly regarded today if it were released as a transmedia project? Not at all. It represents a complete journey for a character (and the Bogart version differs very little from the Hammett original, with writer/director John Huston copying word for word from book to script in several cases), and doesn't need the extensions. It makes no sense.

Transmedia is all about choice and depth. If you have a story that would benefit from the audience going deeper, then go for it. If you can create a vibrant world and want to invite your audience in with that secret handshake, go for it.

You should only use transmedia if it makes story sense and makes your project better. Avoid the chatter about how this is the future of storytelling and how we should all jump on the bandwagon. Remember, most great art was created by those who went their own way.

All I Needed to Know . . .

When I started thinking seriously and deeply about the type of storytelling that will become the norm in the 21st century, I realized that I've been surrounded by it my whole life, just with different delivery systems.

From my days in the bathtub deciding the fate of Cobra Commander to the release of *Whiz!Bam!Pow!* to the publication of this book, this brand of storytelling has been in my blood, even if I didn't know what to call it.

But there were two things that taught me all I needed to know about transmedia storytelling. The first is my training in music composition (discussed at length in the "Transmedia and Tone Color" section of Chapter 3, p. 28) and the idea that a medium is nothing more than another instrument in an orchestra. Like a composer, we have to know how to blend and merge media, creating a wall of sound that will engage and delight an audience.

And the second? Comic books. The subject of the next 200 pages of this book. From the time I pulled my first comic off a spinner rack, I was entranced by the form, by the modern mythologies and in-depth storyworlds they created. Multiverses, universes, canon, crossovers, and creations that have endured for over 70 years. How did they do it?

The Spinner Rack

When my writing partner, Paul Klein, and I were launching our IndieGoGo crowdfunding campaign to fund *Whiz!Bam!Pow!*, we struggled with the campaign video. We tried talking about it, about how things would tie together, but there was something missing. People weren't getting it. Maybe it was in our presentation. No, there really was something missing.

Then we looked at a staple of my office: my antique spinner rack. We looked at the steel head, and the four wire columns that would rotate around. And in looking at it, we figured out how to explain *Whiz!Bam!Pow!*.

It's the 21st-century version of a spinner rack. Each column down represents one volume (we've broken *WBP* up into four volumes). Each rack space represents another media form. And you can pull any media out of there and engage with it and be told a story. Then you can pick another one. And it will stand on its own, but also deepen what was told in the first piece you pulled out, and so on and so forth. It was that spinner rack that fueled the fire in me to create *Whiz!Bam!Pow!*, and 20 years earlier, to pick up my first comic book.

It is that spinner rack that represents the beating heart of transmedia: choice and possibility. And to a nine-year old me, it sent me on a journey that has culminated in the writing of this book. With a solid foundation in place answering "What is transmedia?", it's time to go into the second part of the book—the stylistic evolution of comic books.

Note

1. Otto Penzler, *The Black Lizard Big Book of Black Mask Stories: The Greatest Crime Fiction from the Legendary Magazine* (New York: Vintage Crime/Black Lizard, 2010), p. 105.

Comics
The Creation and Evolution of a Medium

The Elements of Comics Storytelling

The spinner rack represents transmedia, its multiple tiers filled with adventure, possibility, and choice—the choice of depth, of how far you wish to immerse yourself in a project. Each space represents a different form of media, and you can pick and choose which piece of media you absorb within a project. All? None? A few?

When I looked at my first spinner rack at the age of nine, it represented a different kind of choice: the choice of which comic book would be the first I would read, consume, and absorb; the choice that would lead to a 21-year journey of adoration and frustration, and ultimately, this book. The comic book I chose was NOW Comics' *Green Hornet* #3, written by Ron Fortier (who will discuss writing comic books and the Silver Age of comics in Chapter 12's "Thought Balloon"). The feel of the pamphlet format, the colors, and especially the Dave Dorman cover grabbed me immediately.

I was hooked.

Part of what grabbed me with comics was the history of them, the evolution in storytelling, and the spirit of experimentation and "anything goes" that shaped and formed the medium we know today. In all of my creative work, history has played a significant part. Whether I was making documentaries of events in the 1960s or learning the ins and outs of the compositional techniques of the great composers, history has been there. What this experience taught me is that nothing is done in a vacuum, and that history is of a whole cloth.

The next pages are less a history of comics (for a detailed look at the publication history of comics, and the drama behind the pages, I highly recommend Gerard Jones' *Men of Tomorrow*), more a look at the stylistic evolution of the comics medium.

From its beginnings as marriage of newspaper strips and pulp magazines to today's digital comics that integrate a variety of media and are free of format (and, as Frank Miller put it, free of being "slaves to people's Mylar plastic bags,"[1]), there has been a set of storytelling tools that have been bent and molded into powerful stories that have been an integral (if outlaw) part of the popular culture for more than seven decades.

There really are very few components to a comic to exploit. It is an elegant medium, simple, with the power of being either escapist fun

(the superheroes in the Golden and Silver Ages) or the most soul-searing work of art imaginable (art spiegelman's *Maus*, Will Eisner's *A Contract With God*). A medium that is capable of carefree escapism and Pulitzer-Prize-winning art using the same tools is worthy of study, appreciation, and, most importantly, love.

The point of this stylistic evolution/history of a medium is not a boring history lesson. It's to give you a vast toolbox to mine. My own *Whiz!Bam!Pow!* project would not have happened if my team and I didn't know our comics history and have an unbridled love of the Golden Age of Comics, down to the smallest details. It's in that attention to detail that we'll find the great things the medium can offer. Think of it like those little character moments in movies; the looks, the glances. It's in that elegant simplicity that great storytelling can be found, harnessed, and appropriated for your own work.

Beyond the stylistic perspective, we'll also look at what it is about comics that creates such a dedicated fan base, as well as the lasting mythologies that have endured for more than 70 years, constantly reinvented for the times in which they are absorbed. No stylistic movement happens in a vacuum, and in order for a style to be mined and utilized, the societal implications of the rise of each new form of storytelling must be explored. It's only by understanding where we come from that we can lay the foundations of our future.

We'll also look at what's wrong with the current direction of the comics business: missed opportunities, a shift towards nostalgia rather than being of their times, a more exclusive than inclusive attitude (in spite of wanting and needing new comics fans for the medium to survive). It's my belief that at this point, with the comics in such a state of flux, a vibrant "third party" of comics can arise from creatives in other media who can bring their own audiences to comics and open up the rabbit hole of the comics medium to a whole new set of eyes, waiting to be excited by something they haven't yet experienced. That third party cannot rise if it doesn't understand the medium in which it is working, a medium that has offered so much to so many, yet remains viewed as the illegitimate bastard of other media.

What are those elements of comics storytelling? Let's dissect them—and to do that to maximum impact . . .

The Team

Here's a quick look at the team members that put a comic book together. It can be a number of people or only one, but here are the roles that are needed:

- **Writer**—Writes the script for the artist to draw. Functions as the writer and director.

- **Artist**—Includes the penciller, inker, and colorist. In the indie comics world (as well as the likes of Will Eisner and Frank Miller), these roles are often taken by a lone person (who also sometimes will write). They are both the cinematographer and the actors in play.

- **Letterer**—Marries word with image either by hand or by computer.

- **Editor**—Edits the book for content, grammar, and continuity errors.

That's a very simple, very spartan look at the comics team, but you have to bear these roles in mind as you look towards creating a comic book for your project. Even if you write it and draw it yourself, be aware that there are several roles you will have to fill. And I haven't even brought up publishing and printing.

FIG 6.1A Art by Blair Campbell.

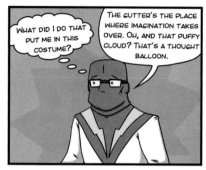

FIG 6.1B Art by Blair Campbell.

Let's go over that again, now that I've gotten that huge book off of me. The main elements of comics storytelling are:

- page
- panel
- art
- narration
- word balloon
- thought balloon
- sound effects
- gutter
- grid.

That's it. Everything that comes from comics, every piece of art, every masterpiece, every piece of crap, comes from that list and the combinations thereof. Throughout each period of comics, we'll look at that period using the "Elements of Comics" as a guideline. In those sections, my *Whiz!Bam!Pow!* collaborator Blair Campbell and I will create a two-page story featuring an original character—Rocketbolt(!)—using the storytelling techniques available at the time we're covering. How did they use the grid? Was it fairly straight and narrow? What about the art? When did thought balloons go out of style? What about little details like panel numbers in Golden Age books around 1938–1939 (because the medium was so new, people didn't know how to read it; these served as a guide)?

Coupled with this analysis, we'll look at the culture in which comics thrived, in which they floundered, and where they paved new roads. A stylistic viewpoint can't go anywhere without a deep look at the culture in which those comics were created. As I said in the transmedia section:

> In any society, the depths to which people seek to escape into entertainment is determined by the times in which they live. The stories and themes must be of their times, their themes relevant, and their values commensurate with the values of those who will hear those stories.

We'll explore the storytelling evolutions in comics throughout history, some surprise connections with today, as well as use that history to point out what comics makers and publishers today can learn about making comics relevant to a whole new generation, by looking at the ins and outs of the society in which they are created. Also, we'll take a look from the perspective of other

media-makers, the film-makers, animators, game designers, and transmedia producers of the title to explore what they can learn from comics.

History is of a whole cloth, and so is story. The media landscape today is the Wild West—and now it's time to go back to the Wild West of the Golden Age of Comics.

You Must Remember This . . .

- The elements that go into creating a comic book are very few. They are: page, panel, art, narration, word balloon, thought balloon, sound effects, gutter, and grid.

- Any stylistic evolution must also be viewed through the lens of the audience—especially with comic books, as they have inspired a devoted and rabid fan base since their inception.

- Several things pioneered in early comics have relevance and usage for transmedia producers and mono-media creators today.

Note

1. Charles Brownstein, *Eisner/Miller: Interview Conducted by Charles Brownstein* (Milwaukie: Dark Horse, 2005), p. 15.

The Funnies, 1933–1938

The comics of the Golden Age can be defined in two words: simple fun. The "simple fun" tales woven in the Golden Age laid the foundations for the most vibrant of American art forms. It's from these nascent fever dream stories that the comics medium grew into the expressive and vital storytelling medium it is today.

The Golden Age was a time of experimentation, of searching for (secret) identities. It was the time that arguably the greatest contribution to storytelling of the past hundred years was born—the superhero, a cocktail of the archetypes of mythology and the power fantasies of male teenagers emerging from the Great Depression.

What no one knew at the time was that they were ushering in the age of superheroes, the Golden Age of Comics, and their creations, innovations, and storytelling techniques (or lack thereof) would inspire and endure for more than 70 years, recognizable across all cultures, and would influence generations of storytellers to bring their own brand of amazing and action to the world.

But to get there, it was a road of media marriage, growing pains, and shady deals.

While the pulps continued their reign, featuring novellas and short stories every month, and radio brought serialized (or episodic) adventure, comedy, mystery, and suspense into homes each and every night, providing escapism for families (who could afford them) ravaged by the 1929 onslaught of the Great Depression, a newfound desire to escape, to rise above adversity, to better yourself for the common good emerged (and in the publishing world, to make a quick buck by exploiting the tastes of your audience). Cheap, simple, thrilling entertainment was the order of the day. It was from that confluence of idealism and monetary sense that comic books emerged in 1933.

In that year, *Funnies on Parade* was produced by Harry Wildenberg and Maxwell Gaines. Acquiring reprint rights to several comic strips, Wildenberg sold the book to Procter & Gamble, as a promotional giveaway.[1] This wasn't the first time that reprint collections of newspaper comic strips were released—The Yellow Kid, the first "comic strip," was collected in book form in 1897—one year after its debut. Also in 1933, Jerry Siegel and Joe Shuster

Formats:
The Anthology

Any new trend in media steals from things that worked before it. Comics bore its pedigree—the lovechild of newspaper comic strips and the pulps—on its sleeve, and was consumed by eager audiences in the anthology format. Any particular issue could feature up to six stories (predominantly non-connected), including prose pieces (Marvel Godfather Stan Lee got his start with a prose piece in 1941), another carry-over from the pulps. These books (comic magazines, as they were originally called) were testing grounds for new characters and stories. Characters that resulted in stellar sales figures often got their own solo series.

Several anthologies are being published today, including *Heavy Metal* and *Drawn and Quarterly*. *Action Comics* stopped being an anthology in the 1950s, shifting entirely to Superman solo stories, while *Detective Comics*, the series that brought Batman to the world, shifted to a Batman solo series in the 1940s. Both *Action* and *Detective* were relaunched with new # 1 issues (their first since 1938 and 1937, respectively) as part of DC's "New 52" universe relaunch. They continue to be Superman and Batman solo books.

The most recent experiment with anthologies came from DC Comics in 2009. *Wednesday Comics* (named after the day of the week that new comics arrive in shops, the day of the ritual pilgrimage of comics fans to pick up their new comics) was a weekly anthology series produced in a 14- x 20-inch format, mirroring the Sunday Comics section of the newspaper, which was one part of the pair that birthed the comics medium in the 1930s.

would publish a story in their own fanzine, Science Fiction, called *The Reign of the Superman*. Inspired by the adventurers and science fiction futurism of the pulps, and the novel *Gladiator* by Philp Wylie,[2] this early version of Superman was a destroyer, a villain, a power fantasy dreamt up by someone caught in his own tragedies and terrors.

After *Funnies on Parade* grabbed readers and its successor, *Famous Funnies*, began turning retail sales, the natural inclination of publishers took hold: reproduce success on a massive scale. If crime pulps were big that month, a gaggle of new crime pulps would appear (and disappear). Romance? Great. Make new ones. Sex? Make it raunchier and spicier. Collections of comic strips? Collect more!

Just as film began as documentary collections of life—essentially reprints of life—and eventually cinematic language was born and original stories became the norm, so it was the same with comics. As the medium gained traction, the public started demanding original stories, and, ever the obliging servants of mankind, the publishers gave them what they wanted. Publishers such as the Comics Magazine Company and Centaur released ultimately forgettable (though nonetheless charming) characters such as Dr. Mystic (created by the ever-present team of Siegel and Shuster), The Clock, and Dan Hastings. For a great look at these comics, check out Fantagraphics's *Supermen!: The First Wave of Comic Book Heroes 1936–1941*.

Ever the eagle-eyed (though less-than-successful) entrepreneur, Malcolm Wheeler-Nicholson began publishing comics in 1934 with the anthologies *New Fun* and *New Comics* (later *Adventure Comics*). When it came time to launch his third title in 1937, Wheeler, drowning in debt, had to partner with pulp publisher Harry Donnenfeld.[3] Together, Donnenfeld and Wheeler-Nicholson published the title that would provide this new company with its namesake: *Detective Comics*. Some 26 issues later, a certain caped crusader with pointy ears and a penchant for nocturnal rodents would appear.

In early 1938, the fourth comic from DC (then National) was commissioned. An anthology featuring a character cobbled together from rejected newspaper strips by Siegel and Shuster, *Action Comics* #1 would become an icon of popular culture, of pop art, and a million-dollar investment. The character in its pages would become as recognizable as Mickey Mouse, and his heroism would inspire generations.

But in June, 1938, that comic book with a man in blue tights and a red cape lifting a car over his head just made good business sense.

You Must Remember This . . .

■ The Great Depression fermented an even greater desire to escape into simple adventure. Comics came around by responding to that desire and fulfilling it.

■ The primary format in the first years of comic books was the anthology, which was a carry-over from the pulps and penny dreadfuls that preceded comics.

■ Although created from cobbled-together rejected newspaper strips, Superman was the first phenomenon of the comics industry, and cemented it as a vibrant storytelling medium.

Notes

1. Les Daniels, *Marvel: Five Fabulous Decades of the World's Greatest Comics* (New York: Abrams, 1990), p. 17.
2. Gerard Jones, *Men of Tomorrow: Geeks, Gangsters, and the Birth of the Comic Book* (New York: Basic, 2005).
3. Wikipedia Contributors, "DC Comics," *Wikipedia: The Free Encyclopedia*, http://en.wikipedia.org/wiki/DC Comics (accessed November 4, 2011).

"Look! Up in the Sky!"
Comics Take Flight, 1938–1941

The story of Siegel and Shuster's creation of Superman is one of the great tragedies of the Golden Age. In it, we find lain bare the double-dealing and shuttered bright-eyed optimism that beleaguered the industry in its nascent stages. The young creative duo sold Superman to Donnenfeld and DC for a whopping sum of $130.

What Siegel and Shuster brought to the world stage for that $130 was an encapsulation of the ideals and wish fulfillment fantasies of a generation of youths raised on pulps, comic strips, and the harsh realities of the Great Depression. It was a generation yearning for a hero, a black-and-white ideal of good and evil, not the shades of gray found in the pulps. The Superman that hurled the car above the thugs on the cover of the now-iconic *Action Comics* #1 is a far cry from the "Big Blue Boy Scout," whose relevance has been questioned at multiple turns in the modern popular culture.

In his nascent years, he couldn't fly, only leaping tall buildings in single (sometimes multiple) bounds. He was a swashbuckler, a man of the people, and, yes, a bit of a prick. But there was something there. A visceral energy and movement to his muscle-man, square-jaw heroics. A "stick-it-to-the Man" willingness to do the job that had to be done for the betterment of the common man. That x-factor hooked readers, and in only a few years Superman would become a pop-culture icon and a hero to millions.

Capturing the Imaginations

To put the influence and success of comics into perspective, one has to look at the times in which the superheroes were created. America was emerging from the Great Depression. It was a time in which all of the American ideals of ownership, of capitalism, of individualism, and self-reliance were splattered all over the streets, trampled under the feet of those who pushed too far, who got too greedy, and made those ideals an asphalt cushion under the feet of the beleaguered and downtrodden, forced to wait in breadlines and uproot their families, while dreaming of a better tomorrow.

Sound familiar?

It was in that landscape that comics brought simple tales of good versus evil. Heroes in vibrant and colorful (sometimes outlandish in the case of the ones

who didn't survive) costumes, fighting the good fight, fighting for the people, and simply telling a ripping yarn. All for a dime.

From that cheap and colorful escapism came our modern mythology.

Golden Age Style: The Page, the Panel, and the Grid

Most comic book stories from the Golden Age would range from 6 to 16 pages (as with anything, there are notable exceptions, which we'll look at later in this chapter). The page was divided up into a grid, usually consisting of 6 to 10 panels (though this would vary depending on the artist).

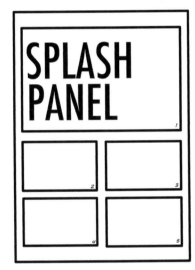
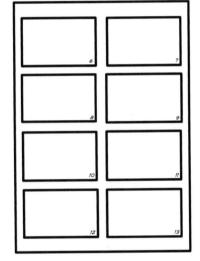

FIG 8.1 Example of eight-panel grid (with standard splash panel) used frequently in Golden Age comics.

The splash page (usually the introductory page to the comic) began life much as its comic strip predecessor, at the top of the page as a "splash panel." Soon, however, the splash page grew into a larger entity, and eventually became its own page by the mid-1940s (though the splash panel was in use throughout the Silver Age).

Initially, comics were book-format comic strips, and much of the usage of the grid adhered to that. Remember, the first "comic books" were collections of reprinted comic strips, and the first appearance of Superman in *Action Comics* #1 was cobbled together from rejected newspaper submission strips from Siegel and Shuster's ten-year odyssey to bring Superman to print.

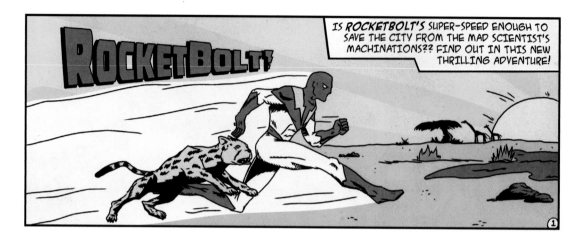

IS *ROCKETBOLT'S* SUPER-SPEED ENOUGH TO SAVE THE CITY FROM THE MAD SCIENTIST'S MACHINATIONS?? FIND OUT IN THIS NEW THRILLING ADVENTURE!

FIG 8.2 Example of splash panel. note introductory narration (art by Blair Campbell).

Like the frame in film, or the note in music, the panel in comics represents time and timing. A wide panel conveys an expanded duration of time, smaller panels, a shorter duration (although a collection of small panels conveys a lengthier period of time). Tall, tight panels give a feeling of claustrophobia and impending dread. During the Golden Age, however, this language hadn't fully developed, and the panel functioned generally as a container for action with little to no (conscious) regard for timing.

Along with the grid comes the "gutter," that space between panels where imagination takes over. The Golden Age left a lot of room for imagination, as most panels simply presented the next story beat, without a defined movement between panels. The panels were treated as action vignettes, each a moment frozen in time, without much in the way of the momentum offered by the gutter that would become part and parcel of the modern comics language. There was a momentum and a breakneck pace, but it was more like a Ferrari repeatedly jumping over the hilly streets of San Francisco and crunching into the pavement versus a smooth drive in said Ferrari along a road with the occasional gargantuan leap over a chasm.

The Hero's Journey/The Mono-Myth

The works of Joseph Campbell have inspired generations of creatives—since he first laid down the mono-myth (popularly known as "The Hero's Journey"). In his seminal work, 1949's *The Hero of a Thousand Faces*, Campbell cataloged the stories and myths that have both encapsulated the times in which they were created, and the universal themes that are inherent throughout every culture on the face of the earth.

In the prologue, Campbell states that

> Throughout the inhabited world, in all times and under every
> circumstance, myths of man have flourished; and they have been the living
> inspiration of whatever else may have appeared out of the activities of the
> human body and mind.[1]

From spoken word to text, from novels to serialized fiction, from Eskimo to
Star Wars, myths have again and again been reflections of their times, whether
in the tales of Homer or the B-movie serial homage of George Lucas' *Star Wars*.

"The Hero's Journey" has again and again shown up in our media today: video
games, films, books, and, of course, comic books. The comic book heroes that
began with Superman (giving them the iconic name "superheroes") became
our modern American mythology, tales of archetypes in morality plays,
metaphors for the human condition throughout each generation in which
they were published.

But what is the "Hero's Journey"? Here is how Campbell describes it:

> The mythological hero, setting forth from his common-day hut or castle,
> is lured, carried away, or else voluntarily proceeds, to the threshold of
> adventure. There he encounters a shadow presence that guards the
> passage. The hero may defeat or conciliate this power and go alive into the
> kingdom of the dark . . . or be slain by the opponent and descend into
> death. Beyond the threshold, then, the hero journeys through a world of
> unfamiliar yet strangely intimate forces, some of which severely threaten
> him, some of which give magical aid. When he arrives at the nadir of the

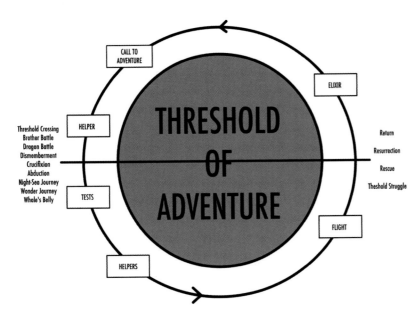

FIG 8.3 **The Hero's Journey.**

mythological round, he undergoes a supreme ordeal and gains his reward
. . . The final work is that of return . . . At the return threshold the
transcendental powers [gained on the journey] must remain behind;
the hero re-emerges from the kingdom of dread. The boon that he brings
restores the world.[2]

It's remarkable when looking at stories through the lens of Campbell's work
how closely those stories follow this journey. The raw emotional power of the
Hero's Journey also comes from recognizing it in our own lives and our own
struggles as we push forward to overcome them.

The Dark Knight

In *Detective Comics* #27, a new hero joined Superman in DC's pantheon. Driven
by revenge, and an unflinching desire to punish those who would prey on the
innocent, Batman, created by Bob Kane and Bill Finger, burst on to the scene,
bringing a pulp sensibility to the comics. Batman was born from the pulp ilk of
The Shadow, Superman from the sci-fi adventure of Lester Dent's Doc Savage.
He was the dark to Superman's light.

As told in *Detective Comics* #33, Batman's origin has become one of the classics
of modern literature. The son of a wealthy and beloved Gotham City family,
Bruce Wayne witnessed the murder of his parents at the hands of a mugger in
a dark alley. Dedicating his life to the pursuit of peak physical perfection to
wage a one-man war against the scourge of Gotham City, he became The
Batman (or, The Bat-Man, in his initial appearances).

In Christopher Nolan's reboot of the Batman film series, *Batman Begins* (2005),
Nolan explored the mythological underpinnings of Batman's origin, one that
was never fully explored in any medium. After the murder of his parents,
Wayne is filled with anger, with rage. He eventually flees Gotham (shedding
the coat and appearance of the wealthy playboy heir to a homeless man), and
immerses himself in training. He has set forth from his common day, on a
journey to channel his rage into a beacon of hope for the beleaguered
Gotham City (the boon he brings to restore the world). He becomes a symbol
of fear and of hope, the hero that Gotham deserves.

A hero may have several journeys throughout their career, and indeed, such is
the way with the comic book superheroes. There is, however, an underlying
level of tragedy to their journeys. For icons like Batman and Superman, their
journeys never end. Batman's ultimate tragedy is that he himself is the elixir to
restore the world; the self-made man who will stop at nothing to prevent
what happened to him from happening to others.

Batman's journey will never end. He will always be The Batman, perpetually
fighting the ills that gave birth to him. Similarly, Superman also carries a layer

of tragedy to his hero's journey. He cannot return to his world. As told in the famous origin by Siegel and Shuster, Superman was the last surviving member of his planet. Rocketed away as an infant in the last moments of the planet Krypton's existence, he was taken in by a "kindly couple" in Smallville, Kansas (the parallels to the Moses story are evident). He was sent on a journey not of his own volition, but carried away. He can never return. He will always be here. This is the tragic beating heart of the mythological underpinnings of comic book storytelling. For stories to endure, their journey can never end.

Should their journeys end, the hero will be "rebooted," as in the current DC "New 52" initiative in 2011. Rebooting every single title in the DC Universe with a new Issue #1, the "New 52" aims to make the mythologies of their heroes relevant to modern times. Whether that will be successful or not is a topic for later discussion.

If DC Comics represents our modern mythology, what does their competition across the street represent? What has defined the competition between Marvel and DC for 70 years?

Golden Age Style: The Art

The art in Golden Age comics isn't Vermeer. It's rough, tumble, and crude. During these nascent years, comics were churned out like a factory. By the end, artistic integrity wasn't something many of these guys considered. At the end of the 1940s, there were nearly 40 publishers selling 300 comics a month.[3] This wasn't an industry where great works of art were demanded, and

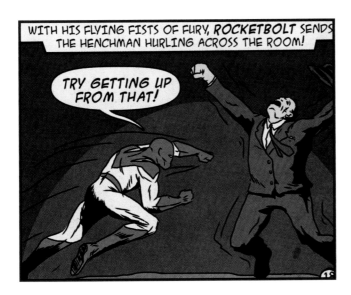

FIG 8.4 Example of art in Golden Age style. Note very simple movements and backgrounds (art by Blair Campbell).

indulging artistic eccentricities wasn't at the top of the publishers' priorities.

Deadlines were the great motivator—comics were communication devices for stories. Make it simple, make it quick, and make it again. For many artists working in the Golden Age, comics was just a stepping stone to advertising or some other form of "real" art and design.

As with any generality, there were exceptions—Will Eisner, Jack Kirby, Jack Cole, C.C. Beck, Carl Barks, for example; master craftsmen who worked within stringent deadlines to create works that endure both as storytelling communication tools *and* works of art.

Sound Effects

In comics storytelling, even sound is visual, hence why I consider it an integral part of comic book art. From the beginning of the medium, the occasional "BANG" has popped up in the art, as well as a "RING" from telephones. Depending upon the storytelling ability of the artist, sound effects could be used to enhance the art or to add clarity to panels where the action was less than clear.

By the 1940s, the lettering of sound effects was becoming decidedly more defined, and more "POP." And then in the 1966 *Batman* series, those sound effects would become synonymous with the comic book . . . ahem, *Whiz!Bam!Pow!*.

Enter: Timely

Spider-Man. The Fantastic Four. Daredevil. The X-Men. Iron Man. Though these heroes did not appear until 20 years after the first Marvel (then Timely) comic book, they have grounding in comics history. The Marvel Universe is renowned for the "just like me" aesthetic of their creations. Their secret identities have normal problems: paying the bills, romantic entanglements. Their heroism is brought from defined character. Each of their adventures spin from some failing of theirs. They're vulnerable. Human.

The traits that make the post-1961 Marvel Universe endure have been there since the very first Marvel Comic. In 1939, mere months after Batman appeared in *Detective Comics* #27, Timely, a company formed by Martin Goodman, who, like DC's Harry Donnenfeld and Malcolm Wheeler-Nicholson, was a man of the pulps, released *Marvel Comics* #1. In its pages, Bill Everett and Carl Burgos unleashed The Sub-Mariner and The Human Torch. The Human Torch is an android man who erupts into flames when he comes into contact with air. A monster to many, a hero to few, he was as much inspired by Frankenstein's Monster as Superman was by Moses. He was considered a menace (foreshadowing Spider-Man by 23 years), but there was heroism in his heart and he became the protector of New York City (unlike DC, Timely/Marvel

has always based their characters in a real-life city). And NYC needed a protector, because the second featured character in *Marvel Comics* #1 wasn't too big on the "protecting mankind" schtick.

Bill Everett's Prince Namor, the Sub-Mariner, was an arrogant, brash, half-human/half-Atlantean hybrid. He was also prone to crushing the heads of deep-sea treasure hunters. He wasn't the "sworn protector of mankind"; rather, he led a crusade against man, enflamed by the inherent racism of the Atlantean people who raised him. Occasionally, he would help out "man," but only when it served him.

It was the difference between mythological archetypes from DC and flawed, (semi-)grounded in reality protagonists from Marvel/Timely that has defined their competition for 73 years. It was those two years (1938–1939) that set the stage for generations of a reborn and reinterpreted American mythology that has continued to evolve to this day.

The Good Captain (Marvel)

Detective Comics, Inc., and Timely weren't the only two publishers battling it out in the early days of The Golden Age. There were several smaller publishers, but the one that rose above all of them was Fawcett Publications. While Fawcett featured several superheroes, such as Captain Video, Spy Smasher, and Captain Midnight, it wasn't until the publication of February 1940's *Whiz Comics* #2 (yes, I borrowed the name of *Whiz!Bam!Pow!* from that comic) and the debut of Captain Marvel, who, with a single word, "SHAZAM!", transformed from a young boy into a powerful god to rival Superman, that Fawcett became a major player (and faced a 12-year lawsuit from Detective Comics over the similarities between the characters).

Captain Marvel took the adolescent fantasy of being a superhero (it could be argued that Captain Marvel was the first post-modern superhero, in spite of coming out less than two years after Superman's debut) and amplified it to levels never before seen. He became the living embodiment of the adolescent power fantasy—with a healthy dose of lighthearted fun.

It's no coincidence that Captain Marvel would find himself the first superhero to be adapted from comics into film with the 1941 Republic serial, *The Adventures of Captain Marvel* (also one of the best adaptations to this day). It's also no coincidence that Captain Marvel's sales figures out-performed both Superman and Timely publications by nearly a two-to-one margin.

War Drums

Superman was the champion of the oppressed, Batman their dark avenger of the night. As a society, we need that dichotomy. In their nascent stages, comics were simple morality plays—good versus evil. It was through our

Sidekicks

When Batman first appeared, he was torn directly from the pulps. A dark, avenging angel of the night, he was merciless—killing criminals (an edict was handed down from editorial that Batman would never kill, which was then tied into the origin story of never using guns because of his parents's murders), or leaving them to die.

In *Detective Comics* #38 (April, 1940), Bob Kane and company gave Batman a sidekick, Robin. Though similarly defined by tragedy like his partner, Robin was a boisterous young boy who Bruce Wayne took in after the murder of his own parents in a circus accident.

Robin brought a lightness to Batman and softened his hard, pulp edges to define him for the duration of the Golden Age. It also didn't hurt that the introduction of Robin doubled the sales of Batman comics.

In the years that followed, the teenage sidekick became a mainstay of comics with characters like Toro (sidekick to The Human Torch), Bucky (Captain America's sidekick), and Sandy the Golden Boy (The Sandman's youthful accomplice).

From a transmedia perspective, the sidekick offers an invaluable asset: further threads to be explored through his or her own solo adventures—much as Robin did in *Star Spangled Comics* throughout the Golden Age. These solo adventures can be used to deepen the meaning of the core thrust of your project.

collective consciousness and absorption of these characters that they evolved into something more—comics became our stone tablets, and the heroes of light and dark, our champion and dark avenger, became our modern mythology.

At Timely, the Human Torch and Sub-Mariner represented the ugly side of us that wanted to be better. That craved the chance to be a hero. The Timely heroes were flawed protagonists; the DC heroes, archetypes that inspired us to create a better world. And Captain Marvel? He was just plain old fun.

But the drums of war were beating loud, and it wouldn't be long until Timely brought a hero that represented our new-found patriotism in his red, white, and blue triangular shield. Idealism was coming to the Timely stable.

In 1941, Captain America would punch Hitler. And comics would never be the same again.

You Must Remember This . . .

- The comics of the Golden Age were, for the most part, simple morality plays where good always triumphed over evil.

- DC Comics represent a modern mythology, using archetypes and morality plays as the basis of their early storytelling. Marvel/Timely is more character-driven and grounded in the real world. In that way, Marvel was quite ahead of its time, though it didn't grab the sales figures at DC did in the early days.

- The art of the Golden Age was simple, crude, and ultimately iconic. It was in this simplicity that comics found their niche and became the phenomenon they became.

- The Hero's Journey, or mono-myth, as popularized by Joseph Campbell, is the foundation for many stories today, in comics, film, and games. It can also be found in our own struggles to overcome adversity in our lives.

- Young sidekicks simultaneously doubled sales and removed the hard edge of many of the heroes, setting the stage for a more kind, "good citizen" type of hero.

Notes

1. Joseph Campbell, *The Hero with a Thousand Faces* (Novato: New World Library, 2008), p. 1.
2. Ibid, p. 211.
3. Gerard Jones, *Men of Tomorrow: Geeks, Gangsters, and the Birth of the Comic Book* (New York: Basic, 2005), p. 237.

Punching Hitler
The Comics Go to War. 1941–1945

The economic climate of the 1930s that created the Great Depression and fermented a desire within the American populace to escape into the four-color displays of derring-do in the comics also created super-villains that were all too real. Superman's first foe, the Ultra-Humanite had nothing on the villains that would bring the world to its knees and imbue the American public with a patriotism never before seen.

Seizing upon the ripple effect wrought by the Great Depression, totalitarian regimes rose throughout Europe as Adolf Hitler and the Nazis unleashed a reign of terror and atrocity that led to the defining conflict of the first half of the 20th century: World War II.

The pre-war years saw the birth and growing pains of the new comics medium. In those pages, morality plays of good versus evil, where good always triumphed. As the United States found itself facing a similar battle in the hues of reality, it was only logical that the superheroes would follow the real-life heroes into battle. Comics became valuable tools for both propaganda and escape: their larger-than-life four-color stories were perfect fodder for winning the "hearts and minds," selling war bonds, or giving folks a break from the insane atrocities unfolding around them.

1941: The Final Stars Shine

In March, 1941, Timely wasn't in the same sales leagues as DC. With DC's bona-fide hit on its hands of Superman, and a growing phenomenon in Batman, not to mention the staggering sales of Fawcett's Captain Marvel. Timely publisher Martin Goodman needed something to push his company into the upper echelons of sales. Aside from *Marvel Comics* (inexplicably changed to *Marvel Mystery Comics* with Issue #2), Timely only had a few other titles, including the quarterly *Human Torch Comics*.

Goodman found his answer in a red, white, and blue marvel who was anything but a marvel. He was scrawny Steve Rogers, who, fueled by patriotism and a desire to serve his country, became the super-soldier known as Captain America. Created by Joe Simon and Jack Kirby, Captain America burst on to the comics scene in March 1941. With a star-spangled shield, the "Sentinel of Liberty" rocketed into the imaginations of the American public with a deft right hook into Adolf Hitler's face. That right hook would cement

The Crossover

With comics becoming big business, and superheroes in particular making a splash, publishers took the next logical step: have the heroes get together and beat the crap out of one another!

The first such crossover was in *Marvel Mystery Comics* #8, between the naturally antagonistic "fire" of The Human Torch, and the "water" of The Sub-Mariner. Told in *Rashomon*-style, with the first two issues of the three-issue battle told from both The Torch's and The Sub-Mariner's perspective, the final issue ended in a draw.

Over at DC, Superman and Batman had been meeting on the covers of *World's Best Comics* (soon to be *World's Finest* with Issue #2), but didn't cross over until Batman appeared on Superman's radio show in 1945.

Timely as a formidable publisher, bringing sales of 1 million copies a month (by comparison, *Time Magazine* was selling just over 700,000 copies a month).[1] Contrast that with today, where a major sales victory, such as DC Comics' "New 52" relaunch of *Justice League* and *Action Comics* sold just over 200,000 copies.

While Captain America, the Sub-Mariner, and The Human Torch unleashed their might on the Nazis, at DC, another type of hero was being created, one who wore the mythological underpinnings of the DC pantheon on her golden, bullet-proof bracelets.

Wonder Woman, created by William Moulton Marston first appeared in *All-Star Comics* #8. She was an immediate hit in the age of Rosie the Riveter and would soon headline the anthology series, *Sensation Comics*. She was DC's star-spangled, female answer to Captain America (with a healthy dosage of eroticism and bondage). In a not-entirely-unexpected phenomenon when one combines bondage, beautiful women, and Nazi-fighting, Wonder Woman's primary audience was not women. It was pre-teen and teenage boys. In fact, her audience was 90 percent male—with more girls reading *Superman* than *Wonder Woman*.[2]

Superman. Batman. Captain Marvel. The Human Torch. The Sub-Mariner. Captain America. Wonder Woman stands as the final hit of the Golden Age. While those heroes mentioned above would sell phenomenally throughout the war, the luster of the superhero would gradually fade. No new hits would arrive. No new phenomena. It was business as usual—and business meant the heroes had to go to war.

Splitting the Difference: Timely and DC at War

Although the war was a horrifying event in the annals of history, the comics industry was engaged in a period of bankability and success that remains unparalleled to this day. At the end of 1942, more than 30 percent of all printed material mailed to military bases were comics. *Superman* was selling 1 million copies an issue. Captain Marvel was bringing in nearly 2 million copies a month for Fawcett.[3] *Captain America Comics* was, like *Superman*, turning in over a million copies a month.

In spite of their growing sales, the approaches of the "Big Two" publishers couldn't have been more different. Goodman's Timely Comics took the Axis head-on, led by the red-white-and-blue patriotism of Captain America. As early as 1940, The Sub-Mariner was battling Nazi subs. The Human Torch and Sub-Mariner got over their natural inclination to kick the crap out of one

another for a team-up against the Nazis. Timely publisher Goodman wasn't going to let a bunch of Nazi bullies pick on anyone—and if the United States wasn't going to jump into war, his superheroes sure as hell would take care of the problem.

But over at DC, things couldn't have been more different. While Wonder Woman fought the Nazis every so often, and the Boy Commandos and Newsboy Legion (created by Captain America creators and recent Timely ex-pats Joe Simon and Jack Kirby) brought the youth of America their own comic book avatars that fought the Nazi menace, Superman was relegated to the occasional USO show (to let the true fighting men win their own battles), and Batman punched a Nazi every once in awhile, retreating into an even more entrenched fantasy mytho-canon. While Timely took the fight to Hitler and stirred up the patriotic passions of American children and adults, DC, for the most part, sought to be an escape.

In the most . . . visual . . . part of Batman's war effort, he faced the "Japs" (according to the ethnic racism seeping out of the script) in Columbia Pictures' 1943 serial *Batman* (the filmic equivalent of the serialized novel from the 19th and early 20th centuries, and a precursor to television—see the following chapter, "Adaptation in the Golden Age," for a more in-depth discussion of the movie serials), starring Lewis Wilson as a middle-aged, overweight Batman and Douglas Croft as an early-30s, cringe-inducing Robin. While I won't lay bare the massive cinematic achievements of the *Batman* serial, it is worth noting that Batman fought Japanese saboteurs lead by Dr. Daka whose goal was to turn Americans into mind-controlled zombies. This was Batman's gargantuan effort to stem the tide of war, all the while churning out now-shocking racial epithets against Daka and his minions.

When I said that comics would never be the same after Captain America punched Hitler, I meant it in two ways—the first, that the divide between Timely and DC would become even more prevalent, shaping the tone of comics for the next 25 years. The second, was that the principle of quantity over quality would take over the industry.

Fortunately for the big comics publishers, people had more on their minds than crappy comic books. But it wouldn't be long until the "industry" as we know it emerged from the "Wild West" that had shaped the comics world in the pre-War years.

With the war taking over the vast amount of American resources, the most precious commodity to publishers became a luxury item: paper. This was the death knell for the small publishers, and, like the railroad bringing "civilization" to the Wild West, the lack of paper and supplies eliminated the Wild West of the WWII-era publishing industry. As Timely, DC, and Fawcett

The Team Books

If crossovers between two heroes made sense, then team books took that and amplified it by a factor of ten. Bursting on to the scene in 1940's *All Star Comics* #3, the Justice Society of America consisted of heroes from both DC (or National Periodical Publications) and All-American Publications sitting around a table discussing their solo adventures. The team aspect at that point was nothing more than a framing device. But DC took quick notice of the sales figures, and slowly but surely, the heroes were sharing adventures, fighting alongside one another.

A fascinating thing about the Justice Society was that it functioned in much the same way as an anthology book, only the characters in the anthology met to discuss their adventures. A character who had his own solo book could only be an "honorary member" of the Justice Society (Superman, Batman, and Wonder Woman— who also functioned as the Society's secretary—were such honorary members). This was spelled out in *All-Star Comics* #5, creating a sort of de facto story bible for the Justice Society, the rules and regulations of membership.

Team books also sprang up at Timely, with groups such as The Invaders and the Young Allies taking the battle right to Hitler's doorstep.

continued their reign at the top of the sales charts, smaller publishers vanished.

The quality of comics dropped precipitously, not out of a disregard or hatred of the medium, but out of practicality; many of the great artists and writers of the time were drafted, leading to a glut of talent and a surplus of hacks churning out quantity over quality.

Golden Age Style: The Captions

Narration

Narration was often the driving narrative force of Golden Age stories—not the visuals, as would be expected with a visual storytelling medium. Frequently, the narration (almost always in the third person) described the action in the panels it was attached to or served as a transition from one action piece to another (with the ubiquitous term, "MEANWHILE . . ."), setting the stage for the next piece of story.

FIG 9.1 Transition and exposition scene in Golden Age style (art by Blair Campbell).

For historical purposes, here's a four-panel sequence of narration that describes the action, from the first appearance of The Bat-Man in *Detective Comics* #27 (May, 1939):

> ...AS THE TWO MEN LEER OVER THEIR CONQUEST, THEY
> DO NOT NOTICE A THIRD MENACING FIGURE STANDING
> BEHIND THEM...IT IS THE "BAT-MAN!"

> THE "BAT-MAN" LASHES OUT WITH A TERRIFIC
> RIGHT...
>
> ...HE GRABS HIS SECOND ADVERSARY IN A DEADLY
> HEADLOCK...AND WITH A MIGHTY HEAVE...
>
> SENDS THE BURLY CRIMINAL FLYING THROUGH SPACE...

The narration in this era was also prone to hyperbole (in the most fantastic eight-year-old fever-dream fashion). For example:

> ...AND NOW IS ENACTED A FANTASTIC, TENSE
> DRAMA...WHICH IS OF SUCH INFINITESIMAL DURATION
> THAT THE HUMAN EYE IS INCAPABLE OF RECORDING ITS
> AMAZING OCCURRENCE—SUPERMAN RACES THE BULLET...

Golden Age narration boxes are a direct descendant of the title cards of the silent film era, as comics creators of that time were raised on silent movies, and many of their creations were inspired by the swashbucklers of the silent era. In that regard, the narration in Golden Age comics is a hybrid of silent film title cards and the bombast of backyard (or city-street) play-acting.

Dialog/Word Balloons

The dialog in Golden Age comics can best be described as "on the nose." Subtext doesn't exist yet. Often expositional in ways that would make seasoned "writers" cringe, it isn't without its charm. Remember, the guys creating these comics grew up watching silent movies and reading the pulps directed at audiences that wanted action, adventure, and thrills—not insightful commentaries on the world around them. Dialog in visual storytelling was something that had yet to become an art form (even films with sound, "the talkies," were less than a decade old). For example, it's OK to say things like:

> THIS IS THE GAS-CHAMBER I USE TO KILL GUINEA
> PIGS, TO EXPERIMENT WITH—BUT NOW YOU ARE MY
> GUINEA PIG!:HEH-HEH!
>
> YOU SEE THAT STEAMER? IT'S THE BARONTA.
> TOMORROW, UNLESS I FIND YOU ABOARD IT WHEN
> IT SAILS, I SWEAR I'LL FOLLOW YOU TO WHATEVER
> HOLE YOU HIDE IN, AND TEAR OUT YOUR CRUEL
> HEART WITH MY BARE HANDS!

It's also OK to use the staple of bad murder mysteries—the third act expositional speech, wrapping the whole thing up in a bit of rousing dialectical flair:

> STRYKER, WHO WISHED TO BE SOLE OWNER, BUT HAVING NO READY CASH, MADE SECRET CONTRACTS WITH YOU, TO PAY A CERTAIN SUM OF MONEY EACH YEAR UNTIL HE OWNED THE BUSINESS. HE FIGURED BY KILLING YOU AND STEALING THE CONTRACTS, HE WOULDN'T HAVE TO PAY THIS MONEY.

Believe it or not, the second one was from Superman's second appearance in *Action Comics* #2 (1938). He hadn't quite honed his "nice guy apple pie" persona that would define him over the rest of the 20th century. The first and last ones were from Batman's first appearance in *Detective Comics* #27 (May, 1939).

Thought Balloons

FIG 9.2 Usage of the thought balloon to show a character's thoughts . . . while he's on his way to the next adventure (art by Blair Campbell).

The thought balloon, that equally famous (though now passé) trait of comic books also began with the Golden Age, often fulfilling multiple functions to counter the third-person of narration. It could act as a thought to oneself, a snide inside joke with oneself, or, in its most fascinating usage

(such as in Carl Barks's Donald Duck stories and more recently Brian Michael Bendis' attempted revival of the thought balloon in his *Mighty Avengers* comic book), as a counterpoint to dialog (saying one thing, thinking another).

Although not used today (as most narration has moved to fulfill the thought balloon first-person dynamic), thought balloons remain an iconic part of our culture. Ji Lee, the creative director of Google's Creative Lab, created a side project called "The Bubble Project" to add levity to corporate messaging in the streets of New York. Lee would place blank thought balloon stickers on advertising throughout New York, which would encourage passersby to fill in the thought balloons with their own creative dialogs.[4]

And it all started out of a creative necessity, an attempt at answering the question "How do we show thought?"—not out of an urge to do anything great or enduring.

The End of the War

The comics of World War II were hopeful and "in-your-face." In the power fantasies of their creators lain bare on the pulpy pages of comics, we saw the fighting spirit of those creators who grew up in hellish times. They were attacking the personification of the evil that arose from the economic factors that inspired the superheroes. Their fervor enthralled a generation of kids, a rallying cry for them as their fathers were off fighting the war—an idealized version of the heroism they saw in their parents brought into their hands.

When World War II concluded in 1945, it marked not only the end of the deadliest conflict the world had ever known, but the end of the first phase of the Golden Age of Comics. The war was won. Good had triumphed over evil. And with that triumph, the black-and-white morality plays of superhero comics slowly faded into irrelevance, and the industry—now fully formed—scrambled to find its place.

Like the United States, the comics industry was left wondering, "Who do we fight next?"

You Must Remember This . . .

- By 1942, over 30 percent of all printed material shipped to military bases was comic books.

- During World War II, comics were selling in the millions. Contrast that today with the sales of comics, where DC Comics is thrilled with the 200,000 copy response to their "New 52" relaunch.

- Timely fought the war head on, while DC stayed back, only occasionally sending Superman to USO shows, or having Batman punch a Nazi. Wonder Woman was the Nazi-fighter of that group.

- By the middle of the war, the superhero was fading out of popularity.

- The storytelling in comics declined greatly during the war, with many of the writers and artists that birthed the medium being drafted to fight, and a philosophy of quality over quantity taking shape.

- The narration boxes were inspired by silent film title cards, as many of the first comics creators grew up in love with silent film.

- The "Comics Industry" as we know it took shape during this time, as rising paper costs forced many small publishers to shut down, setting the stage for the DC/Marvel rivalry that has continued to this day.

Notes

1. Les Daniels, *Marvel: Five Fabulous Decades of the World's Greatest Comics* (New York: Abrams, 1990), p. 37.
2. Gerard Jones, *Men of Tomorrow: Geeks, Gangsters, and the Birth of the Comic Book* (New York: Basic, 2005), p. 211.
3. Ibid., p. 213.
4. Scott Belsky, *Making Ideas Happen: Overcoming the Obstacles Between Vision and Reality* (New York: Penguin, 2010), p. 173.

Adaptation in the Golden Age

In 1951, George Reeves burst through a wall as Superman in the new television show, *The Adventures of Superman*. Television was in its infancy (indeed, this period was known as "The Golden Age of Television") and shows like *I Love Lucy*, *Leave it to Beaver*, *Dennis the Menace* (itself a comic strip adaptation), and *Dragnet* (which began life on radio) were the big hits of the day.

For all of its wonder as a means of escapist entertainment, television was a merciless killer of media when it first arrived. In its wake fell radio, the serials, B-movies (a genre of film that birthed film noir) and the pulps. It brought families around another new black box and became the community device of its age, bringing serialized and episodic (or serio-episodic) entertainment directly to the homes of the audience.

The Beginnings

George Reeves wasn't the first time Superman had appeared in a medium other than comics. The iconic character was first adapted into a cartoon series by Max and Dave Fleishcer's studios for 17 short films from 1940 to 1943. Initially reluctant to take on *Superman* for Paramount, the Fleischers proposed an exorbitant budget in the hopes that the studio would balk. They didn't. The result? My personal favorite interpretation of Superman and an influence on such amazing pieces of animation as Bruce Timm's *Batman: The Animated Series*.

While the Fleischers brought Superman to animated life, the character nearly became the first comic book hero to move to live action for a serial from Republic Pictures.

Unfortunately, Republic couldn't wrest the rights to Superman from Donnenfeld and DC, and the planned *Superman* serial became *The Mysterious Dr. Satan*, featuring a hero created exclusively for the serial, The Copperhead (who shared a last name, Wayne, with the other big DC hero of the time, The Bat-Man).

Soon after their failure to grab Superman, Republic made a deal with the much more amenable Fawcett Comics to bring their sensation, Captain Marvel, to the big screen in not only the first comic book superhero adaptation, but also one of the finest, 1941's *The Adventures of Captain Marvel*.

Adaptation

Adaptation is the act of translating a story from one medium to another. To do so, you must be cognizant of the needs and storytelling techniques of each medium. Several storylines may be compressed, characters altered, etc., to fit the needs of the medium. Throughout this book, we'll look at several successes and failures, most recently, the "too faithful" adaptations of *Sin City* and *Watchmen*. There is an argument that adaptation could be a form of transmedia, though I argue against it. While it does add visual depth to a story, it doesn't deepen a story or have an interactive realtionship with the original source. If it did, then I would certainly deem it transmedia.

Movie Serials

First produced in the early 20th century, movie serials brought the storytelling techniques of the penny dreadfuls and pulps to the big screen, organizing action-packed adventures into 10–15 chapters, the precursor to television. These were often produced on a shoestring budget and shot on location (such as Louis Feuillade's 1915 chapterplay [another term for serials] *Les Vampires*, filmed in the streets of Paris, largely abandoned during the outbreak of World War I). Ending each 15–20 minute episode with a cliffhanger, the serials brought kids and adults alike into theaters each week to see just how, exactly, the hero managed to escape the car that was careening off the cliff.

The Return of the Scorpion

Another instance of transmedia usage occurred in 1946, when Fawcett, the publishers of the comic book adventures of Captain Marvel, published *The Return of the Scorpion*, featuring the villain of the Republic serial brought back to life to challenge Captain Marvel yet again. While not published as a comic book, it was published as a "Dime Action Book," Fawcett's version of the highly popular "Big Little Book," that was published from the 1930s until the latter half of the 20th century, and continued the battle between the good Captain and the nefarious Scorpion in book format.

Largely eschewing the humor and goofiness that made the comics so endearing, *The Adventures of Captain Marvel* starred Tom Tyler (most famous as John Wayne's adversary in John Ford's classic Western, *Stagecoach*, and later, as another comic strip superhero in the serialized adaptation of Lee Falk's *The Phantom*) as Captain Marvel and Frank Coghlan Jr. as a much-older-than-ten-years Billy Batson. The villain of the piece was The Scorpion, a masked villain who was bent on, of course, world domination (and who, in the tradition of all the great serials, would be unmasked at the conclusion of the serial as one of the group of distinguished men of honor who had frequent board meetings and was a friend to the hero). Through the 15 action-packed serials, Captain Marvel tracked down The Scorpion, brought him to justice, and restored order to the world.

Other heroes eventually made it to the big screen as well. We briefly discussed Batman's first foray into the serial world with the lackluster 1943 Columbia Pictures effort, *Batman*. In 1944, Timely made its way to the movies with *Captain America*, though in an inexplicable (unless you take in to account the miniscule budget) move, Steve Rogers, military man, was replaced with Grant Gardner, overweight and pudgy District Attorney with a patriotic need to fight the bad guys.

In 1948, *Superman* finally arrived on the big screen, with two film serials (1948 and 1950, respectively); *Superman* and *Atom Man vs. Superman*. Both starred Kirk Alyn as Superman, and featured animated sequences for the flying scenes. Low budget, but effective. It's worth noting that in 1950's *Atom Man vs. Superman*, the atomic paranoia was at an all-time high, and the movie serials adjusted themselves to highlight and exploit that concern. Another fun fact is that *Atom Man* was the first filmic appearance of Lex Luthor, played by character actor Lyle Talbot (who also portrayed the first live-action Commissioner Gordon in 1949's *Batman and Robin* serial, the sequel to 1943's *Batman* effort).

While the *Superman* serials marked the first time Superman had appeared in live action, he had been on the radio airwaves throughout the 1940s in *The Adventures of Superman*, the show that would, along with his appearances in *Action Comics*, *Superman*, *World's Finest*, and his regular newspaper comic strip, cement Superman as a national icon.

TRANSMEDIA TOOLS: Writing Radio

One of the biggest joys in the creation of *Whiz!Bam!Pow!* was creating an era-authentic radio show experience for our audience. A few things to bear in mind when writing radio:

1. You can't show anything. You have to figure out a way to convey ideas through sound.

2. You have to over-emphasize things in dialog.

3. If at all possible, figure out a way to get everyone in a room to record the show. For *Whiz!Bam!Pow!*, we used Skype to record over several sessions. It was one of the most fun directing experiences of my life.

In today's MP3-digital-download-podcasting world, a radio show—even if set in modern day—can be a fun and cost-effective way to expand your transmedia world.

"Up! Up! and Away!"

On February 12, 1940, Superman made his radio debut, voiced by Bud Colyer (whose identity was kept a secret until 1946—much like Boris Karloff's uncredited and iconic performance as the Frankenstein monster in director James Whale's 1931 classic). Crafting a strong difference in the origin story, Superman arrived on earth a grown man after being rocketed away from Krypton as a baby. No more kindly old couple. He landed, saved someone, and went off to be a reporter.

Numerous traits that we now associate with Superman, including "Look, up in the sky!" came from the radio show (since you couldn't show anything with a radio show, you had to do so aurally), as did "Superman's pal," Jimmy Olsen. Notably absent from the show were Superman's villains, like Lex Luthor. The radio show also contained the first instance of Superman and Batman sharing an adventure in 1945.

Airing 15-minute episodes daily (presented by Kellog's PEP cereal), the show wasn't afraid to court controversy, as in 1946 when Superman took on the Ku Klux Klan in a multi-part (stories could range anywhere from single, 15-minute stories to multi-part cliffhanger episodes), 16-episode milestone in radioplay history. It has been reported that the incredible ratings amassed by the show led to Klan leaders denouncing it, and a precipitous drop in membership and recruiting in the racist organization.

It's fascinating that while the Superman of the comics took on a decidedly more good-natured and good citizen aesthetic throughout the war, and particularly in the post-war era, the radio Superman was the place to find the original Superman, the defender of the little guy, fighting the good fight for a better world.

Signing Off

In 1951, the radio show ended as the *Adventures of Superman* television show went into pre-production. As *Superman* ended, so too did the medium of radio, going from a mainstream media to a more niche form (as did the movie serial—with television taking over the B-movie serialization of the movie serials). Eventually, so too would the *Adventures of Superman* television show in 1957, and in 1959, the life of Superman George Reeves would end with the world-shocking headline "Superman Kills Self."

Seduction of the Innocent

Comics Under Siege, 1945–1954

Since 1929, America had had defined enemies who left in their wake economic or physical decimation that fostered a desire in the populace to rise up and overcome those forces. During the Great Depression, it was the corporate "fat cats" whose carelessness and greed plunged the country into an economic spiral, leaving countless out of work and destitute. From those ashes arose an American fighting spirit, a desire to return to the prosperity that they had once enjoyed. It was in that fighting spirit that the comic book superheroes staked their claim on the collective consciousness of the youth (and young-at-heart) of America, and a new pop-culture sensation was born.

World War II brought Hitler and the Nazi regime, bullies who stuck it to the little guy—and America (and the superheroes) fought back. First, the Timely heroes got into the struggle (even before the United States), then comics became a valuable propaganda tool to win the "hearts and minds" and inspire a nation to double down and fight evil. In 1945, after the dropping of the bomb in Hiroshima, the war was over and the Allies were victorious. Good had toppled evil.

While America's fighting spirit transformed into victorious celebration, the love for superheroes faded into obscurity (also owing largely to the declining quality of those comics, as most of their creators were off fighting the war). When the real-life heroes didn't have an enemy to fight any more, who could the superheroes possibly fight who would resonate in the same way?

It was that question, "Who do we fight?", that led to a new American anxiety. Although the country (and the comics industry) flourished in many of those postwar years, there was ugliness looming on the horizon, an ugliness that would turn American against American as we sought to find the next enemy to fight, and found it in the differing political and religious beliefs of our neighbors. Less than ten years after fighting back the worst villainy of the 20th century, we would become a country of conservatism, conformity, and finger pointing, preoccupied with unmasking the "Reds," as the McCarthy era took hold.

And it wouldn't be long until the entire comics industry faced certain destruction.

Golden Age Style: The Covers and Format

At a city news-stand, hundreds of publications competed for the attentions of buyers. The comics covers were no different. The goal wasn't to communicate the story inside but to drive sales in a highly competitive market. The brighter the colors, the better. The more action, the better. The more gore, the better. Action, violence, and sex sells! It's one of the few certainties in sales.

Rarely did the covers have anything to do with the content inside the book, a trait shared with the pulp magazines (the original art to the covers of which are highly sought-after collector's pieces today). One of the most notable exceptions to this generality is the iconic cover to *Detective Comics* #31 (1939), which featured the tale of Batman fighting "The Monk," a vampiric menace in the vein of Bela Lugosi's Dracula. The cover evokes the classic *Dracula* film aesthetic, and has been an iconic representation of Batman throughout history (most recently paid tribute to by Frank Quitely's cover to Grant Morrison's *Batman and Robin* #2 [2009]).

The Formats

Most comics published in the Golden Age were 64–96 pages in length, featuring a number of stories (see p. 64 in Chapter 7), all for a dime! The more popular the character, the longer the story. The stories averaged from 6 to 16 pages in length, and would be continued in the next month's tale. As with any format, there were exceptions, such as the massively popular *Walt Disney Comics* anthology, where Carl Barks crafted 32-page Donald Duck stories on a regular basis.

When a superhero or character was popular enough to receive their own magazine, the anthology format stuck, though instead of featuring other characters, they contained multiple 8–12 page adventures of the hero. Often times, these adventures continued in "parts" in each issue. Eventually, with the halving of comic book lengths during the Silver Age (from 64 to 32 pages), this format morphed into the 22- to 32-page adventures we know today.

Action Mystery Adventure

In 1939, at the beginning of the Golden Age, a 22-year-old artist wanted to try something different. His 65-year career and contributions to the comics medium would influence generations to come. But in 1939, he just wanted to do something different. His name was Will Eisner.

Busby Arnold, the head of Quality Comics, had made an arrangement to produce a comic book insert for the Register and Tribune syndicates in Des Moines.[1] He offered Eisner the chance to do the gig, but Eisner wanted to craft his own feature. Selling out his half of his studio (during those days, comics were created by "studios" of artists; for instance, Siegel and Shuster had a "studio" of artists in Cleveland to produce the voluminous amount of work for their *Superman* series) to his partner, Jerry Iger, Eisner embarked on a journey to create a comic for adults. He held firm to a belief that comics could be literature—even if that wasn't where the prevailing winds of "rational" (read: business) thought blew.

But Eisner took this one step further. He agreed to do the job, if he could maintain ownership of all the characters and stories he would create for the newspapers. This was unheard of (remember, Siegel and Shuster sold Superman to DC for $130, after Eisner and numerous others turned them down) at the time. Throughout his career,* Eisner would merge a business savvy unmatched in the creative world with a talent for innovation and design that would result in him being considered the godfather of the comics medium.

After debuting in 1940, *The Spirit* became Eisner's playground for pushing the comics medium to the utmost. In a mere seven pages a week, Eisner would tell short stories of real life (with a blue-masked superhero at the center—sometimes) that brought comics with a literary verve and inclination into the living rooms and breakfast tables of countless Americans.

After being drafted into the war in 1942, Eisner began creating instruction manuals—in comics form—for the Army. Following his service, Eisner returned to the States and *The Spirit* in 1945, ushering in an era of experimentation never before seen in the comics industry, pushing the boundaries of comics storytelling every week until the final *Spirit* comic in 1952.

And then he, as did many others, left the industry. But when he returned, it would be with a new form, one that pushed his belief of comics as literature even further than any had thought possible.

* Eisner's career ended only with his death in 2005, shortly after completion of what would be his final work, *The Plot: The Secret Story of the Protocols of the Elders of Zion*.

TRANSMEDIA TOOLS: The Power of Serialized Storytelling

From the penny dreadfuls to the pulps, from radio to comics and television, serialized storytelling has been a classic tool for bringing audiences back for each and every installment of your story. The infamous phrase, "To be continued," inspires anger, rage, and frustration, but also a desire to return again, to see exactly how your favorite characters will get themselves out of the latest cliffhanger (a technique coined after author Thomas Hardy left the hero hanging off a cliff at the end of an installment of *A Pair of Blue Eyes*[2]) concocted by the writers whose job it is to toy with our emotions and allegiances (and to generate ratings).

Serialized (or fragmented) storytelling is the act of designing stories that occur over multiple installments (see Chapter 3 for a look at serialized narrative in other media and its usage in transmedia applications) within the same medium. While a staple of comics storytelling since its inception, (Superman's first adventures in *Action Comics* #1 and #2 [1938] are an example of early comic book serialization) and a necessity for the survival of the newspaper comic strips, another form of fragmented storytelling became part and parcel of the comic book: episodic storytelling.

Episodic storytelling features the same characters in different adventures, but starting at a point where all has returned to normal. In comics parlance these are known as "done in one" adventures, something the Golden and Silver Ages used to great effect. The episodic structure makes much more use of the audience's goodwill towards the characters, as you visit them when all is normal—not when they're facing certain death.

A combination of serialized and episodic storytelling is "serio-episodic," which feature stories that are episodic in nature, but have an overarching mystery to them. *Lost* is a prime example of this, as (especially in the early seasons), there were trials and tribulations to work out, but an overarching mystery that was not resolved until the very end of the show (and even then, many questions were left unanswered).

A technique I made use of with my *Whiz!Bam!Pow!* project was what I call "perceived serialization." Perceived serialization creates the illusion that the adventures of a character in a comic are ongoing, even though we only produced one comic book. By numbering the comic, *Whiz!Bam!Pow! Comics* #7, we implied that there were issues before and, of course, issues that followed by ending the adventures of both characters (The Sky Phantom and The Sentinel) with a cliffhanger. We created a fake reality, one where you could imagine people returning to buy Issue #8, or following the anthology since Issue #1.

This was done by making the comic book a character itself, with a distinct back story, fleshing out the creators of each book (the creator of The Sky Phantom, for instance, is the lead character in the novella *The Treacherous Path of Peril*), and creating a mythology around that particular comic book as it's viewed today (in the *Whiz!Bam!Pow!* world, the comic book is worth $1.5 million, and the backup character of The Sentinel went on to become that universe's Superman).

Serialization is a powerful tool in the transmedia arsenal, both as a standard cliffhanger tale (though be careful not to make it *expected* for the audience to jump media forms to learn the outcome of your cliffhanger), and by employing tricks such as perceived serialization to deepen the world and the legend of the story you're telling.

Paranoid Western Romantic Horror

By the end of the 1940s, in spite of the waning interest in superheroes, comics were being read by an even greater number of readers. New genres had taken hold (seemingly a new genre was "in" every week), and every publisher at the time was taking advantage of it. It was the pulp attitude all over again—if Westerns are selling, make more Westerns. If romances are selling, make more! If Westerns and romances are selling, combine them (as Timely did with *Western Romances*). Crime comics were big—by 1948, 14 percent of all comics on the market were crime comics.[3]

By the end of the 1940s, comics nearly became mainstream. According to Gerard Jones:

> By the end of the decade, there were about forty publishers selling 300 titles—50 million comics a month. One study found that over half the readers were twenty or older, that adult readers averaged eleven comics a month, that nearly half the readers were female, and that white-collar workers read the most comics of all.[4]

But, as is always the case with any new form of entertainment, derision, fear, and outright hostility soon appeared. As Janet Murray said in her *Hamlet and the Holodeck* (quoted in Frank Rose's *The Art of Immersion)*: "Every new medium that has been invented, from print to film to television, has increased the transporting power of narrative. And every new medium has aroused fear and hostility as a result."[5]

A wide swath of individuals and groups are (and have always been) afraid of fiction. From the titular protagonist of *Don Quixote* who read too many books and went insane in the early 1600s, to 1950s America, the fear and hostility

that comics aroused in the good, decent folk resulted in Nazi-esque book burnings, and a 1947 Supreme Court ruling that it was the duty of the states and Congress to punish those who dare sell such lurid and tawdry material to the youth of America.[6]

Comics has always been an outlaw medium, even if the heroes in them weren't (by this time, Superman and Batman had gone from being men of the people to men of "the Establishment," good citizens [upstanding cops in brightly colored costumes] who fought the bad guys and made the world safe for Johnny and Susie Homemaker). Comics had never been subject to the same stringent laws that neutered the films of the 1930s and policed radio and the new medium of television. Comics were something you read (as the *North British Review* said of the serialized novels of Charles Dickens)[7] stealthily. You tucked them in your schoolbooks. You read them under the covers with a flashlight. Husbands stuffed them in their newspapers to read while wives went about the day's activities. Usually, the husbands had taken them from their children and appropriated them for their own escapes into fantasy.

But almost as soon as crime comics became bona fide hits, the interest in them dwindled. Soon, publishers turned to romance comics, the plights of star-crossed young lovers in titles such as *Young Romance*, *Sweethearts*, *My Romance*, *My Life*, *My Love Story*, *My Love Life*, *My . . .* on and on. Just as it had been in 1948, when 14 percent of all comics on the market were crime comics, by 1950, one-fifth of the nearly 650 comics published were romance comics.[8]

As the crime comics waned and the more wholesome genre of starry-eyed romance became "in," fear of the comics medium dwindled. Over-legislation and book burning had lost its luster, the superheroes were suitably neutered—from vengeful seekers of justice for the oppressed to (in the case of DC) "Establishment" family men—crime didn't pay (at least not the bills in the industry), and romance was the belle of the ball. Maybe comics would be mainstream after all.

Nah.

The Horror . . .

EC Comics (previously "Educational Comics," now "Entertaining Comics") publisher Bill Gaines and editor Al Feldstein launched their "New Trend in Comic Books" in 1950 with the publication of two horror anthologies, *The Crypt of Terror* and *The Vault of Horror*.[9] Rarely featuring recurring protagonists (save for the "host" of the comics, The Cryptkeeper), EC Comics were something different. Clearly inspired by Eisner's short story aesthetic, each of

the horror tales in the anthologies followed literary formats (and concluded with a surprise ending). Eventually, *Crypt of Terror* would become *Tales from the Crypt* and EC would begin publishing a war comic, *Two-Fisted Tales*.

Material for quality horror and terror was all over the place in the EC era. In 1949, it was discovered that the Soviet Union had tested an atomic bomb, an event that would further fan the flames of anti-Communist sentiment and escalate the Cold War (as well as make the imaginations of the American public fertile ground for atomic zombie tales). Closer to home, the veneer of domesticity, of the nuclear family, made for perfect murder fodder, as husbands would kill wives and vice versa each month in the pages of EC's *The Haunt of Fear*.

As with any trend in comics and pop culture, imitators soon lined up. Timely Comics, who, in spite of losing their trifecta of heroes, Captain America, The Sub-Mariner, and The Human Torch to "Weird Tales" titles (such as the final issue of *Captain America Comics*, renamed *Captain America's Weird Tales*[10]), was, in 1952, the most successful publisher in the comics industry under the stewardship of editor Stan Lee, nearly doubling sales of DC/National.[11]

While EC had nowhere near the sales of the major publishers, and very little in the way of any incentive to keep readers loyal (remember, they had no major heroes, no major recurring characters), there was one area where they could outdo the competition: shock and awe. Decapitation, brain splatter, body roasting . . . it was all in the name of sales. And it kept raising the middle finger to the censors and outraged citizenry of the U.S.

Just as had happened with crime comics in 1948 (14 percent of the market), romance comics in 1950 (one-fifth the market), by 1952, horror comics dominated nearly one-third of the comic book market.[12] Soon enough, just as in 1948, the comics industry would become the bane of the elite, of the hard-working and sensible protectors of taste across the country, and with them, a certain bespectacled super-villain (who, in the fashion of all great antagonists, believed himself to be righter than right) named Dr. Frederic Wertham, who would nearly decimate the comics industry with his outlandish theories and "protect the children from becoming crazed sex fiends and psychopaths" ethos.

Comics were about to become Public Enemy Number One.

The Seduction of the Innocent

As the 1950s wore on, and Senator Joseph McCarthy's obsession with rooting out the dirty Commies who had infiltrated the highest echelons of government, Hollywood, and everyday American life turned into a frenzy of backstabbing, double-dealing, self-preservation, and paranoia, comics

continued their reign of terror over the erudite and proper sensibilities of the respectable public.

As a modern-day mirror to the "Great Comics Scare," look no further than the spate of angry statements from politicians, parents' groups, and Church activists over the violence and sexual content of the *Grand Theft Auto* series. Then amplify that to include the very real fear that we were all going to die in a nuclear holocaust, that our neighbor was secretly a spy for the evil Soviet government, that there were at least 57 varieties of Communists who had infiltrated *our* government, and that our children were certain to become depraved lunatics thanks to the 10-cent pamphlets that warped their brains and were readily available at any candy store.

As the move to ban comics faded, then surged back to life with a toothy roar, kids and comics readers fought back, most notably in this letter published in the *Syracuse Herald-American* in 1949 (reproduced in David Hajdu's *The Ten-Cent Plague*), written by a group of high school students:

> Sale of some types of comic books to the young people of our community has been forbidden. This, in most cases, is a very good measure, but why stop there? How about the so-called best sellers that are so freely circulated among the parents of these same children? These adults, who were directly responsible for the enactment of this curb on the funnies, read this type of book constantly and don't consider it good unless it is full of the vile language and corrupt thoughts which thoroughly disgust any decent person . . . In our estimation these actions by our elders are of no constructive use and stimulate only disrespect in their children's minds.[13]

Fear of the fellow American, of decaying moral values, of the foreign interloper, and of nuclear holocaust intermingled with fear of fiction is a deadly cocktail, leading not only to censorship of the most dangerous order, but to the curbing of imagination, of creativity, and of independence. It also would lead to the "leave it to the professional" mentality* that has been part and parcel of the second half of the 20th-century media landscape.

Public Enemy Number One

While now regarded as classics of the comics medium, the horror and crime output of EC Comics riled the conservative masses towards one end: the eradication of the comics medium. In Frederic Wertham, they found their poster child, their icon.

*Discussed in Chapter 4, "Into the Rabbit Hole."

While the EC Comics caught the attention of parents and the U.S. Senate, Wertham's book, *Seduction of the Innocent,* published in 1954, referred to nearly all comics as "Crime Comics," though he aimed his sights primarily on superheroes—a genre that by the time of publication, was on its last legs.

With a vivid imagination that should call into question Wertham's own predilictions and paranoias, Wertham laid bare the horrifying effects that comics had on the youth of America, such as Batman and Robin's blatant homosexuality and Wonder Woman's rampant lesbianism inspiring countless children to go gay.

Running parallel to Lex Luthor's insecure obsession with Superman as an inhuman ideal that fueled his hatred was Wertham's singling out of Superman (now a model citizen) for particular ire:

> How can they respect the hard-working mother, father, or teacher who is so pedestrian, trying to teach the common rules of conduct, wanting you to keep your feet on the ground and unable even figuratively speaking to fly through the air? Psychologically Superman undermines the authority and dignity of the ordinary man and woman in the minds of children.[14]

From Wertham's testimony to the Senate Committee on Juvenile Delinquency in 1954 (shortly after the publication of *Seduction of the Innocent*):

> I would like to point out to you one other crime comic book which we have found to be particularly injurious to the ethical development of children and those are the Superman comic books . . . They arouse in children fantasies of sadistic joy in seeing other people punished over and over again while you yourself remain immune. We have called it the Superman complex.[15]

Wertham concluded his testimony by noting that *Seduction of the Innocent* had just been selected as a Book of the Month Club selection.[16]

Golden Age Style: The Stories

For the most part, the creators in the Golden Age didn't have aspirations to be more than creators of entertainment. The stories crafted were deliciously pop, simple morality plays where good would triumph over evil (with the occasional cliffhanger thrown in for good measure) that would thrill and entertain in 6 to 16 pages each month. Subtext and meaning? Not so much. Remember, these stories were created to entertain, not to "matter." No one looked at these stories through the historical lens through which we look today. They were cheap entertainment meant to be read, enjoyed, traded, and disposed of.

The pace was breakneck, flying from one sequence to the next, breathlessly dragging along the reader waiting for the next punch to be thrown. They were the epitome of Elmore Leonard's writing tip to "cut out all the boring parts." The forward propulsion of dramatic beats can best be described as "and then," versus the more dramatic "but" or "therefore," usually guided forward by narration or dialog.

In the first Superman adventure in *Action Comics* #1, Superman saves an innocent woman from execution, takes down a wife abuser, asks Lois Lane out on a date (as Clark Kent), is rebuffed for being a coward, saves Lois (as Superman) from kidnappers, travels to Washington D.C., and taunts a corrupt lobbyist by walking on electrical wires. All of this in 13 pages, with another 51 for more adventures of other characters.

By contrast, it would take most comics today six issues to tell that story. While most stories today are *highly* decompressed and drawn out, the stories of the Golden Age were compressed to the nth degree, bringing more, More, MORE! to the masses.

The Comics Code Authority

To save the comics industry, it was decided that the industry would have to adopt its own code to make comics fit for public consumption. In the vein of 1933's Hays Code (the precursor to the MPAA) that brought motion pictures in line, the Comics Code Authority was established. In order to be sold in the United States, all comics would have to feature the seal of the CCA, "Approved by the Comics Code Authority."

Among the regulations imposed on the comics industry by the CCA were the following:

- Policemen, judges, government officials, and respected institutions shall never be presented in such a way as to create disrespect for established authority.

- No magazine shall use the word horror or terror in its title.

- All scenes of horror, excessive bloodshed, gory or gruesome crimes, depravity, lust, sadism, masochism shall not be permitted.

- Profanity, obscenity, smut, vulgarity, and words made up of symbols that have acquired undesirable meanings are forbidden.

- Passion or romantic interest shall never be treated in such a way as to stimulate the lower and baser emotions.

- Respect for parents, the moral code, and for honorable behavior shall be fostered.

- The treatment of love-romance stories shall emphasize the value of the home and the sanctity of marriage.[17]

With a mighty swipe, the comics industry became the last media frontier to be brought in line. Superheroes who stood for something beyond the moral imperative of the day were all but forgotten relics of a different time. The EC horror comics that offered something different for an adult audience were gone by the end of 1955. Will Eisner had quit *The Spirit* and the only newspaper comics were the strips, just as it had been before the comic book arrived on the scene. The industry was decimated, a shadow of what it had been before. The number of comic books published dropped precipitously, from 650 to around 250.[18] Publishers disappeared, and artists were out of work, afraid to even admit they worked in the comics industry. According to DC Comics artist Carmine Infantino (who would go on in a year to help usher in the next great age of comics) in an interview with David Hadju in *The Ten-Cent Plague*,

> The work dried up, and you had nowhere to go, because comics were a dirty word. You couldn't say you were a comics artist, and you had nothing to put in your portfolio. If you said you drew comic books, it was like saying you were a child molester.[19]

As the old adage goes, it's always darkest just before the dawn. And the dawn was coming . . . in a flash.

You Must Remember This . . .

■ Will Eisner crafted the first comic book to be included in newspapers, reaching a wider audience than the standard stand-alone comic book. In eight pages a week, he told complete, literary stories that revolutionized the comics storytelling medium.

■ A serialized story continues from one installment to the next, resolving the cliffhanger left at the end of the previous installment; episodic storytelling returns to normal, but features the same characters in a new adventure.

■ The tastes of audiences changed rapidly, from superheroes to crime to romance to horror—all within the space of a few years.

■ Fear of fiction (and the immersive qualities of that fiction) is a driving force behind the push for censorship that pops up at least once every decade.

■ A confluence of Frederic Wertham's *Seduction of the Innocent*, the 1954 Senate hearings on Juvenile Deliquency, and parental and bureaucratic outrage nearly decimated the comics industry and led to the creation of the self-policing Comics Code Authority, which sought to regulate the content of comics. This regulation shaped comics for the next several decades.

Notes

1. Gerard Jones, *Men of Tomorrow: Geeks, Gangsters, and the Birth of the Comic Book* (New York: Basic, 2005), p. 194.
2. Frank Rose, *The Art of Immersion: How The Digital Generation is Remaking Hollywood, Madison Avenue, and the Way We Tell Stories* (New York: Norton, 2011), p. 90.
3. David Hajdu, *The Ten-Cent Plague: The Great Comic Book Scare and How It Changed America* (New York: Farrar, Straus, and Giroux, 2008), p.110.
4. Gerard Jones, *Men of Tomorrow: Geeks, Gangsters, and the Birth of the Comic Book* (New York: Basic, 2005), p. 237.
5. Frank Rose, *The Art of Immersion: How the Digital Generation is Remaking Hollywood, Madison Avenue, and the Way We Tell Stories* (New York: Norton, 2011), p. 36.
6. David Hajdu, *The Ten-Cent Plague: The Great Comic Book Scare and How It Changed America* (New York: Farrar, Straus, and Giroux, 2008), p. 97.
7. Frank Rose, *The Art of Immersion: How the Digital Generation is Remaking Hollywood, Madison Avenue, and the Way We Tell Stories* (New York: Norton, 2011), pp. 92–93.
8. Ibid., p. 157.
9. Ibid., p. 175.
10. Les Daniels, *Marvel: Five Fabulous Decades of the World's Greatest Comics* (New York: Abrams, 1990), p. 61.
11. David Hajdu, *The Ten-Cent Plague: The Great Comic Book Scare and How It Changed America* (New York: Farrar, Straus, and Giroux, 2008), p. 190.
12. Ibid., p. 189.
13. David Hajdu, *The Ten-Cent Plague: The Great Comic Book Scare and How It Changed America* (New York: Farrar, Straus, and Giroux, 2008), p. 147.
14. Grant Morrison, *SuperGods: What Masked Vigilantes, Miraculous Mutants, and a Sun God from Smallville Can Teach Us About Being Human* (New York: Spiegel & Grau, 2011), p. 55.
15. David Hajdu, *The Ten-Cent Plague: The Great Comic Book Scare and How It Changed America* (New York: Farrar, Straus, and Giroux, 2008), p. 264.
16. Ibid.
17. Ibid., pp. 291–292.
18. David Hajdu, *The Ten-Cent Plague: The Great Comic Book Scare and How It Changed America* (New York: Farrar, Straus, and Giroux, 2008), p. 326.
19. Ibid.

Five Mantras for Writing a Comics Script

Although this entire book is about giving you the stylistic tools through a look at the evolution of comics storytelling, it wouldn't be complete without a section, no matter how small, about how to create a comic script.

Although I had been a comics reader for more than 20 years by the time I wrote the script (along with my writing partner Paul Klein) for *Whiz!Bam!Pow! Comics* #7, there was a bit of a learning curve to switch to the comics medium (from our original medium of film). Here are five mantras we kept repeating to ourselves when writing the script.

1. Comics is Not Film

They are a completely different medium. Sure, there have been innumerable adaptations of comics into film (and vice versa), but they are a separate media with their own strengths and weaknesses. Do not expect what you write in a film script to translate well to a comic script. For instance, voice over. While it doesn't work very well in film (unless used exceedingly well by a great writer for a good reason, like Billy Wilder in *Sunset Boulevard*), it lends itself marvelously to comics. Comics can take the best of both the worlds of novels and film—the inner thoughts represented by novels and the visuals represented by film—and give them a new and exciting life in comic form.

2. Comics are Immersive, Personal Experiences

Until digital comics really takes off and the shared experience is more likely, reading comics is a personal experience. Your work will be held in the hand of one person. Can you create a more intimate experience in a comic? While looking for elements to spread your story across the comics medium ask yourself: Is there something in your screenplay or game that lends itself to that personal experience?

3. Remember the Main Elements of Comics Storytelling

Comics, like film, has its own language that must be understood. You don't visit a foreign country without at least learning a few phrases. Those elements are: page, panel, art, narration, word balloon, thought balloon, sound effects, gutter, and grid.

That's it. Make the most of them.

4. Limitless Storytelling Potential

Never forget this. Comics is a fun, vibrant, challenging and exciting medium with near-limitless storytelling potential. You don't have to worry about a budget. You don't have to worry about anything. You can do the most soul-searing work of realistic fiction or the deepest, most defined fantasy world ever created (or combine both) and not spend any money. You are not held back by the "real world" budgetary constraints of film. Unleash your inner child and have fun with the medium. Fun and play are contagious.

5. It's All About "The Moment"

Unlike a film or television series, where you have images constantly in motion, a comic has only one chance, one image, to convey the action intended and provide a seamless transition to the next panel. You cannot fill a panel with multiple forms of action. You have to pick the optimal angle and image for the artist to give life. If you've written a panel of a character smashing through a planet, grabbing the planet from the other side, and hurling it back at a bad guy, you've done something impossible to replicate in a single panel (though it may work in a panel sequence). Find that optimal moment of action with each panel and you will start unleashing the storytelling potential of the comics medium.

Into the Silver Age, 1956–1961

After Frederic Wertham and his ilk nearly destroyed the comics industry and, bowing to the restrictions of the Comics Code Authority, became a survival necessity, comics were in a bad way. Distribution was drying up (by 1958, even Timely—now Atlas—publisher Martin Goodman was turning to DC/National for a distribution vehicle),[1] sales had plummeted, and publishers were disappearing. News-stands were becoming a thing of the past, a nostalgic memory absorbed into the supermarket as cities gave rise to the domesticity of the suburbs. Comics were losing their primary vehicle for sales and facing new competition for attention thanks to the overwhelming popularity of television and the newly "busy" lifestyle of their primary demographic—kids. In a desperate attempt to maintain sales and create some form of economic security, the once titanic 64-page comic books were halved—half the content for the same dime. The industry was a ghost town, the once-unbridled creativity and boundary-demolishing kicked out of the saloon doors.

Who would come in and save the industry? As it turned out, the same brightly colored characters who had ignited the industry less than two decades earlier. A new age of superheroes was about to begin.

Showcase #4

Although DC had published Superman, Batman, and Wonder Woman non-stop since the Golden Age (they are the only three heroes of the first popular wave of heroes [1938–1941] that have been published since their first appearance), other heroes had disappeared. The Justice Society was gone. The original Flash, gone. Green Lantern, gone. Without the definite enemies of the Great Depression and World War II to fight, the world simply didn't need superheroes, instead turning to other genres such as crime, romance, and horror for their entertainment (much to the chagrin of the more "pure" minds of the age).

It was in an anthology series, that stalwart format of the Golden Age, *Showcase* that DC editor Julius Schwartz hit upon the idea to resurrect one of the disappeared heroes, The Flash, but rebuilt from the ground up. The Flash would no longer be the frying-pan capped Jay Garrick, but a new character, with a new identity, a new costume, and a new, scientific (as was the popular thing at the time) explanation for his origin. The new Flash was Barry Allen,

a police scientist, who in a freak lab accident was covered in a mixture of chemicals and hit by lightning, making him the super-speedster, The Flash. The Barry Allen iteration of The Flash is also notable for being perhaps the first "meta" superhero. He took on his heroic namesake by being a comic book reader himself, thrilling to the adventures of his hero, Jay Garrick, the Golden Age Flash (whose numbering and title he would soon inherit as the new Flash).

META

"Meta" refers to a phenomenon in literature of "X about X." For comics, it would be "comics about comics," hence the meta-nature of Barry Allen's inspiration for taking on the namesake of his favorite hero, the Golden Age adventurer, The Flash. We'll also see examples of this in the Marvel Universe as a tool to bring the "Shared Universe" concept to a pinnacle.

The Flash was followed three years later by Green Lantern in *Showcase* #22 (October, 1959). The Golden Age version, Alan Scott, had possessed green-hued mystical lantern powers (as well as a pre-disco purple cape), but Schwartz's (along with writer John Broome and artist Gil Kane's) reinvention of the character saw Green Lantern as jet fighter test pilot Hal Jordan, an intergalactic space cop defending Sector 2814 from the evils of the universe by wielding a green ring that harnessed willpower into unbelievable contraptions to save the day. Then Hawkman was reborn in another DC anthology, *The Brave and the Bold*; then The Atom, now a research scientist irradiated by a white dwarf star who could shrink to miniscule proportions, was brought back to heroic relevance in 1961.

The Icons

Why have the original comics characters—Superman, Batman, Wonder Woman, Captain Marvel, Captain America—remained a powerful literary force 70 years after their creation? Is it the enduring nature of their stories? Sure. But it's more than that. They are enduring characters because of their core simplicity. That core simplicity lifts these characters above mere "characters" and transforms them into icons that inspire evolution and creativity.

Every creative team that works on these characters brings something new to them. They are blank slates; they are what we make them. Like Dracula, Dr. Jekyll and Mr. Hyde, the iPad, and Lee Harvey Oswald, the characters created in the Golden Age are open to any interpretation, any artistic license we bring to them. They are allowed to evolve.

It was an unparalleled burst of creative energy, one that hadn't been seen since the Golden Age. DC was again creating heroes and mythologies of their time. In the 1930s and 1940s, it was characters who stood tall against the dark injustices plaguing the world population, black-and-white defenders of truth, justice, and the American way who resolved problems with all-business, take-no-prisoners fisticuffs.

In the new Silver Age, it was heroes who operated within the confines and structures of a well-oiled and prosperous society. With The Flash as a police scientist and Green Lantern as a test pilot and member of an intergalactic police force, DC was positioning itself as the "mainstream" publisher in the end of the Eisenhower era. These were the good guys, free of any flaws. They were the new mythology, heroes to aspire to be . . . and let's be honest, they looked pretty cool too.

Tarnished Icons

Superman, Batman, and Wonder Woman have been continuously published since their creation in the Golden Age, but in the first part of the Silver Age their stars were fading fast, passed over by the newness and excitement of The Flash and Green Lantern. In fact, in a poll conducted in *Green Lantern* #3, it was found that he was the favorite character of DC readers. The results? Green Lantern: 888 votes. Superman: 600. The Flash: 521. Batman: 512.[2]

Superman, once the defender of the little guy, had morphed into an Eisenhower citizen, upright, stand-up, and always willing to point out the benefits of serving the Establishment. While hugely successful during its run from 1952 through 1957, the television show, *The Adventures of Superman* transformed Superman comics in the 1950s into four-color versions of the television show, forgetting that comics, unlike television, had an unlimited budget. If anything, the Superman comics of the time were low budget in imagination, as Superman fought gangsters and other low-powered buffoons who were no match for his strength and power. It was an instance of a lack of antagonistic imagination due to bowing down to another medium.

Silver Age Antagonism

It's been said that every hero is only as great as the villains they fight, and in the Silver Age of Comics, we see that lain bare. DC heroes were fighting gangsters and space freaks that presented little to no danger. It was a time when heroes won, good triumphed over evil (much like the early comics), and the threat level was considerably low. Even the classic rogues of Batman and Superman were either forgotten or transformed into mockeries of their original menace. How can one expect the heroes to be heroic when they're fighting villains so beneath them?

Contrast that with the Marvel Universe, where the rogues gallery of nefarious nefarities are legend: Spider-Man had The Green Goblin, Doctor Octopus; The Fantastic Four had Doctor Doom—these villains posed increasingly dangerous threats to the heroes and no doubt led to the staying power of the 1960s-era Marvel Comics.

Silver Age Style: The Page, the Panel, and the Grid

In comics of the Silver Age, the page count was halved due to economic pressures from the fallout of the Wertham book, *The Seduction of the Innocent* and the Senate hearings of 1954. Now 32 pages (still for a dime), and following the rebirth of the superhero with *Showcase* #4, comics still adhered to a clean, clear, and contained panel layout.

The Icons *continued*

It was also that ability to interpret the comics characters in multiple ways that saved the comics industry after the dark "Wertham-ed" years. The Flash and Green Lantern, once largely dismissed Golden Age heroes, became the harbingers of a new age of comics through a new and enduring interpretation, taking them from throwaway characters in the Golden Age into iconic ones in the Silver.

When we created The Sentinel for *Whiz!Bam!Pow!*, I specifically left out his origin story, and anything about backstory—even though I know it. I wanted to bring that iconicism and simplicity to the character, not so that they would endure for 70 years, but so that the audience (who will hopefully become absorbers and co-creators) can add their own elements on top of the character, allowing the *Whiz!Bam!Pow!* universe to perpetually grow as a Golden Age sandbox. It was that simplicity that transformed Superman from a character in blue tights into a pop-culture icon.

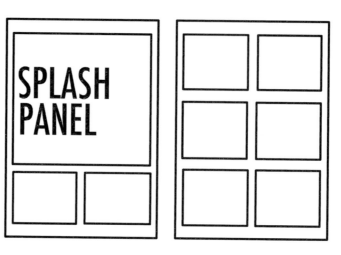

FIG 12.1 Example of a typical Silver Age grid layout, still using the traditional splash panel from the Golden Age. Note the switch to six panels per page, versus eight to ten. This was due to a desire for clarity in the art and the reduced width of Silver Age comics.

FIG 12.2 Example of a typical Silver Age grid layout, still using a splash page. This was typical of comics in the later Silver Age, as they switched from multi-part stories in the same issue to a single, 32-page (or less) story.

The majority of early DC Silver Age books were presented with a fairly uniform five to six panels per page, while the Marvel books varied. The variance of panels in the Marvel books is in no small part thanks to the Marvel Method, where artists would have the prerogative in panel design and distribution. The primary function of the panel was to be a container for action.

The shape of panels began to vary, especially as the "flashback" panel became a valuable tool for exposition, taking on the appearance of a "thought balloon" to represent both dialog and inner thought (which, technically, a flashback is), such as the example in Figure 12.3.

By the conclusion of the Silver Age, panel layout would become widely varied and experimental, setting the stage for today's usage of the panel.

FIG 12.3 Silver Age flashback panel. Note the character inset delivering the exposition, with the panel shape reflecting a thought balloon (art by Blair Campbell).

Barely Superman

Preserving the sanctity of marriage and importance of the nuclear family was a staple of 1950s comics, and Superman became a gangster-fighting family man. Other than fighting gangsters, Superman was beset by the marriage machinations of the once-fiercely independent girl reporter Lois Lane. It was Superman's midlife crisis (at only 20 years old).

As with any midlife crisis, it was time for a revitalization. Editors Schwartz and Mort Weisinger recognized that the Superman of the 1950s represented nothing but wasted potential. While they couldn't take him back to his roots as a realistic (even though he was from another planet) defender of the oppressed (it didn't fit with the times—or within the confines of the pro-Establishment Comics Code Authority), they decided to take his alien heritage and use it as a springboard for stories to thrill and entertain (as well as cash in on the current interest in all things space and sci-fi).

TRANSMEDIA TOOLS:
The Multiverse

While (meta) Barry Allen thrilled to the comic book adventures of his hero, the original Flash, Jay Garrick, in his first appearance in *Showcase* #4, Allen would meet his heroic namesake by vibrating across the universe into a parallel universe, where the Golden Age heroes still lived and fought the good fight against evil in 1961's *The Flash* #123.

A popular storytelling technique since the pulps, the parallel universe/multiverse opened up realms of story possibility within the developing DC Universe (though by the 1980s, would result in massive confusion), making new readers salivate at the prospect of more heroic adventures in store for them in this unexplored parallel Earth—and grab the interest of their parents who had thrilled to the adventures of the Golden Age heroes not more than ten years earlier. Nostalgia is a powerful force in the evolution of the comics industry.

Don't be afraid to explore this concept with your own projects. Today, shows like *Fringe* have used parallel Earths and timelines to broaden the scope of their stories, presenting new takes on characters, slightly tweaked, yet still recognizable, as foils and partners for the original beloved characters. This represents a concept called "multiplicity," or, multiple takes on the same characters. It is a powerful storytelling tool used to great effect throughout the history of comics.

If using different media forms can grab more absorbers, imagine what creating a whole new parallel universe can do. But, as with anything, use it only if it makes story sense.

To revitalize their once-brightest star, *Superman* editor Weisinger turned to a man who had been the bane of DC's existence throughout the 1940s, the lead writer for Fawcett's sensation (and DC's favorite litigation target) *Captain Marvel*, Otto Binder. Binder was renowned for the sci-fi fun he brought to *Captain Marvel*, and DC wanted that for *Superman*. With the lawsuits out of the way (Fawcett Comics ceased publishing *Captain Marvel* [and all of their comics] in 1953).[3] DC turned to Binder to bring that sci-fi sensibility to *Superman*, and unleash the storytelling potential of Superman's alien heritage.

Binder's job was to give *Superman* a universe as vital as that created for *Captain Marvel*. Elements like The Fortress of Solitude, the planet-shrinking intergalactic super-foe Brainiac, and the "red sun" aspect of his powers were all brought in by Binder and his imagination. The plot possibilities became endless as Binder and company introduced concepts like Red Kryptonite and imaginary stories to the Superman mythos.

One of Weisinger's first things to do with the new era was to add a letter column, "The Metropolis Mailbag," to the pages of *Superman* comics.[4] It was the first time anyone had asked the kids reading the comics what they wanted to read. It was a new form of engagement with the audience, akin to the pulps, the serialized fictions of Dickens and others, and the one-on-one interaction allowed by social media today. And what did the kids want? Hundreds of girls wrote in demanding a female counterpart to Superman, and thus was born Supergirl, a mainstay (in various incarnations) of the Superman family to this day (another Binder contribution, taking cues from his work in creating the "Captain Marvel Family" of Captain Marvel, Mary Marvel, and Captain Marvel Jr., plus other memorable characters).

Superman had been reborn, with a new world, new characters, and a foundation for an era of fantastical and fantastic storytelling. It was from those early Binder stories (1958 to 1960) that Grant Morrison mined the possibilities for his seminal modern-day (or any era) Superman series, *All-Star Superman*, now regarded as one of the greatest Superman stories ever told.

Zebra Costumes and Bat-Purses

Of all the superheroes, Batman suffered the most from the stringent regulations of the Comics Code Authority and parental outcry. He was a hero who had begun as a pulp-influenced vigilante, and was consistently reinvented to cater to the perceived tastes of his readership. The problem was that in so doing, they made Batman a parody of himself, strangling the one character trait that made him the hero he was: he was the self-made man, a man who pushed himself to the peak of physical and mental perfection. He was driven, obsessed, and a loner, fighting his fight with focused intensity.

By catering to the non-existent and invented demands of readers, they took his self-made intensity and made him the product of imaginary focus groups, fighting whatever was "big" or "in" at the time.

Batman, once a dark avenger of the night, a mythological predator of evil, was now an upright, daylight-dwelling citizen who fought the jesterly Joker and random sci-fi villains that resulted in him landing in garish costumes. By the end of the 1950s, the Batman was reduced to fisticuffs with time-traveling aliens and the like, his dark avenger status destroyed. In a stroke of modern-day genius, Grant Morrison, the most recent *Batman* writer, would bring these stories back into continuity, though as a result of hallucinations induced by self-inflicted isolation testing.

Seeing how well it had worked with Superman, Batman also gained a family in Batwoman, Batgirl, Bat-Mite, Ace the Bat-Hound and a Bat-Gorilla. The stealthy lines of his original appearance had given way to a bulky, "gee whiz" suburban dad, fending off the marriage advances of Batwoman (no doubt a tool to demolish the Wertham "Batman as poster-child for man-boy love relationships" argument), and strolling about Gotham wishing its citizens a good day—in sunlight!

Batman was nearly doomed. But, as we'll see later, many great innovations come from a reaction *against* something after it reaches its tipping point.

Thought Balloon: Ron Fortier

Ron Fortier is a professional writer with more than 35 years experience. He has worked on comic book projects such as The Hulk, Popeye, Rambo *and* Peter Pan. *Among his most popular works are* The Green Hornet *and* The Terminator *(with Alex Ross) for NOW Comics. In this brief chat, we talk about the influence the Silver Age of Comics had on his own writing, as well as a few thoughts on what you need to know to write comics.*

Tyler Weaver (**TW**): What was it about comics in the Silver Age that grabbed you? What made you pull that first comic book off the rack and dig in?

Ron Fortier (**RF**): The rebirth of the super hero genre at Timely Comics. They arrived on the news-stands in midyear and by the end of that summer the company was now calling itself Marvel.

TW: How has your love of the Silver Age influenced your writing style?

RF: Writers like Stan Lee and Denny O'Neil saw potential for much more characterization in comics and took advantage of that potential to help the literature mature. I still consider the writing in those days superior to any other time in comic history and I try my best to write to those incredibly high standards.

As the Justice Society decreed in *All-Star Comics #5*, any hero who receives his own series would switch to honorary status. But what would lead a character to receiving his own series?

After a trial run in one of the many anthology series, if a character would prove popular enough, he would get his own series, much like Superman, Batman, etc. These series would exclusively feature the adventures of that single hero (sometimes with multiple stories per issue during the Golden Age, though that had changed to a single, longer-form adventure during the Silver Age).

Today, the ongoing single-hero magazine (of 22–32 pages) is the primary form of comics storytelling—with a much more serialized bent (owing in no small part to the massive success of highly intricate and serialized television shows like *Lost* and *The Sopranos*) than the done-in-one adventures of the past.

TW: What are the three most important things a writer can convey to an artist to make the collaboration a successful one?

RF: The basic elements of the story. First the setting, time and place. Second the characters in his or her drama. Finally, a detailed sense of the core of the plot, why are we telling this story? What is the importance it to our readers? If a writer can share this succinctly with his artist, then [the] magic of graphic storytelling is possible.

TW: What lessons can today's publishers learn from the Silver Age? What are modern comics publishers doing wrong?

RF: Although the media was moving to more sophisticated tales that would appeal to all ages, the writers and artists of the Silver Age never forgot they were still "funny books" and didn't take on grandiose airs about their roles in society. Today's industry people are so dollar driven, so market and business orientated, they have forgotten how to make fun comics and we're left with dark, gloomy, angst-ridden trash.

The Justice League

With a stable of newly revitalized heroes in place (as well as three classic icons in Superman, Batman, and Wonder Woman) and a stable foothold in the marketplace, DC made the next logical move—team the new heroes up. So, in *The Brave and the Bold* 28 (1960), the Justice League of America was formed, using their combined might to fight the evils of a mind-controlling starfish named Starro the Conqueror. Sales immediately went through the roof, and a *Justice League of America* series was ordered.

The team book was huge in the age of the nuclear family, and Marvel publisher Martin Goodman was salivating at the prospect of his own nuclear family, viewing it as the meal ticket to save his publishing empire. But, as with everything Marvel takes on, it was going to be something different. Something fantastic.

When you've got nothing to lose, you have the possibility of everything to gain.

You Must Remember This . . .

- The Silver Age of Comics began in 1956 with *Showcase* #4, featuring the first appearance of the new Flash, Barry Allen.
- While DC was revitalizing defunct Golden Age characters and creating new heroes, the big three—Superman, Batman, and Wonder Woman—were languishing.

- As in the Golden Age, the panel functioned primarily as a container for action, not a device for timing and dramatic embellishment, but by the middle to end of the Silver Age, that had changed thanks to the Marvel Method and the new talents emerging in the field such as Neal Adams, John Buscema, and Jim Steranko.

- The post-Wertham years and the creation of the Comics Code Authority led to a more familial aspect to heroes, with Superman and Batman both becoming "family men."

- Iconicism and simplicity go hand in hand—the more simple a character, the more iconic they become. This also opens the characters up to multiple interpretations (hence the Silver Age beginning with the rebirth of Golden Age characters in new identities and concepts).

Notes

1. Les Daniels, *Marvel: Five Fabulous Decades of the World's Greatest Comics* (New York: Abrams, 1990), p. 81.
2. Gerard Jones & Will Jacobs, *The Comic Book Heroes: The First History of Modern Comic Books from the Silver Age to the Present* (Rocklin: Prima, 1997), p. 35.
3. Gerard Jones & Will Jacobs, *The Comic Book Heroes: The First History of Modern Comic Books from the Silver Age to the Present* (Rocklin: Prima, 1997), p. 14.
4. Ibid., p. 17.

Flame On!

The Rise of the Marvel Universe

After the conservative rebirth and respect for authority brewed by the Eisenhower Administration, America was ready for something new; a bold vision of the future and a leader to show them the way. They found that leader in the young, charismatic senator from Massachusetts, the second son of America's "Camelot" political dynasty, John F. Kennedy. In his inaugural address, he implored a rejuvenated populace to "ask not what your country can do for you, but what you can do for your country." He both embodied and proselytized that bold vision of the future, a vision of a "new frontier" in the stars.

But on Earth, beneath the glossy headlines and today's soft-focus nostalgia for the era, lay a bleak and terrifying chapter in American history. Fresh out of the McCarthy era, the Cold War was in full swing between the United States and the Soviet Union. The presidency that JFK assumed was rife with tumult from the start, with the Bay of Pigs debacle in Cuba launching a years-long struggle with a tiny Communist island no more than 90 miles off the coast of Florida. A war in South Vietnam had been waged by multiple countries since 1954 to fend off the advances of a Communist North Vietnam, and by the autumn of 1962, the world would face the very real threat of nuclear annihilation during the Cuban Missile Crisis (the historical backdrop for 2011's X-Men film, *X-Men First Class*).

The New First Family

By 1961, Martin Goodman's perpetually name-changing (it was Timely in the 1940s and Atlas in the 1950s) publishing empire was in shambles. The Wertham years had nearly obliterated his company and distribution, and Timely (then Atlas) was pared down to Stan Lee, his brother Larry, and a small group of artists.[1] After fiddling around with an odd assortment of romances, Westerns, monsters, and other genres, by 1961, Lee was ready to walk. But, at Goodman's request (inspired by DC's massive success with *Justice League of America* and the revitalization of their core heroes), Lee made one final go of it. Partnering with Captain America co-creator Jack Kirby, Stan Lee created The Fantastic Four, the "first family" and cornerstones of the new Marvel Universe.

The Fantastic Four were a family, composed of the "father" figure (Reed Richards, AKA Mr. Fantastic), the "mother" (Sue Storm, the Invisible Woman),

the hotheaded brother (Johnny Storm, the reimagined Human Torch), and the angry "uncle" (Ben Grimm, The Thing). And, like any other family, they were prone to infighting and drama as they dealt with the ramifications of their newly acquired superpowers.

Following in the footsteps of their rivals, Marvel and Stan Lee brought a Golden Age character back from obscurity and giving him a new lease on life. When Carl Burgos created the original Human Torch (the cover boy of *Marvel Comics* #1) in 1939, he was an android, a Frankenstein monster unable to control his power. When Lee reinvented The Torch, he was Johnny Storm, and his atomic-space ray infused powers of combustion grew from a character trait—he was tempestuous, a hothead, so of course he had to catch fire. Later, in *Fantastic Four* #4, the second of the Golden Age trifecta would return as the Sub-Mariner was discovered by Johnny Storm (after recognizing him from a 1940s comic book) as a homeless man, who eventually regained his powers and bad attitude to become a world-conquering anti-hero with a particular fancy for Johnny's sister, the beautiful Susan Storm. From there, the Sub-Mariner would discover the lost, Hitler-punching icon of World War II, Captain America, frozen in a block of ice in *The Avengers* #4. Thawing him out, the Sub-Mariner brought Cap into the modern age as the leader of the Marvel super-team, The Avengers.

Just as their competition had done, the Marvel icons had returned for a new generation, though without the total overhauls of DC's revitalization.

TRANSMEDIA TOOLS: The Marvel Method

In addition to ushering in a new age of heroes, the first and most vibrant since the original Golden Age debuts of Superman and Batman, Stan Lee and Marvel also created a new method for producing comics, dubbed "The Marvel Method." Like most innovations, it didn't come from an honest attempt to innovate, but to make the work more efficient.

At the time, Marvel was still a small company. Lee, in addition to being Marvel's main writer, was also the editor and art director. As more and more books were released, Lee had to crank up the pace. Fortunately for him, he was working with some of the most talented comics artists of that (or any other) era. With names like Jack Kirby, Steve Ditko, Bill Everett, and Wally Wood, sometimes the best thing you can do is let them do their job.

With "The Marvel Method," Lee would provide a simple synopsis of the story of each issue, a beginning, middle, and end. He would then hand that off to the artist to work their magic and create the visual flow of the story. This

method also created more of the visual language of comics storytelling, providing a momentum and velocity to Marvel Comics that others simply did not have. Once the art was done, Lee would add dialog and captions over the art, and the comic would be ready to go.

According to Lee in an interview with Les Daniels:

> The best thing about this method of working was that the artists could use their creativity. I never restricted them or said they had to follow what I gave them to the letter. Once in a while I wanted something very specific and I would take great pains with the synopsis, but usually I just gave them the broad outlines and a description of how I wanted the problem solved at the end. How the artists arrived at it was their business.[2]

How can you apply this method of working to your own projects? Remember all transmedia is a collaboration, both between you and the audience and you and your collaborators. This method only works if you work with the best—so bear that in mind when building your team.

It's important to remember, when working with a transmedia project and the multiple media forms inherent in the creation of that project, that you will be collaborating with multiple people in multiple disciplines. It is your responsibility to bring out the best in those working with you. Never forget that the best way to get people to do their best work is by giving them the space to do the work that they love.

Silver Age Style: The Art

The Silver Age marked a notable stylistic difference. Costumes became simpler and design became a key component. At DC, the order was clean and clear art that didn't get in the way of the plot, whereas at Marvel, Steve Ditko brought an angular, spider-like sensibility to Spider-Man while Jack Kirby cornered the market on kinetic action.

While there was some notable use of perspective (high angle, low angle) to alter the reader's involvement from panel to panel, the primary representation of the action was from an eye-level perspective, much as it had been in the Golden Age. By keeping things at a "realistic" perspective (as we see things), it creates a sense of detachment between reader and action.

By the conclusion of the Silver Age (1970), the art had taken on a starkly different look. From the simple cleanliness of Gil Kane and John Romita or the angular oddities of Steve Ditko and the kinetic, manic action of Jack Kirby, came another style, an illustrative style, with artists like Jim Steranko, John Buscema, Gene Colan, and Neal Adams taking the comic book and

FIG 13.1 **The square-jawed Kirby aesthetic. This is the same panel as in Figure 8.4, though featuring the Kirby style and a typically "fantastic" Silver Age antagonist (art by Blair Campbell).**

infusing it with a realistic aesthetic, ushering in a new era of comic book art as well as a new era of comics.

Sound Effects

Thanks to the *Batman* TV series, the sound effect became a staple of pop art in the Silver Age. Although they were simply a means to an end (an icon representing sound as a visual, as per the necessities of the medium) in comics, they evolved throughout the Silver Age to consciously reflect the pop culture phenomenon of the *Batman* show.

The Linchpins of the Marvel Universe

The new Human Torch represents one of the linchpins of the longevity of the Marvel Universe. His powers and the stories that result from those powers are indelibly tied to his character. From the first *Marvel Comics* in 1939, a focus on character and other key traits have defined the Marvel stable of heroes and titles. With The Fantastic Four, Lee brought those defining principles of story development to a new generation with a dash of the national obsession with space and the fears of the atomic bomb that pervaded the 1950s and 1960s. The Marvel Universe was both of its time and timeless.

Over the page, the linchpins that make Marvel Marvel(ous) . . .

Linchpin #1: The Flawed Protagonist

The DC characters were (and have always been) archetypes. They were never "like us" in the way that the Marvel Comics heroes were. The DC characters were above us, protecting us. The Marvel ones *were* us: human beings with the same problems we have: paying bills, romantic entanglements, self-doubt. To protect us, they overcame those fears and foibles to become the heroes they needed to be.

Let's look at the most popular character in the Marvel canon, Spider-Man. If Batman can be considered the crazy uncle, and Superman (especially the Silver Age version) the pipe-smoking, newspaper reading dad, Spider-Man is the older brother. You could relate to him, but at the same time, you looked up to him. You looked up to him even in spite of his dweebish exterior, his lack of confidence, and his yearning for acceptance. Take that, mix in a character-driven super power, and you have the successful Marvel recipe. The driving motivator behind Spider-Man is responsibility through guilt. Because he was so caught up in the glitz and glamour of his newfound televised wrestling fame, he allowed a burglar to escape and eventually murder his Uncle Ben. Spider-Man is defined by that guilt. His journey as a hero was to take his selfish failure and turn it into a selfless crusade—while much of the public distrusts and hates him.

Linchpin #2: The Core Concept

With Spider-Man as a flawed protagonist defined by guilt and a sense of responsibility to both save innocent people from evil and atone for his own failings, it's worth taking another look at Coppola's quote reproduced in Chapter 2:

> When you make a movie, always try to discover what the theme of the movie is in one or two words. Every time I made a film, I always knew what I thought the theme was, the core, in one word. In *The Godfather*, it was succession. In *The Conversation*, it was privacy. In *Apocalypse* [*Now*], it was morality.
>
> The reason it's important to have this is because most of the time what a director really does is make decisions. All day long: Do you want it to be long hair or short hair? Do you want a dress or pants? Do you want a beard or no beard? There are many times when you don't know the answer. Knowing what the theme is always helps you.[3]

The characters of that first dawn of the Marvel Universe in the 1960s can be summed up in one word. The Fantastic Four = Family. The Hulk = Rage. Spider-Man = Responsibility. It was in that simplicity of theme and core idea

that the Marvel Universe found its greatest groundings and allowed the characters to evolve.

Linchpin #3: In Your Backyard

While DC creates fictional cities for their heroes to inhabit, Marvel places their heroes right in the heart of New York City (though it's worth noting that Batman, or The "Bat-Man," originally operated in New York before it became Gotham City), bringing immediately recognizable landmarks into the fold. Readers would thrill to see Spider-Man swinging from the Empire State building, or Daredevil cleaning up the streets of Hell's Kitchen.

Both approaches have their merits. On the DC side, creating fictional cities allows for a deep mythology to be built up around the city, making the fictional city as much a character as the main protagonist. Think of Batman, you think of Gotham City. Think of Superman, and it's Metropolis. Both cities represent the character traits of their protectors (this is one of the primary ways DC ground their stories in reality, by having the city reflect the character of its hero). While making an attempt to ground their stories in reality in a fake city, the fake city arguably adds a deeper element of creativity and flexibility than the tangibility and reality of the real-life city.

On the other hand, Marvel's method of situating their characters in real cities (like New York) adds a layer of immersion that a fictional city cannot provide. The Marvel Universe is an alternate, stylized reality overlaid on top of real life. By bringing that alternate reality to the comics world through placing their characters in (primarily) one city, Marvel opened the door for another comic innovation (that had been around for a while, though used to greatest effect within the pages of the 1960s Marvel Comics)—the Shared Universe.

Linchpin #4: The Shared Universe

As a comic book reader for most of my life, and with a taste for transmedia on my palette since my first bathtub adventures with *GI Joe*, the one area—an area that inspired this writing—shared by both are the concepts of shared universe and canon.

A shared universe is made up of an interplaying canon (or "mytho-canon" as I prefer). The *Batman* stories have their own canon: Bruce Wayne. Alfred. The Joker. Batcave. Batmobile. Shark-repellent Bat Spray. Superman is the same: Clark Kent. Lois Lane. Lex Luthor. Distant planet. Kindly farm couple. The canon is the rulebook for the universe that is accepted and embraced by fans. The shared universe places those respective canon into a sandbox and lets them play with one another.

The DC Universe is a shared universe. Heroes know each other, face off against each other's villains and team up in vast intra-company crossover events against evil so vast only the combined might of the world's greatest heroes (many times to mixed effect, but that's a writing for a later chapter).

Whereas DC took a much more laid-back approach to the Shared Universe concept in the Silver Age (the occasional Flash/Green Lantern meeting, the Justice League), Marvel embraced the Shared Universe with all of the gusto of Stan Lee's hyperbolic writing. Characters would meet at random, not to fight, but just because they happen to be in the same city (including most notably, the wedding of Susan Storm and Reed Richards in *Fantastic Four Annual #3*, where every single Marvel character appeared to wish the new couple the best on their journey towards wedded bliss). Even Marvel's new spate of movies (since the Jon Favreau-directed 2008 hit, *Iron Man*) are part of their own shared universe; "Easter eggs" abound, characters cross-over and intermingle with the stories being told in their individual films.

Comic books have been creating vibrant universes since they began—which is exactly what we as transmedia producers aim to do.

Linchpin #5: Plot Versus Character

The final defining difference between Marvel and DC Comics is the importance of character over plot. DC Comics have long been meticulously plotted affairs, adhering to a defined story structure. This is the archetypal and mythological aspects of the DC Universe seeping in. The DC characters are icons on which any story can be presented. Especially in the Silver Age, there was a push towards a focus on plot as the main ingredient of DC Comics, with editors Schwartz and Weisinger insisting on tightly structured, done-in-one tales of adventure. The truth is that any DC story of this era could feature any character in their universe and not suffer for it.

Marvel Comics are the flip side of this coin. Instead of featuring iconic characters jammed into plots, Marvel plots come from character. Spider-Man feels a sense of responsibility to protect his heart-attack prone Aunt May, so he flees a battle with The Green Goblin and is branded a coward by the public at large who increasingly distrust him. This wouldn't work with any other Marvel character, which is what leads to the intense identification and passion for these characters shared by fans the world over (especially the 1960s era Marvel comics).

The stories feel organic because they come from character. It's why these stories hold up much better than DC's tales of the era. While DC's elicit a chuckle and smile of whimsy at the sheer audaciousness and lunacy of

General Hulkspital

Ongoing stories that have made the most of what serialized media has to offer. Characters that have engaged, enraged, and been a part of lives for 70 years. A deep canon and sense of place. Death, rebirth. Fantastical, melodramatic heightened reality. A dedicated fan base that sets aside valuable time from their day to be transported to another world, much like their own, only skewed.

Welcome to soap operas. Even though the target audience is different, soap operas have learned more about longevity from comic books than

some of their Silver Age output, Marvel shines a light on the times they were created in, with characters and stories that are timeless, engaging, and, most importantly, fun.

Civil Rights

They were reviled, looked upon with fear and distrust. They were different than us, some called them a different species, a subspecies. All they sought was equality with their neighbor, for the country to look at them with a singular thought: "different is different, not better." They wanted to be looked at as one of us, in spite of their now-legendary powers and countless savings of the world.

A month after Martin Luther King's "I Have Dream" speech, Stan Lee and Jack Kirby gave the world *The X-Men*, a new team book featuring characters who didn't get their powers from a lab accident or from being rocketed from a dying planet—they were born with their powers. They were Mutants.

Originally hoping to call his new group The Mutants, Lee was convinced by publisher Martin Goodman to come up with something less confusing, so he hit upon the name "The X-Men."[5] With a nice note of mystery to it, The X-Men were a group of super-powered teens, carrying with them the same level of misunderstanding of themselves and their powers that Lee's previous teen co-creation (with Steve Ditko) Spider-Man carried on his shoulders.

But with *The X-Men*, Lee pushed it further. These teenagers had their powers since birth, born different from the mainstream. They were feared by those who viewed their evolution as a threat to the sanctity and dominance of the human species. Of course, as with all literature, that relevance wasn't the driving principle of the book. It was to sell copies and entertain (over-persuade). But *The X-Men* represents a shifting set of values in comics. When they first appeared on the scene, comics were still thought of as pre-adolescent power fantasies and entertainment for a lower class. *The X-Men* showed that comics could be about something.*

*Much in the way that Ross MacDonald, one of the "holy trinity" of crime writers along with Dashiell Hammett and Raymond Chandler, used his crime fiction to highlight environmental issues during the same time.

General Hulkspital— *continued*

they'll ever admit. Twisty, turny melodrama that grabs viewers and makes them feel as though they're part of the story. Fictional towns and cities that one can imagine living in (between commercials for laundry detergent and soap, hence the title "soap operas"). Stories that make the utmost use of the medium in which they're being told—in the 1930s, soap operas first appeared on radio; the 1950s: television. Now, some may make the move to web serials (though it appears that that medium shift may not happen after all).

In the Marvel Universe, soap operas became a (likely unintentional, though that's not for certain) inspiration when *The Hulk* received his own series, drawn by Steve Ditko.* This first regular series featuring the character, *The Hulk* broke ground in comics by being the first super-hero series to be composed of a cast of characters involved in intricate and complex plots, each issue ending with cliffhangers tying into the overarching plot featuring the villainy of "The Leader." It was the first comic series to make a play for the attentions of regular comic readers—not the casual buyer.[4]

Comics create the exact level of engagement and faithfulness in their fans as soap operas do in theirs. How can you harness that?

*Which is odd, given that Jack Kirby is a perfect fit for *The Hulk*; I liken this to Bela Lugosi playing Frankenstein in *Frankenstein Meets The Wolf Man* instead of Boris Karloff.

Silver Age Style: The Captions

Narration

While the art marked a vast stylistic difference between Marvel and DC, nowhere was that difference more prevalent than in the use of narration and captions. As in the Golden Age, the narration was the primary driving force of DC storytelling. As an example:

> UNKNOWN TO THE LOVELORN GIRL, THE MAN OF HER DREAMS IS RIGHT BESIDE HER IN HIS SECRET EVERYDAY GUISE!
>
> BUT FATE IS GOING TO PLAY A STRANGE TRICK ON YOU, CLARK (SUPERMAN) KENT...BEGINNING WITH A DANGER OUT OF NOWHERE!

In these Otto Binder-written *Superman* adventures, there was a playfulness emerging in the narration, with a third-person omniscient bent to the proceedings—the "FATE IS GOING TO PLAY A STRANGE TRICK ON *YOU*" line, giving Binder's narration (and indeed, most of DC's narration at the time) a god-like presence over the goings-on in the DC Universe (this is no doubt due to the editorial influence over intricate and complex plot-based storytelling).

The "god-like" third-person omniscient storytelling that was so prevalent throughout much of the Golden and early Silver Ages occasionally gave way to the flashback panel, often narrated by one of the characters in the story, becoming a mixing of voice-over and first-person narration. This would evolve over time to the now-standard first-person narration throughout comic books.

At Marvel, however, things were much different. Marvel had personality. Marvel editor and lead writer Stan Lee (who was the boisterous "god" of Marvel's particular brand of omniscient narration) made it his mission to make the reader feel like they were part of an exclusive club, a family, where all of these crazy and wild adventures took place, such as this wonderful instance from *Fantastic Four* #10 where the action of Reed Richards' and Susan Storm's romantic problems were interrupted by writer's block in the Marvel offices:

> AND THAT, DEAR READER, IS AS FAR AS JACK KIRBY AND I GOT WITH OUR STORY, BEFORE THE UNEXPECTED HAPPENED! BUT LET US SHOW YOU JUST HOW IT ALL CAME ABOUT...OUR SCENE CHANGES TO THE STUDIO OF KIRBY AND LEE ON MADISON AVENUE WHERE WE FIND...

Lee is pulling the readers into the inner workings (highly stylized, as it's reported that Lee and Kirby never worked in the same room together) by ripping back the Fourth Wall and bringing Doctor Doom into the Marvel offices as story inspiration.

As I mentioned in the section about art (see p. 112), the primary perspective used by many artists was at eye level (though this evolved to feature more cinematic angles and perspectives as a new generation of artists took over), creating a sense of detachment on the part of the reader, leaving them emotionally unconnected to the action at hand. Stan Lee made an extraordinary effort with his chummy, "behind the scenes" narration to pull readers into the action, making the Marvel Universe as immersive as it was fun. Additionally, Lee made frequent use of "Editor's Notes" to clarify things and demonstrate how stories fit into continuity (which we'll look at in depth in later chapters—by looking at how continuity can become a problem) with asides such as (from the above mentioned *Fantastic Four* #12):

> SEE <u>FANTASTIC FOUR #6</u>—THE DIABOLICAL DUO JOIN FORCES!

or one of my personal favorites from the first Silver Age appearance of Captain America in *The Avengers* #4:

> <u>EDITOR'S NOTE:</u> WE SINCERELY SUGGEST YOU SAVE THIS ISSUE! WE FEEL YOU WILL TREASURE IT IN TIME TO COME!

Which is then followed by a history lesson:

> THE MIGHTY MARVEL COMICS GROUP IS PROUD TO ANNOUNCE THAT <u>JACK KIRBY</u> DREW THE ORIGINAL CAPTAIN AMERICA DURING THE GOLDEN AGE OF COMICS... AND NOW HE DRAWS IT AGAIN! ALSO, <u>STAN LEE'S</u> FIRST SCRIPT DURING THOSE FABLED DAYS WAS CAPTAIN AMERICA—AND NOW HE AUTHORS IT AGAIN! THUS, THE CHRONICLE OF COMICDOM TURNS FULL CIRCLE, REACHING A NEW PINNACLE OF GREATNESS!

Or, a "confidentially" dispatched admission on the first page of Spider-Man's first appearance in *Amazing Fantasy* #15 (1962):

> LIKE COSTUMED HEROES? CONFIDENTIALLY, WE IN THE COMIC MAG BUSINESS REFER TO THEM AS "LONG UNDERWEAR CHARACTERS"! AND, AS YOU KNOW, THEY'RE A DIME A DOZEN! BUT, WE THINK YOU MAY FIND OUR <u>SPIDER-MAN</u> JUST A BIT...DIFFERENT!

Contrast that with a more . . . rote introduction to a DC Comic of the same era, from *Batman* #156's (1963) "Robin Dies at Dawn:"

> THE FRIENDSHIP OF <u>BATMAN</u> AND <u>ROBIN</u> IS ONE THAT HAS STOOD STEADFAST AS A ROCK! TO <u>BATMAN</u>, <u>ROBIN</u> IS LIKE HIS OWN SON—AND <u>ROBIN</u> WOULD BRAVE ANY DANGER TO KEEP <u>BATMAN</u> FROM HARM! NOW THIS FRIENDSHIP BECOMES THE PIVOTAL POINT OF A STRANGE ADVENTURE IN A FANTASTIC WORLD—A WORLD WHERE DOOM WAITS, AND WHERE <u>BATMAN</u> IS CONFRONTED BY THE TERRIBLE TRUTH THAT . . . <u>ROBIN DIES AT DAWN!</u>

Although I used this example before, it's worth repeating here. During the Silver Age, DC was the Microsoft to Marvel's Apple. DC was more tightlybuttoned, white-collared mass entertainment (though by the end of the Silver Age, that would dramatically change as a new generation of creators came in and brought a bit of Marvel to DC). Stan Lee's goal at Marvel was to give the audience something they didn't even know they wanted: a sense of play, of involvement, and fun. And he did it almost entirely through his hyperbolic and bombastic narration.

Dialog/Word Balloons

The crafting of rich dialog had yet to become an art form in comics. In fact, most dialog was still expositional and explanatory, such as this gem from the previously mentioned *Batman* tale, "Robin Dies At Dawn":

> ONE OF <u>MAN'S</u> MOST PRIMITIVE FEARS IS LONELINESS! WHEN A MAN IS ISOLATED TOO LONG THE MIND PLAYS STRANGE TRICKS...IN YOUR CASE YOU IMAGINED THAT YOU WERE INDIRECTLY GUILTY OF <u>ROBIN'S</u> DEATH...YOUR CONSTANT CONCERN ABOUT THE BOY'S SAFETY CAME TO THE SURFACE IN YOUR HALLUCINATIONS!

Subtlety still hadn't eked its way into the dialog of comic books, often taking shape as proud proclamations or witty one-line explanations for the action in front of the reader. But hey, these are comics, not Kafka. They're supposed to be fun, as evidenced in the following panel, a Silver-Age reinterpretation of Figure 9.1.

Thought Balloons

The trend of thought as an "aside" to readers continued, but developed into longer-running commentaries on the adventures in front of the heroes. For instance, this bit from another Otto Binder-penned Superman adventure (Issue #108):

> SURE ENOUGH! THIS STEEL PLATE IS TOO THIN AND BRITTLE TO LAST MORE THAN A FEW YEARS. I WON'T EXPOSE BENSON UNTIL I FIND OUT WHO'S SUPPLYING HIM WITH THESE INFERIOR MATERIALS. HMM...THAT SIGN GIVES ME AN IDEA!

While this over-reliance on exposition and "saying what's being seen" may seem amateurish to a "seasoned" writer, you have to remember that the (perceived) primary audience of comics in these days was: kids. The unfortunate thing is that most of the adults in the comics industry didn't have much faith in their intelligence.

In a more developed usage of thought balloons, they functioned as counterpoint to the dialog. In the same *Superman* adventure quoted above . . .

> [*Dialog*] FOLLOW ME, BRENT!
>
> [*Thought balloon*] HA, HA! AN INSPECTOR ISN'T USED TO HEIGHTS LIKE STEEPLEJACKS! HE'LL GET DIZZY AND SCARED! AH, HE'S FALLING...GOOD RIDDANCE!

121

I briefly mentioned it in the discussion on panels, but flashbacks became a frequent staple of Silver Age comics. The panel shape was transformed into a "Panel Thought Balloon," as action from the past was presented inside the balloon, narrated (most of the time) by the character having the thought (such as in the demonstrative "Rocketbolt" panel from Chapter 12, p. 102).

The Tipping Point

In the final year of his administration, Kennedy was turning from a hawkish conservative democrat to a progressive leader with a solid vision for the future and the leadership capability to make that vision a reality. In May, 1963, shaken from the world's flirtation with nuclear annihilation during the Cuban Missile Crisis, he announced a nuclear test ban treaty. By the last months of his life, he was ready to withdraw American forces from Vietnam (a war, which, in all fairness, he had escalated in 1962). But all that would change with bullets in the Dallas sky.

Two months after The Avengers first assembled and The X-Men first fought Magneto and fear, the American dream of a "new frontier" was shattered when President John F. Kennedy was assassinated, crumbling the American innocence and launching the true reality of the 1960s into the national consciousness. The events of November 22, 1963 would transform the 1960s from a time where we looked forward with hope . . . to a decade of strife, of upheaval, of violence, and of a deep-rooted cynicism.

It was also a turning point for comics. It wasn't a hurried, fast change. It was slow. Steady. Comics were becoming about something. Their status as homogenized, cheap entertainments was about to end. The Marvel Universe was the opening shot in that revolution.

Just as Harry Donnenfeld, Siegel and Shuster, Bob Kane, Will Eisner, Carl Burgos, Bill Everett, Stan Lee, and the other founding fathers of the comics medium led the charge into the unknown during the Golden Age, a transitional period was about to begin in the mid-1960s (much like the current path we're paving towards the future of storytelling), and it would be led by a new generation who had never known a time without comic books; a young, socially conscious group of creatives who would forever shatter the image of comics as "kid's stuff" and move the medium into a realm of literate, powerful storytelling.

But first, they had to go through Adam West.

You Must Remember This . . .

- The Marvel Age of Comics was launched in 1961 with Stan Lee and Jack Kirby's *Fantastic Four* #1, featuring a family dynamic unusual in comics storytelling at the time. It would set the precedent for Marvel Comics from that point on.

- Icons from Marvel's past, including the Sub-Mariner, Captain America, and The Human Torch (now the hot-headed youngest member of the Fantastic Four) were revitalized for a new audience, just as DC had done when they launched the Silver Age of Comics.

- The five linchpins of the Marvel Universe, the traits that make Marvel Marvel are: the flawed protagonist, the core concept, place, the shared universe, and character over plot.

- The X-Men marked the first mainstream comic series to be "about" something; in this case, civil rights. This, along with movement in the underground "comix" scene, and the new generation of comics creators arriving propelled the Silver Age towards its end and the maturation of the comics medium.

Notes

1. Gerard Jones, *Men of Tomorrow: Geeks, Gangsters, and the Birth of the Comic Book* (New York: Basic, 2004), p. 279.
2. Les Daniels, *Marvel: Five Fabulous Decades of the World's Greatest Comics* (New York: Abrams, 1990), p. 87.
3. Ariston Anderson, *Francis Ford Coppola: On Risk, Money, and Collaboration*. The 99u. Available online at: www.the99percent.com/articles/6973/Francis-Ford-Coppola-On-Risk-Money-Craft-Collaboration.
4. Gerard Jones & Will Jacobs, *The Comic Book Heroes: The First History of Modern Comic Books from the Silver Age to the Present* (Rocklin: Prima, 1997), p. 92.
5. Les Daniels, *Marvel: Five Fabulous Decades of the World's Greatest Comics* (New York: Abrams, 1990), p. 111.

Adaptation in the Silver Age, 1956–1961

In the mid-1960s, with the threat of nuclear annihilation, Civil Rights, the impending all-out quagmire of the Vietnam War, and multiple assassinations making the time a less-than-utopian one, audiences again turned towards media as an escape (while others, as we'll soon see, turned to media to expose the ills of the world and society-at-large). The Marvel Age was in full swing, with a hip and fun character-driven creative renaissance thrilling readers (though losing out to DC by a margin of nearly seven to one[1]), and DC Comics were filled with absolutely insane plots featuring their largely interchangeable archetypes.

It was found that for some, laughter was the best medicine. Irreverence and satire became popular with fare like The Beatles' *A Hard Day's Night* heating up the box office, and Stanley Kubrick's nuclear annihilation comedy, *Dr. Strangelove, or How I Learned to Stop Worrying and Love the Bomb*.

What was stopping anyone from bringing irreverence to the adaptations of comics? After all, these were a bunch of guys running around in tights saving the world. It was perfect fodder.

Bam! Pow! Sock!

On January 12, 1966, *Batman* leapt from the comic book page to the small screen in the form of Adam West and Burt Ward's campy portrayals of The Dynamic Duo. It was colorful, flashy (and organized, as Batman was prone to labeling every single thing in his Batcave), and completely over-the-top. It was everything a kid could want in a television show, delivering two thrill-packed episodes a week, the first always ending in a cliffhanger, the second resolving it with Batman and Robin the heroes of the day.

Batman became a national phenomenon. But it wasn't the Batman that those kids in the Golden Age had grown up loving. This was something different. This was comics portrayed as camp (the effects of which are still being felt in much of the derision of the medium). It was parody. Adults would analyze Wednesday night's cliffhanger around the water-cooler on Thursday morning (and marvel at their intelligence for irreverence), and tune in with their kids that night to watch the resolution. It was a four-post television show: young, old, male, female—that entranced kids with the hyperkinetic action and fisticuffs, and enamored adults with its swinging campiness.

After the first season of the show came the first feature film-length adaptation of *Batman* (or of any superhero, though The Shadow had had his own B-movies in the 1940s, featuring a nearly unrecognizable version of the titular character), spinning out of the television series and pitting West and Ward's Batman and Robin against a pantheon of villains like Catwoman (Lee Meriwether), The Joker (the white grease-paint-covered mustachioed Cesar Romero), The Penguin (Burgess Meredith) and The Riddler (Frank Gorshin). The film is most remembered for two things: the "Shark-Repellent Bat-Spray" and the bomb disposal sequence, proving that even Batman runs into days where he "just can't get rid of a bomb."

Batman launched a comic book adaptation craze, including a new cartoon version of *Superman* (as well as the Man of Steel's stage and singing debut in the Broadway musical, the short-lived *It's a Bird . . . It's a Plane . . . It's Superman!*) and the first-ever adaptations of the Marvel Universe in a spate of series featuring Captain America, Iron Man, The Hulk, Sub-Mariner, Thor, and of course, Spider-Man ("Spider-Man, Spider-Man / does whatever a spider can") that remain animation classics—in spite of their . . . lacking . . . in the animation department. They captured the kinetic fun and visceral energy of the 1960s Marvel Universe in a way that makes them memorable to this day.

Also, the producers of the *Batman* show would produce a television version of *The Green Hornet*, which, unlike its *Batman* counterpart, would be played seriously. It would also introduce American audiences to a young martial artist named Bruce Lee.

Jiro Kuwata and The Batman of Japan

While the adventures of Batman were playing out in the comics and television show, in Japan, another Batman adaptation was happening. The Batman television show was just about to air on Japanese television, and comic book (manga) publishers wanted a *Batman* series to run in their *Shonen King* comic book anthologies. The publishers approached manga master Jiro Kuwata (co-creator of one of the few popular Japanese superheros, 8-Man) to produce the new manga adventures of Batman.[2]

What Kuwata produced stands up as my favorite *Batman* comics of the Silver Age and proof of the enduring staying power of these American icons across cultures. Fast-paced with insane villains and plots (including my favorite, Lord Death Man—a Kuwata creation recently resurrected by *Batman Incorporated* writer Grant Morrison—and American standby villains like Clayface) and strikingly beautiful art, the Kuwata *Batman* comics prove yet again that simplicity and evolution through multiple interpretations are the key ingredients to longevity and endurance.

What is Manga?

The term "manga" refers (outside of Japan) to comics produced in Japan. Featuring stories of numerous genres (though superheroes have never really caught on in Japanese culture), manga stories are consistently serialized. Read from right to left (as opposed to the Western left-to-right tradition), manga storytelling is the combination of influences from Japanese and American cultures fermented during the occupation of Japan following World War II from 1945 to 1952.

The readership of manga tends toward more mature and realistic subject matter, as recounted by Jiro Kuwata in an interview with Chip Kidd and Kana Kawanishi, discussing the need to transform American stories for a Japanese audience:

> One example I clearly remember was when a villain posed to Batman a nonsense word riddle at an extreme life-or-death situation. Batman was seriously trying to answer it when he was about to die! That particular scene lacked so much reality to me and seemed awfully awkward. The stories had to be more mature and real for the Japanese readers. Such a thing would have been very wrong to them.[3]

The End of Bam! Pow! Sock!

As quickly as it had become a phenomenon, the *Batman* show became lost in its own campiness and self-reverence. The novelty had worn off, and by the end of the show's run in early 1968 the show's patented cliffhangers had given way to single episode stories and Zsa Zsa Gabor and her hairdryer of doom. In an effort to boost ratings, Batgirl (Yvonne Craig) was brought in, but not even the appeal of Craig on a motorcycle in a skin-tight costume could save the show.

Batman was once again relegated to the funny books, where he languished as DC editors tried to figure out what to do with him. The solution wouldn't be found until the next era of comics in the form of a "new generation" writer born in St. Louis, Missouri, in May, 1939—the same month and year as The Bat-Man's first appearance in *Detective Comics* #27.

Notes

1. Gerard Jones & Will Jacobs, *The Comic Book Heroes: The First History of Modern Comic Books from the Silver Age to the Present* (Rocklin: Prima, 1997), p. 67.
2. Chip Kidd, Paul Speer, and Saul Ferris: *Bat-Manga: The Secret History of Batman in Japan* (New York: Pantheon, 2008), p. 10.
3. Ibid., p. 12.

The No-Prize Marching Society

The Comics Fans

As content creators today, engaging our audience with behind-the-scenes info, real-time updates and one-on-one interaction via social media, and establishing a back-and-forth dialog is standard practice. It's a simple truth: if you want to survive in today's media landscape, you need your fans, and you have to know how to market yourself as a genuine character and brand.

In the mass media heyday in which comics found themselves during the Silver Age, this was a completely foreign concept. Television was a one-way communication form: whatever you saw is what you got. Movie stars and directors? The maximum engagement you could expect from them was maybe an autographed picture (signed by a secretary) in the mail.

As comics were forced to adhere to the mainstream edicts of decency, they lost a lot of what made them so unique. They were forced to appeal to a wide swath of audiences: young, old, male, female. They had lost that secret ingredient, that special spice that made them wonderful.

The genius of Stan Lee in re-engaging this audience cannot be underestimated. While he didn't do anything that hadn't already been done (at DC, letter columns were becoming the norm, allowing the audience to write in with continuity errors and the like, even influencing the addition of characters like Supergirl into the DC Canon,[1] and even those were influenced by the letter columns of pulp giants like Hugo Gernsbach), he did it better than anyone else. In that way, he was the Steve Jobs of the comics industry. He made comics, as Jobs would say, "insanely great."

Publishing Addresses

The fandom for comics and pulps represented the first social network. Before Facebook, there were the letter columns in the pulps, and Hugo Gernsbach was the first to publish the complete addresses of his letter writers, leading to the creation of science fiction fan clubs (including giving Jerry Siegel a sense of belonging, leading to his creation of his own sci-fan fanzine, another staple of the comics fandom). DC editors Mort Weisinger and Julius Schwartz followed this with the letter columns in DC Comics, creating another social network around the DC universe.

But publishing letters and addresses wasn't enough for Stan Lee. He knew that the way to separate comics from other media was to give the audience access like no other publisher had before. He was crafty, careful, and full of hyperbolic gusto. He really was Steve Jobs.

The Marvel Fan

Being a fan of Marvel Comics during the height of the Marvel Age was like being part of an exclusive gang of hopped-up enthusiasts who only cared about saving the world and having a good time doing it.

Stan Lee did away with the "Dear Editor" verbiage and replaced it with "Dear Stan and Jack [Kirby]" in 1962.[2] Moving people to a first-name terms with the formerly "man pulling the strings" mystique of the editor was the opening salvo in a campaign to engage and delight fans. He brought the whole roster of comics creators to the forefront: writer, penciler, inker, letterer (previously comics had only carried the name of their lead character's creators). If a reader correctly pointed out a goof, he would send them a "Marvel No-Prize" (an empty envelope). To be a Marvel Comics reader in the 1960s was to be part of a family, an inner circle of the "cool kids."

If Twitter was around in the 1960s, Marvel would have made other social media campaigns and presences seem quaint and boring. Lee offered fans peeks inside the Marvel offices (via the Marvel Bullpen Bulletins pages), which included fourth-wall-breaking visits from the likes of Doctor Doom (such as his appearance in "the real world" at the end of part one of *Fantastic Four* #10 to give Stan Lee and Jack Kirby some inspiration in the crafting of his villainous return) and other Marvel characters. By the mid-1960s, Lee had added a regular feature, "Stan's Soapbox" to the Bullpen Bulletins page, bringing his own thoughts on comics and social issues. Stan Lee had become a brand in and of himself.

In 1965, Lee and company announced "The Merry Marvel Marching Society," described (in typical Stan Lee irreverence) as "an honest-to-gosh far-out fan club in the mixed-up Marvel manner"[3] with membership fees of $1. Even Marvel was stunned by how big it became, with Flo Steinberg telling Les Daniels, "There were thousands of letters and dollar bills flying all over the place. We were throwing them at each other."[4] Other than the "honest-to-gosh" merriment of the Merry Marvel Marching Society, one other thing is worth noting: this fan club wasn't a fan club for one character, but for an entire shared universe of characters. It was for the brand, not the product. In an age of "Like"able Facebook pages where fandom seems so cheap and simple, the sheer amount of effort (and money) that Marvel fans dedicated to their beloved brand should be a testament to the basic need that comics provide their fanship—a sense of belonging and community.

As the Marvel Universe grew, so too did the distinctive voice of Marvel Comics. Lee's goal in the narration was not to talk at fans, to tell them a story (like DC Comics), but to make them a part of the story, by making the fan feel like he was talking to them, making comic book reading a personal experience and giving the reader the chance to "hear" a distinctive voice in the four-color pages of Marvel Comics.

Nostalgia and Value

As Marvel was becoming a phenomenon and DC was watching Batman sales skyrocket (the average paid total unit figures for 1966, the first year of the *Batman* television show, were nearly 900,000 units[5]), another movement was taking place in another demographic of fandom: adults who were children during the heyday of the Golden Age and were now yearning for the stories that had enchanted them as kids.

Other than action, adventure, and fun, the fourth defining characteristic of comic books is nostalgia. While kids (in the early years of comics and the Silver Age, before the primary reading demographic of comic books turned to adults) cared only about the next issue, adults cared (and care) about recapturing their own youth. The comic book adventures of their times were a way to do that.* And the fanzines were there to sate those appetites.

In 1965, *Newsweek* readers were shocked to learn that there were some crazed lunatics who were actually shelling out exorbitant prices for old comics (that mom no doubt threw away or burned in the Wertham years), like *$100* for a copy of Superman's first appearance in *Action Comics* #1. Today, a copy of that very comic sold at auction for over *$2 million*.[6] Another family was able to save their home from foreclosure when another copy of *Action Comics* was found in their basement, valued at *$1.5 million*.[7]

The New Generation

From the fanzines that sprang up out of nostalgic memories of comics past and a love of interactive discourse among like-minded pop culture addicts came a new phenomena—the writing contest. Charlton Comics, a smaller publisher that published titles such as *The Phantom*, held a contest that was won by first-year high school teacher and comics aficionado Roy Thomas.

* Look at the market for 1980s toys among my generation—I'm 30 and still bounce with excitement when I see a complete set of *GI Joes*. That there are stores dedicated to recapturing our past youth should be demonstrative of the buying and dedication power of nostalgia.

Thomas' win in the contest led to a phone call from DC Comics, then another from the merry master of Marvel, Stan Lee.

The new generation of comics creators was about to arrive from the pages of fan fiction.

You Must Remember This . . .

- Letter columns and other fan clubs were the social media of the Silver Age. "Social Media" as we know it today is basically an extension of the sense of belonging created by the comics industry.

- Stan Lee took the concept of fan interaction and made a genuine family surrounding the Marvel Universe, creating one of the most vibrant and exciting fan communities ever established—all by taking something that had already been there and doing it better than anyone else.

- A feeling of nostalgia began creeping into comics as early as the 1960s. This nostalgia brought fanzines, and from the fanzines, the new generation of comics creators slowly emerged. Never underestimate the power of fan-generated content.

Notes

1. Gerard Jones & Will Jacobs, *The Comic Book Heroes: The First History of Modern Comic Books from the Silver Age to the Present* (Rocklin: Prima, 1997), p. 17.
2. Ibid., p. 65.
3. Les Daniels, *Marvel: Five Fabulous Decades of the World's Greatest Comics* (New York: Abrams, 1990), p. 106.
4. Ibid.
5. "1966 Comic Book Sales Figures." Available online at: www.comichron.com/yearly comicssales/1960s/1966.html (accessed December 2, 2011).
6. Andy Lewis, "Nicolas Cage's Superman Comic Nets Record $2.1 Million at Auction," *Hollywood Reporter*, November 30, 2011. Available online at: www.hollywood reporter.com/heat-vision/nicolas-cage-superman-comic-record-2-million-sale-267770.
7. Ray Sanchez, "Superman Comic Saves Family Home from Foreclosure," *ABC News*, August 13, 2010. Available online at: http://abcnews.go.com/Business/superman-comic-saves-family-home/story?id=11306997#.UBKWgDFSRgs.

"What Do You Have?"
The New Generation Arrives

Following the assassination of John Kennedy, the mood in the country shifted dramatically. Once filled with hope and excitement for the future, the prevailing American sentiment was one wary of authority and questioning anything resembling the "Establishment."

For men, the ties loosened and the hair grew longer. Women fought against the "June Cleaver" image of the perfect housewife and asserted themselves as strong individuals. Pop culture shifted from the head-bouncing melodic escapism of the early Beatles to music that was about something. Artists like Bob Dylan took stands on issues, the Beatles morphed from the mop-tops to musical geniuses. To borrow a now clichéd yet suitable phrase, the times were a-changin'.

Civil rights, the Vietnam War and the assassinations of the mid to late 1960s (Malcolm X, Martin Luther King, and Robert Kennedy) all pushed the country to the brink of chaos, as riots broke out at the 1968 Democratic Convention. What once was an undercurrent of distrust and disgust burst on to the streets of Chicago, blasted back by authorities with hoses.

After the Wertham years, comics had become a clean, safe form of entertainment. But the new generation that was coming in, a generation of fans who thrilled to the adventures of Superman when he was an anti-establishment fighter for the little guy, wanted to change that. They believed that comics could be about something. It was in that combination of dedicated fans breaking the "leave it to the professionals" mentality of mainstream media (decades before the democratization of content creation*) and rising social strife and anxiety that comics would find their new voice.

Silver Age Style: The Covers and the Formats

At DC, editor Julius Schwartz had an unusual (for the time) edict: all covers would be designed and drawn *before* the story was written. More often than not, Schwartz would have a plot idea in mind, making the plots of DC Comics more highly entwined with their covers than in the era past. As the covers were designed to grab young readers and kids, the stories often pushed towards more fantastical elements.[1]

* Discussed in Chapter 4, "Into the Rabbit Hole."

At Marvel, Stan Lee was being Stan Lee, adding to *The Fantastic Four:* "THE WORLD'S GREATEST COMICS MAGAZINE!!"

More of that patented Stan Lee modesty.

The Formats

After the halving of comic book length from 64 to 32 pages, the storytelling became more economical. Anthologies shrank to two or three stories instead of six, and the ongoing superhero comic became a staple. When the Marvel Universe began in 1961, Lee still employed the multi-part storytelling style, though by *Fantastic Four* #15, had dropped it in favor of single-issue stories of an episodic nature (though by the mid-1960s, when The Hulk received his own series, it was the first time that comics had featured perpetual cliffhangers, fully embracing serialized storytelling [appealing to the more dedicated fans] in addition to the more prevalent episodic "done in ones" [which appealed to the casual readers]).

Another format that emerged in the Silver Age was the annual. A 64-page collection of stories, "behind-the-scenes" stuff (like a look inside The Fantastic Four's headquarters, pin-ups, or "secret origins"), and other tales. The very first *Fantastic Four* annual proclaimed on its splash page, "THE LONGEST UNINTERRUPTED SUPER-EPIC OF ITS KIND EVER PUBLISHED!!"

When looking at an annual ("72 BIG PAGES!") for 25 cents, you have to remember that during the Golden Age, comics came out monthly or quarterly, containing 64 or more pages, and cost a dime. Now the monthly comic book contained 32 pages for 12 cents. Also, the physical size of comics was changed for economic purposes by chopping out a quarter inch of width from every comic. The annual was a way to give dedicated fans more bang for their quarter each and every year.

Underground Comix

Away from the massive sales and lights of the major comics publishing houses, a reaction against the staid and safe medium that comics had become was fermenting. These guys were tired of comics always being about "the man." They believed, as Will Eisner believed, that comics could be literature. A new movement was being born out of the conservatism of the last 20 years. The independent comics (underground comix) movement was taking shape.

To many, the superheroes represented the Establishment, especially the DC characters (a space-cop, a police scientist), and comics were yet again in danger of falling out of favor with the youth of America. The new generation was anti-establishment, anti-authoritarian. It was generational warfare, and

nowhere was that more represented than in the aforementioned 1968 Democratic National Convention riots in Chicago.

When Richard Nixon (finally) won the White House in the 1968 election, it appeared as though the anti-establishment fight had died off. Nixon ascended to power through a promise to end the Vietnam War (and was the darling of the older generation who yearned to get those "damn kids" in line). Clearly, the establishment-loving heroes of the DC Universe (Marvel Comics, on the other hand, were regarded as hip and cool[2]) weren't going to inspire anyone as they were.

In the underground scene, fanzines (such as *Alter Ego*, where future Marvel Comics Editor-in-Chief Roy Thomas got his start) were becoming the preferred reading material of the college set—a youth informed of (and angered by) the issues facing them, the very real possibility that theirs would be a generation less prosperous than the previous (that reality is now plaguing the current generation).

It was in this landscape that self-publishing became the saving grace of comic books. Anti-authoritarian satires were hugely popular among the college crowd (especially in the wake of the campy, pop-culture satire of the Dozier *Batman* series, now nearing its end). The self-published fanzines also proved to be breeding grounds for the artistic talent that would help shape the 1970s like Bernie Wrightson, Jim Starlin, and Mike Kaluta.

It was that distrust of authority and passion for anti-establishment ideals that writers such as Denny O'Neil would bring to the mainstreams—and would eventually save the industry.

Silver Age Style: The Stories

The comics of the Silver Age featured stories of the fantastic, with a science fiction slant befitting the times in which they were created. In the Silver Age, as in the Golden Age, the Editor was the most important creator on the team. This slowly eroded with Stan Lee making sure to credit every single person on the creative team in each of their books, but by the end of the Silver Age, the writers ruled the roost.

Earlier Silver Age comics made frequent use of "imaginary stories," and dreams to push the fantastical even more. This pushed the plot complexities and possibilities to a whole new level, especially at DC, where editorial policy dictated single-issue, done-in-one stories. Also, many stories at both DC and Marvel had a distinctive "space" theme, as was popular at the time of the Silver Age, with DC's characters figures of the space "Establishment" (Green Lantern), or having their powers derived from a space exploration accident (The Fantastic Four).

While DC pushed for the more fantastic, Marvel kept their stories, no matter how spaced-out, grounded in reality. Their stories flowed organically from character, creating a more timeless quality to them (even though they were clearly based in the "swinging sixties").

The Silver Age represented a time of rebirth and a focus on survival after the decimation of the industry in the 1950s. From taking discarded Golden Age characters and revitalizing them into icons of Establishment and order, or creating a whole new shared universe from the ground up, the Silver Age represents both the best (wanton creativity) and worst (simplistic pandering to the flavor of the month) of the industry. In the latter half of the Silver Age, a new generation took over, bringing a sense of realism, of street-level storytelling, and a social relevance that brought comics back from the brink and into a new age of comics as literature.

"No More Camp!"

For all the attention the William Dozier-produced, Adam West-starring *Batman* television show brought to *Batman* and to comics in general, it also caused the most irreparable harm to the medium since *Seduction of the Innocent*. As a cultural product of the "swinging sixties," the show is unparalleled. It captured a moment in time that for some was the greatest few years in their lives. It also cemented a viewpoint of comics as nothing but campy male power fantasies of running around in tights where everything was "POW," "BAM," and "BAMF." Even Stan Lee (ever the showman, and never afraid to poke fun at himself) remarked to Denny O'Neil that the best part of the show was the animated title sequence.[3]

By the time the show ended in (1968), it was a relic of a time that seemed never to have existed. The last best hopes to bring the country to greatness (Robert Kennedy and Martin Luther King) were felled by an assassin's bullet. Richard Nixon was in the White House. Vietnam was an unending quagmire of senseless death and political anti-Communist posturing. "POW" and "BAM" didn't matter any more.

DC, the voice of the comics Establishment, with their clean lines and fantastical stories, simply didn't appeal to the highly intelligent and socially conscious kids that wanted something more from their comics, comics that dealt with the social issues they cared about. The sad truth is that the kids reading the comics saw more potential for the medium than the company with the highest sales figures (which were rapidly declining). To put all of this into a modern perspective, think (again) of DC in the mid-1960s as Microsoft, Marvel as Apple: the Underground Comix movement (the Indies) would be Open Source/Linux adherents.

DC's other big problem was with their art. It was nice, neat, tidy. Nothing offensive, nothing action-packed. It was the Wonder Bread of comics. It was another time of experimentation—with characters like Deadman, Brother Power the Geek (featuring the comics return of Captain America co-creator Joe Simon and lasting only two issues), Doom Patrol, and The Creeper (created by Steve Ditko, a combination of Ditko's other creations, Spider-Man [with Stan Lee] and The Question [for Charlton Comics] and lasting only in the single issues)—and nothing was working.

Had camp killed heroes? Not really. It was that DC was out of touch with its audience. DC at the time was still run by guys who had gotten their start in the pulps, had been there during the Golden Age, and barely survived the Wertham era. There was fear running through the veins of DC editorial: as O'Neil told me, "They were still afraid of the damn witch hunts!"[4] It was time to throw caution to the wind and clean house.

Julius Schwartz, having saved Batman from cancellation and being relegated to the dusty bins of nostalgia in 1964 with the "New Look" (adding the yellow oval around the Bat Symbol among other changes), knew it was getting old and wearing thin in the wake of William Dozier's television adaptation. There had to be a change. But what kind of change? Oftentimes, when reinventing something, the first question to ask is "What made them work at the beginning?", hitting, as Steve Jobs would say, "the rewind button."[5]

The answers to those questions? Batman worked in the beginning because he was a lone wolf avenger of the night whose primary motivation was revenge and an unwavering need to vanquish crime from the streets of Gotham City and ensure that no one endured the pain he endured. Where did they go wrong?

In my mind, they went wrong with the introduction of Robin.

While a great character, DC took away the first thing that had made Batman great by trying to increase sales (and thereby ushering in the age of kid sidekicks). He was no longer a loner. It was the first step in a long road toward the neutering of the character to the point where the once-dark avenger would be dancing the "bat-tusi."

For inspiration, all Schwartz needed to do was to look out his window at the grimy cesspool into which New York City was transforming. It was a city in need of a dark avenger. Gone would be the domesticity of the Gotham City of years past, replaced with a city in need of a hero (though this vision of Gotham wouldn't be fully realized until Frank Miller and David Mazzucchelli's seminal *Batman: Year One* in 1986). To facilitate this change, Robin would be shipped off to college and Bruce and Alfred would move into a penthouse in the heart of Gotham City, to be at the beating heart of the city that needed him (and that he needed as well).

The gears of change were churning . . . but something hadn't yet clicked. The final transformation would come from a team who produced a book about "Hard Traveling Heroes."

With Batman on the road to recovery, there was one other puzzle that Schwartz, the man who had started the Silver Age, had to solve. What was he going to do with Green Lantern?[6] The heroic space cop, member of an intergalactic police force whose bosses were little blue men (and science fiction was on its way out), was the poster child for the Establishment that was now so reviled. Schwartz was about to end the Silver Age of Comics (and the era of the Editor having all the power) just as he had begun it—by revitalizing a mythology that had run its course and asking Denny O'Neil, "What do you have?"[7]

You Must Remember This . . .

- The Underground and Independent "Comix" movement emerged as a result of the fanzines and a growing dissatisfaction with the mainstream, "safe" publishers.

- The "camp" fun that had made the *Batman* show a hit in 1966 was responsible for its own downfall in 1968 and the near-death of the *Batman* comic book, which had taken on the show's penchant for camp.

- Hitting "rewind" is the best way to fix a problem. What made something work in the first place?

- By the end of the Silver Age, character-based elements from Marvel seeped into DC Comics, ushering in the Bronze Age of Comics (1970–1985)

- It was because comics and their characters are allowed to evolve that they have endured. Fear of change is the number one killer of any medium.

Notes

1. Gerard Jones & Will Jacobs, *The Comic Book Heroes: The First History of Modern Comic Books from the Silver Age to the Present* (Rocklin: Prima, 1997), p. 22.
2. Gerard Jones & Will Jacobs, *The Comic Book Heroes: The First History of Modern Comic Books from the Silver Age to the Present* (Rocklin: Prima, 1997), p. 119.
3. Author's interview with Denny O'Neil, December 13, 2011.
4. Author's interview with Denny O'Neil, December 13, 2011.
5. Walter Isaacson, *Steve Jobs* (New York: Simon & Schuster, 2011), p. 373.
6. Gerard Jones & Will Jacobs, *The Comic Book Heroes: The First History of Modern Comic Books from the Silver Age to the Present* (Rocklin: Prima, 1997), p. 144.
7. Author's interview with Denny O'Neil, December 13, 2011.

Formatting the Comics Script

A film script is an easy thing only in that there's a very strict, set format to follow. Tabs, indentations, dialog, all that, is laid out clearly and concisely. With a comics script, however, it's completely open.

The first thing you have to ask yourself is, "Is the script clear enough for the artist?" It doesn't matter how you format the script, it only matters if it's clear enough so that the artist can work their magic to bring it to life. Remember, in visual storytelling, a script is only a blueprint, a communication device for the team building the final structure that is open to interpretation and should inspire creative collaboration.

Although many writers work differently, here is an excerpt from my script for the first "Sentinel" adventure in my transmedia project, *Whiz!Bam!Pow!—Whiz!Bam!Pow! Comics* #7 (drawn by Blair Campbell):

PAGE 3 (8 PANELS)

1.
The SENTINEL flies towards the DAILY RECORD Building
 28. NARRATION—THAT MORNING . . .

2.
The SENTINEL swoops into an open window.
 29. **SENTINEL**—AND BACK TO WORK!

3.
Changes to civilian garb in a storage closet.
 30. NARRATION—HIDDEN FROM VIEW, THE SENTINEL DONS THE CLOTHING OF HIS SECRET IDENTITY—ALAN WALKER—ACE REPORTER!

4.
Office of EIC—Walker and EIC Two-shot. EIC looks out a window, Walker stands in front of his desk.
 31. **EDITOR IN CHIEF**—DIDYA HEAR ABOUT THE DEPUTY MAYOR? COPPED TO BEATING HIS WIFE?!
 32. **WALKER**—NO CHIEF, I HAVEN'T!

5.
A smile comes across Walker's face.
 33. **WALKER** (thought balloon)—IF YOU ONLY KNEW . . .

6.

The EIC sits down at his desk.

 34. **EIC**—THE FRENCH AMBASSADOR IS GIVING A SPEECH TONIGHT AT A BANQUET. MARGOT WILL BE JOINING YOU.

7.

Walker turns to see MARGOT PARKER standing in the doorway.

 35. **MARGOT**—ISN'T IT "HE'LL BE JOINING ME?"

8.

The EIC leans back in his chair, exasperated. His fingers on his temple.

 36. **EIC**—JUST GET ME THE STORY YOU TWO!!

Let's break the script down a bit here. First of all, I give each page its own page (or two, however many needed). This makes it easy for the artist to scribble ideas on the script, and gives plenty of room to breathe. So, in this case, "Page 3" gets two pages because it's long, but there is a page break before Page 4.

Next to the page title, I place the number of panels per page. In the case of *Whiz!Bam!Pow! Comics*, it's a Golden Age book, so it adheres fairly closely to the confines of "the grid". Depending on how much room I want to leave the artist to play, I'm very open to more or fewer panels, depending on the needs of the story and the artist's own narrative inclinations.

The artist functions as the cinematographer and actors of the story. You must leave room for them to play and bring their own creativity to the project. I always say that if you want to be extremely particular, just do it yourself. The nature of collaboration is to make something better than you could do yourself. By bringing on a great artist, you have a responsibility to make the final project even better than you dreamt it could be—if you don't, the project is a failure.

Breaking down by panel:

—**—

1.

The SENTINEL flies towards the DAILY RECORD Building

 28. NARRATION—THAT MORNING . . .

—**—

I always include the panel number first, so, in this case: "1.". Immediately below, I describe the action in the panel. I usually take a much more spartan approach to describing the panel as I like to leave a lot open to the artist and give them room to bring their own voice to the work. Remember, unless

you're doing it all yourself, comics is a highly collaborative medium, a much more intimate collaboration than film. I capitalize the names of all characters and major landmarks.

Immediately below, indented, I describe the narration boxes or dialog. I number each one (it makes discussion and edits much easier to refer to "Caption 28" as opposed to "Page 3, Panel 1, Caption 1"). In the previous sentence, "caption" refers to the narration box. I underline each NARRATION demarcation.

Let's look at a segment with dialog.

—**—

4.
Office of EIC—Walker and EIC Two-shot. EIC looks out a window, Walker stands in front of his desk.
 31. **EDITOR IN CHIEF**—DIDYA HEAR ABOUT THE DEPUTY MAYOR? COPPED TO BEATING HIS WIFE?!
 32. **WALKER**—NO CHIEF, I HAVEN'T!

—**—

Again, I number the panel, then describe the action in the panel. In this case, I was a bit more descriptive, giving the artist the direction of a "Two-shot." Instead of a narration box in this panel, we have two pieces of dialog. Again, they are numbered, 31 and 32, respectively. I place the character's name in boldface to differentiate between narration and dialog.

No matter which format you choose, or if you create your own, you must make sure it's a clear representation for your vision to the artist. In collaborative forms of storytelling, a script is a communication tool, not the final product.

The Battle of Generations

The Great Depression spurred a period of creativity and innovation that led to the creation of the comics medium. World War II pushed that era into the mainstream and a storytelling language was developed. Then came the post-war boom, and with it a renewed sense of American prosperity and greatness. Comics were ostracized, burned, regulated, and neutered to the point of outright blandness. From that emerged a sense of rebellion in other media, like music, when rock and roll was born, and in film, where movies like *Rebel Without a Cause* and others became rallying cries for the youth.

The first years of the 1960s, though appearing neat and tidy thanks to the Kennedy era, was actually an era of simultaneous economic prosperity and terrifying foreign policy realties, bringing the world one step closer to nuclear holocaust. From that emerged the Marvel Universe, with its "they're one of us" flawed protagonists and core concepts. The civil rights strife bore the X-Men, and in the years following the murder of President Kennedy, a new social relevance came to comics by way of a new generation of creators, those who had had comics their whole life—a generation of fans—who didn't know a world without the four-color thrills of the comic book medium.

This new generation was of a world that needed comics not to be the mainstream, Wonder Bread medium, but a niche one, an outlaw medium—one that both said something and said nothing, a commentary and an escape. They grew up with these modern American mythologies and saw nothing but possibility. And they were frustrated by the perceived squandering of that possibility.

Bronze Age Style: The Page, the Panel, and the Grid

During the previous eras of comics storytelling, the page, the panel, and the grid were fairly uniform, with very little variance in size and scope of panel. The panels were simply containers for action, keeping the reader at arm's length and removed from the proceedings.

During the Bronze Age that began to change. As the art style evolved, so too did the usage of different panels to convey different moods and atmosphere. The grid was still present, though not static; it moved, it became organic to the wants and needs of the artist creating within its confines.

FIG 17.1 **An example of Bronze Age style grid layouts—anything goes!**

By the conclusion of the Bronze Age, the complete modern language of the comic book had been established, and, with few exceptions, would remain unchanged.

"The Fourth World"

In 1970, Jack Kirby made the leap from Marvel Comics to DC Comics (another concluding moment of the Silver Age) and took over DC's lowest selling title, *Superman's Pal, Jimmy Olsen* (of all things). This was part of the deal that would bring Kirby to DC. The other part of the deal was that Kirby would get to create three new series of his own.[1]

From those negotiations arose *The New Gods*, *The Forever People*, and *Mister Miracle* in 1971, collectively known as Jack Kirby's new playground (or, in the transmedia parlance, sandbox) "The Fourth World," a meta-series featuring interconnecting comic books (this is representative of what Henry Jenkins would term "radical intertextuality"). Free to do what he pleased, he crafted a unified epic of the fate of mankind, played out between the new gods, as they waged battle against the malicious god, Darkseid.

Kirby's "Fourth World" tackled grandiose themes (the fate of mankind) and was truly a mythology for a new age . . . but no one got it. It was to be the climax of Kirby's career, a career that had helped launch the medium, then

reignited it with the Marvel Age, and finally, culminated in his final grandiose statement (indeed, his art in this series is simply unparalleled in its scope and imaginative constructs). It was too intelligent in its bombastic mastery . . . it was deceptively simple (and simplistic) and fantastic for an audience that wanted something resembling reality.

It was a classic moment of the showdown at dawn: two wildly divergent styles, the perpetual generational battle played out in the pages of the comic books. Kirby represented the apex of sequential cartooning when fandom wanted realistic sequential illustration. Of Kirby's "Fourth World," fans at the time remarked "we always knew he could draw—now we know he can't write."[2]

With the end of "The Fourth World," the generational battle was over . . . and the new generation had won.

Hard Traveling Heroes

If Kirby's "Fourth World" signaled the end of the old generation, with its grand themes and massive operas playing out in the four-color medium, Dennis O'Neil and Neal Adams' *Green Lantern/Green Arrow* represented the social documentary brought to comics, and nowhere is the generational divide lain more bare than in the stark differences between these two series.

O'Neil responded to Julius Schwartz's query of "What do you have?" with a new take on Green Lantern, intergalactic space cop and the symbol of civil obedience and order across the universe. Pairing the conservative-leaning, Dixieland-listening Hal Jordan with the liberal Green Arrow (a Mort Weisinger creation from the 1940s who had been appearing in *Justice League of America* under O'Neil's pen and previously was relegated to being the back-up feature in other anthologies), O'Neil took the heroes on the road, tackling issues like civil rights and race relations, and black poverty.

Partnering with O'Neil on *Green Lantern/Green Arrow* was the artist whose style would come to define the 1970s: Neal Adams. At Marvel, he brought a new, humanistic and illustrative life to the flagging *X-Men* series. From there, he went to DC Comics, first on *Deadman* ("intended to appeal to the sophisticated and alert reader"[3]), then finally teaming with O'Neil on this new experiment.

The new, topical *Lantern/Arrow* series pushed social issues in much the way Superman fought for the downtrodden in his original Golden Age adventures, though placed through a lens that was decidedly of its time. Regardless, it was popular, popular enough Stan Lee soon did the now-famous (for shipping without the almighty stamp of the Comics Code Authority) "drug issues" of *Amazing Spider-Man* (#s 96–98, 1971) featuring Spider-Man's friend (and son

of the dreaded Green Goblin) as a pill-popping junkie. This issue resulted in the first amendments to the Code since it was crafted in 1955: drug use could now be mentioned (so long as it was anti-drug) as well as portrayals of vampirism and lycanthropy.[4] These issues single-handedly paved the way for not only the social realism that dominated the early part of the Bronze Age, but also for the renewed spate of genre experimentation that defined the mid-1970s with such classic titles as *Tomb of Dracula* (from Marvel) and *Swamp Thing* (from DC).

Soon after the "drug issues" of *Amazing Spider-Man* were published, O'Neil and Adams crafted the now-legendary *Green Lantern/Green Arrow* #s 85–86 (1971), in which it is revealed that Green Arrow's teen sidekick, Speedy, is a junkie. The issues earned praise from the mayor of New York City and O'Neil and Adams found themselves on the lecture circuit.

But it wasn't topicality that would cement O'Neil and Adams as comics legends. It was melodrama of the best sort.

"The Batman" Returns

After spending the 1950s and 1960s in gaudy, over-the-top space adventures as a good citizen of Gotham City, Batman was barely a shell of the character he was at the time of his creation. The television show had destroyed his credibility and the comics made an inane attempt to replicate its look and feel. O'Neil and Adams wanted a different spin when they came to the books. They wanted the Dark Avenger of the night that Bob Kane and Bill Finger had created in 1939 (coincidentally, O'Neil was born in May, 1939, the same month and year that "Bat-man" first appeared in *Detective Comics* #27). They wanted the Dark Knight. The silent, stealthy sword of vengeance cutting through the city. They wanted The Bat-Man.

Gone were the over-the-top trappings of the Silver Age. The clean-cut, starry-eyed, "aw shucks" aesthetic of a "new frontier" was gone. O'Neil and Adams transformed Batman back into that dark avenger, and in the process, defined the look of the Dark Knight for the next 40 years. Batman was back on the prowl in Gotham City. He was dangerous. But he was more than that—he became a world traveler, as O'Neil and Adams introduced the villain that would define Batman in the 1970s: Ra's al Ghul (portrayed by Liam Neeson in Christopher Nolan's 2005 rebirth of the Batman film series, *Batman Begins*). Thus began, as Grant Morrison said, Batman's "hairy-chested love-god" time.[5]

Beyond the "hairy-chested love god," O'Neil added an important, if not *the* most important element to the Bat-mythos: obsession. Batman is obsessed with his war on crime, obsessed by his need to prevent the pain that

Timelessness

The greatest testament to the endurance of these characters is their ability to evolve based on the needs of the times in which they're created (both the overt needs of salability and the underlying needs of mythologies being reinvented for their times). Characters like The Shadow are a fascinating study—they are timeless because they are particularly "of their time" (like the Beatles are "of" the 1960s). The Shadow could not work in a modern-day setting (though attempts have been made, most notably in 1986–1987's *The Shadow Strikes*), but he still endures as a fan-favorite.

The ultimate failure of the "socially relevant" stories of the O'Neil/Adams *Green Lantern/Green Arrow* run (and other stories of a topical nature) is that they are so topical and so "of their time" that they fail to be timeless. Tread very carefully when working on topical stories. Know from the outset that your intent is to be topical—and remember there's a difference between topic and theme. Topical storytelling focuses on stories ripped from the day's headlines; themed storytelling deals with universal questions that are constant from culture to culture, century to century.

shaped his life from entering the lives of the citizens of Gotham City and the world. It was that obsession—brought to the character after O'Neil read writer Alfred Bester's essay on the advantages of obsessed characters[6]—that would truly define the character for years and decades to come.

Not only did O'Neil bring Batman back to his darker roots, but he also returned the Batman Rogues Gallery to prominence. The Joker returned in the seminal classic, "The Joker's Five-Way Revenge," brought back to his roots as a vicious and demented killer, just as he was when he first appeared in *Batman* #1 ("Batman vs. The Joker"). The classic Batman rogues had barely been seen in the 1960s. Under O'Neil, they roared back to life with a vengeance.

As we talked about earlier, sometimes the best way to fix a problem is to hit the rewind button. What worked before? Where did we go wrong? What worked with Batman before (during, I would argue, the only time prior to the O'Neil and Adams revitalization that Batman lived up to his true potential) was Bill Finger. Finger was the primary writer of the Batman stories of the Golden Age, and he brought the pulp sensibility to Batman that was needed to make him a smash hit. When I spoke with O'Neil, he mentioned Finger as a primary influence, and when he asked Finger who his primary influence was in creating Batman, he told O'Neil, "The Shadow."[7]

Bronze Age Style: The Art

The most drastic change from the Golden and Silver eras to the Bronze was the art style. Gone were the simple and crude communicative drawings; in their place was the deft draftsmanship of the new generation of comics artists—led by Neal Adams—who brought a humanness and realism to his work. With that realism came a lack of simplicity, that core element that made the early comics so iconic. For all of the beauty of Adams's work, it took away something that made comics comics. It took away the fun of the simple—for example, Figures 17.2 and 17.3 show our daring hero, Rocketbolt, done in the Adams style.

The previous style of art, like that of Jack Kirby, for example, fell out of favor as comics fans (increasing in age) leaned towards the artwork of Adams and the like. The simple, crude art that had been such a part of the Golden Age of the began appearing in independent comics, most notably the work of Robert Crumb and others, where it was used to convey satire and other more complicated ideas in a clear and concise fashion.

FIG 17.2 Rocketbolt in a Neal-Adams, *c.* 1970–1971 style. Note the much more realistic depiction of the hero as opposed to the more "iconic" versions from before (art by Blair Campbell).

FIG 17.3 Rocketbolt in the Jack Kirby style of the Silver Age. Note the much more "hyper-stylized" representation (art by Blair Campbell).

Sound Effects

Sound effects were still very much in use, with some going so far as to define a character. Ask any comics fan what sound Wolverine's claws make when they pop out of his hands, and they'll invariably say "SNIKT!".

However, in more "mature" comics, such as those by Alan Moore (*Swamp Thing*, *V for Vendetta*), sound effects were gone, instead taking a more subtle approach to action. The absence of sound effects left it completely to the reader's imagination to add a soundtrack to the action in the panels.

Revitalizing the Pulps

If the Silver Age was about rebirth and the Bronze Age would be a mirror version of the Golden Age (the modern twist of the new generation of comics creators), there was one group that needed to come back: the pulp characters.

Fresh off his seminal run on the *Batman* titles, O'Neil turned his attention to *The Shadow*, bringing Walter Gibson's pulp character to the comics medium in a largely unsuccessful (only in sales; I personally feel that this is one of the best works of the entire Bronze Age) 12-issue run. Borrowing Gibson's "From the Private Files of The Shadow" and "As Told To . . ." means of immersion and perceived reality to make The Shadow feel like a real-life avenger of the night, O'Neil and Michael Kaluta brought The Shadow into the 1970s (although his setting remained the 1930s; a fascinating thing about The Shadow: he is both of his time [the 1930s] and timeless). At the conclusion of the first issue, there was a wonderful piece written by O'Neil recounting how he came to write *The Shadow* (that The Shadow asked him to).

Over at Marvel, writer Roy Thomas convinced Marvel publisher Martin Goodman to pay the licensing fee to bring pulp character *Conan the Barbarian* to comics in 1970. Created by Robert E. Howard in 1932 for *Weird Tales*,[8] this comic book version of *Conan* would introduce Barry Windsor-Smith to the comics community and become one of Marvel's biggest selling titles, firing the opening shot in the next Marvel revolution of comics, a period of massive experimentation with genres, minorities, and an ever-shifting vision of the company's future. "Marvel, Phase II," as Stan Lee called it,[9] was in full swing.

The 1970s would prove to be a decade of change, of rising cynicism. What place could the mainstream comics possibly have?

You Must Remember This . . .

- During the Bronze Age, the usage of panels became organic to the art as opposed to the containers for action they had been during the Golden and vast majority of the Silver Ages.

- The failure of Jack Kirby's "The Fourth World" universe represents the ultimate generational battle between the generation that created comics and the generation that was raised on comics. The new generation won.

- *Green Lantern/Green Arrow* brought topical, "ripped from the headlines" storytelling to comics.

- There's a difference between topical (ripped from the headlines) and thematic storytelling. Topical rests on the news of the day, forever grounding that story in the time it was created. Thematic deals with issues and questions that endure from culture to culture over centuries.

Notes

1. Gerard Jones & Will Jacobs, *The Comic Book Heroes: The First History of Modern Comic Books from the Silver Age to the Present* (Rocklin: Prima, 1997), p. 156.
2. Ibid., p. 160.
3. Ibid., p. 122.
4. Ibid., p. 146.
5. Newsarama.com: Wonder Con '06: DC: The Best Is Yet to Come! Available online at: www.newsarama.com/WonderCon2006/DCU/besttocome.html.
6. Author's interview with Denny O'Neil, December 13, 2011.
7. Author's interview with Denny O'Neil, December 13, 2011.
8. Les Daniels, *Marvel: Five Fabulous Decades of the World's Greatest Comics* (New York: Abrams, 1990), p. 148.
9. Ibid.

Marvel Phase Two

Vietnam was in full swing. Richard Nixon was in the White House. Within four years, Nixon would resign in the wake of the Watergate scandal. A new generation of film-makers, inspired by the neo-realism and auteurism of European cinema, began making their presence known. Dennis Hopper released *Easy Rider* in 1969. Scorcese was coming with *Mean Streets* in 1973, and Francis Ford Coppola released *The Godfather* (written by eventual *Superman: The Movie* screenwriter Mario Puzo) in 1972. Cinema was growing up, and without a massive change—and soon—comics would forever be doomed to existence not as a medium, but a genre.

With the laxing of the Comics Code regulations in the wake of the "Drug Issues" of *Amazing Spider-Man* (#s 96–98, 1971), it was time to go wild at Marvel, letting the comics industry's own "New Generation" out to play. The first "new genre"—sword and sorcery—out of the gate at Marvel wasn't an original creation, but a licensed one (something that would figure prominently throughout the 1970s and 1980s at Marvel). The Roy Thomas-scripted, Barry Windsor-Smith-drawn *Conan the Barbarian* opened the floodgates to genres other than "super heroes" and ushered in a new era of experimentation in the mainstream comics industry not seen since the pre-*Seduction of the Innocent* days.

The Marvel approach to expansion was best characterized by Les Daniels:

> Marvel's new policy of expansion involved blanket coverage of a genre, and permitted the marketplace to decide which characters would stand the test of time. This scattershot approach, combined with a reliance on many characters and concepts from the past, created the paradoxical impression that Marvel was moving forward by looking backward.[1]

As is often the case with storytelling, the greatest inspiration and vision for the path forward comes from what came before and building upon the foundations it laid.

Vampires, Lycanthropes, and Swamp Monsters

When Marvel brought vampires and werewolves to the comics pages, it wasn't without a twist (in the typical Marvel fashion). The "Marvel Monsters" would no longer be mindless creatures of the night preying on unsuspecting virgins (though there was some of that), but they would

become the heroes of their own books, taking the Marvel "Flawed Protagonist" aesthetic one step further. In quick succession, Marvel debuted The Man-Thing in *Savage Tales* #1 (1971), *Werewolf By Night* (1972), *Ghost Rider* (1973), and brought the Universal Classic Monsters to comics life in *Tomb of Dracula* (1972) and *The Monster of Frankenstein* (1973).

Tomb of Dracula is a unique title. It is the single longest-running title featuring a villain as the lead (70 issues—by contrast, a series featuring The Joker lasted only 9 issues). It is a continuation of the Bram Stoker novel, set within the same boundaries created by Stoker, yet featuring a modern setting and characters descended from the Stoker original, fighting the newly reawakened Dracula, as well as introducing Blade, The Vampire Hunter, who would, in the 1990s prove that Marvel was ripe for the Hollywood adaptation machine. The characters created for the book, such as Rachel Van Helsing, the granddaughter of Stoker's vampire hunter Abraham Van Helsing, frequently interacted with characters in the Marvel Universe (she was killed by Wolverine after being transformed into a vampire by Dracula). Dracula himself, while functioning alternatively as a protagonist and antagonist in *Tomb*, would show up as an antagonist to other heroes in the Marvel Universe. It signaled an integration of two mythologies into a deeper shared universe, with *Tomb of Dracula* representative of a supernatural corner of the Marvel Universe.

The Kree-Skrull War

Around the launch of "Marvel Phase Two," Stan Lee hung up his Editor-in-Chief hat and moved on to the corporate position of publisher, taking over from longtime chief Martin Goodman. Encapsulating the fandom ideal of one day taking over their favorite industry, fan-turned writer Roy Thomas became the second Marvel Editor-in-Chief.

Perhaps Thomas' greatest contribution to the Marvel Universe is the first "Event" comic, "The Kree-Skrull War," running uninterrupted throughout the pages of *The Avengers* from June 1971 to March 1972. In "Kree/Skrull," Thomas tied together the entirety of Marvel continuity, making it seem that "every comic book Marvel had ever published was part of an endless, ongoing saga," tying together Golden Age characters as popular as the original Human Torch and as obscure as The Angel (the original with a mustache) and The Fin.

It was fan culture run wild with the keys to the kingdom, and is a watershed moment not only in comics, but in the Marvel Universe.

Genre

A common misconception about comics is that they are a genre. To the public-at-large, "comics" as a genre represent superheroes on one hand and the "funnies" in newspapers on the other. This couldn't be further from the truth, but sadly adds to the still-prevalent (though slightly lessened, especially as film adaptations of lesser-known, independent material like *Road to Perdition* and *American Splendor* have been made) dismissive attitude toward comics in general.

Comics are not a genre. Comics *is* a medium. And, as I hope you've seen throughout this book, it's a vibrant one at that. Comics is capable of tackling any genre, non-genre, or story you can imagine. Never think that you should only add comics to a transmedia project if it's superheroes or sci-fi. Go crazy. Try adding one to romantic comedy. It'll work.

Bronze Age Style: Captions

Narration

The trend of third-person narration continued, the author the voice of the book (or in the case of Marvel, Stan Lee's voice representing the voice of God). However, instances of first-person narration were becoming more prevalent, such as in this flashback from *Tomb of Dracula* #9, written by Gardner F. Fox (it is also worth noting here that one of the primary styles of Bronze Age writing was the over-writing style—all of what follows is from a single panel):

> "IN THAT LITTER-STREWN ALLEY I LAY FOR WHO KNOWS HOW LONG—BUT, THROUGH MY STILL-FOGGED BRAIN I HEARD NOISES—THE SOUND OF DISTANT ENGINES—THE MURMUR OF ANGRY VOICES—STRUGGLING, I LIFTED MY HEAD—AND THERE, IN THE ALLEYWAY, WAS A BAND OF YOUTHS—<u>RIDING MOTORCYCLES</u>."

It was the "penny a word" pulp era again—don't forget, though, this new generation wasn't from the Golden Age, they grew up reading Golden and Silver Age comics. They were obviously influenced by that style in their own writings.

Dialog/Word Balloons

The dialog continued its declarative and expository trend throughout the Bronze Age, with the exclamation point remaining the favorite punctuation mark. Again, let's look at *Tomb of Dracula*, this time from Issue #12, written by Marv Wolfman (who would write most of the series). In this panel, Dracula gives an interloper a right ribbing in *three dialog balloons in a single panel*:

> "<u>MORON</u>—YOU THOUGHT YOUR SILENT STEPPINGS COULD TAKE ME <u>UNAWARES</u>?"

> "YOU THOUGHT TO <u>FOOL DRACULA</u>—WHO CAN <u>SENSE</u> THE FOOTSTEPS OF THE MOST <u>INSIGNIFICANT</u> OF INSECTS— THE <u>FLUTTER</u> OF THE MOST <u>FRAGILE</u> OF FLOWERS?!"

> "NO, QUIET ONE—TO DRACULA NO SOUNDS REMAIN <u>UNHEARD</u>—NO SIGNS OF <u>TREACHERY</u> REMAIN <u>UNOBSERVED</u>!"

Harsh.

The dialog was also not above mingling blaxploitation with the comic book hyperbole, such as this exchange between Green Lanterns Hal Jordan and his new partner, John Stewart:

"JOHN—YOU WERE STUPID...AND IRRESPONSIBLE!"

"SO MAYBE I MISSED MY <u>AIM</u> WITH THE <u>POWER BEAM</u>, AND THE <u>SENATOR</u> GOT A LITTLE <u>BLACKENED</u>!

WHAT'S TO <u>WORRY</u> ABOUT? I'VE BEEN DARK ALL MY LIFE...AND <u>I'M</u> SURVIVING!"

"I DON'T BELIEVE YOU MISSED..."

"OKAY...I <u>DIDN'T</u>! LISTEN, WHITEY, THAT WINDBAG WANTS TO BE <u>PRESIDENT</u>! HE'S A <u>RACIST</u>...AND HE FIGURES ON CLIMBING TO THE <u>WHITE HOUSE</u> ON THE BACKS OF <u>MY PEOPLE</u>!"

And the proceedings conclude with my favorite Green Lantern line ever:

"ONE LAST THING! DON'T CALL ME <u>WHITEY</u>! SOMETHING IN THAT REMINDS ME OF THAT BIT ABOUT 'HE WHO IS WITHOUT SIN' CASTING 'THE FIRST STONE!'"

If you're going to go for it, go for it.

Thought Balloons

The penchant for overwriting continued in the thought balloon, again regulated to their role as expository devices, lead-ins to flashbacks, or snide asides. Again, let's look at two panels from *Tomb of Dracula*, Issue #5:

"<u>AYE</u>! IT WAS ABRAHAM VAN HELSING WHO PUT THAT <u>STAKE</u> IN MY <u>VAMPIRIC HEART</u>—<u>SLAYING</u> ME...

"...SO THAT I LAY <u>DEAD</u> AND <u>ROTTING</u> UNTIL THE FOOL CLIFTON GRAVES PULLED IT <u>OUT</u> AND RESTORED ME TO <u>LIFE</u>!

"<u>GRAVES</u> I MADE INTO MY <u>SLAVE</u>, SO THAT HE DOES <u>EVERYTHING</u> I ORDER...

"BUT VAN HELSING—<u>AHHH</u>! HOW <u>SWEET</u> WOULD IT BE TO TAKE MY <u>REVENGE</u> ON HIM WHEN HE <u>DOESN'T SUSPECT</u> I AM ALIVE!

"I MUST—SEEK HIM OUT!"

Punishment and Claws

During this era of expansion and experimentation, Marvel would create what were perhaps the last two new superheroes who would continue to be

popular to this day. They were reflective of the uncertain and dark times that were the 1970s, a decade of cynicism and simmering anger, of people who were, to quote the oft-quoted Howard Beale from *Network*, "mad as hell and not going to take it anymore."

Seeking a "dark, street-tough opponent for Spider-Man,"[2] writer Gerry Conway brought the idea to the new Marvel EIC, Roy Thomas. With an iconic costume created by John Romita (who had recently become Marvel's art director), The Punisher made his debut in *Amazing Spider-Man* #129 (February 1974), obsessed with taking out Spidey. The character proved immensely popular, and would soon make guest appearances throughout the Marvel Universe. He was Travis Bickle before *Taxi Driver*.

On the final page of *The Incredible Hulk* #180 (October 1974), arguably the greatest creation of the 1970s unsheathed his claws all over the comic book scene, the mutant known as Wolverine. Fighting against his own feral nature (and after being transformed from his original interpretation as a teenager[3] into the gruff and tough 5 ft 2 in Clint Eastwood with a mysterious past that we all know and love) he would go on to become a leading figure in the next revitalization of the 1970s—the X-Men.

The X-Men

After languishing for over a decade since its debut in 1963, *X-Men* was in trouble. Largely abandoned by Stan Lee and Jack Kirby after their debut, there was no singular voice guiding the team. They hadn't found the hook. Sure, the X-Men were a comic-book-ified statement on civil rights, but, as we've seen, topicality isn't enough (though Lee was more adept at disguising the real-world parables than O'Neil in those days—the Spider-Man "Drug Issues" notwithstanding).

After assuming the Editor-in-Chief job, Len Wein (the creator of Wolverine and now the third Marvel EIC, following Stan Lee and Roy Thomas, who left the post in 1974), writer of *X-Men* and *The Incredible Hulk*, had a choice to make. He decided to drop *X-Men* and hand it off to his writing assistant, a young writer named Chris Claremont.[4] Claremont's run would go on to define the X-Men and set them apart from all other "super-teams," transforming them from an almost-forgotten team into what would become the biggest selling comic book of the 1990s speculator market.

First, from the original X-roster of Scott Summers (Cyclops), Jean Grey (Marvel Girl), Hank McCoy (The Beast), Bobby Drake (Iceman) and Warren Worthington III (The Angel), Claremont (and Wein, in *Giant Size X-Men* #1), brought diversity to the team: an African-American woman (Ororo Monroe, AKA Storm), a steel-plated Russian code-named Colossus, a teleporting German code-named

Nightcrawler, a Canadian brawler with claws who had given the Incredible Hulk a run for his money, and a Native American code-named Thunderbird.

It was that final character who would provide the seeds of innovation and inspiration. By the end of his third appearance, Thunderbird would be dead, signaling that no character was safe, drawing readers in each and every month, and giving *X-Men* that uncertainty and hook that was so desperately needed. Claremont created a world within a universe, vibrant, ever-changing characters who fought to defend a world that feared and loathed them—and, in typical Marvel fashion, fought among themselves.

In a Galaxy Far, Far Away

In 1977, George Lucas released the patriarchal franchise of the transmedia world, *Star Wars*. Often discussed in transmedia texts, I won't waste this space with another look at it. What we will talk about is the *Star Wars* comic book adaptation produced by Marvel in 1977.

While everyone was off in their own corner, producing different genres with alternating strings of success (*Tomb of Dracula*, Claremont's *X-Men, Master of Kung-Fu*) and failures (*The Cat*), Roy Thomas brought *Star Wars* to the Marvel offices. George Lucas was looking for a way to promote the film before its release and Thomas eventually wrote the six-issue comic adaptation of the film. It was the first comic since the 1966 *Batman* craze to sell a million copies an issue.[5]

The *Star Wars* adaptation brought a whole new interest to comics in a decade that was for the most part a slow one. Soon, everyone was bringing space elements into their comics. Chris Claremont created the Shi'ar empire and unleashed the Dark Phoenix saga.

An area not often talked about when speaking of *Star Wars*, with Lucas citing the movie serials of the 1930s and 1940s and Joseph Campbell as primary inspirations, is the work of Jack Kirby. In *The Comic Book Heroes*, Gerard Jones makes the following statement:

> One man watching *Star Wars* with close attention was Jack Kirby. Everyone who knew Jack's work could see where Lucas got his central ideas. Darth Vader had Dr. Doom's scarred face, metal mask, armor, and cape, plus a trace of Darkseid's name and presence. The Death Star looked like a scaled-down Apokolips. Luke Skywalker echoed Orion [of the *New Gods* and Kirby's *Fourth World* meta-series]: the mutilated lost son of the villain, raised in ignorance of his destiny to fight his father to the death. People asked Kirby if he was angry, but according to his old assistant . . . "Stuff like that didn't bother Jack . . . It just gave him more ideas for other things."[6]

Playing It Safe

I have one mantra when it comes to storytelling: never, ever play it safe. If Claremont's run on *X-Men* (later retitled *Uncanny X-Men*) should prove anything it's that audiences like things to change. They may not admit it, but if you hook them correctly and give them things to chew on, you will build up good faith and have the ability to change things as you see fit. Remember, the longevity of the comics medium is due largely to its penchant for evolution. Never give people what they want—give them what they never knew they wanted.

After the success of the *Star Wars* licensing (following the adaptation, Marvel continued to publish an ongoing *Star Wars* series, written by Archie Goodwin), Marvel quickly went after other properties like *Battlestar Galactica*, *Rom*, *Micronauts*, and in a highly demonstrative business move, *Star Trek*, wrestling the rights away from former *Star Trek* license holder Gold Key just as *Star Trek: The Motion Picture* was about to come out.

As Goodwin took over the *Star Wars* series, he resigned as Editor-in-Chief, the final of the "revolving door" EICs of the 1970s. Stan Lee had even remarked, "Don't paint his name on the door. Just tack it up."[7] The next EIC, Jim Shooter, would preside over Marvel's ascension to the top spot of the industry, a boy wonder who had sold his first comics work to DC at 14.

You Must Remember This . . .

- Stan Lee's "Drug Issues" of *Amazing Spider-Man* (#s 96–98, 1971) were published without approval from the Comics Code Authority, and resulted in the relaxing of stringent code regulations. This lead to the wide breadth of genre experimentation that permeated every single Marvel book of the 1970s.

- Throughout the 1970s (and following the ascension of Stan Lee to publisher), Marvel had a string of Editors-in-Chief. The first new one was Roy Thomas, fan writer turned steward of the Marvel line. The final was Jim Shooter, a phenomenon who had sold his first comic book work at age 14.

- Chris Claremont's run on *X-Men* transformed a slagging title into a massive seller and influenced countless comic book storytellers with its labyrinthine plots and serialized storytelling.

Notes

1. Les Daniels, *Marvel: Five Fabulous Decades of the World's Greatest Comics* (New York: Abrams, 1990), p. 155.
2. Ibid., p. 163.
3. Ibid., p. 169.
4. Ibid., p. 169.
5. Gerard Jones & Will Jacobs, *The Comic Book Heroes: The First History of Modern Comic Books from the Silver Age to the Present* (Rocklin: Prima, 1997), p. 222.
6. Ibid., p. 223.
7. Les Daniels, *Marvel: Five Fabulous Decades of the World's Greatest Comics* (New York: Abrams, 1990), p. 176.

Adaptation in the Bronze Age

With the exception of the 1960s animated cartoons and assorted licensed merchandise, Marvel Comics hadn't spread into other media. That would change in the 1970s . . . with varying degrees of success. But it would be DC that would define the adaptations of the 1970s when Christopher Reeve made you believe a man could fly.

The Incredible Hulk

The familiar strains of "the Lonely Man" theme are forever etched in pop culture (most recently parodied on Seth MacFarlane's *Family Guy* as Stewie began a journey). It accompanied Bill Bixby as he walked the lonely road towards his next adventure, forever seeking the cure to his affliction that caused him to turn green and rip all of his clothes off (except for his pants) and help those in need.

It could be argued that *The Incredible Hulk* (1977) was the first successful comic to television adaptation. *The Adventures of Superman* wasn't terrible, but it did feature unimaginative plots and adversaries unworthy of the titular hero. The William Dozier-produced, Adam West-starring *Batman* show was wildly successful, but not as an adaptation of the comic book and certainly didn't do any favors for Batman. *Wonder Woman* (1975), starring Lynda Carter, was closer, and remains a fondly remembered sojourn into the television medium. But *The Incredible Hulk* was successful because of Bill Bixby, who played David (no longer the apparently "homosexual sounding" Bruce as focus groups decided) Banner, the tortured scientist, who in a moment of grieving obsession with improving his own strength, transformed himself into the green-painted Lou Ferrigno.

The stories followed a structure laid out by the comic: serio-episodic. There was an overarching plot to the entire show (Banner's—now believed dead —search for a cure), but each episode started with Banner arriving in a new location, and helping out someone in need, which would result in an appearance by his larger other self. It was a green-skinned version of *The Fugitive* and a wildly successful formula, and was the first adaptation to make Hollywood take serious notice of comics.

Buoyed by the success of *The Incredible Hulk*, other Marvel heroes were rushed into production: actor Nicholas Hammond portrayed Peter Parker/Spider-Man

in *Spider-Man* and its subsequent sequels; *Doctor Strange* made the leap to the televised dimension in a tripped-out 1978 film starring Peter Hooten, and Reb Brown put on a winged motorcycle helmet to transform himself into *Captain America* in two atrocious television films.

In 1980, Marvel found their animated niche when they formed Marvel Productions Ltd., and put *Spider-Man & His Amazing Friends* on Saturday mornings and immediately turned it into a hit. *Spidey* was soon followed by *The Incredible Hulk* (which inspired the young me to hide behind things and peek out when Banner transformed into the titular character). The studio eventually animated shows outside the "superhero" genre, including *Transformers, GI Joe*, and surprisingly, *My Little Pony*, and *Muppet Babies*.[1]

The Incredible Hulk as Partial Transmedia

It's worth noting here that when *The Incredible Hulk* ended in the 1980s, Banner's story was continued in television movies, concluding with 1990's *The Death of the Incredible Hulk,* quite literally bringing his story and life to its end. I would classify these as a partially transmedia approach, as the story of Banner did continue in a separate medium (made-for-television movies are a different medium than serio-episodic television), but remained on the same distribution channel (television).

Media Mix Comes to American Shores

In the early 1980s, Hasbro wanted to reintroduce their popular GI Joe toy line. To do so, they adopted the "media mix" strategy from Japan, and brought it to American shores. Hasbro's advertising agency approached Marvel about producing a comic:

> "Hasbro's advertising agency approached us," says Michael Hobson [Marvel's then-VP in Charge of Publishing], "With the idea for a three-pronged campaign that included the toys, an animated television show, and a comic book. So we had our comic book advertised on national television and it really sold comics."[2]

GI Joe was straight-up adventure, fueled by writer–artist Larry Hama, and represented a massive success on the news-stands (though not in the "Direct Market," which we will discuss in a future chapter).[3] The synergistic interplay between the toy line, the animated series, and the comic book would prove a potent combination for market success, as *GI Joe* (alongside the similarly marketed and released *Transformers*) would define the media consumption tastes of an entire generation. It (along with other properties, like *Thundercats, Super Friends,* and *M.A.S.K.*) taught a generation to play with action figures as with their media. On a personal level, I wouldn't be writing this book without *GI Joe*.

How Action Figures Taught a Generation to Play

In the first chapter of this book, I relayed the story of my bathtub experience playing with GI Joes, creating my own narratives to fit inside the gutter between television shows and movies. GI Joe was a big part of my life, but my first exposure to comic book superheroes (I didn't pick up my first comic until

The Green Hornet #3 in 1989–1990) was from *Super Friends*. I amassed an army of plastic superheroes—Superman, Batman, and the most awesome of all, Green Lantern (he really was the best-looking figurine out of that bunch) from the Kenner toy line inspired by *Super Friends*, Super Powers.

It was that toy line that taught me how to play. What was it that appealed to me so much about action figures and how has that influenced my passion for transmedia storytelling? First, I was able to create my own adventures featuring pre-established characters. It was a juvenile form of private fan-fiction theater. Second, it taught me (by doing) how to intermingle media. Would Superman and Green Lantern be a good team-up here? Replace Superman with "Comic Books" and Green Lantern with "Film" and you get the picture.

Remember earlier I included the word "play" in my definition of transmedia. It's defined by the interplay of media fragments, and the key element in the word "interplay" is play. Storytelling should be fun. It should be a wildly exciting thing for audiences to absorb. They should want to play with action figures, even if your action figures are a different media. Play is the key to transmedia.

Super Friends

The DC Heroes came to Saturday mornings in 1973 in the form of *Super Friends*, a fun and forgettable* half-hour of Justice League (Superman, Batman, Robin, Wonder Woman, Green Lantern, Aquaman, the Wonder Twins, and an inexplicably flight-capable Flash) fighting the mad machinations of The Legion of Doom (Lex Luthor, Sinestro, Gorilla Grodd, Captain Cold, and others). The plots were uninspired, but they were fun.

But in 1978, inspiration would be the key word coming from movie theaters as audiences all over the world believed that a man could fly.

"You've Got Me, But Who's Got You?!"

Every 20 years or so, Superman is defined in another medium. In the 1950s, it was television. In the 1970s, it would be a feature-length film directed by Richard Donner and starring Christopher Reeve (as the definitive Superman/Clark Kent), Gene Hackman (as the less-than-definitive Lex Luthor), Margot Kidder (as the definitive Lois Lane) and Marlon Brando (as Marlon Brando as Superman's Father). It was directed (if not produced) with love and

* Although unforgettable to me, as the toy line that came from *Super Friends* was a cornerstone in my adolescent storytelling development.

Japanese Media Mix

The unfortunate thing about this book is that I haven't gone into great detail or depth about international storytelling (that would be another complete book in and of itself).

While I grew up playing with GI Joe and Transformers (produced by Hasbro), then watching the television show or the movies, then reading the comics (produced by various divisions of Marvel), this wasn't anything new in the media landscape. However, this sort of mixed-media marketing strategy across multiple media channels available at the time to maximize audience immersion (and profits) (what we now call transmedia) was very new to American audiences in the 1980s.

In Japan, "media mix" began appearing in the 1970s with *Macross*, a wildly popular anime with mechanized, walking armored vehicles (very similar to Transformers). The mechanized vehicles created a demand for action figures, supplied by Bandai. The *Macross* saga would go on to be played out over video games, films, and more.[4] Other examples include *Gundam* and, in the modern era, *Pokémon* and *Yugioh*.

The Battle for Creator's Rights

In 1938, Jerry Siegel and Joe Shuster sold their creation, *Superman*, to DC Comics and Harry Donnenfeld for $130. There were no royalties assigned to them, and they never made a dime from the various adaptations of Superman—radio, television, animation—not a dime. Not only that, but their creator's byline was removed in 1947 by DC Comics. In the 1970s, Warner Brothers paid DC (now a subsidiary of Warners) a whopping (at the time) $3 million dollars for the rights to Superman.[5] And the guys who created him didn't get a cent.[5]

It was the work of Neal Adams and Jerry Robinson that brought this issue to light (as well as Siegel's bombastic diatribes against his former employer in the pages of *Variety*), and in 1977, new DC publisher Jeanette Kahn issued a mea culpa: Siegel and Shuster would be paid $20,000 a year for their creation.

It goes without saying that the remunerations paid to Siegel and Shuster were 40 years overdue, but it's a valuable glimpse into the comics business in its nascency and a cautionary tale for any creative working today: know your rights and always negotiate the best deal. By the time the *Superman* film was coming out in 1978, Jerry Siegel worked as a mail clerk in Los Angeles, having long before walked away from the comics business. Joe Shuster was nearly blind and destitute.

respect, a distillation of everything that made Superman super. There were the little touches (saving the cat, the slight smile as he banked right into space), there were the amazing super-heroics (the greatest super-scene ever filmed in a comic adaptation, the Helicopter rescue scene ("If you've got me, who's got you?!"), and there were the less-than-super moments (most of Gene Hackman [even though I love Gene Hackman], Miss Teschmacher, and Otis).

What this film will be remembered for, even more than producing the definitive version of Superman in the eyes of countless fans, is producing the era-specific nostalgia that has seeped into the comics medium. Current DC Chief Creative Officer (and *Justice League* writer) Geoff Johns worked as Richard Donner's assistant after falling in love with the film, and that guiding spirit of nostalgia has shaped the path of DC Comics for the past ten years.

I could talk about George Lucas' adaptation of *Howard the Duck*. But I won't.

Notes

1. Les Daniels, *Marvel: Five Fabulous Decades of the World's Greatest Comics* (New York: Abrams, 1990), p. 182.
2. Les Daniels, *Marvel: Five Fabulous Decades of the World's Greatest Comics* (New York: Abrams, 1990), p. 193.
3. Gerard Jones & Will Jacobs, *The Comic Book Heroes: The First History of Modern Comic Books from the Silver Age to the Present* (Rocklin: Prima, 1997), p. 268.
4. Frank Rose, *The Art of Immersion: How the Digital Generation is Remaking Hollywood, Madison Avenue, and the Way We Tell Stories*. (New York: Norton, 2011), p. 42.
5. Gerard Jones, *Men of Tomorrow: Geeks, Gangsters, and the Birth of the Comic Book* (New York: Basic, 2004), p. xiii.

Original Voices

Comics as Life

The superhero genre was born out of the minds of two teenagers from Cleveland, Ohio—Jerry Siegel and Joe Shuster—when they sold (as we've seen throughout this book) Superman to DC Comics leading to his first appearance in 1938's *Action Comics* #1. This red-and-blue symbol of the oppressed launched the comic book as we know it and began a roller-coaster cycle of creation, experimentation, revitalization, and stagnation.

It was that stagnation that once again made Cleveland, Ohio, part of another comics movement when Harvey Pekar, a file clerk at the Cleveland Veteran's Administration (VA) Hospital, met underground comix artist Robert Crumb (of the famous *Keep On Truckin'* comic) at a jazz records swap meet. The result of that meeting, *American Splendor*, was an ongoing series (running from 1976 to 2008, and adapted into the 2003 Paul Giamatti-starring film of the same name) that chronicled Pekar's life in Cleveland. Said Pekar of *American Splendor*:

> It's an autobiography written as it's happening. The theme is about staying alive. Getting a job, finding a mate, having a place to live, finding a creative outlet. Life is a war of attrition. You have to stay active on all fronts. It's one thing after another. I've tried to control a chaotic universe. And it's a losing battle. But I can't let go. I've tried, but I can't.[1]

Pekar's partner in *American Splendor*'s early issues was Robert Crumb, a luminary and founder of the Underground Comix scene (all too briefly discussed in Chapter 17) in the 1960s. Crumb had moved to Cleveland in the 1960s, working as a designer for the American Greeting Card Corporation, and met Pekar at the intersection of their love of jazz and comics. His style, a mixture of LSD and Looney Tunes, brought a distinctive flavor to the series that is considered to have launched the Underground Comix scene with *Zap Comix*, a 16-issue satire series.

It was that movement towards stylized autobiography that pushed comics into a new realm, showing the possibilities of combining two seemingly disparate realities: the four-color (or black and white) "reality" contained in a comic book (no matter how non-realistic it may be) and the stark reality of America in the 1970s.

The country was in the midst of another massive transition. Richard Nixon, the perpetual presidential candidate turned president, had been brought down in the Watergate scandal, the Church Committee was airing all of the

The Fourth Wall

American Splendor remains one of the greatest autobiographical comics ever produced, and one of the main reasons is Pekar's unique voice, of his casting himself as the lead character and talking directly to the audience (much in the way that superheroes used to do in the Golden Age, with the occasional wink-wink of Superman/Clark Kent when he was proud that Lois never realized his true identity).

The "fourth wall" is the direct descendant of the Shakespearean "aside," when characters would break the bonds of fictional narrative and speak directly to the very real members of the audience, moving the story forward and giving deeper insight into their motivations.

dirty laundry of the Cold War, and the House Select Committee on Assassinations was opening up the dual wounds of the John F. Kennedy and Martin Luther King assassinations.

The dominant vision of America of the 1970s was Martin Scorcese's *Taxi Driver*, with its grime-infested streets and vigilante justice pushing the frustrations of a country that only ten years earlier had been all about peace and love.

The Bee Gees sang about "Stayin' Alive." The comics produced by these original voices showed the stylized reality of that very mission. And superheroes were nowhere to be seen.

The Direct Market and Comic Shops

In Chapter 16, we discussed the inclusive nature of great comics storytelling, that it makes you feel part of a special club. We also looked at the rise of comics fandom (leading to the hiring of superfan Roy Thomas at Marvel, who eventually became Editor-in-Chief), fueled by a love of Golden Age comics. That second generation of comics creators, those who grew up not knowing a world without comics had a powerful love of nostalgia, a look back at the classics that came before and a passion for the heroes of old.

It was that same love of vintage comics that caused the first comic book shops to pop up. Numerous antique comics dealers, fueled by their customer's love of nostalgia, had opened up retail shops to sell rare back issues of comics.

As early as the 1950s, the news-stand market had started to dry up, especially with the large post-war exodus from cities to suburbs, causing the news-stands themselves to fold, absorbed into suburban supermarkets and box stores. It was that combination of passionate nostalgia and the downward spiral of news-stand sales that fermented the creation of the Direct Comics market, now the single largest means of comic book retail.

Phil Seuling, an entrepreneur, saw that confluence of nostalgia and need, and came up with the idea that the new comic book shops should also sell new comic books. Seuling started approaching publishers as early as 1976 to be distributors to comic shops, and by 1982, the direct market accounted for nearly half of Marvel Comics' sales.[2]

The comic book shop became a gathering place in the 1980s and 1990s for like-minded fans, a community built around their shared love of the medium. It would prove to be one of the best and worst things to happen to the industry.

In the worst column, it pushed comics into the realm of something less than "kid's stuff." It made them a too-exclusive club, but unlike most "exclusive clubs," no one in the "mainstream" wanted to join that culture. Comic Book Guy from *The Simpsons* is a more than accurate representative distillation of the comic book shop experience. It turned people off to comics, many of whom, if they were alive in the 1940s, would have had no problem with picking up a comic and thrilling to their adventures, just as they had done with their pulps. The comic book shop fermented a social stigma around comics that has only recently begun to subside thanks to the "geek chic" urban style and the proliferation of large-scale and successful Hollywood comics adaptations.

In the best column, it gave publishers a new venue to make up for the continued downward spiral of news-stand sales (though it never helped bring comic sales back to earlier levels consistently). It created a gathering place, a watering hole (without the alcohol) for fans to congregate, and fostered a sense of community. It also gave discerning fans a place to find underground comix, graphic novels, and other things that would never have found a place on the news-stand. It gave comics a new life, and gave creators who wanted to push the envelope a means to survive and thrive.

The direct market saved the medium.

A Contract with God

"Nobody I started with except Will Eisner had the temerity to admit that he loved the medium and that he would spend the rest of his life doing it,"[3] said Will Eisner to Frank Miller in the interview book, *Eisner/Miller*. Since *The Spirit* ended in 1952, Will Eisner had devoted his artistic talents to creating instructional and educational material for the U.S. Army. In the 1960 and 1970s, *The Spirit* returned in reprints published by Warren and Harvey Comics, showcasing Eisner's immense talents to the new generation of comics creators shaping the next 30 years of the medium.

From their inception in the 1930s, comics have always had a defining stigma about them: impermanence. The newspapers that comic strips appeared in would be thrown out with the next day's trash. The comic books would be seized by thought-police parents and thrown out. Kids would read, reread, and eventually destroy their comics. They were made cheaply, meant to be consumed quickly, and disposed of almost as quickly.

Eisner saw and hoped for something different. He sought permanence. He believed that comics were a vibrant art form, filled with possibility and worthy of being held up on a pedestal, of hanging in museum walls. Again, recounted from *Eisner/Miller*:

In 1940, I gave an interview with the *Baltimore Sun* when *The Spirit* first came out, and I said, "This is a literary art form." And the guys were laughing at me and said, "What are you trying to prove, Will, who do you think you are?" [Newspaper cartoonist] Rube Goldberg told me what I was saying was bullshit. He said, "Shit, boy, you're a vaudevillian. Don't forget this is vaudeville."[4]

He always believed that comics were literature, that they were the perfect melding of image and words (which themselves are images—especially in the Asian languages). After a 25-year absence from the "vaudeville" of comics and influenced by the work of master engraver and storyteller Lynd Ward, Eisner returned to the medium he so loved and created a new form of literature (the graphic novel) with one of the most important works in the history of comics, *A Contract with God*. He would put comics on bookshelves. He would finally give them permanence.

In *A Contract with God*, Eisner tells three stories of life on Dropsie Avenue, the mytholigized storyworld he created from his own experiences growing up in Depression-era New York City. He considered himself "a graphic witness reporting on life, death, heartbreak and the never-ending struggle to prevail . . . or at least to survive."[5] In *A Contract with God*, he took what he had honed on *The Spirit* and mastered during his time away from comics and presented a medium that was neither "comic book" nor "book." It was a graphic novel. Text and image played with one another in a way never before seen. The confines of the panel and the grid were eschewed for a timeless feeling of freedom as the frame gave way to no frame, as brick and mortar framed the action going inside the windows.

The images were stylized, adults presented as caricature against a stark and realistic vision of Depression-era New York City. Casual readers complained about that very dichotomy. Denny O'Neil feels (as do I) that "the exaggerated features of the characters work for the whole. The child in us does not remember the adults as they actually were; he remembers them as archetypes—as caricatures, almost."[6]

With *A Contract with God*, Eisner would cement himself as the Godfather of Comics, giving the next generation a desire for permanence and endurance in their own work, showing everything that comics could accomplish, and cementing his vision of comics as literature to the world at large—even though that world is still trying to catch up.

Format: The Graphic Novel

If monthly comics are the television of print, the illegitimate inheritor of the serialized novel, then the graphic novel is the inheritor of the novel and

feature film legacy. Featuring (more often than not) a single story playing out in a non-serialized narrative, graphic novels are the feature films of the comics medium.

Often lasting between 60 and 200 pages (on average—this number can vary wildly), the graphic novel is a synergy of the novel and the comic. Don't confuse the graphic novel with the trade paperback. A trade paperback is a collection of stories originally presented in the serialized comic form—just like DVD editions of a television season. Notable examples of graphic novels include Eisner's *A Contract with God*, *A Life Force,* and *Dropsie Avenue*, Brian Azzarello and Lee Bermejo's *Joker*, David Mazzuchelli's *Asterios Polyp*, Brian K. Vaughan and Nico Henrichon's *Pride of Baghdad*, and . . .

Maus

art spiegelman (yes, that's correct) grew up knowing very little of his father's survival through the Holocaust. When he made the decision to tell the story, his love of and work in the comics medium gave him the freedom to tell the story as he wanted to tell it, "it would be opaque to [his father] Vladek. I could do what I needed to do and not have him question it because it was all alien turf to him."[7]

First published as a work-in-progress in spiegelman's *RAW* magazine (itself a seminal achievement in pushing the boundaries of the print medium) in 1980 and published in the longer form in 1985 as *Maus I: My Father Bleeds History*,* *Maus* tells the story of Vladek Spiegelman's survival through the Holocaust. Featuring simple, inky lines and the central concept of portraying Jews as mice and Nazis as cats, *Maus* is the ultimate realization of the Underground Comix movement. Taking what was once a fun cartoon game (cat and mouse) and turning it into the most soul-searing work of comics ever created, *Maus* won the Pulitzer Prize in 1992 (following the publication of the follow-up *Maus II: And Here My Troubles Began*).

Maus succeeds on two counts: first, the powerful parallel narratives of Vladek's survival through the Holocaust, and second, the semi-reconciliation of father and son during the process of telling the story. spiegelman makes use of all the illustrative aspects that comics has to offer: Vladek would draw diagrams of where he hid from the Nazis; methods for repairing shoes would be shown. By reducing the gargantuan struggle between Jews and Nazis to a cartoony cat-and-mouse tale—to an iconic and symbolic representation—spiegelman made the story that much more poignant. It was simple and visceral.

* In an attempt to beat Steven Spielberg's own (highly sanitized) Jewish mouse story, *An American Tail,* to theaters—which it did, thanks to Union problems among the animators.[8]

The "Symbolic Valley"

Why do so few comics work that are adapted from television shows or films? Why do they fail miserably when they attempt to re-create the realistic feel of the show (realistic in that a real person is playing a role)?

I argue that it's because of a concept I like to call the "Symbolic Valley." Like the "Uncanny Valley" of computer-generated films like *Polar Express* and *Beowulf* (apologies for picking on you, Robert Zemeckis), it is a feeling of "just barely" perfection—a feeling of coldness, of reproduction that tries to be authentic.

I advocate going the other way. Instead of realistic, go for symbolic. Look at *Maus*. Nazis are cats, Jews are mice, all drawn in an inky, simple cartoon style. And it remains the single most staggering and powerful work ever created in the comics medium.

By using all that the medium has to offer, spiegelman (like Eisner and Pekar/Crumb) made something unique in the arts: a story that is *of* the medium in which it is created—a story that could only be told in comics form, not a movie transformed into a comic because he couldn't afford to make a movie.

The Stories We Can Tell

The tales discussed in this chapter (*American Splendor*, *A Contract With God*, and *Maus*) represent the most important shift in comics storytelling since the invention of comics. While the superhero genre is wildly popular (and of utmost importance in the construction of worlds and mythologies in the transmedia discipline), the works of Pekar, Eisner, Crumb, and spiegelman demonstrate that absolutely *any* story can be told in the comics medium. Be it the tale of a lone survivor of a doomed planet rocketing to Earth and becoming the red and blue tight-wearing hero of Metropolis, punching Hitler, surviving in 1970s Cleveland, the interconnected tales of a Bronx tenement, with its stylized vision of adults amid a starkly realistic cityscape, or the story of a family's survival through the Holocaust stylized as a struggle between cats and mice, comics represent nothing but possibility and creative freedom.

Denny O'Neil told me of an "argument" he had with Will Eisner one evening. Eisner believed that any story could be told in comic books. O'Neil countered by saying that you couldn't do Shakespeare in comics.

A few months later, Eisner recreated the famous "To Be Or Not To Be" soliloquy—in comics form.[9]

You Must Remember This . . .

- A storyworld is not exclusive to vast sci-fi universes or deep superhero mythologies. It can be as simple as a street in New York City. Create a vehicle for your stories and the possibilities are limitless.

- Comics can convey anything—from superheroes to cat-and-mouse Holocaust stories to survival in 1970s Cleveland.

- Many film-to-comics adaptations fail because the art tries to replicate the realism of the film. Go the other way—make it simple and iconic and your work will endure.

Notes

1. "Harvey Pekar," *The Telegraph*, July 13, 2010. Available online at: www.telegraph.co.uk/news/obituaries/culture-obituaries/books-obituaries/7888494/Harvey-Pekar.html.
2. Les Daniels, *Marvel: Five Fabulous Decades of the World's Greatest Comics* (New York: Abrams, 1990), p. 187.
3. Charles Brownstein, *Eisner/Miller* (Milwaukie: Dark Horse, 2005), p. 161.
4. Ibid., p. 163.
5. Will Eisner, Preface to *The Contract With God Trilogy* (New York: W.W. Norton, 2006), p. xiii.
6. Denny O'Neil, *Introduction* to Will Eisner's *A Contract With God and Other Tenement Stories* (New York: DC Comics, 2000).
7. art spiegelman, *MetaMaus: A Look Inside a Modern Classic, Maus* (New York: Pantheon, 2011), p. 37.
8. Ibid., p. 76.
9. Author's interview with Denny O'Neil, December 13, 2011.

The Crisis on Infinite Earths

Continuity Conundrum

In 1984, DC Comics was in a bad way. Very bad. Marvel was pushing a 70 percent market share. DC had 18 percent. Things were bad to the point that Bill Sarnoff, head of the publishing division at Warner Brothers (which included DC Comics), approached then Marvel Editor-in-Chief Jim Shooter about the possibility of Marvel Comics licensing and publishing DC Comics.[1]

Said Shooter in a February 21, 1984 memo:

> Their recently-published statements of ownership show that their sales are embarrassingly low, and that, almost across the board, they have fallen during the last year.
>
> What's in it for us is the money we'd make publishing those characters and the elimination of an irritation. Intelligent and creative editorial management can make the DC characters profitable without hurting our own line.[2]

The buyout eventually folded thanks to a lawsuit from another publisher, but the writing was on the wall. DC Comics was *not* doing well, and there had to be something that could be done.

Although by 1985 DC had somewhat closed the gap with Marvel, rising to somewhere around 30 percent market share, and Marvel falling to below 50 percent.[3] DC editorial knew they had one shot to close that gap, and it needed to be huge. The option they went with was the nuclear option: erase the old continuity and start from scratch. To get to that blank slate, they would launch the *Crisis on Infinite Earths*, a 12-issue maxi-series written by former Marvel Editor-in-Chief Marv Wolfman (the sixth of eight EICs in under a decade at Marvel) and *New Teen Titans* artist extraordinaire George Pérez. A massive effort featuring every character in the DC Universe (beautifully rendered by master craftsman Pérez), *Crisis* told the story of the DC Universe's battle against the Anti-Monitor, and resulted in the erasure of nearly everything that had come before.

Gerard Jones summed it up best in *The Comic Book Heroes*:

> the charting of the pasts and futures of dozens of characters, the folding together of parallel Earths, the mountains of explosions, the endless fight scenes—made it impossible to understand. Flash died, taking the brightness of the Silver Age with him. Supergirl died, killing the last

remnant of an era of kids' and girls' comics . . . The company had made progress as the "new DC," and although its first flush of joy had inspired a fond looking back . . . it was the "new" that was expected to sell to kids. *Crisis* was to be the death, not just of Earth-2, Earth-3, and all the rest of them, but of the DC that was.[4]

There are two schools of thought when it comes to the erasure of nearly 50 years of history and continuity in an effort to bring in new readers. Some view it as the single biggest mistake DC Comics ever made. Others view it as an essential building block for the current comics market. I'm going to share both views and offer my take on the subject, because this offers a valuable lesson for transmedia producers working today, as well as a continuous look at the evolving history of the comics medium.

The First Argument—Worst Thing Ever

By 1985, the DC Universe was a mess. The mythologies DC had produced were in danger of imploding on themselves. There were multiple Earths with multiple versions of characters (see "Transmedia Tools: The Multiverse," p. 106), and there was a huge problem: the mythologies had become mired in a mish-mash in their own sometimes wildly divergent and mangled continuities, largely due to editorial teams that never talked to one another for much of the DC history.[5] It was as far from "new reader friendly" as you could get.

Crisis erased nearly 50 years of history. In our world, that's like going to England and getting rid of Stonehenge, saying that English history began when John Lennon and Paul McCartney met in 1956, simply because that pre-1956 history is too complicated to understand.

Many of the linchpins of the DC mythologies would remain in place: Superman was still from the planet Krypton and raised by a kindly couple in Smallville, Kansas (this time, they were still alive). Bruce Wayne would still become the obsessed avenger of the night, The Batman, following the brutal murder of his parents. But 50 years of history? Gone.

The Second Argument—It Works

By 1985, the DC Universe was a mess. The mythologies DC had produced were in danger of imploding on themselves. There were multiple Earths with multiple versions of characters, and there was a huge problem: the mythologies had become mired in a mish-mash in their own sometimes wildly divergent and mangled continuities, largely due to editorial teams that never talked to one another for much of the DC history. It was as far from "new reader friendly" as you could get.

Continuity

Continuity is an integral part of comics storytelling. It is the bread and butter of fan immersion and longevity of mythologies. Continuity is consistency of ideas throughout a comic storyworld (unlike in a film, where continuity simply means that the pants are the same length in each shot, or that the love interest is wearing a blue-red shade of glasses, not orange-red). For example: Superman is from the planet Krypton. He was raised by the Kents. In "Pre-Crisis" continuity, the Kents were deceased by the time he became Superman and moved to Metropolis. In "Post-Crisis" continuity, they lived for several years up until the "New 52" continuity, where again they don't live to see Clark become Superman.

Several tales are considered "out of continuity," like Grant Morrison's *All-Star Superman* or Frank Miller's *Dark Knight Returns* (more on this in Chapter 25). Freedom of continuity is considered a necessary element to attract "new readers," hence the decision to demolish the continuity and restart the DC Universe in the 1980s—though freedom of continuity has yet to be a proven means of attracting new readership.

The validity of that decision remains up in the air, as continuity can be a marvelous reward for faithful fans, encouraging deep immersion and the potential for fan fiction. It is one of the defining characteristics of comic book (and transmedia) storytelling.

And they were right.

Mythologies such as the DC Universe have to be revitalized to reflect the shifting values and beliefs of the society in which they're created. By divesting themselves of the burden of massive history and relationships, it opened the doors for a new era of creativity and allowed the characters to again evolve—which is the key to the longevity of the superhero comics genre.

It saved the history of the DC Universe from being mired with the conflicting values of a different generation, allowing that second generation of comics creators to put their own stamp on the medium. Remember, comics were created by kids having fun and trying to make a quick buck. Saddled with decades of continuity and the like, results in a marshland of conflicting voices.

The Middle Ground

Both views are not without merit. I agree with the reasoning behind both arguments. History is immensely important. It provides a sense of legacy both in character and in creator.

On the flip side, loads of continuity results in muddled messages and a discord between the needs of the dedicated fans hungry for nostalgia (which had been growing steadily since the Silver Age) and the lifeblood of the comics industry—new readers. Bear in mind, there is no other medium (save soap operas potentially) that is as mired in a need for legacy and history. Reinvention and evolution are the hand-holding dance partners of enduring storytelling.

Where I believe DC failed is in the erasure of the Multiverse. It limited the parallel world/alternate reality storytelling potential that would be (and is) amazing in the hands of skilled and visionary writers. However, we need to bear something in mind. When DC killed the Multiverse in *Crisis*, we didn't have the media absorption technology we have now. Digital comics, direct markets, bookstores . . . the list is endless, and so is the potential for usage of all the storytelling possibilities offered by parallel/alternate Earths.

Another fatal flaw with the erasure of the Multiverse is that it appears to place little faith in the archaeological tendencies of the comics audience. Comics readers will dig and hunt—and love it—for fascinating and fun pieces of continuity. The elimination of the Multiverse erased something that I described way back in Chapter 4, "Into the Rabbit Hole." The readers of DC Comics were beholden to the new vision laid out by the DC powers-that-be: one Earth, one world of possibility, and one avenue in which to experience that new mythology.

By keeping the Multiverse while concurrently launching a new continuity, DC could have saved a lot of face and opened up avenues of even greater storytelling potential. A new continuity, created as a new reader-friendly sandbox could have existed in one of the universes inside the Multiverse, while the DC of old could have existed somewhere else inside the Multiverse. This is the concept of multiplicity—the idea of multiple versions of a character to inspire and allow for maximum creativity on the part of producers and choice for fans.

My issue with the pro-reboot stance is that it comes from a marketing perspective (those nebulous "new readers" who no one seems to be able to find) rather than an effort to tell better stories (though some of the best tales of the DC Universe have come since the reboot) and foster deeper creativity. My issue with the anti-reboot crowd is that it hinges on nostalgia, which can be both a source of good and evil in the comics medium. As my good friend Paul Montgomery (of iFanboy dot com) said of the 2011 "New 52" relaunch and fan worries of their comics "not mattering," "no one's coming into your house and stealing those comics."

Bronze Age Style: The Stories

The stories varied throughout, much as they had in all literature. If one type of storytelling was popular, then more were produced along the lines. If the topicality of *Green Lantern/Green Arrow* was in vogue, it was followed by more topical issues.

There was a decidedly realistic slant in the storytelling of the Bronze era. This is most prevalent in the abject failure of Kirby's "The Fourth World," which was big, boisterous, operatic and thematic action on a cosmic scale. Readers wanted street-level, realistic stories. Gone were the sci-fi fantastic trappings of the Silver Age, replaced by a neo-Golden Age type of story: realistic, though action packed, character dramas. It was a period of transition away from plot-based stories toward character ones, and the stories reflected the difficulties for some in that transition.

Why Marvel Survived

A fascinating question that I've been struggling with throughout this research has been "why has DC gone to such great lengths over the years to reset and rebuild when Marvel hasn't had to?" At the time of *Crisis*, the Marvel Universe, created in 1961 by Stan Lee and Jack Kirby, was only a few years younger than the Silver Age DC Universe. So why do I think that the Marvel Continuity survived? There are three main reasons.

The Shared Universe and a Unified Vision

Even though Marvel went through eight Editors-in-Chief throughout the 1970s, there has always been a unified vision of stories. Editors-in-Chief following Stan Lee always felt that they were perpetuating Lee's vision of that shared Marvel Universe.[6] Sure, there's a retcon* here and there (Spider-Man was really a clone but not really), and continuity errors have abounded, but Marvel loved those, handing out No-Prizes for spotting them—a way of fan immersion and making the fan an integral part of the continuity of the shared universe, and rewarding the fans for their expertise, a key ingredient to Marvel's ongoing success.[7]

DC, on the other hand, had a wide swath of continuity that was managed by multiple editors who rarely spoke to one another.[8] The other problem, as Gerard Jones relays, was that DC was perpetually worried about what Marvel was doing better.[9] In that way, the Marvel as Apple and DC as Microsoft argument holds water. Apple releases a graphic interface operating system with the Mac, and Microsoft follows with Windows.

It was that reliance on fandom that made Marvel Marvel. DC kept a closed-door policy, even though they were making efforts to Marvel-ize themselves. It didn't work. Marvel operated on trying new things and endless experimentation (though they didn't do so without their flaws) based on what seemed like a good idea at the time (they were very brazen about embracing blaxploitation, for example), and scuttling it when it didn't work. DC based their experimentation on a perception of what fans wanted, usually by seeing what Marvel was doing.

DC's move to streamline their universes for the betterment of a perceived market was a false step. Marvel made a buck or two from trusting the intelligence of the fans they already had, and going to great lengths to reward the expertise of that fan community.

Everything Happened—The Ongoing Saga of the Marvel Universe

This was the single biggest loss in *Crisis*. Nearly 50 years of history erased in a snap. It was viewed by many fans as a slap to the face, especially in an age of a slowly surging back-issue market thanks to the proliferation of comics shops. Fans still had access to those back issues. And Marvel, quite rightly, took advantage of this and recognized this phenomenon. In the Marvel Universe, everything has happened. Seeking out how pieces fit is fun—it's like *Bioshock:* you don't have to find everything to enjoy the story in front of you, but it adds depth and fun to your story experience.

* We'll look into the wall-punching perils of the retcon on p. 200.

Character over Plot

DC Comics has been the plot company. As the universe grew and expanded into multiple continuities, these threads became a tangled mess that was always in danger of folding into itself. Editorial lack of communication didn't help matters.

Marvel's stories, on the other hand, came from character. Spider-Man doesn't stop a robber because he's too full of himself and becomes a hero in the end. This character-driven storytelling is a constant throughout the Marvel Universe. The key tenets are always there. By creating a universe based on character, Stan Lee and Marvel managed to create a Universe where the fans genuinely cared what happened to those characters. An audience only cares about a plot if they care about the characters. The fostering of unrelenting love for the characters created by Lee and company was the single biggest contribution to the comics industry since its inception. The audience cared deeply about these characters and they absorbed and felt a level of protection for those characters, going so far as to police continuity when needed. It was because of this that the Marvel Universe endured and thrived.

Thanks to the strength of Stan Lee's vision of the Marvel Universe—a vibrant shared universe filled with heroes who could be your nextdoor neighbor or your brother or sister—and the unparalleled ability of his team (and his successors) to execute and perpetuate that vision, the Marvel Universe has endured with a long-lasting continuity, stretching back to the very first *Marvel Comics* #1 in 1939. Transmedia producers today would do well to study further what made the Marvel Universe thrive.

The Generational Battle Ends

Throughout my research for this book, I've come to define the Bronze Age as singularly about a generational battle; a battle between the generation that created comic books and the generation that began working in 1965 when Roy Thomas came to Marvel from the fanzines (discussed in Chapter 16).

There were three key moments in this battle, culminating in *Crisis on Infinite Earths*. The first was Denny O'Neil and Neal Adams's work on *Green Lantern/Green Arrow*, bringing social relevance of the time to comics. This heralded the beginning of the battle. The second was the business failure of Jack Kirby's DC epic "The Fourth World." This was the consequent to *GL/GA*'s antecedent. The failure of "The Fourth World" showed that the old generation had lost the battle, and that the new direction was naturalistic

and human (or at least a hyper-stylized human naturalism), not fantastic and out-of-this world. And the final culmination of everything comics had represented was *Crisis on Infinite Earths*. It was the dawn of a new day, a day both filled with light and blinded by it.

You Must Remember This . . .

◾ In an effort to fix massive continuity errors and a byzantine level of complexity, DC erased 50 years of continuity in the Multiverse-spanning *Crisis on Infinite Earths*, and restarted their universe. The wisdom of this move is still up in the air.

◾ There are three reasons that Marvel's universe has endured: a strong, unified editorial vision, a policy of "everything happened," and a storytelling aesthetic of character over plot.

◾ *Crisis on Infinite Earths* represented the end of comics as everyone knew them since 1956.

Notes

1. Jim Shooter, "Superman—First Marvel Issue!" Available online at: www.jimshooter.com/2011/08/superman-first-marvel-issue.html, August 26, 2011.
2. Ibid.
3. Gerard Jones & Will Jacobs, *The Comic Book Heroes: The First History of Modern Comic Books from the Silver Age to the Present* (Rocklin: Prima, 1997), p. 294.
4. Ibid., p. 295.
5. Ibid., p. 294.
6. Author's interview with Denny O'Neil, January 11, 2012.
7. Author's interview with Henry Jenkins, January 12, 2012.
8. Author's interview with Denny O'Neil, January 11, 2012.
9. Gerard Jones & Will Jacobs, *The Comic Book Heroes: The First History of Modern Comic Books from the Silver Age to the Present* (Rocklin: Prima, 1997), p. 294.

The Art

Comics represents the ultimate merging of imagery with written word. Great comics art is iconic; it can immerse you in a world that you want to revisit month after month. The artist in comics is the director, cinematographer, and actor; their work will either make or break your story. As with all great collaborations, the art in a comic should bring your words to life in ways you never thought possible.

What goes into transforming your collection of words into a perfect marriage of art and prose? Artist Stephanie Buscema and I chat about it.

Thought Balloon: Stephanie Buscema

Stephanie Buscema is an illustrator, painter, and cartoonist living and working in New York City. Her work has appeared in publications from DC Comics, Marvel, IDW, Penguin Books, Target, the Make-a-Wish Foundation, and many more. In this thought balloon, we chat about comics art as well as the differences in working in print vs. web-based comics.

Tyler Weaver (**TW**): When you are handed a script for a comic book—or write one yourself—what are the first things you look for as an artist? What draws you to a project?

Stephanie Bruscema (**SB**): First and foremost, a script that's a good fit for the work! Sometimes there might be scripts or stories that just don't work well with how I draw and paint. It's important to know what I'm capable of working with and what I'm not before I dive into a new project. A strong story with a good sense of fun and play is really what's important to me as an artist.

TW: Do you prefer working with deeply detailed scripts or do you prefer ones where you are able to more fully develop the visuals according to your voice and style?

SB: I think that all depends on the project, the writer, etc. I don't prefer one over the other as long as it helps create a good story. I also feel it's important to take the vision of the writer into account when working. Sure I can make something look stylized and like my own, but if I completely miss what the writer's vision is as well, I've failed.

TW: What is your work process? How do you take something from script to finished page?

SB: When I get a script, I'll usually make notes as I read through, from there I sketch out thumbnails. If need be, character designs and a quick color study with paints, usually for larger projects like picture books, etc. From there I move on to rough pencils, final pencils then on to final art. I usually run my watercolor paper through my printer for blue line, from there I paint right on to the paper. When the art is done, I scan it in and color-correct it. When I'm happy with how it's printing, I send it over to my editors or art directors.

TW: You've recently made the transition to web comics/digital comics. What were some of the difficulties of the new format that you encountered?

SB: It's pretty much the same process for me, only I'm not color correcting any pages for print. It's quite easy to upload everything and get it web ready! However, while I embrace digital with open arms, I'll always favor print books.

TW: What artistic and/or industry advice did you receive from your grandfather [Marvel artist, John Buscema]? What would you like to pass on to a new generation of artists and comics creatives?

SB: It was drilled into my head as a teen to have good, strong work ethic; get up early, draw till the evening. You don't really take days off—you have to always be "on." It's a job, You have to treat it as such. I think the best advice is just draw. Constantly, be obsessed with your work. If you just pick up a pencil once and awhile, this is not the career path for you!

I'd like to add one important thing here: the relationship between writer and artist is the single most important one in all of comics. Never—ever— underestimate the importance of this collaboration. It will make or break your project. It's often said that great art serves the story, not the other way around. While that is true, I also believe that in comics, both art and story *are* the story. You cannot have one without the other; comics is a harmonization of image and word. It's when one overshadows the other that dissonance and discord infects the storytelling. A deeper look at collaboration is provided in Chapter 31.

For a more in-depth look at producing art for comics, please check the Appendix to this book, which features recommended reads and more.

1986

From the multiversal destruction of *Crisis on Infinite Earths* was born a new DC Universe. One Earth. New origins. Marvel was still the dominating force in the comics market, amassing nearly 50 percent of sales (not 20 years before, DC outsold Marvel by a seven to one margin), but by the time 1986 turned over to 1987, it would be the other way around.

The Dark Knight Returns

Frank Miller burst on to the scene during the Marvel "Phase II," period of experimentation with a stint as the artist on Denny O'Neil's *Daredevil*. Eventually, Miller would take over writing duties, bringing his love of crime films and femme fatales to the streets of Hell's Kitchen. He made *Daredevil* a gritty, street-level crime book; a Sam Fuller or Anthony Mann film—two of Miller's biggest influences—brought to the vigilante-in-tights genre and splashed all over the streets of Marvel's New York City.

Following a run on the Chris Claremont-penned *Wolverine* mini-series, which transformed the character from a Canadian berserker with claws to a Canadian berserker with claws and the heart of a samurai, Miller left Marvel for DC. He was promised the moon.

He delivered first *Ronin*, a samurai/ninja tale set in a post-apocalyptic New York City, most notable for displaying a new Miller style: minimalist, sometimes devoid of backgrounds. *Ronin* is also notable for being the first comic to retail at the exorbitantly high price (for the time) of $2.50 an issue (taking advantage of the rising direct market), as well as for not being the "big hit" for which Miller's *Daredevil* fans were clamoring.

The Dark Knight Returns (*TDKR* for short) took the Alfred Bester-inspired obsession of the O'Neil/Adams days to a new level. In *TDKR*, we find a retired Bruce Wayne, brought back to the role of The Batman by the "beast" inside him to take on the rising violence and rampant corruption in Gotham City. Commissioner Gordon is near retirement. Robin (Jason Todd) is dead—murdered by the Joker.

Miller's Batman became a symbol of rabid libertarianism in the Reagan era, fighting the cultural bastardization of the Silver Age Superman as the symbol of oppression and "the good old boys." The visual impact—inspired less by the clean and humanistic elegance of Neal Adams and Jim Aparo and more by the bombast of Jack Kirby covered in mud, blood, and rage—shook readers and still holds up as one of Miller's linchpin artistic works.

In one issue, Miller created the new definitive version of Batman. It is Miller's Batman that has been with us since, permeating every issue of every *Batman* series (even in reactions against Miller's Batman) and every adaptation into other media.

TDKR was the opening salvo in a year that would push comics into the mainstream. Miller was featured in *Rolling Stone* and the word on the street was that comics had grown up. They were no longer disposable kid's stuff. They looked like books (thanks to the new—more expensive—Prestige Format DC used for the first time with *TDKR*). They tackled adult themes and were violent fantasies of the world in front of them. Miller was everywhere—and even Cleveland writer Harvey Pekar began appearing on David Letterman.

In the wake of *TDKR,* Miller became a fighter for the individual rights of creators, leading to DC publishing a statement eviscerating the practice of publishers (including DC) keeping original art. Artists and writers dallied on the subject, some keeping silent. Others, like *X-Men* and *Fantastic Four* writer/artist John Byrne jumped ship to DC. Byrne's project—the reboot of Superman in *The Man of Steel*, a modern take on the hero—would lead to DC finally overcoming Marvel's dominance in sales.

This made Marvel Editor-in-Chief Jim Shooter very worried.

The New Universe

Jim Shooter started selling stories to DC Comics when he was 14 years old. When he took over the Editor-in-Chief role at Marvel in 1978, he did away with the writer/editorships that had resulted in a non-unified (yet still somehow successful) vision of the Marvel Universe. This brought a newly cohesive vision for the Marvel Universe, as well as the idea of "The Marvel Way" of creating comics—immortalized in Stan Lee and John Buscema's *How To Draw Comics The Marvel Way*.*

In the wake of DC's massive success in 1986 with *The Dark Knight Returns* and other series (including one that we'll talk about shortly), Shooter became obsessed with creating a new universe, one free of the trappings of the 25 years of Marvel history. He wanted to create "his" universe, one with entirely new characters and concepts.** He would call it, creatively, "The New Universe," and he predicted it would sell a million copies. It sold 150,000.[1]

Jim Shooter's contract wasn't renewed.

* Which in all fairness, nearly transformed me into a comics artist—until I learned I couldn't draw.

** Although Shooter's idea revolved entirely around new characters, the "New Universe," free of continuity, predates the idea of the "Ultimate" Marvel line begun in 2000 with new, updated tellings of their greatest heroes.

Alternate Futures

The Dark Knight Returns does not represent the "set in stone" future for Batman. It represents a possible future—Frank Miller's vision of Batman's future. It is an "out of continuity" story in regards to the canonical *Batman* stories.

The concept of alternate futures is one with broad appeal for transmedia creators. How can you give your audience a sense of the future of your storyworld? Can you leave it open to their interpretation? Can you plant seeds and clues throughout the project?

It's a powerful tool for audiences in that it allows them to add their own conclusions to your story. You may have the end of your story in mind, but sometimes, what the audience comes up with may be even better than you had dreamt.

Watchmen

Alan Moore was the man who bid farewell to the Silver Age Superman in the classic "Whatever Happened to the Man of Tomorrow?" A British writer who had soared to acclaim with classics like *V for Vendetta* (unfinished at the time of *Watchmen's* publication) and a run on DC's *Swamp Thing*, Moore was asked (along with artist Dave Gibbons) to bring his ideas of superheroes to a limited series. Taking the old Charlton heroes (the recently purchased by DC Captain Atom, The Question, and The Blue Beetle) and transforming them into Dr. Manhattan, Rorschach, and Nite Owl, Moore and Gibbons created the world of *Watchmen*, a 12-issue maxi-series that demolished the nostalgic ideals of the superhero into a thousand pieces, subverting the genre, and crafting a tale that would make it on to *TIME Magazine's* "Greatest Pieces of Literature of the 20th Century" list (the only comic book series to do so).

In *Watchmen*, Moore and Gibbons eschewed the panel and framing innovations that had been evolving throughout the history of comics, instead focusing on a tight, focused nine-panel grid, and eliminating the third-person narrative captions that had been the staple of comics since their inception. By doing so, they utilized the "arm's length" feeling created by containing action within a defined panel, using what was once a trait of Golden Age and Silver Age comics that came from necessity and lack of a defined storytelling language as a way to create documentary naturalism and bring a new and unnerving feel to the story.

To deepen the world of *Watchmen*, Moore added what we would now consider transmedia elements to the comic (though everything lived within the pages of the comic book). The first were excerpts from the "tell-all" memoir of the first Nite Owl, a hagiographic look at the glories of the superheroic past of the *Watchmen* heroes; the second, a pirate comic book read by one of the kids in the street, *Tales of the Black Freighter*, among other newspaper articles, scientific papers on the super powers of Dr. Manhattan, and psychological evaluations of Rorschach.

Although contained in a single medium (comics), Moore's usage of other print media within the pages of *Watchmen* offers a valuable look at the potential of depth and immersion. In 12 issues and through multiple avenues of media that existed within his vibrantly realized world, Moore created a definitive statement on superheroes.

Year One

With the massive success of John Byrne's Superman reboot in *The Man of Steel*, it was time to reinvent The Batman. In 1986, one final work would come out that would define Batman as viscerally as *The Dark Knight Returns* had done a

year earlier. It was the antecedent to *TDKR*'s consequent, the beginning of The Batman's career, as opposed to the end. Again scripted by Frank Miller, with art by his *Daredevil: Born Again* (considered *the* classic Daredevil story) partner David Mazzuchelli, *Batman: Year One* told the story of how Batman came to be in Gotham City, largely from the perspective of a long-ignored character, Commissioner James Gordon (though in the early days represented by Miller, he's Lieutenant Gordon). Newly crowned *Batman* group editor Denny O' Neil had convinced his old *Daredevil* partner Miller to publish *Year One* in the pages of the *Batman* comic book, and would subsequently follow it with *Year Two* and *Year Three*.

Year One was as shocking an interpretation of Batman as *TDKR* had been. Gone were the usual trappings of the DC City—modern, a place you would want to live. Miller's Gotham City was a city in need of a hero, inspired more by the paintings of Hopper (Hopper's Diner even shows up in one panel) and less the art deco majesty of Gothams previous. Corruption, decay—it was a city crying for someone to save it (and raises an interesting question: given the appearance of Gotham City in *TDKR*, did Batman really save Gotham during the course of his career?). Selina Kyle—Catwoman, forever etched in the minds of pop culture aficionados as Julie Newmar in a black leather suit from the Dozier *Batman* series—was reimagined as a tough-as-nails prostitute, one with a particular hatred of the organized crime permeating through Gotham.

The Silver Age of DC was wiped off the face of the Earth. In its place was a DC Universe in need of heroes. The Modern Era of comics had begun. Now, it was time for the next shot, and for that, O'Neil would look to Miller's *Dark Knight Returns*, a 1-900 number, and the past (and future) for inspiration.

"A Death in the Family"

Dick Grayson had been shipped off to college. During the Pre-Crisis continuity, a new Robin, Jason Todd, had been introduced. This Jason was a red-haired circus acrobat, just like his predecessor (minus the red hair). In fact, without the different name, one would have thought it was Dick Grayson.

But in the new continuity, Jason Todd was a street thug, recruited by Batman after being caught stealing the hubcaps from the Batmobile. Recognizing a special sort of talent, Batman took Todd under his wing and trained him to be the new Robin in the wake of Dick Grayson's ascendancy into the role of Nightwing in the pages of *The New Teen Titans*.

This Todd was unlikable, belligerent, and a killer when he felt it was worth it (such as letting a diplomat's scumbag son fall to his death in *Batman* #424 [October 1988], including a note on the cover—"DC Comics aren't just for kids!"—that would prove a prescient indicator of fandom for comics). The fans

Alternate Histories

The flip side of the "Alternate Future" coin is the concept of "Alternate History." *Watchmen* takes place in a 1985 where a superman (Dr. Manhattan) appeared in 1959, consequently leading to even more unrest and upheaval in global politics and economics—and leading Richard Nixon to be president for more than the two-term limit.

It is in this alternate history that fertile ground for stories can be found. What key events shaped your world? How is the world of your story different than ours? It can be something as deep and complex as a superhuman altering the course of American history, or it can be one powerful, visceral image, such as the image of the still-standing World Trade Center at the end of season one of *Fringe* that signals "you are in for something different."

Like the "alternate future," "alternate histories" are fertile ground for audience and fan-driven content creation. Remember, if you make the right holes, your audience will want to fill them in.

reviled him, and in a move that received the most mainstream attention yet for the comics world, DC Comics and now-Batman group editor Denny O'Neil brought it to a vote. Call one 900 number and Jason Todd lives. Call another, and he dies. Jason Todd died at the hands of the Joker in *Batman* #428 (1989).

The death of Jason Todd stands as one of the first moments in comics where fans had a say in what happened creatively. It features shades of the serialized stories of Dickens, of letter-writing to influence what happened in the next installment of one of his novels. O'Neil wasn't prepared for the backlash of "Death in the Family." To many—especially those outside of comics—he hadn't killed Jason Todd, a cocky, arrogant, non-empathetic character. He had killed Robin. He had killed a symbol of teenage heroism. He was accused of constructing a "Roman Circus." It was at that moment that O'Neil realized that he was more than "just a writer-editor. I was the keeper of post-industrial folklore."[2]

You Must Remember This . . .

- Frank Miller's *The Dark Knight Returns* propelled comics into the mainstream.

- *Watchmen*, by Alan Moore and Dave Gibbons, brought comics into literature, demolishing the storytelling conventions and adding a transmedia element to comics.

- The death of Jason Todd in "A Death In the Family" was the first time the fans had had a direct role in the outcome of a comic book storyline.

Notes

1. Gerard Jones & Will Jacobs, *The Comic Book Heroes: The First History of Modern Comic Books from the Silver Age to the Present* (Rocklin: Prima, 1997), p. 309.
2. Author's interview with Denny O'Neil, January 11, 2012.

Grim 'n' Gritty Chromium Holograms
The 1990s

Until the 1970s, the visual aesthetic of mainstream comics was defined by the "King," Jack Kirby. His kinetic action, simple lines, and maximum impact with minimal effort shaped what the superhero comic book should look like to readers and fans for two generations. By the 1970s and 1980s, comics were infused with a neo-realistic (used loosely here), illustrative quality thanks to the pens of artists like Neal Adams, Jim Steranko, Berni Wrightson, and Barry Windsor-Smith.

By the 1980s and 1990s, a new movement was taking place. This artistic movement combined the kinetic action of Kirby with the neo-realism of the 1970s and brought a baroque sensibility of "more is more" to the medium. Some new "young lions" of comic book art were coming into their own: Rob Liefeld breathed new life into the flagging Marvel series, *The New Mutants*, introducing Cable to the X-Universe (and launching the 1990s trend of gun-toting, shoulder-pad wearing, half-cyborg killing machines as heroes). Todd McFarlane stormed on to the scene with DC's *Infinity, Inc.*, and *Detective Comics* in the follow-up to Frank Miller's *Year One*, *Batman: Year Two*—where his baroque stylization made Batman's cape envelop the Gotham cityscape—before attaining super-stardom with Marvel's *Amazing Spider-Man* and eventually, his own spin-off, *Spider-Man* (which he would write and draw). Jim Lee brought his bombastic draftsmanship and detail first to *Alpha Flight*, then *Punisher War Journal*, then ultimately to the *X-Men*.

These artists succeeded because they were so different, so unlike anything anyone had seen in comics up until that point. Artists like Frank Miller and Bill Sienkiewicz opened the floodgates to hyper-stylized art, but Liefeld, Lee, and McFarlane (along with others like Whilce Portacio, Marc Silvestri, and Jim Valentino) pushed that stylization to a level of 1980s excess that had never been seen before. Fans ate it up.

In the wake of the massive success of *Dark Knight Returns*, *Watchmen*, and *Year One,* a new type of market was about to join the news-stand and the direct market: the speculator's market. And the superstar artists mentioned above were going to be front and center.

The Big Three

In comics, the surest of the sure-fire ways to entice audiences is with a new "Issue #1." It is a signal of a fresh start, a new beginning. It represents a "jumping-on" point for new readers, those mythical unicorns of the comics industry. The 1990s were ushered in with three era-defining (for better or worse) "Number 1s"—all from Marvel.

Todd McFarlane, wanting more freedom to write, launched *Spider-Man* in August, 1990—selling 3 million copies of multiple regular, gold, and silver variant covers[1]—telling the story (a term used loosely here) of Spider-Man (whose web-line is *advantageous*[!] in McFarlane's vernacular), fighting a horrific version of The Lizard. Rob Liefeld and Fabian Nicieza brought the relaunched *X-Force* (formerly *The New Mutants*), polybagged with multiple covers and trading cards (which forced speculators to buy five copies to get all of the trading cards). And finally, Jim Lee and Chris Claremont launched *X-Men*, the first new X-Men title since 1963 (complete with five variant covers that formed a large massive one), and sold 8 million copies.[2] It was by far the best of the bunch, with Claremont bringing his trademark group storytelling style to the new series with aplomb. By Issue #3, however, the honeymoon would be over between Claremont and Lee's partnership, with Lee wanting more control over the stories.

McFarlane, Lee, and Liefeld were as smart as their art style was over-the-top. They made a ton of money for Marvel, but they also realized they could make a ton of money for themselves. In some ways, they were pioneers in the self-publishing/"publishing as entrepreneurship" movement that we see today.

Image

Along with artists Jim Valentino, Eric Larsen, and Marc Silvestri, the young lions—McFarlane, Lee, and Liefeld—jumped ship from Marvel in 1991 (sending Marvel's stock into a tailspin) and formed their own company: Image. Liefeld, now widely known thanks to his appearance in a Levi's advertisement directed by Spike Lee (*Do the Right Thing*), was first out of the Image gate with *Youngblood* (April, 1992), breaking a million units sold. Then came Todd McFarlane's *Spawn* (May, 1992), shattering that record at 1.7 million (and selling more than quadruple the highest selling independent comic sold until the Spring of 1992).[3] Both were followed by Jim Lee's *WildC.A.T.S.*, Marc Silvestri's *Cyberforce*, Jim Valentino's *Shadowhawk*, and Eric Larsen's *Savage Dragon*.

The stories were anything but amazing, though to be fair, there were some excellent efforts put forth, especially in the early issues of *Spawn*, with guest writing appearances from the likes of *Sandman* writer Neil Gaiman and *Cerebus* creator Dave Sim. Mostly the stories were there to serve the art, not

Substance Over Style

If the above and subsequent chapters show anything, a good story is of the utmost importance in any medium. In the 1990s, when "artist as superstar" reigned supreme (and artist Todd McFarlane was talking about how writers weren't needed in the letters page of *Spider-Man* #1), style was the primary motivator of sales. And you'll see how that turned out.

With transmedia, it's the same deal. I have issues with the usage of the term transmedia as it focuses more on the media than the story. Never, ever create something with the form or the cool tech or the cool connections at the forefront. Always, always do a project as a transmedia project when the story warrants it. Deliver an exciting, irresistibly deep story to your audience, and they will be not only satisfied, but willing to spread your story to others.

If you put the "transmedia" ahead of the story, you are creating a glut of "stories" that do nothing to further the future of storytelling. Use the 1990s comics as a cautionary tale of style over substance.

The Influence

We've looked at the style (over substance) of the 1990s comics, but any discussion of a storytelling movement is useless without putting it into the context of the times. By the time Image rolled around, video games were becoming the primary entertainment source for America's youth. Movies were still somewhere in the midst of being a great storytelling form, where even action pictures *Under Siege*, *The Fugitive*, and *In the Line of Fire* were fantastic pieces of storytelling.

Video games, however, were still in their nascency. They had grown from the good, clean, fun of *Super Mario Brothers* and *The Legend of Zelda* (though these iconic franchises continue to thrive). Run and gun games like *Contra* were highly popular (Up Up Down Down B A B A Select Start), and offered non-stop gratification and action.

It was only logical (either consciously or unconsciously) that comics would follow suit. Image Comics (in their early days) represent this influence to the nth degree. Constant action, over-the-top boyhood fantasies, gratuitous T&A . . . then again, they're a lot like the pulps and the early comics of the Golden Age.

There goes history being all cyclical again.

the other way round. The early Image comics—which sold exceedingly well—were the equivalent of Michael Bay movies: a solid distraction for a couple of hours, pretty pictures of explosions, and something resembling fun.

It was those pretty pictures that would shape the art style of subsequent years, either in emulation or reaction. The Image guys—especially Jim Lee—inspired an "Image Style": baroque, over-the-top, muscular dudes, and well-endowed women in battle poses. To be fair, Lee's art was (and has become even more so) spectacular, in all projects ranging from his early *X-Men* work to his work on *Batman: Hush*, *Superman: For Tomorrow*, and the relaunched *Justice League*.

The early 1990s were the Image years, shaped by the independence of artists and creators, and creating what would become a large island between the continents of Marvel and DC.

Valiant

If Image reflected the influence of video games on comics, Valiant represented a nostalgic look back at the Silver Age (especially the early Marvel Comics). With the de-facto comic book story becoming an amped-up version of *Dirty Harry* with cyborg enhancements and the speculator's market salivating at the latest chewy morsel dropped in their lap, former Marvel Editor-in-Chief Jim Shooter decided to make good on his promise to create a new universe, like he had failed to do with the "New Universe" in 1986 at Marvel.

Following his success with the *Star Wars* license at Marvel, he licensed the Nintendo properties for comics publication. They proved an admirable success, and he moved on to purchase the rights to Gold Key/Western characters Magnus, Robot Fighter and Solar: Man of the Atom.* Valiant launched their universe with the titular *Magnus, Robot Fighter* (May, 1991) and *Solar: Man of the Atom* (September, 1991).

Valiant proved to be a massive success, riding the middle ground between Marvel's over-the-top bombast and DC's lack thereof. They were out and out solid pieces of storytelling, sold to the direct market. Eventually, the Valiant Universe grew to include massive amounts of titles like *Bloodshot* (capitalizing on the gun-toting Cable craze), *X-O Manowar*, *Shadowman*, *Ninjak*, *Rai*, and others, and for a time succeeded in creating a vibrant new universe, an alternative to the massive land masses of DC and Marvel. But it, too, like the

*Ironically, the company that would provide Shooter with the most material for Valiant, Gold Key, was nearly ruined when Marvel, under Shooter, took the *Star Trek* license away from them at the same time as *Star Trek: The Motion Picture* came out.

other publishers that popped up (including Defiant [another Shooter company),Tekno, Malibu, and others] would eventually fade as the looming bursting of the comics bubble was on the horizon.

Sidelines

After gatefold covers and trading cards became boring, publishers pushed things even further. Hologram covers. Chromium (some shiny metal type thing, I don't know—I was ten when all this was happening). Lenticular (moving covers, like the one for *Robin III: Cry of the Huntress*). Everything you could put on a cover to try to appease "the market" was put on. The writing quality slipped to abysmal levels (save for a few shining exceptions like Neil Gaiman's *Sandman* and Mark Waid's *The Flash*) and the cover (much as in the age of the pulps) became the main selling point.

Sitting on the sidelines through all of this had been DC. Their sales were flagging. They had to survive, and survival is sometimes decided by joining with the pack and seeing what happens. DC had been out of the headlines since Jason Todd was killed (excepting Superman's engagement to Lois Lane).

By the end of 1993, Superman would be dead and The Batman would be broken.

You Must Remember This . . .

■ Todd McFarlane, Jim Lee, and Rob Liefeld became superstar artists, creating the single-highest selling comics of all time, and eventually using that clout to form their own company, Image Comics, which remains the third pillar of the comics industry along with Marvel and DC.

■ Valiant Comics, created by former Marvel EIC Jim Shooter, proved highly successful in the early to mid 1990s, providing a middle ground between the violent action extravaganzas of Image, the gritty angst of Marvel, and the run-of-the-mill DC.

■ The 1990s in comics is best summarized as "style over substance." And the industry would pay the price dearly.

Notes

1. Gerard Jones & Will Jacobs, *The Comic Book Heroes: The First History of Modern Comic Books from the Silver Age to the Present* (Rocklin: Prima, 1997), p. 330.
2. Ibid., p. 342.
3. Ibid., p.345.

Legacy
The Hero's Journey Ends

One of the lasting characteristics of the DC Universe is the concept of the "legacy hero": an ascension of another character to the rank and title of a hero in the mythology, the beginnings of a new hero's journey, the realization of the ideal of the hero as more than a man, but a symbol (Christopher Nolan plays with this idea to great effect in his *Batman* trilogy).

The concept of the hero's death and the ascendancy of another character, thus perpetuating the heroic identity (and bringing change and modernity to a storyworld in need of updating), was demonstrated most viscerally during the fallout to the *Crisis on Infinite Earths* maxi-series. In Issue #8, Barry Allen sacrificed himself to save the universe from the machinations of the Anti-Monitor. Following the *Crisis*, the former Kid Flash, Wally West, ascended to the role of The Flash in June 1987. This would prove the most long-lasting (over 20 years) and beloved legacy ascendancy, as for a generation of readers Wally West was their Flash. Barry Allen was a relic of the past, an elegiac nod toward an old continuity and an old world (except for his appearance as The Flash in the unfortunately short-lived television series *The Flash*, portrayed by actor John Wesley Shipp).

After the success of Wally West's ascension to The Flash, DC used the concept of legacy to attempt more revitalizations of their heroes. Some legacies didn't work so well. Some legacy ascensions were designed to not work, but rather to show the need for a hero. And some ended up lasting for more than a decade. But in order for the legacy ascension to take place, heroes had to die (or at least be maimed). In the 1990s, the hero's death was a perfect sales gimmick.

The Hero's Death

Joseph Campbell describes the death of the hero as:

> The last act in the biography of the hero is that of the death or departure. Here the whole sense of life is epitomized. Needless to say, the hero would be no hero if death held for him any terror; the first condition is reconciliation with the grave.

> The hero, who in life represented the dual perspective, after his death is still a synthesizing image: like Charlemagne, he sleeps only and will arise in the hour of destiny, or he is among us under another form.[1]

other publishers that popped up (including Defiant [another Shooter company),Tekno, Malibu, and others] would eventually fade as the looming bursting of the comics bubble was on the horizon.

Sidelines

After gatefold covers and trading cards became boring, publishers pushed things even further. Hologram covers. Chromium (some shiny metal type thing, I don't know—I was ten when all this was happening). Lenticular (moving covers, like the one for *Robin III: Cry of the Huntress*). Everything you could put on a cover to try to appease "the market" was put on. The writing quality slipped to abysmal levels (save for a few shining exceptions like Neil Gaiman's *Sandman* and Mark Waid's *The Flash*) and the cover (much as in the age of the pulps) became the main selling point.

Sitting on the sidelines through all of this had been DC. Their sales were flagging. They had to survive, and survival is sometimes decided by joining with the pack and seeing what happens. DC had been out of the headlines since Jason Todd was killed (excepting Superman's engagement to Lois Lane).

By the end of 1993, Superman would be dead and The Batman would be broken.

You Must Remember This . . .

■ Todd McFarlane, Jim Lee, and Rob Liefeld became superstar artists, creating the single-highest selling comics of all time, and eventually using that clout to form their own company, Image Comics, which remains the third pillar of the comics industry along with Marvel and DC.

■ Valiant Comics, created by former Marvel EIC Jim Shooter, proved highly successful in the early to mid 1990s, providing a middle ground between the violent action extravaganzas of Image, the gritty angst of Marvel, and the run-of-the-mill DC.

■ The 1990s in comics is best summarized as "style over substance." And the industry would pay the price dearly.

Notes

1. Gerard Jones & Will Jacobs, *The Comic Book Heroes: The First History of Modern Comic Books from the Silver Age to the Present* (Rocklin: Prima, 1997), p. 330.
2. Ibid., p. 342.
3. Ibid., p.345.

Legacy
The Hero's Journey Ends

One of the lasting characteristics of the DC Universe is the concept of the "legacy hero": an ascension of another character to the rank and title of a hero in the mythology, the beginnings of a new hero's journey, the realization of the ideal of the hero as more than a man, but a symbol (Christopher Nolan plays with this idea to great effect in his *Batman* trilogy).

The concept of the hero's death and the ascendancy of another character, thus perpetuating the heroic identity (and bringing change and modernity to a storyworld in need of updating), was demonstrated most viscerally during the fallout to the *Crisis on Infinite Earths* maxi-series. In Issue #8, Barry Allen sacrificed himself to save the universe from the machinations of the Anti-Monitor. Following the *Crisis*, the former Kid Flash, Wally West, ascended to the role of The Flash in June 1987. This would prove the most long-lasting (over 20 years) and beloved legacy ascendancy, as for a generation of readers Wally West was their Flash. Barry Allen was a relic of the past, an elegiac nod toward an old continuity and an old world (except for his appearance as The Flash in the unfortunately short-lived television series *The Flash*, portrayed by actor John Wesley Shipp).

After the success of Wally West's ascension to The Flash, DC used the concept of legacy to attempt more revitalizations of their heroes. Some legacies didn't work so well. Some legacy ascensions were designed to not work, but rather to show the need for a hero. And some ended up lasting for more than a decade. But in order for the legacy ascension to take place, heroes had to die (or at least be maimed). In the 1990s, the hero's death was a perfect sales gimmick.

The Hero's Death

Joseph Campbell describes the death of the hero as:

> The last act in the biography of the hero is that of the death or departure. Here the whole sense of life is epitomized. Needless to say, the hero would be no hero if death held for him any terror; the first condition is reconciliation with the grave.

> The hero, who in life represented the dual perspective, after his death is still a synthesizing image: like Charlemagne, he sleeps only and will arise in the hour of destiny, or he is among us under another form.[1]

In the wake of the massive success of the grim and gritty, the "pure" archetypes of the DC heroes seemed woefully outdated. By the early 1990s, with DC rapidly losing the sales game to Marvel and Image, with their bulging biceps and gun-toting angst, DC had to face a disturbing question: did the archetypal heroes matter anymore? Were their heroes, those who had sworn never to kill too tame for the "videogame generation"? Would heroes who had so inspired generations before them be inspirational only now in their death? They were about to find out.

The Death and Life of the Man of Steel

If the age of heroes began with Superman, it was only fitting that parts of it would end with him as well. Originally, DC and Superman group editor Mike Carlin had planned on making the Superman headline-grabbing event a happy one—his marriage to the love of his life, Lois Lane. Fortunately (or unfortunately) for Carlin and DC, the most recent television incarnation of Superman, ABC's *Lois and Clark: The New Adventures of Superman* had already planned on marrying the two characters, and didn't want the comic to conflict with their story. The next option? Kill him.

Beginning in *Superman: The Man of Steel* #18 when a massive fist with stony protrusions hammered through a steel entombment and unleashed hell upon the DC Universe, "Doomsday" would go on to make national headlines throughout the world as the saga that turned the comics world on its head: "The Death of Superman."

Making use of the Image aesthetic of massive pin-up pages of action (in retaliation more than reverence), the "Doomsday" story unfolded via a panel countdown. In *Adventures of Superman* #497, the countdown began. Four panels per page in *Adventures*. Three in *Action Comics* #684. Two in *Superman: The Man of Steel* #19. And finally, massive splash pages on every page in *Superman* #75 (January, 1993) as Superman and Doomsday brought the battle to Metropolis for a final stand, shattering windows and reducing skyscrapers to rubble. Then the deadly punch and a massive gatefold final page . . . "FOR THIS IS THE DAY—THAT A SUPERMAN DIED."

To mark the sad occasion—November 18, 1992 (though the cover date was January, 1993)—and sate a collector's market thirsty for extras and collectibles, two editions of *Superman* #75 were released. The first, a news-stand version with a simple (and now iconic) cover: Superman's torn and tattered cape billows in the wind against a backdrop of a Metropolis reduced to rubble. The second, a black, poly-bagged affair. Inside the black poly-bag with a bloody "S" symbol: a comic book where the cover was a tombstone: "HERE LIES EARTH'S GREATEST HERO"; a black armband, a trading card, a set of

stamps, and an official "Daily Planet" obituary for the fallen hero. Sure, it was a stunt, but it was—at least to my pre-teen mind—a compelling story. And it sold 6 million copies thanks to the continuing power of the rabid speculator's market.[2]

Of course, no hero stays dead forever. In a serial medium like comics (especially in the Superman books, this was known as the "triangle" era—every issue was stamped with a triangle that would show where it fit in that year's worth of stories), the hero has to come back. "Doomsday" was followed with the elegiac *Funeral For A Friend*, which culminated in the disappearance of Superman's body in *Adventures of Superman* #500 (June 1993) and the emergence of four potential Supermen—a black man named John Henry Irons, a teenage clone formed from the DNA of Superman and Lex Luthor, a Cyborg, and a merciless killer (the latter two representing shades of the "new normal" in comics in the 1990s). Their struggles for legacy ascension were played out over the course of the final part of the "Death of Superman" saga, *The Reign of the Supermen*. In the end, the true Superman emerged (it turned out to be none of the potential successors, though all the replacement characters have survived in various forms to this day), and saved the day from a psychotic Cyborg Superman, who destroyed Coast City, the home of Hal Jordan—Green Lantern—who would soon face his own dramatic metamorphosis.

While "The Death of Superman" saga remains a ripping good yarn (and was my first real experience with the overwhelming immersiveness of lengthy serialized comic book storytelling), it also reeked of gimmick. Was it a good story? Yes. Was it a deep exploration of the final phase of the hero's journey? Maybe. Maybe not. But it was a gimmick, and it worked. Throughout the "Death" saga, Superman titles were selling at near *X-Men* levels.[3]

Breaking The Bat

In the Batman universe, group editor Denny O'Neil had been setting up what would be known as the "Knightfall" saga. First, he introduced two new characters to the Batman supporting cast: Azrael (AKA Jean-Paul Valley), a computer science student who, it turned out, was actually trained from birth to be the assassin's blade in the Order of St. Dumas; and Bane, raised from infancy in a Santa Prisca prison, addicted to "Venom" (a steroid introduced in O'Neil's first story in the 1989 Batman title, *Legends of the Dark Knight*) and a tactical mastermind possessing great brute strength.

Beginning in *Batman* #492 (April, 1993), Bane released the prisoners of Arkham Asylum, sending an already exhausted Batman into full-on obsessive mode, refusing the help of Nightwing (Dick Grayson's new identity) and the

third Robin (Tim Drake, who assumed the mantle after deducing that Batman was Bruce Wayne and that he needed a Robin—a sort of fanboy dream realized), and wearing himself to the point of total exhaustion. It was then, in *Batman* #497 (July 1993) that Bane struck. The two combatants faced off in Wayne Manor and the Batcave, ultimately breaking Batman's back over his knee and leaving him for dead in his home.

Jean-Paul Valley assumes the mantle of The Bat, and ultimately takes down Bane after modifying the Batman costume into an armor and shoulder-padded pastiche of the "grim 'n' gritty" "heroes" that pervaded the comics market. Valley would remain Batman for a year's worth of stories ("Knightquest: The Crusade"), while a broken Bruce Wayne and Alfred would scour the globe for the kidnapped Shondra Kinsolving (a character introduced prior to Knightfall) in "Knightquest: The Search."

Ultimately, Valley would give into his assassin programming, breaking the solemn oath of Bruce Wayne never to kill, killing the serial killer Abattoir and allowing his prisoner to die. Upon learning of this, Wayne, now healed from a broken back, embarks on a retraining mission to reclaim the mantle of The Bat from the now-crazed Valley in "Knightsend." The culmination of this tale brought Wayne back to the cowl with a refocused mission and a new outlook that would shape the next several years of stories.

The point of "Knightfall," first and foremost, was to tell a ripping good yarn. In that regard, O'Neil and his team succeeded beyond most expectations. Where "Knightfall" differs from "The Death of Superman" is in regards to the hero at its core. Batman has always been cool (even if several of his stories and adventures weren't). Superman, on the other hand, has ridden undulating waves of massive popularity and irrelevance. Batman (for better or worse) has always been in the public eye, and in the 1990s, was still a wildly popular character in the wake of Burton's 1989 *Batman* and 1992's *Batman Returns*. In spite of that coolness, there was a degree of antiquation to the character—he would never kill. As Denny O'Neil said, "James Bond pushes someone into a snowblower and makes a bad joke about it."[4]

Like the "Death of Superman," the legacy ascension attempted in "Knightfall" was not intended to succeed. O'Neil's greatest fear with "Knightfall," he told me, was that the Jean-Paul Valley Batman (AzBats in fan parlance, a combination of his Azrael and Batman identities) would be a success. As O'Neil told me, "had it come out that the audience loved the grittier version of Batman, I honestly don't know what I would have done."[5]

Fortunately for Batman, O'Neil, and for the comics industry, that wasn't the case. The team behind "Knightfall" had proven that real heroes still had a place in the world.

Hal Jordan Goes Nuts

During "Reign of the Supermen," Hal Jordan's home, Coast City, was destroyed by the psychotic Cyborg Superman (one of the four pretenders to Superman in the wake of his death). Overcome with grief, Jordan attempted to use his power ring to rebuild Coast City, but was stopped by the patron saints of law and order (and his bosses), the Guardians of the Universe. Enraged, Jordan went crazy, killing nearly every Green Lantern that stood between him and Oa (the Green Lantern homeworld) and snapping his arch-enemy Sinestro's neck before flying into the Central Power Battery, becoming the villainous Parallax. All of this in three 1994 issues of the second volume of *Green Lantern*.

At the conclusion of *Green Lantern* #50, a new Green Lantern is chosen, the last remaining Green Lantern after Jordan's decimation of the Corps. Kyle Rayner, an artist, assumes the role as the last Green Lantern standing and carried the torch for over ten years until Jordan returned to the role in 2005's *Green Lantern Rebirth*.

Like Wally West, Kyle Rayner's ascendancy into the role of Green Lantern was a massive success (even though there were vocal anti-Kyle fans out there who never gave up their anti-Rayner rhetoric). Rayner succeeded in being a new kind of Green Lantern, one in tune with the values and livelihoods of the then current generation of comics readers. There was also a healthy dose of "Marvel-ization"—though not the 1990s version of Marvel, more the 1960s Marvel Age—of Flash and Green Lantern. These were real guys thrust into the hero role. They had lives, bills, and worries. They were human, and for that very reason, they proved to be massive successes. Out of all the characters in the DC stable, both original incarnations of the Flash and Green Lantern were woefully out of date and products of the conservative 1950s in which they were created, no matter how many modern traits and revitalizations were attempted.

Both West and Rayner would go on to have long careers as their respective legacies, and for many—including myself—these were the Flash and Green Lantern fans grew up with.

The Legacy of the Marvels and Kingdom Come

The final stroke of 1990s comics storytelling (and the comics that made me leave collecting—not because I loathed them, but because I knew we wouldn't see storytelling of that magnitude for a *very* long time [and I was kind of right] was the work of Alex Ross in Kurt Busiek's *Marvels* and

Mark Waid's *Kingdom Come* for DC. Ross brought a Norman Rockwell on speed aesthetic to his work—photorealistic paintings that brought mountains of majesty and nostalgia in each and every panel. The two works were reflective looks back at the legacy of "real heroes," heroes that had been long forgotten or passed over in the new generation.

Telling the story of photographer Phil Sheldon's journey through the Marvel Universe, of capturing the images of "the Marvels" for the Daily Bugle, *Marvels* was a love letter to an era that had passed, an era where heroes mattered, where they were more than big guns, big breasts, and big shoulder pads. It came out in 1994, and was the last great success of the 1990s—until *Kingdom Come.*

Kingdom Come told a story of a possible future of the DC Universe (much in the vein of Miller's *The Dark Knight Returns*, though without its latent nastiness). Again painted by Alex Ross, it was a nostalgic look back (by looking forward) to what real heroes meant. In a future DC beset by the reign of the aforementioned "Big Guns, Big Breasts, and Big Shoulder Pads" heroes, a middle-aged Superman emerges from retirement following a hero-caused holocaust in the Midwest to show to the world that the old hero code of never killing works—in the minds of the heroes, killing makes them no better than the bad guys they stop. It's the one thing that separates hero from villain.

Of *Kingdom Come*, Mark Waid says:

> Superman and Batman and Wonder Woman have stood the test of time without armor, without bazookas, without veined biceps the size of cannons. They have survived—they are important—because they are a reflection of our dreams, not our nightmares.[6]

For the comics industry, however, the nightmare was just beginning.

The Death of the Comics Industry

As is true with every bubble in our consumerist society, they all burst. The speculator's market caused an implosion of the industry thanks to overprinting because of perceived demand and the lack of anything resembling storytelling ability.

As in the 1950s, there was another problem for the comics industry: distraction. There was *Magic: The Gathering*. There were video games. Blockbuster movies. Television shows. The busy lives kids led in the 1950s seemed like child's play compared to the band practice, football practice, debate teams and other necessities for maintaining a tolerable social life. The industry was no longer for kids—it was for adults who wanted to remain kids and for speculators hoping to strike gold by hoarding copies of

something that sold 8 million copies in the hopes that one day it would be valuable (obviously the concept of supply and demand was not ingrained in the minds of speculators).

Storytelling was at an all-time low. Spider-Man was revealed to be a clone for 20 years (an instance of Marvel attempting a *Crisis*-like event and failing miserably). Big breasts fought big guns without any goal other than the creation of splash pages. The comics medium had fully transformed into the comics industry, an industry of flash over foundation, style over substance. Valiant Comics was gone, bought out by Acclaim (the video-game maker) and shuttered. The mini-publishers who rose up were gone.

Then finally, in 1997, Marvel Comics declared bankruptcy. It was all over. But, like any good superhero, comics would roar back to life with a new generation—a legacy ascension—and a new lease of life thanks to a different medium.

A new legacy was about to begin.

You Must Remember This . . .

- By the 1990s, the speculator's market had taken over, and most stories were designed to capitalize on this.

- Superman's death and Batman's breaking were designed to show the world that they needed real heroes. It wasn't until *Kingdom Come* that most people got the point.

- One of the defining traits of DC in the Modern Era is the idea of "Legacy Heroes," where the hero is more than a man, but a symbol.

- By the late 1990s, the comics industry was decimated.

Notes

1. Joseph Campbell, *The Hero With a Thousand Faces* (Novato: New World Library, 2008), pp. 306–307.
2. Gerard Jones & Will Jacobs, *The Comic Book Heroes: The First History of Modern Comic Books from the Silver Age to the Present* (Rocklin: Prima, 1997), p. 354.
3. Ibid.
4. Author's interview with Denny O'Neil, January 11, 2012.
5. Ibid.
6. Gerard Jones & Will Jacobs, *The Comic Book Heroes: The First History of Modern Comic Books from the Silver Age to the Present* (Rocklin: Prima, 1997), p. 365.

The Modern Age Adaptation

From Burton to The Dark Knight

After the success of *Superman: The Movie* in 1978 and *Superman II* in 1980, the *Superman* film series became . . . lacking. 1983's *Superman III* brought comedian Richard Pryor into the mix (and revived one of the Red Kryptonite stories), but *Superman IV: The Quest For Peace*, was the final nail in the *Superman* film series coffin. It was a bleak time for comic adaptations, just one year after *The Dark Knight Returns* and *Watchmen* took the comic book and mainstream worlds by storm.

Comic book adaptations have been alternately defined by Superman and Batman. In the 1940s and 1950s, it was the animated Fleischer *Superman* shorts and *The Adventures of Superman* starring George Reeves. In the 1960s, it was William Dozier's camp-fest adaptation of *Batman*. In the 1970s, it was again Superman, with *Superman: The Movie*. The 1980s onward would be defined by The Batman, in both success and failure.

Batmania Returns

After 1986 and the one–two punch of Miller's *Dark Knight Returns* and *Batman: Year One*, the time was ripe to bring *Batman* back to the big screen. Only this time, he would be less inspired by the satire of *Strangelove* and the swinging sixties and more inspired by *Blade Runner* and Miller.

Directed by Tim Burton and starring the unusual casting choice of Michael Keaton (which turned out to be inspired) as Batman, 1989's *Batman* took the world by storm, bringing in an estimated $251 million gross in the U.S. alone and hundreds of millions more in merchandising.[1]

It brought a legitimacy to the comics medium, blasting away the preconceived notions in the mass media that that comics were only for kids, all *Whiz!Bam!Pow!* (ahem) and simple tales of adventure.

And then came the 1990s and rubber nipples.

McDonalds and Wal-Mart

Toys are a big business. Toys based on superheroes are a bigger business. Toys based on superheroes appearing in massively profitable films are a massively bigger business. And so the toy companies helped destroy the *Batman* film series in the 1990s, after Burton's *Batman* sequel, *Batman Returns* (1992), proved too dark for the kiddies (though those rocket-launching penguins were *awesome*). Joel Schumacher came in and turned the *Batman* series back 30 years, bringing in the pastiche and bright colors of the *West* series, adding nipples to the costumes, and causing the series to fade into obscurity for seven years starting in 1997.

But there was one vision of the *Batman* and DC Comics in general that carried the torch: *Batman: The Animated Series*.

Batman: The Animated Series

Debuting in the fall following the 1992 release of *Batman Returns*, *Batman: The Animated Series,* led by Bruce Timm, Alan Burnett, Paul Dini, and others; brought what many (including myself) view as the definitive vision of The Batman to television. Featuring sleek art and animation inspired by the 1940s Fleischer *Superman* cartoons, *Batman: TAS* (as it's popularly known) inspired 20 years of DC animation.

Batman: TAS is noteworthy (in the manner of *The Adventures of Superman* radio show with Jimmy Olsen) in that characters who began life in the Animated Series would go on to become integral supporting characters in the Post-*Crisis Batman* comic continuity. Renée Montoya, would become a key player in the Greg Rucka/Ed Brubaker-scripted *Gotham Central*, and eventually become the second character to wear The Question's hat and blank face. Harley Quinn, the Joker's moll, would earn her own comic book series, *Harley Quinn* from 2001 to 2003, then became a member of the Paul Dini-scripted series *Gotham City Sirens* in 2009. She also features prominently in the *Batman: Arkham Asylum* and *Batman: Arkham City* video games. It should be noted that this is not a transmedia application of these characters—both characters were transferred to the DC Universe, which is a different world than the animated universe. We will look at the transmedia implications of both *The Animated Series* and *Arkham City* in Chapters 33 and 34.

Marvel's Filmic Pains

With the exceptions of *The Incredible Hulk* television series and *Spider-Man & His Amazing Friends*, Marvel has historically had a lot less luck in the adaptation department. The early 1990s did little to transform that downward

trend. Horrible adaptations of *Captain America* (1990) starring Matt Salinger (son of *Catcher in the Rye* author J.D. Salinger)—complete with plastic ears, only a slight upgrade from Reb Brown's motorcycle helmet—an unreleased *Fantastic Four* (from Roger Corman), a made-for-television version of *Generation X* (1996), and Dolph Lundgren as *The Punisher* (1989) made fans wonder if they would ever see their heroes on the big screen in films deserving of their adoration.

Surprisingly, it was a little-known vampire slayer from the 1970s Marvel "Phase II" that made fans (and the general public) stand up and take notice. 1998's *Blade*, starring Wesley Snipes, finally propelled Marvel on to the big screen. In quick succession, the *X-Men* (*X-Men* [2000] and *X2: X-Men United* [2003]) film series began under the directorship of *Usual Suspects* director Bryan Singer, *Spider-Man* (2002) finally came to the big screen courtesy of *Evil Dead* director Sam Raimi, and audiences were introduced to eventual *Pan's Labyrinth* director Guillermo Del Toro with *Blade II* (2002).

The Dark Knight Begins

After the nipple-infested, strobe-light fluorescence of the Joel Schumacher-directed *Batman Forever* and *Batman & Robin*, Warner Brothers let the *Batman* film series lie dormant. Several attempts were made to revive it: a third Schumacher film, *Batman Triumphant,* would go back to the darker version of the Burton films with the Scarecrow, Man-Bat, and Harley Quinn. Independent auteur Darren Aronofsky (*Pi, Requiem for a Dream, The Wrestler*) teamed up with *Batman: Year One* writer Frank Miller to craft a new beginning for The Bat, featuring Alfred as a car mechanic named "Big Al." Wolfgang Petersen, director of *In the Line of Fire*, *Troy, Air Force One,* and *Das Boot*, nearly brought a Jude Law and Colin Farrell-starring *Batman versus Superman* to the big screen. All failed to make it to production.

It wasn't until Memento director Christopher Nolan and *Blade* screenwriter David Goyer crafted *Batman Begins* (2005) and brought a realistic and real-world take on the Dark Knight that the *Batman* film series roared back to life.

Featuring Ra's al Ghul, created by Denny O'Neil and Neal Adams in the 1970s revitalization, the film went on to spur countless adaptations of comics, including the lackluster *Sin City* (2005) and *Watchmen* (2009) adaptations and eventually, the largest-grossing superhero film ever, the 2008 follow-up to *Batman Begins*, *The Dark Knight*, featuring Heath Ledger as the symbol of chaos and destruction, inspired by his first appearance in *Batman* #1, The Joker.

Too Faithful

Where *Watchmen* and *Sin City* both failed was that they were too reverential to the source material and didn't properly adapt to a new medium (it's also arguable that *Watchmen* was adapted to the *wrong* medium). Whenever you adapt from one medium to another, you must utilize the wants and needs of the medium to which you're adapting, otherwise there's no point. Comics are more than storyboards or stepping stones to movies, as I hope I've proven by now. *Watchmen* was especially hit by the translation to film. A contained serialized medium such as a television series would have been a much better fit. Could you imagine *Watchmen* as an HBO series?

The Marvel Film Universe

After the successes of their early 2000s efforts, Marvel kicked off a new film series—just as they had done in the Marvel Age of Comics in the 1960s—with a shared universe. Launching first with the Jon Favreau directed and Robert Downey Jr. starring *Iron Man* (2008), the films began criss-crossing each other with *The Incredible Hulk* (2008) (where Downey Jr.'s Tony Stark shows up to discuss a matter with William Hurt's General Thunderbolt Ross), and the less-than-successful *Iron Man 2* (2010) (which sacrificed story for connections, introducing Scarlett Johannsen's Black Widow). Following those up with *Thor* (2011) (where Jeremy Renner's Hawkeye made an attempt to subdue Thor in a breakout from S.H.I.E.L.D. captivity) and *Captain America: The First Avenger* (2011) showed the journey of Steve Rogers from skinny patriot to the symbol of the American war effort; all of these films are preludes for the 2012 release of Joss Whedon's *The Avengers*.

It has been a fascinating experiment to watch, though one that has had to tread carefully with balancing stories and Easter eggs. This approach worked wonders in comics, where the ongoing nature of the Marvel Universe allowed for seemingly infinite numbers of guest appearances and meta-storytelling statements. In film, however, it's a dicier prospect, evidenced most plainly by the abysmal storytelling in *Iron Man 2*, which seemed to be more *Avengers 0.5* than *Iron Man 2*. This is representative of the need for transmedia (or the radical intertextualizing of film) to be treated like exposition—handled judiciously and as an integral part of the story when the audience demands it, not when the demands of setting up another project depend upon it.

Where Will It Go?

The comic book to film adaptation craze will no doubt continue, with new versions of *Superman*, directed by Zack Snyder and starring Henry Cavill, sequels to the Marvel films, and the conclusion of Christopher Nolan's *Batman* trilogy with *The Dark Knight Rises*. Comic books are ripe for adaptation, especially superhero ones, as they feature simple stories of heroes and good triumphing over evil (with a pre-built and faithful audience). And who knows, maybe comics will finally get the respect they deserve?

As Denny O'Neil said, "anything that makes a billion dollars is respected in America."[2]

Notes

1. Les Daniels, *Batman: The Complete History* (San Francisco: Chronicle Books, 1999), p. 168.
2. Author's interview with Denny O'Neil, December 13, 2011.

Today

Storylines cross over. Characters from wildly divergent backgrounds meet at random moments. An overarching mystery beguiles the characters in the serio-episodic stories. An event brings a group of heroes together; their might is the only thing that can stop the evil plaguing the world.

No, this isn't an episode of *Heroes* or *Lost*. It's the state of comic books in the 21st century, inspired as much by shows like *Lost* or *Dexter* as the comics that came before and largely eschewing the "done in one" stories for lengthy ones that promise to "forever alter the landscape of the universe." We have entered the age of the "Event Comic."

Story-Driven

The artist-as-superstar thing didn't work out so well for the comics industry in the 1990s. After the speculator's bubble burst and Marvel declared bankruptcy, it was time for a return to form, a return to the guiding principle of storytelling: it's the story, stupid. As I said way back in Chapter 2 (and has been evidenced throughout in the longevity of the Marvel Universe), character is everything. A plot only matters if you care about the character to whom the bad stuff is happening.

It was with that in mind that comics began a resurgence in storytelling. The opening salvo in this was Marvel's relaunch of *Daredevil* under the Marvel Knights imprint, overseen by future Marvel EIC Joe Quesada. Bringing in film-maker Kevin Smith (*Clerks, Mallrats, Dogma*), Smith and Quesada (who also co-created Azrael with Denny O'Neil in the 1990s) crafted a dark tale of Daredevil's protection of a child believed to be the Anti-Christ in "Guardian Devil." This series would go on to launch the mainstream comics careers of superstar writers like Brian Michael Bendis and cement itself as one of the pinnacles of Marvel's stable.

The Other Guys

Following the success of Kevin Smith's *Daredevil* run, other writers from other media began working in the comics industry, furthering the "writer as superstar" attitude of the comics industry in the first decade of the 21st century. Allan Heinberg (*The O.C.*) created *Young Avengers*. *Buffy the Vampire Slayer* and *Firefly* god (and future *Avengers* director) Joss Whedon turned in an era-defining run on *Astonishing X-Men*. Smith returned to comics with a resurrection of *Green Arrow* in 2002, and was then followed on the same title

with novelist Brad Meltzer who would go on to kick off the DC "Event Era" with *Identity Crisis*.

Not all of these superstar runs were met with praise—Smith became notorious for unfinished projects like *Daredevil: The Target*. Novelist Jodi Piccoult failed to live up to her promise on *Wonder Woman* (as did Allan Heinberg).

This should provide an important lesson: just because you can write well in one medium doesn't mean you will do well with comics. Tread lightly and know your craft.

Thought Balloon: Alison Gaylin

*Alison Gaylin is a crime novelist and journalist, with four books (*Hide Your Eyes, You Kill Me, Trashed, Heartless*) and a fifth coming out in 2012,* And She Was. *Before Vertigo Crime folded, Alison and fellow novelist Megan Abbott were writing a graphic novel for the imprint. In this interview, we discuss the challenges—and rewards—of moving from prose to comics. The interview opens with how the graphic novel came about . . .*

Alison Gaylin (AG): Megan Abbott is a really good friend of mine. We became friends because we were both nominated for the Edgar for the "Best First Novel" at the same time, and we just became great friends. We both lost that time; she went on to win "Best Paperback Original" for *Queens Noir*. We always wanted to do something together, and we thought about possibly writing a book together, but because we both had contracts, it seemed kind of time-consuming.

Actually, Megan says it was me that suggested a graphic novel, but I'm pretty sure it was her! We wanted something that sort of combined both of our talents. I'm more of a plotter, and Megan is great with character and time period—she's a noir expert and her books tend to be set in previous periods to our own, although her most recent was a little more indistinguishable. But we just sort of had this idea for a character, a strong female lead that you don't see that often in graphic novels.

We both are huge fans of 1970s conspiracy movies, so we wanted to combine our love of that with a strong lead—like a female Dirty Harry was what we were going for. Very laconic, doesn't speak, she's just all about revenge. We just started writing this thing together and we found that we worked really well together. We pitched it to Vertigo Crime before it was written. We had a very detailed proposal and they bought that. We wrote it and then Vertigo Crime folded! (Laughs.) So now it's ours again!

Tyler Weaver (**TW**): What were the biggest challenges you faced going from prose to comics; the demands of the medium that you had to get used to?

AG: I actually really loved it. Coming from writing plays, the thing that trips me up in writing my novels is the inordinate amount of time you have to spend on description and creating the place with words. I love dialog and I love showing rather than telling. As far as the graphic novel went, to me, all those restrictions were somewhat freeing.

When you think of writing, all you're doing really is—and it's different than a screenplay or a play too—probably a little closer to a screenplay —because it's not something—the script for a graphic novel isn't something that you intend anybody to read without artwork, and what you're doing is you're not communicating with audience, you're communicating with an artist. It's like "this is exactly what we want this to look like." You don't need to worry so much about turning a beautiful phrase except for in the dialog or in the captioning, you know?

You also can't be as subtle as you can be in film. We did a lot of things with very close views because of that whole seventies conspiracy thing, we describe a lot of close ups on somebody's eyes or hands clutching a phone cord. But you can't really have somebody exchanging a subtle look. You really need to think about what's the strongest visual statement you can make with each panel. It's a challenge, but I think, kind of exciting.

TW: Right, it's all about grabbing that one iconic moment.

AG: It's also figuring out how many panels you want per page, when you want to do that really dramatic splash . . .

TW: How much did you leave up to the artist? Did it even get to the art stage?

AG: We ended up finding an artist and then Vertigo Crime folded! It's interesting, I think it's Max Allan Collins that will actually take a still from a movie and stick it in the script. "I want it to look like this." Say we want Robert De Niro's eyes in the rear view mirror from Taxi Driver. "This kind of feel." We were pretty liberal as far as "we would like it to look like this."

I would think that once you have a really great collaboration with an artist they might find things that you could never even imagine. We definitely did have a really specific look that we wanted to get across. We'll see when—and if—we eventually work with an artist. We'll see.

But just because this concept is so visual—we have this seventies conspiracy movie thing in our minds—I think if somebody else shares that same vision, it will be really helpful.

Trade paperbacks consist of anywhere from three to twelve (or even more) issues of the same story arc from a monthly series collected into an attractive book format. Think of it as the DVD release of a television season.

The unfortunate thing is that many publishers think that way too, pushing for a decompressed storytelling that will expand a story from one issue to six to sell more trade paperbacks to bookstores (remember my comparison of *Action Comics* #1 to today in Chapter 11?).

While the trade paperback is a delivery system rather than a medium, it isn't without its merits. Collections of Silver Age and Golden Age stories abound (and made up the bulk of this book's research, offering a window into another time). Most bookstores (the few remaining anyhow) stock a healthy supply of trade paperbacks, giving non-comics readers the chance to read a complete story (or at least a significant portion of a story) without the issue of going into a comics shop week after week.

TW: Would you do it again if you had the chance?

AG: *Yes!* Absolutely. In a heartbeat. It excites me that we're having interest in it now—things are looking good—because this is the most fun I've had. It's been the most painless writing experience I've ever had. Probably the plays would be up there with it. First of all, collaborating with someone I can really collaborate well with, but also just the whole medium is so wonderful and freeing and exciting. I just love it. I like the restrictions. I find a lot of freedom within those restrictions. It excited me in the same way that playwriting does, because there are so many restrictions, but within those restrictions you can be so powerful.

Ultimate Marvel

Before the "Event" era could take over, there was something that had to come first. That came in 2000, when a new Marvel Universe was created, one that ran parallel to the regular Marvel Universe. "Ultimate Marvel" was designed as a new reader-friendly universe where the major characters of the Marvel Universe—Spider-Man, The Avengers, and The X-Men—were reinterpreted and reimagined into a brand new (and one could argue even more tightly shared) shared universe. The characters were updated with new origins in modern times. The new universe—another instance of multiplicity in comics (without the peskiness of multiple, parallel Earths) was an immediate success and helped further the mainstream comics careers of superstar writers Brian Michael Bendis (who, more than ten years on, continues to write *Ultimate Spider-Man*) and Mark Millar (*Ultimate X-Men*). It was a lesson on how to create a new continuity while simultaneously keeping the one that "deep" fans held so dear.

The Ultimate Universe was indicative of the "DC as Microsoft, Marvel as Apple" argument. According to Walter Isaccson's *Steve Jobs* biography, when Jobs returned to Apple in 1997, he slashed product lines and focused on four core elements: desktop, laptop, consumer, professional, and made one computer for each. The Ultimate Universe followed much the same tact: four main titles: *Ultimate Spider-Man*, *Ultimate X-Men*, *Ultimate Fantastic Four*, and *The Ultimates*.

By focusing on those four titles, Bendis and company created a tight, focused universe with only a few minor continuity hiccups (the Hulk was green in his first appearance in *Ultimate Team-Up*, but gray in *The Ultimates*, for instance). It was when they began expanding the universe to multiple series, mini-series (like Orson Scott Card's *Ultimate Iron Man* mini series that made Iron Man's origin unintelligible) and mini-events that the Universe started to fall apart (in spite of the intent of many of those series to deepen

the Ultimate Universe). Eventually, a "universe-shattering event" came in the tidal wave (literally) of Jeph Loeb's *Ultimatum* that was greeted with . . . mixed reviews.

Fortunately, the Ultimate Universe has corrected itself, and made one of the most brazen moves in all of comics: killing Peter Parker and removing him as the Spider-Man of the Ultimate Universe, replacing him with Miles Morales, a 13-year-old half-black half-hispanic teenager. If the first issues (of the still-Bendis-written) *Ultimate Comics Spider-Man* are any indication, it is a move that paid off, paving the way for the continued vibrancy and experimentation that led to the creation of the Ultimate Universe in the first place.

Identifiably Infinite yet Final Crisis

After the universe-altering and scaling back of the original *Crisis on Infinite Earths* and thanks to the 1990's "death craze," the DC Comics of the early 21st century had become a noticeably darker place. Batman was a paranoid "Bat-God," acting more like a third-world dictator whose paranoid delusions overtake his governing ability than the hero he once was. Superman was reduced to an antiquated bastion of hope, who, as Batman so eloquently pointed out in *Infinite Crisis*, last inspired when he died. Wonder Woman was (still) a muddled mess. It was the mirror-universe, "Spock-with-a-beard" version of the 1950s DC Comics. Instead of the happy hokum of the 1950s, it was the "chip on the shoulder" remnants of the 1990s.

It was that love of nostalgia and a yearning for the days of the creative sandbox of the Multiverse that brought about the three *Crises* in the 2000s. First, in *Identity Crisis,* the loving detective couple of the Silver Age, Ralph Dibney, The Elongated Man, and his wife Sue, were brutally split apart when Sue was murdered by The Atom's crazed wife, Jean Loring, in an effort to bring her family back together. It was the peak of the "Dark Ages" for DC, when villains like Dr. Light were turned into rapists and the Justice League was revealed to have "Mind-Wiped" (erasing the memories of) Batman, making him even more of a paranoid psychotic. It placed the superheroes in a starkly realistic light, more Showtime than Warner Brothers. Separated from the times in which it was created, *Identity Crisis* is a searing piece of comics storytelling. In the DC Canon, however, it was the beginning of the end of the events of the first *Crisis on Infinite Earths*.

The universe-altering destruction that was the first *Crisis* was followed up in 2005's *Infinite Crisis*, by Geoff Johns (formerly Richard Donner's assistant) and a rotating series of artists. In it, it is revealed that the Golden Age Superman, the one who started it all, is alive and well in a crystal heaven with his Lois Lane, and the Earth-Three Alexander Luthor (who is a hero in his universe), and

Earth-Prime's Superboy, the only hero of his world. They were the sole survivors of the Multiverse following its destruction at the conclusion of *Crisis on Infinite Earths*.

Infinite Crisis was all about "fixing things" perceived to have been broken by the post-*Crisis* continuity as well as restoring the heroes of the DC Universe to a more heroic glory, lifting the darkness that had pervaded the universe—and, by extension, the darkness that had pervaded the comics industry since the late 1980s. In the end, the Golden Age Superman and Lois were dead, and the Superboy of Earth-Prime (Superboy-Prime) had gone crazy, smashing in heads and "punching walls."

Wall Punching

In *Infinite Crisis,* the "retcon" (short for retroactive continuity) was more prevalent than in any other comics event in recent memory. Don't like something in the current continuity? Retcon it. Retconning is a way of retroactively fixing perceived glitches in continuity. For example, Jason Todd, who was killed in 1988 at the hands of 1-900 number dialing comics absorbers, was brought back to life thanks to a retcon. In the case of *Infinite Crisis,* the retcons were handled poorly, the result of the deus ex machina of Superboy-Prime punching a wall. Yes. He punched a wall and changed continuity.

If you're going to retcon anything in your storyworld, don't make it the comic book equivalent of "jumping the shark." An example of a fantastic way to reinvent and revitalize a storyworld is the recent J.J. Abrams reboot of the *Star Trek* franchise, transforming something that had run its course into a vibrant and exciting new world. Why did it work? It didn't insult the intelligence of the fan community. We will look at *Star Trek* in Chapter 28.

At the conclusion of *Infinite Crisis*, a kind-of-new DC Universe emerged. The Multiverse returned, and the "Big Three" (Superman, Batman, and Wonder Woman) returned to something resembling their former glory. A new (yet grounded in history) experiment in comics storytelling (and the best thing to come out of *Infinite Crisis*), the weekly series, *52*, was born, featuring intersecting stories of "B Level" heroes saving the world in the wake of the post-*Infinite Crisis* departure of Batman, Superman, and Wonder Woman for a year. All of the core DCU titles jumped ahead one year to a new heroic time in *One Year Later*.

But then came the first big misstep. At the conclusion of *52*, a new weekly series began, *Countdown*, counting down from Issue #51 to Issue #0, becoming *Countdown to Final Crisis* after week 26, announcing the coming of a new, FINAL *Crisis*, to be penned by superstar writer Grant Morrison. Making the utmost use of the newly returned Multiverse, *Countdown* was eventually ignored by Morrison in *Final Crisis* in favor of his own stories, the Kirby "Fourth World"-inspired *Seven Soldiers* meta series (interlocking mini-series running for a total of 30 issues) and Morrison's own run on *Batman*, bringing a new villain, Dr. Hurt, and the Black Glove organization to terrorize Batman and intermingling with the machinations of the villain of *Final Crisis*, Darkseid (from Kirby's "Fourth World" stories).

In the pages of *Final Crisis*, the newly heroic heroes would face Darkseid, and Batman would "die" (in name only) thanks to Darkseid's Omega Sanction—"THE DEATH THAT IS LIFE!"—thrown back through time, while Dick Grayson, the first Robin, assumed the mantle of the Bat with Bruce Wayne's son—sired with the daughter of Ra's al Ghul—as the new Robin.

Whew.

If that sounds like a mouthful, it is. Conflicting visions of how a universe should be were running unchecked. The result of *Final Crisis* wasn't a universe-wide reboot. To be honest, I'm not really sure what the result of *Final Crisis*

was. I'm not even sure what it was really about. I know I enjoyed it, but I still don't know what it was about.

What happened in the wake of these "Crises" was a comic book universe that was muddled, mangled, and imploding on itself. It was a convoluted mess in a way that even the pre-*Crisis* continuity wasn't.

Thought Balloon: Henry Jenkins

Henry Jenkins is the Provost's Professor of Communication, Journalism, and Cinematic Arts at the University of Southern California. He is the author of Convergence Culture: Where Old and Media Collide, *and* Fans, Bloggers, and Gamers: Exploring Participatory Culture. *In this interview, we discuss the importance of comics fandom, and the connection to fans that make comics such a unique and powerful medium.*

Henry Jenkins (**HJ**): What I say about almost all fandoms is that they're born from a mixture of frustration and fascination. Comics fandom is as much that way as any other, which, unless you're fascinated with something, you don't engage with it over as long a period of time as comics fans deal with it. At the same time, if it fully satisfies you, you're not going to engage with it as critically or creatively as comic fans deal with it, right?

If you go on the boards with comics fans, they rip everything, right? If you're a comics artist, you've got to have an incredibly thick skin because they're gonna be the most precise critical readers you can get—and it's born from love. I think people who understand fandom just as "passion" or "fascination" but don't understand the frustration don't get the complexity of that dynamic. It's because they really care that they're being incredibly critical. And if they really care and they're critical, they want to get information as soon as they possibly can, and they like to have input while the decisions are still being made. I think this is a push across all of the media industries right now; fans are spoiling, in part, to head off at the pass, bad decisions where they start to effect the quality of the experience. They have access to more rich sources of information. They have more capacity—collectively—to access, process, and respond to information than ever before. And they want to be under the hood helping to make the decisions that effect the franchises they care about.

That's where "spoiling" starts to come into this. Spoiling in comics in particular used to be not about just antiquating what's going to happen before it happens, but critically responding to it before it's printed in ink.

Tyler Weaver (**TW**): What role, then, does "the power of anonymity" have in this community? Does it make them more critical in some ways?

Channel-Surfing Comics Storytelling

One of the most fascinating—if confusing—things to come from *Final Crisis* is the stylistic choice that Grant Morrison made in telling it. Morrison described his style in *Final Crisis* as "channel surfing," popping in and out from one story to another. In one sequence, Batman would be captured by a rogue Alpha Lantern. In the next, Superman would be fighting Mandrakk, the vampiric Monitor, in a 3-D world. Another segment would see Black Lightning become possessed by the Anti-Life equation of Darkseid.

What this did was create holes in the narrative—holes where stories and connections could be imagined. But what if they were opened up to the audience to fill in the gaps with their own creations?

HJ: In some cases, yes. I think that's a classic frame. I'm not sure it matters. You see these guys sitting around in the comic shop or sitting in the Con, they're every bit as bitchy about this stuff as when you can't see who they are [laughs]. Many of these guys are in the business of building a reputation in terms of their mastery and their critical skills—their access to information and decision makers. The idea that it's based on anonymousness goes against the idea that it's about building a reputation. I think a lot of these guys are—I think there are cases where anonymous stuff matters; but I think you could make everything "on the record," and you wouldn't fundamentally change the tone.

TW: How much sway do you think that holds with the big companies or independent creators?

HJ: I think there's a very real dialog that takes place. Some of them are choosing to insert themselves in the middle of that dialog and some are not. Some of them are making very strong web presences, seeking out that fan feedback, and others are trying to block it out and not interfere with their creative process. It's where all creative industries are at right now. You suddenly have greater access to the response of your readers than before—what do you do with that?

It's always been there. We have stories of Dickens rewriting his serial novels as they're unfolding based on the response of his readers. That kind of response has always been there. But the amount of it now—and all the industries struggle with the question, "Is this fan representative of something other than himself?" Or, even if it's a niche of fans, how much does that represent the dominant fan market?

Comics are odd in that way because if you've got a hundred thousand readers, the fan forums attract a thousand of them. That's a pretty different phenomenon than 6 million viewers of a television show and a thousand of them respond. You've got a much larger percentage of the whole participating in online conversation because the readership is so hard-core. The industry—when it gets that—sort of struggles between the response of "you're not gonna tell me what to do, I'm the creator and I control this" and their position that they're trying to hold on to a market that's very precarious. They want to hear what the audience is thinking at every step along the way and if they can head off a decision that's going to be a costly one, they probably want to do it at this point.

TW: What is it that's so irresistible about continuity to people? Comics is one of the few media that can really really do it well, and their fan base is so protective of that continuity.

HJ: Continuity is a place where fans can demonstrate their mastery. The continuity rewards people who read over time, who read across multiple books. As a publisher, you want to build up that loyalty, you want to make it as eclectic in what it reads as possible; get them reading all 52 books a month. That's your ideal consumer. Odds are they're not. You've got to design continuity in a way that people can pick and choose and it becomes a very complex thing to manage. On the producer side, that's the biggest hook for consumer loyalty. On the audience side where the payoff comes from being the guy who's read this book for 40 years and knows every issue by number and can tell you when you make a mistake. That mentality rewards the collector—of the expertise—of fans in a way that few other media do.

The Secret Civil Invasion of the War of the Dark Reign

As we've seen throughout the history of the comics medium, if one publisher does something, another publisher has to do a competing story. In the case of the titanic battle between DC and Marvel, that competing story from Marvel was *Civil War*, the kick-off in a year-long "universe altering" event that would kill Captain America, replace him with his once-dead partner Bucky, and pit hero against hero.

Marvel ripped the idea for *Civil War*, of a superhuman registration act in the wake of a massacre caused by a villain with out-of-control powers from the headlines, making it semi-topical, especially in the age of the neo-conservative and war-mongering presidency of George W. Bush. With "Whose Side Are You On?" as the tagline, *Civil War* divided the Marvel Universe, with the pro-registration side led by Iron Man and the anti-registration side led by Captain America. In the end, registration won, Captain America was arrested (and eventually killed, though not really, because he was sent back in time and had his mantle assumed by his first partner, then eventually returning as Captain America—sound similar to a certain Caped Crusader?), and Iron Man became the leader of the superhero world.

From there came the *Secret Invasion*, where it was revealed that many of the heroes we knew were in fact Skrulls, the shape-shifting alien baddies who first appeared in *Fantastic Four* #2 in 1961. They were "Skrull sleeper cells," bent on destroying the world by taking out the heroes of the Marvel Universe from within. At the conclusion, Norman Osborn, the former Green Goblin, was the victor, destroying the Skrulls and rendering Tony Stark (Iron Man) an illegitimate and ineffective leader in the eyes of the world.

Thus began the *Dark Reign*, where Osborn and a crew of super-villains became the *Dark Avengers*, a corrupt version of the Avengers. Eventually, Osborn would be revealed for the psycho that he was, and the heroes would come together to take him down, ushering in the new Heroic Age, a shifting, like DC had attempted, back to the clear-cut delineations of Good versus Evil.

Whew.

There's a reason I laid out these stories in massive, quick succession: this is what the comics experience is today: both breathless and leaving no room for breath.

Flashpoint and The "New 52"

With a post-*Final Crisis* world of confusion and crazy, rumblings could be heard in hushed Internet whispers that something big was coming. Barry Allen, the Flash who had ushered in the Silver Age in 1956 and died ending the Bronze Age in 1985, had returned. He was always there when it was time for something big. Soon, it would become evident what that was: *Flashpoint*.

After his time-traveling nemesis, Professor Zoom altered the fabric of time, Barry Allen awakes in a new world, a world where he has no powers, and where his mother is still alive. A world where Wonder Woman and Aquaman have sunk most of Europe into the sea in their struggle for power, and where Batman is Thomas Wayne, the father who witnessed his young son Bruce die at the hands of a mugger (and most powerfully, a world where Martha Wayne is the Joker).

In June, 2011, it was announced that every single DC title would start over with a new #1 issue, even the long-running *Detective Comics* (since 1937) and the title that started it all, *Action Comics* (June, 1938). It would be the dawn of a new DC Universe, revitalized, accessible. It was everything that the "Crises" had initially promised.

With the relaunch dubbed the "New 52" (harkening back to the *52* weekly series and the *52* parallel universes in the Multiverse), DC Comics took the comics world by storm (*Justice League* #1 [September, 2011] sold a remarkable—for today—255,000 copies).[1] Spinning from the events of *Flashpoint*, the "New 52" promised an accessible and revitalized world, one where the mythologies (as I have repeatedly said throughout this book) would be updated to reflect the times in which they exist.

Time will tell how that will play out. Be sure to check comicstoryworld. com for articles, analysis, and updates on the progress of the "New 52"

Format: The Finite Series

While the universe-altering machinations abounded in the mainstream publishers, another format was gaining ground: the finite series. Lasting longer than a mini-series or limited series, the finite series is more akin to the long-form series on Showtime and HBO as well as ABC's *Lost*, with a defined end point. Example of this are Brian Azzarello's *100 Bullets*, Jason Aaron's *Scalped*, and, most notably in the modern age, Neil Gaiman's comics epic, *Sandman*.

DC Universe and the comics world of today. Because now we shift away from what has been done, and begin laying the groundwork of the future. The future that you will help build.

You Must Remember This . . .

■ The 1990s were the age of the superstar artist. The first decade of the 21st century was the age of the superstar writer, returning to a focus on great storytelling.

■ One form of a retcon is "wall punching," a *deus ex machina* used in *Infinite Crisis* to explain the transformations in the DC Universe continuity. It is a much-derided means of eliminating continuity that doesn't work, thus enraging fans proud of their expertise in a storyworld's continuity.

■ Continuity is a way for fandom to demonstrate expertise and is a powerful tool in the creative arsenal.

Note

1. John Jackson Miller, "2000 for 2011: Top 1000 Comics and Top 1000 Trades with Comichron Estimates," The Comichron. Available online at: http://blog. comichron.com/2012/01/2000-for-2011-top-1000-comics-and-top.html.

Comics and Convergence

Convergence

Welcome to the final part of this book. It's what we've been leading up to since we talked about playing with GI Joes in the bathtub. If anything has been proven over the course of this book, it's that comics is a vibrant medium with a rich, deep history that provides transmedia producers not only another medium to add to their arsenal, but also the realization that many of the "innovative" storytelling methods employed in transmedia story experiences have been with us since the Golden Age of comics.

If the previous section of the book showed that transmedia concepts have been present in comic books since the first crossover between The Human Torch and Sub-Mariner (or The Shadow of the pulps and The Shadow of the radio show being one and the same), then this chapter is to show you how to create opportunities within your own projects for a transmedia application of comics, using all of the stylistic elements you have learned from the previous chapter.

The Gutter

Throughout our discussion of the storytelling style of comics, and as espoused in "The Elements of Comics Storytelling," we have to look at the gutter, that magical space between panels. Geoff Long, a transmedia scholar, has long discussed the similarities between the gutter in comics (the space between panels where the imagination has to fill in the holes) and the gutter in transmedia storytelling (the spaces between media fragments).* I would like to add my voice in support of this, as all of your work will now be in finding holes and leave spaces either for the imagination and collaboration of your audience, or where you can fill with a different media. In the case of this book, our discussion is focused on filling that gap with comics. What types of stories can you tell with the medium? Where would comics be of most benefit to your story?

Dig Deeper

This book began as a reaction against a current trend in screenwriting and film-making to transform a failed screenplay into a comic book in the hopes that Hollywood will adapt the comic book to a film. This is not only a

* This has also been discussed by Scott Walker in his excellent article, "The Narrative (and Collaborative) Gutter of Transmedia Storytelling."

daydream, it is a slap in the face to what I hope I have proven is a vital, vibrant storytelling medium. More than that, though, it is a creative limitation in a media landscape where limitations aren't rewarded, they're steamrolled over.

Now we're going to look at how to integrate comics with films, games, and animation. For each section, we will look at the immersive qualities of that focus medium. How does the medium make audiences want to dig deeper? What role could comics have in deepening that? For each medium, we will look at three to four case studies. With each case study, we will examine four questions, each tied into my definition of transmedia storytelling:

The crafting of stories that unfold across multiple media platforms, in which each piece interacts with the others to deepen the whole, but is capable of standing on its own, giving the audience the choice as to how deep into the experience they go:

- What is the story—both in the focus medium and in the comic book extension?

- How does the comic book interact with the focus medium to deepen the story experience?

- Who is the intended audience of the comic book extension?

- How is the comic book an irresistible part of the story experience?

Case Study: *Whiz!Bam!Pow!*

Begun in 2007 after I was tired of dealing with bad news from making documentaries, *Whiz!Bam!Pow!* started life as a feature film (which may still be an element of the project down the road). At its core was a comic book, the most valuable comic in the *Whiz!Bam!Pow!* storyworld, *Whiz!Bam!Pow! Comics* #7, the first appearance of that universe's hero, The Sentinel.

After playing with the idea for a while, I figured that by not making an actual physical comic book and a heroic universe to play with, I would be wasting an incredible opportunity. From there, my writing partner, Paul Klein, artist extraordinaire Blair Campbell, and myself embarked on a journey to create an era-authentic comic book, designed to look as though it was made in 1939, complete with vintage advertisements (for donors to our crowd-funding campaign). Paul wrote a lead story, *The Sky Phantom*, and I wrote The Sentinel's first adventure. We created a backstory around the comic book, that The Sentinel was a back-up feature to *Sky Phantom* and eventually became a national phenomenon, particularly as he fought against the Axis powers in a non-existent World War II comic book (perceived serialization, discussed in Chapter 11).

The saga of *Whiz!Bam!Pow!* is intended to continue indefinitely with short stories and films from the universe. But right now, let's look at how the comic book functioned in the *Whiz!Bam!Pow!*-iverse.

For the first example, I'm going to lay bare what I feel are the successes and failures of my own project, *Whiz!Bam!Pow!*

What is the Story?

Whiz!Bam!Pow! began with me answering the question "What would I do if my mom threw out my comic books?" From there, the story of Ollie, a grandfather whose mother threw out his copy of *Whiz!Bam!Pow! Comics* #7, the first appearance of "The Sentinel," grew into a story of secret identities, family, and nostalgia wrapped in a comedy about Ollie's attempts to make a forgery of the comic book he so loved and cash in on the comic's million-dollar valuation.

How Does the Comic Book Interact with the Focus Medium to Deepen the Story Experience?

Whiz!Bam!Pow! is a different beast than the other projects we will discuss in that there is no focus medium. It was conceived to be a native transmedia project (taking place in multiple media forms at once), and thus has no focus medium. If one focus medium could be discussed, it would be the comic book, as it is the linchpin of the entire *Whiz!Bam!Pow!* storyworld.

Every single story we tell in *Whiz!Bam!Pow!* has something to do with the comic book, be it set in the past or the present. Inside the comic, the primary themes of *WBP* are found, including the overall concept: everyone has a secret identity, something they hide from all of those around. In the comic, it's as blatant as a window dive to transform into The Sentinel. In the radio show, The Sentinel is about to be unmasked. In the novella, Frank has a secret that throws everything into tumult. Stories spin from the comic, creating what amounts to two universes: the universe of the comic book, of The Sentinel, of The Sky Phantom (The Sentinel is further deepened in the radio show, *The Adventures of the Sentinel*); and the second universe of the creators and readers of the comic book, including those who wish to profit from its value.

What we did most successfully with *Whiz!Bam!Pow!* was transform the comic book from a tie-in into a physical character, one with as much of a backstory and history as any character in the entire universe—something we couldn't have done without a deep knowledge of comics history and a love of the Golden Age.

Who is the Intended Audience for the Comic Book?

We designed the comic to be accessible to audiences who have never picked up a comic book and are curious, as well as die-hard collectors and fans who will enjoy the homages and Easter eggs to the inspirations behind our making of the comic.

Is the Comic Book Capable of Standing on Its Own?

Absolutely. We designed the project with that in mind. A reader could simply pick up the comic book and have a fun little superhero adventure without any need to go deeper or see what else there is. On the flip side, should audiences listen to the radio show or read the novella, it isn't required that they read the comic book to know what's going on. Each piece is capable of standing on its own but plays with one another in fun ways. The comic book deepens the world, just as the novella and radio show deepen the comic book.

How is the Comic Book an Irresistible Part of the Story Experience?

While it's an integral linchpin that sets every story in motion, it's not necessary for people to read it. However, we tried to make the comic such a character in the stories that audiences would want to pick up the comic book to figure out why exactly we keep mentioning it, and why the entire story experience hinges on this one comic book, both in legend and in physical possession.

* * *

The final part of each section will be a thought experiment: how could we add a comic book to an already existing, stand-alone project? One thing I want to make perfectly clear before we go into these: these thought experiments are not meant to endorse the idea of "everything should have a comic book." Each of the projects I will put through this experiment work *perfectly* as a mono-media story. Remember—only add transmedia elements to a project if it makes story sense, and is not a painfully obvious cash grab.

Now that you've seen how we're going to pick apart each story, it's time to dive in. With everything you've learned in the preceding sections in mind, let's do this. Let's help make you an integral part of the future of comic book storytelling.

Comics and Film

Unlike comics, which consist of singular, iconic images of action unspooling at a pace set by the reader, film unspools in a stylized "reality" of 24 frames per second. Within the language of film, you find several "Relative Media."* For the purposes of this book, we will look primarily at the feature film medium.**

Where film excels is in telling contained stories that represent a complete journey for the characters; a beginning, middle, and end (just not necessarily in that order—if you listen to Jean-Luc Godard). As a visual medium, film operates best when the stories told are based on action; showing rather than telling. It is far better to show someone placing a bomb under a chair than it is to say, "He placed a bomb under the chair."

The cinematic experience (that is, the act of seeing a feature film in the communal setting of a movie theater) is incredibly immersive, sucking audiences into the world of the film like few other media can.

Art of Immersion author Frank Rose comments:

> The cinematic experience is incredibly immersive. Even though it's not necessarily participatory in any way, people get wrapped up in it in a way that they do in few other things . . . what's been incredibly powerful about film, which is its ability to capture the emotional resonance of other human beings. We're incredibly attuned to other people. Even video games, which uniquely give you the opportunity to become another character, still aren't as strong for most people as watching another character on film as captured by a terrific actor and a brilliant director. [1]

If film represents a complete journey for a character, how can comics fit in to further deepen that journey? How can a medium that is composed of singular, iconic representations of action expand and deepen a cinematic storytelling experience?

* How I define media forms that use the same storytelling language, but have different demands placed on them by format, form, and delivery; a feature film is a relative medium to film, as are short films. Digital comics are a relative medium to the comics storytelling language.

** Although several of the ideas presented here can be applied to short films and more.

Expanding the Narrative

Comics are primarily used as quickly made tie-ins for films, either directly adapting the film to the comics medium or to tell the backstory of a character. In this usage, comics function as a serialized prologue, almost a no-budget version of a television show. This method may use comics well (in some cases, as we'll see), but is severely limiting in its opportunities for world-building. My issue with both of these methods is that it doesn't take into account the primary audiences for comics. Comics are, for better or worse, a niche medium, as Henry Jenkins says in *Convergence Culture:* "Films and television probably have the most diverse audiences; comics and games the narrowest. A good transmedia franchise works to attract multiple constituencies by pitching the content somewhat differently in the different media."[2]

Here are three ways where the integration of comics into a film project can augment the world of the film.

1. Exposition

Exposition is the most problematic component of all narrative forms. In the hands of an amateur, it is a calling card for mediocrity, doled out at the wrong time in the wrong place, free of conflict, and simply a means to fill in deficiencies in storytelling ability. It is especially difficult in a medium like the feature film (let alone the short film) where you have a time limit defined strictly by the distribution needs of the medium.

Like transmedia storytelling, exposition revolves around irresistibility. You have to give the audience the information they want not when you think they need it, but when they crave it—and you have to do it in a fascinating way. An example used frequently is the introduction of Clarice Starling (Jodie Foster) in *Silence of the Lambs*. In the scene, her mentor, Jack Crawford explains her role to her, sets up the menace of Hannibal Lecter, and also manages to work Starling's burgeoning professional life into the conversation. There is conflict, there is a building of atmosphere. You've witnessed a great scene and learned a bit about the protagonist. The exposition has done its job.

But what if you could do some of that exposition in another medium? What if it isn't *essential* to the story, but is nonetheless some form of information your audience *craves*? If you leave gaps in the backstories of well-defined (and well-performed—this is key) characters, you will make it irresistible for the audience to dig deeper.

2. Thought and Voiceover

Film is all about action. The addition of voiceover, with rare exceptions, takes away from what makes film film. Film is in the present, no matter the time period, unfolding at 24 frames a second in front of our eyes.

However, comics can use voiceover exceedingly well—first-person narration is effective in comics storytelling when done correctly. When moving a story to the comics medium from film (and assuming the reader of the comic has seen the film first), you have an added bonus: the audience will hear the narration with the character's voice from the film when reading it—especially if the actor's performance of that character is one that makes an impact on the audience member.

3. Shifting Perspectives

Because of the budgetary constraints of film, there are inevitably stories that cannot be explored. With rare exception, you cannot look at the same story through multiple perspectives and satisfy an audience (a notable exception is Akira Kurosawa's *Rashomon*, which bases the entire film around this concept).

Comics allow for this shifting perspective, offering the events of the story told in the film from another character, or a glimpse into their lives between frames. Even if you don't intend to create a storyworld with your film, you are nonetheless transporting your audience to another glimpse of life, another world. If you've done your job as a film-maker and told an engaging story with well-drawn and deep characters that inspire empathy on the part of the audience, you have the capability to expand and build stories upon that original story that your audience will find irresistible. But, just remember: no amount of "transmedia-ifying" can save your film if it's a piece of crap.

* * *

From here on out, we're going to look at real-world instances of adding comics to a film project. The first, a look at *Superman Returns* shows the most mundane usage of a comic book in a transmedia application: the prequel. Then, we'll shift gears to J.J. Abrams's 2009 reboot of *Star Trek* and IDW Publishing's line of comics that function as a prequel (that works!) and a wonderful use of an ongoing series in the space between the film and its 2013 sequel. Then, we'll take a look at the exception to my rule: the graphic novel version of Darren Aronofsky's *The Fountain*, and finally, a thought experiment: how to bring Sam Mendes' *American Beauty* to comics.

Finding the Gutter

The above examples are just a few of the ways that you can expand your script with comic books. Here are a few occurrences to look for in your narrative that can be deepened through comic books:

1. A character goes off-screen. What were they doing? Does it affect the outcome of the film? This is a prime gutter for that sort of character exploration.

2. A character is mentioned, but not seen until the end—the best example of this is Carol Reed's *The Third Man*. Mentioned by other characters throughout, Orson Welles' Harry Lime character isn't seen until the third act. When he does show up, it's unforgettable. It makes the audience ask more questions—who is Lime, really? What other plots has he been part of? This gap is fertile ground for filling with comics.

3. A sudden betrayal. What were the motivations behind the betrayal? What incident occurred that led to this?

These are just a few ideas—always be on the lookout for gaps and gutters in your narrative (that actually make narrative sense). However, never leave a gap that interferes or hinders your ability to tell a story in a single medium just because you feel you must "transmedia-ify" your story. What is a key element of my transmedia definition? "Capable of standing on its own." Never forget that.

Case Study: *Superman Returns*

After an absence of five years to search for remnants and survivors of his destroyed homeworld, Krypton, the Man of Steel (Brandon Routh) returns to Metropolis to find his adopted world changed. It is now a world that doesn't need a Superman. The love of his life, Lois, is engaged and has a son (of Steel). But of course, Lex Luthor (Kevin Spacey) isn't far behind with another land-scheme plot further cementing his status as the world's most evil real-estate agent.

Although the film itself failed to reignite the Superman film series, the continuity ramifications are nonetheless fascinating.* Director Bryan Singer chose to set *Superman Returns* in the world of the Richard Donner directed, Christopher Reeve starring *Superman* films.** Making use of the "retcon" (*Superman III* and *Superman IV: The Quest for Peace* never happened), Singer crafted a story that was tied into the mythology previously established by the last time Superman was defined by another medium.

How Do Comic Books Interact with the Main Story to Deepen the World?

Written with the direction of Singer and *Superman Returns* screenwriters Michael Dougherty and Dan Harris, four issues were released weekly in the month leading up to the June 28, 2006, release of *Superman Returns*. The prequel comics told the stories of Superman's supporting cast in the wake of his disappearance from Earth, all leading up to his titular return in the film. While the comics functioned primarily as a prologue to the events in *Superman Returns*, they also deepened the stories in *Superman* (1978) and *Superman II*.

The first issue, "Krypton to Earth," written by Jimmy Palmiotti and Justin Gray, retells the story of Superman's origin in the Donner-verse. While it doesn't deepen that iconic narrative, it does offer a slightly different perspective, as it is the same story told through the lens of writers Palmiotti and Gray (with story credit to Bryan Singer, Dan Harris, and Michael Dougherty).

* The *Superman* film series is being rebooted under the auspices of producer Christopher Nolan (*Batman Begins, The Dark Knight*) and director Zack Snyder (*300, Watchmen*). *The Man of Steel* is slated for release in 2013.

** Although Donner only directed one released Superman film, he directed nearly 80 percent of Superman II, filming much of it at the same time as *Superman: The Movie*. The sequel was taken over by *A Hard Day's Night* director Richard Lester. Donner's version was subsequently released as *Superman II: The Donner Cut* on DVD in 2006.

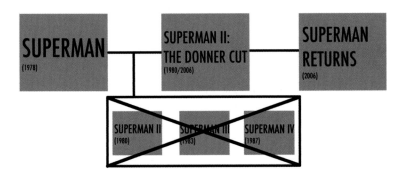

FIG 28.1 The "Donner-verse."

Issue two, written by Marc Andreyko, deepens Ma Kent's character from the first film while showing what happened to her after her son became Superman. Then, in a mirror of the post-Pa Kent funeral departure of Clark from the first film, "Ma Kent" shows Superman deciding he has to leave Earth (to investigate the possibility that Krypton is still around), again with his mother by his side. It then leads into the film by showing Superman's rocket crashing into Earth, returned from his journey. "Ma Kent" is the first issue that offers the stories in the first film from the perspective of a supporting character. It makes use of the comics medium in a poignant way, especially with the first-person narration of Ma Kent overlaid on top of scenes from the first film, showing the love she has for her adopted son and the pain and loneliness she feels when he leaves Earth.

The third issue focuses on Lex Luthor's time in, and escape from, prison following the events of *Superman II*. In it, we meet Kal Penn's character (with a role greatly expanded from the non-speaking one he had in the film), and learn how Kitty Kowalski (played by Parker Posey) came into Lex Luthor's life. It replays the initial confrontation between Superman and Luthor from *Superman: The Movie*, again using first person narration to shift the perspective to Luthor's inner thoughts. The comic primarily expands the narrative* to show what happened between Luthor's final appearance in the Donner-verse and his return in *Superman Returns*.

The fourth and final issue focuses on Lois Lane, her engagement to Richard White (played by James Marsden in the film), and the journey that compels her to write her Pulitzer Prize-winning article, "Why the World Doesn't Need Superman." Again, writer Andreyko offers Lois's commentary on events from the first film, their first meeting and fills in the gaps between *Superman II* and

* An in-joke in Luthor's megalomanical dialog says that the "real estate scam was beneath him." Indeed it was.

Superman Returns, revealing her sense of loss and abandonment at Superman's disappearance.

Here is a look at how the comics fit in with the Donner-verse diagram displayed earlier:

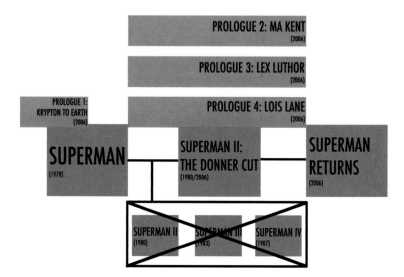

FIG 28.2 The "Donner-verse" plus Prologue comics.

Who is the Intended Audience for the Comic Book?

Fans of the original Donner films who want to know what happened to the supporting cast in the wake of Donner's films and in the interim between *Superman II* and *Superman Returns*. This speaks to the problem with using a universe that hasn't been mined in 20 years as the basis for your new film. First of all, by tying the film so directly to the Donner-verse, Singer risked creating a nostalgic film rather than a redefining one, which, as we have seen, is the death knell of mythologies and continuities. Every mythology must be reinvented for the generation in which it is told, according to Joseph Campbell. While Singer's intentions were noble, the execution left much to be desired. The comic books were intended for an audience that was passionate about the Donner-verse, not a generation who was passionate (or could be passionate) about Superman.*

* The exception to this critique is the first issue, "Krypton to Earth," which retells Superman's Donner-verse origin (complete with Marlon Brando Jor-El). Unlike the other issues of *Superman Returns* prequel, Bryan Singer, Mike Doughtery, and Dan Harris have a "Story Adapted by" credit. In Issues #2 through #4, they take a "Story by" credit.

How is the Comic Book Series an Irresistible Part of the Story Experience?

It isn't. The story in *Superman Returns* wasn't gripping and didn't make for an irresistible urge to dig deeper. Irresistibility comes from an emotional engagement with the focus medium and in this case, it didn't happen. Singer made a fatal mistake in tying his film to the Donner-verse, banking on nostalgia for the emotional wallop that it didn't deliver.

The release of the comic book represents a flaw in the release of comic book prequels for films. The prequels came out before the film itself, thereby enforcing that the audience either to be deep fans of the previous films or to have the utmost trust and faith in the film-makers. The short is that the prequels are often nothing but backstory doled out at the wrong time. More often than not, they're unnecessary to the plot or character development of the main film. For maximum effect, they should have come out after the film arrived (or prior to the DVD release)—not before—when (hopefully), the audience would have craved learning more about the characters. This was not to be the case.

This issue ties back into the argument of irresistibility. If you want people to purchase your comic, they will shell out cash to do so out of a need to dig deeper *after* they become intrigued in the world you have created.

* * *

Are the comic tie-ins to *Superman Returns* a failure? No. They are (for the most part) good—even if forgettable—reads that require knowledge of the previous films for meaningful engagement with the reader. In the context in which they were created—prequels meant to remind an audience of the Donner-verse while simultaneously deepening it and reaching endpoints to set *Superman Returns* in motion—they work. The ultimate failure of *Superman Returns* isn't from the comics, it's from the core concept that *Superman Returns* be set in the same universe as the Christopher Reeve films with entirely new actors, banking on nostalgia for a universe that hadn't been mined in 20 years instead of embracing the opportunity to craft a new filmic mythology for a new generation. It doomed the project from inception.

How could *Superman Returns* have been saved? A new mythology for a new generation with comic books to supplement and deepen that new mythology after the film was released to theaters and prior to the DVD/digital release.

Shelling Out Cash

Unless you're going to give away the comic book for free (which is absolutely fine!), you have to keep one thing in mind: people will only spend their hard-earned money to dig deeper into a storyworld if they're emotionally invested in the gateway to the project, be it a film, television series, or comic book. Never, ever assume that just because you have a comic book, it will add value to your franchise or intellectual property. You are asking the audience to make an investment of something that is even more important than money: time. Never take that for granted.

Case Study: *Star Trek*

If Bryan Singer's *Superman Returns* was a failed effort because of his slavish reverence to continuity a generation old, J.J. Abrams' 2009 reboot of the *Star Trek* franchise is one of the most successful (if not *the* most successful) reboots in film history, taking a universe that had run its course and transforming it into one of the most exciting sci-fi universes ever to hit the big screen. It was both reverential toward what had come before and unapologetic in its mission: to save the *Star Trek* series and reintroduce it to a new generation.

How Do Comic Books Interact with the Main Story to Deepen the World?

In the first series from IDW, *Star Trek: Countdown*, writer Mike Johnson told the story of how Nero, the Romulan "big bad" of the film, became so big and bad, detailing the destruction of Romulus and Ambassador Spock's role in attempting to save the planet, leading right up to the stunning pre-credits sequence of the *Star Trek* film. Johnson also provided a send-off for the *Next Generation* crew, setting the story eight years after the tenth *Star Trek* film, *Nemesis*. Captain Jean-Luc Picard is now the Ambassador to Vulcan. Data is now the Captain of the Enterprise. Both are working with Ambassador Spock to stop the destruction of Romulus—and fail.

Following the prologue of the film, Nero and his crew next surface 25 years later to take on the Enterprise and destroy Vulcan. A second *Star Trek* series was published in August, 2009: *Star Trek: Nero*. *Nero* tells the story of what happened to Captain Nero and his crew during those 25 years leading up to the marooning of Ambassador Spock and Nero's destruction of Vulcan.

In September, 2011, IDW Publishing began an ongoing *Star Trek* series, this time with one of the most imaginative usages of comics as part of a transmedia property. With the new timeline created by Abrams's film, the *Star Trek* mythology was ripe for creation and mining. In this case, writer Johnson uses the series to retell original, classic *Star Trek* episodes with the new "prime" timeline and crew. Additionally, writer Johnson says that hints to the next *Star Trek* film (slated for a 2013 release) are found within the comic series.[3] It must also be noted here that Roberto Orci, one of the screenwriters and producers of the 2009 film and its sequel is the creative project director for the IDW comics. This ensures the deep continuity established between film, comic, and video game in the new *Star Trek* mythology.

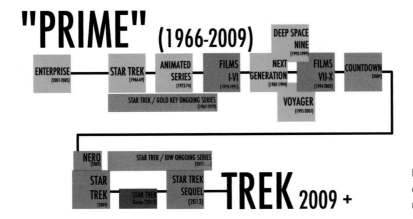

FIG 28.3 The *Star Trek* timeline with comics and the new "alternate" reality.

Who is the Intended Audience for the Comic Book?

The initial release of the *Countdown* mini series was intended for *Star Trek* fans. As with any reboot of a beloved continuity (ahem, DC Comics around 1985 or 2011), there is going to be some backlash. That *Countdown* provided a fitting end for the original continuity before blasting into the new *Star Trek* universe was fitting and appropriate.

I say "initial release" because of two reasons: first, the series was serialized from January, 2009, through April, 2009, to familiarize the hardcore fans with the direction the film would take, as well as offer a conclusion to the original *Star Trek* continuity. This is a rare case where releasing a comic prequel prior to the release of the main film actually works—it is targeted directly toward the hardcore fans to reward their expertise and secure their support for the new film universe. Second, the series was collected in trade paperback in April 2009, available in bookstores for new fans following the release of the film to provide them with backstory into what happened to Romulus.*
It was a fascinating study of a comic book both satisfying hardcore fans and becoming available to new ones in venues familiar to them following the release of the film. *Star Trek: Nero* is similarly for both the hardcore and new fans of the film.

The 2011 *Star Trek* ongoing series similarly targets both new and hardcore fans with its innovative story usage in retelling episodes of the original *Star Trek* television series with the new timeline and characters. For new fans who

* The collected version of *Star Trek Countdown* also secured a place on the *New York Times* Bestseller List for Graphic Novels.

came onboard with the film, it's a fun way to continue the *Trek* tale in continuity. For hardcore fans, it rewards their expertise by bringing a new perspective on the tales they love, as well as placing little clues throughout as to the storyline and plot of the 2013 *Star Trek* sequel.

How is the Comic Book an Irresistible Part of the Story Experience?

Star Trek succeeded in appealing to both hardcore and new fans alike with rich, complex characters and pitch-perfect casting. It is from that perfection that irresistibility is inevitable. As audiences eagerly await the 2013 sequel, they have the continuing adventures of the Enterprise—their Enterprise crew in comic book form.

* * *

Star Trek stands as one of the finest examples of the rebooting of a decades-old universe for a new generation (outside of the comics industry). Its innovative usage of exceedingly well-told comics that stay true to the vision and characterization of the film, either as a prologue, gap-filler, or reimagined tellings of classic television episodes is one that should be emulated by other productions. That the Bad Robot team is notorious for comic book references (*Fringe* fans can remember the "Alternate Universe" versions of classic DC Comics) should indicate where their expertise comes from.

Thought Balloon: Roberto Orci

Roberto Orci is a writer and/or producer of films such as The Legend of Zorro, The Island, Eagle Eye, *and the co-writer and executive producer of J.J. Abrams's 2009* Star Trek *film. His television credits include Fox's* Fringe, *which he co-created, and* Hawaii 5-0, *for which he serves as Executive Producer. In this interview, we discuss the role comics play in the new "Star Trek" universe and his role as the creative director of the "Trek" comics, keeping a fluid continuity between the film, the comics, and video games.*

Tyler Weaver (TW): Part of the book is about the importance of universe revitalization and evolution—that is one of the keys to creating a mythology that endures. *Star Trek* has been around for 40 years. What were the goals in revitalizing and evolving the *Star Trek* universe?

Roberto Orci (RO): Well, first, I thought it was heresy to attempt it. So, first, our goal was to "do no harm." That was mine and Alex's [Kurtzman, co-writer of *Star Trek* with Orci] goal in terms of approaching it from a writer's point of view. We passed when the studio first approached us to

develop another version of *Star Trek*. It seemed like there had been enough; the idea of going back to the original characters seemed like just an impossible task.

And then, when we hit upon the idea of connecting it to what came before—through time travel, through the return of Leonard Nimoy as his original character—we felt that if we could do that, then perhaps we could revitalize the franchise based on its own rules. So that was one goal.

The second goal was to make sure that if you were a fan of that particular franchise that your knowledge was going to be rewarded. If you had been paying attention to everything over 40 years, we didn't want that to go—to be thrown out the window. On the other hand, if you didn't know *Star Trek*, we wanted to make sure that we were introducing you to what it is that drew all of us into the original *Star Trek*.

TW: What was it about comics that made them a perfect fit for expanding the revitalized *Star Trek* universe and at the same time rewarding those fans that had been with it for 40 years?

RO: Well, the first thing, one of the reasons comics were perfect is that they had already been an extension of the *Star Trek* universe and of properties that we loved. It seemed like a—the idea of keeping the universe that we couldn't see in the movie for various reasons—that is, the cast of *The Next Generation*—it seemed like a great way to connect. Because we were able to do a four-parter as a graphic novel, it obviously had a very cinematic quality as opposed to just doing a novelization or something. That's what was great about the comics. It let you kind of see it—because we participated in the comic, we shared artwork from the movie that no one could see, but we shared it with the artists, we shared it with IDW. It got to be a very holistic experience, the movie and the *Countdown* comic. As a fan of *Star Trek* before, I appreciated how—I appreciated the attempts at having the larger universe be consistent and related, so it was a pleasure to be able to do that.

TW: In your role as "Creative Director" of the *Star Trek* comic, how do you work with series writer Mike Johnson to keep the continuity consistent between the comics, the films, the video game?

RO: The first *Countdown* comic is a story that we all generated together, and Tim Jones and Mike Johnson actually scripted it. Going forward with the comics that have been coming out, Mike Johnson, who before he left to write full-time was an executive at our company, so he had access to all the information and all the things that we were thinking about. He's able to both avoid the things we want to avoid but also be close enough that

they're not completely separate or unconnected. We just shoot ideas back and forth, you know? So it's really about agreeing to the stories together, and then off he goes to write it, and off he goes with the artist, and whatever artwork or whatever insights I can share with him, I do.

TW: What are the differences with the comics expansions of *Fringe* as opposed to *Star Trek?*

RO: The goal there was to do more of an anthology, where half of the stories seem related, and half of the stories are more *Tales from the Crypt* or *Weird Science,* or a *Twilight Zone* episode. The idea was that most shows that deal with the sort of thing that *Fringe* deals with tend to be more of an anthology, so it was interesting to play with that idea.

The difference is that the *Fringe* comic and the *Fringe* show are being unspooled simultaneously, whereas for *Star Trek*, we first figured out exactly where the movies were going before we would allow ourselves to think of the comics. We didn't want to cannibalize ourselves. We wanted to make sure the comics were a build-up to the movies. On the show [*Fringe*], the comics were more of a parallel thing to enjoy.

TW: Do you view the *Star Trek* comics in particular as a chance for *Trek* fans to dig deeper into that world, or do you look at it as a potential entry point for new fans?

RO: Both. If you don't know the stories that we're harmonizing with—as I like to call it—you're still getting some great elements of the old *Star Trek,* even if you don't know the stories. If you do, you get to play a little bit with what you might have done. Because we're harmonizing with a melody that we all know—the old *Star Trek*—for old fans, it's kind of interesting to see "well, I might have done this or that," it's not just entirely out of left field. You can almost play the "home game" as we call it. I think that's interesting for fans; that's what's interesting for me to see—stories told, given that events have changed. But, the original architecture is there from the original canon that hopefully would hook new fans as much as it hooked us at the time.

TW: Coming from film and television, what freedoms do you most envy that comics creators have?

RO: (Laughs.) The first is the unlimited production budget! I love that you can just—if you can think it, and you can imagine it, you can do it. There's no limitations to the storytelling. That's number one. Number two is that it's a much more individual experience; it's a much smaller group. It's interesting to be able to just answer to your small little team. There's no studio. There's no actors. There's no focus puller. There's none of that.

It's a very gratifyingly immediate thing. A movie—it can be years before you see the fruits of your labor, whereas a comic, you can have it out very quickly. You have a greater learning curve as you see stories released that fast and as you see the reaction to them. That's something you just can't get in the other forms.

Case Study: *The Fountain*

In spite of my fervent loathing of turning failed screenplays into comic books, there is one failed screenplay-to-comic book adaptation that worked exceedingly well: Darren Aronofsky's own adaptation of his first version of *The Fountain*, his epic story of Thomas (or Tomas, Tommy, and Tom), who, across different periods of time-spanning centuries (the Spanish Inquisition era, the present day, and the future), attempts to prolong the life of the woman he loves through any means possible.

How Do Comic Books Interact with the Main to Deepen the World?

Why did it work? Multiplicity: two different versions of the same script. The graphic novel showed the first version of the film Aronofsky intended to make, starring Brad Pitt and Cate Blanchette. By doing so, Aronofsky created the ultimate DVD extra feature: an entirely different version of the film, his original vision, free of budgetary concerns.

The Fountain graphic novel doesn't expand the narrative of the film at all. It is a different version of the film entirely, repurposed to make use of the comic book medium to tell the story free of budgetary concerns. In 2002, Aronofsky's big-budget version of *The Fountain* was shut down. In the fall-out, Aronofsky spoke with Vertigo Executive Editor and VP Karen Berger and the two set out to turn the original version of *The Fountain* into a graphic novel.

At the same time, Aronofsky transformed the version of *The Fountain* that became the graphic novel into a "mean, lean indie film."[4] The new version, starring Hugh Jackman and Rachel Weiz was released in 2006, around the same time as the graphic novel version of the original film. Says Aronofsky in the afterword to the graphic novel:

> Kent [Williams, artist] and I always joked about which would be finished first, the novel or the film. Well, it was almost a tie. And I think that's perfect. They have the same parent, the story, yet the siblings are completely unique.[5]

The Experience Gap

One of the things we must keep in mind when applying a transmedia approach to a project is "the experience gap." To many, the concept of transmedia is foreign, even if the idea has been around for decades. There are so many new communication forms that it is overwhelming for many who belong to previous generations, generations where one-way media communication was the norm.

Art of Immersion author Frank Rose comments:

> There's a sense in which people tend to get immersed in all kinds of entertainment, and this is really just another way of making entertainment more immersive. I do see it to some extent as a generational phenomenon, not that it's only under 30-year-olds who are into it, but for people under 30, probably under 20, it's an entirely natural way of communicating. People who grow up with all sorts of different screens around them and expect that you'll be able move more or less seamlessly between one type of screen to another, and the technology hasn't really kept pace with people's expectations of it, which is actually often the case.
>
> The idea of immersiveness—that's something just about anybody can understand. The specifics of how do you combine a TV show with a web component and a comic book or whatever, I think those are—

What the graphic novel and film represent, the unique siblings birthed by the same parent, the story, is the transmedia application of multiplicity. The same story told in different ways. The same characters with a different twist.

While I don't condone this in all cases, the adaptation of failed script to graphic novel in the case of *The Fountain* is a staggering achievement, displaying an unbelievable mastery of the of comics medium by Aronofsky and Williams.

Who is the Intended Audience for the Comic Book?

The graphic novel is intended for those who want a deeper picture into Aronofsky's work. It is the ultimate "behind the scenes" look at the making of *The Fountain*, a look at the original vision of the film. For most audiences however, they'd look at it and say, "Oh, another comic book adaptation." It's unfortunate that this seems to be the case, as the graphic novel version of *The Fountain* is just as soul-searing a work as the film itself, one that makes the utmost use of the comics medium.

How is the Comic Book an Irresistible Part of the Story Experience?

If you love the film version of *The Fountain* or Aronofsky's other work, it is irresistible for you to want to see his original vision. This is irresistibility that comes as much from the creative vision of Aronofsky as it does from the story of the film (if not more so). This is a different sort of irresistibility, one that can only be used in special circumstances—and in this case, it works marvelously.

*　　*　　*

The "unique sibling" relationship of the film version of *The Fountain* and its graphic novel sister is truly unique, and one that should be explored more often—though only in certain cases. In the case of *The Fountain*, it comes from a desire on the part of Aronofsky's fans to dig deeper into his own work, and see what he can do with the comic book medium. I hope we see more applications of comics in this method—which is decidedly different than an amateur screenwriter turning their screenplay into a comic book because they can't get it picked up by Hollywood. This is a true cinematic auteur working in another medium and delivering a unique story experience to his faithful fans.

Thought Experiment: *American Beauty**

Winner of the Best Picture Oscar in 2000, *American Beauty* is the story of Lester Burnham, a suburban husband and father coming to terms with the inadequacies of his idyllic existence, and experiencing an awakening to the riches of life. It is a study of the destructive nature of failing to be who we truly are, masking ourselves behind the secret identities of domesticity. Their neighbors, Colonel Frank Fitts and his wife Barbara are the other side of that coin, with Colonel Fitts, whose self-loathing and outward violence due to his military background and self-enforced repression of his homosexuality have rendered Barbara devoid of life. She is a husk of a human being.

Throughout the course of the story, everyone comes to terms with who they really are—for better or worse. The only one who experiences no change is Barbara. She's the same constant throughout the film.

How Do Comic Books Interact with the Main to Deepen the World?

We will use comics to show what's going on inside someone's head. As Mrs. Fitts rarely speaks, instead observing and taking everything in, reacting, we never know what she's thinking—or if she's thinking.

By taking the concept of multiple perspectives, we will show the story of *American Beauty* through her perspective. What are her impressions of her new neighbors? How does she see them? How does she view her husband? How does she want him to view her? Does she know about his closeted homosexuality? Have the clues always been there?

This approach to an *American Beauty* comic book satisfies three things: a deepening of character through another medium (perhaps the use of vertical panels repeatedly to demonstrate the claustrophobia of her own mind and of the life she leads, then opening to wide shots when we go into fantasy), as well as functioning as both prologue (several of the events would take place prior to the beginning of the film), and running throughout the main events of the movie, offering another perspective on events, one which is silent throughout the film.

* Let me be clear with these sections: just because I say a comic could be added, it doesn't mean that a comic *should* be added. Many stories told in a single medium are perfect (like *American Beauty*). Remember, only add a comic to the story if it adds depth and is an irresistible story extension.

TRANSMEDIA TOOLS: The Experience Gap— *continued*

obviously they're important to anyone who's a producer—but to a consumer (that's a word I hate), to people who are enjoying these stories one way or another, it really doesn't matter. Any way that is possible for them to engage with it is something they're going to want to do.

What's happening now is that people are telling the same story, or different aspects of the same story through a number of different media. Obviously that becomes more complicated, especially for the producer, but if it's done well, it becomes seamless and potentially an immersive experience.[6]

I would take it one step further: the issue is that we have to use media both that we love and that are used in the everyday lives of our target audience. If our audience is used to one-way communication, we should find new ways to do that, and not be disappointed if they don't send emails to our lead characters.

Comic books have been around for a long time and have something resembling ubiquity. They are a perfect gateway medium for many into a deeper story experience.

Who is the Intended Audience for the Comic Book?

If you had never seen *American Beauty*, you would be able to pick up the comic book and partake in a non-superhero story that would be accessible to a wide variety of audiences, creating a fascinating gateway comic.

The format I would choose here would be a graphic novel, not necessarily a serialized comic book (or one that makes use of perceived serialization) to reflect the contained nature of the film. This graphic novel would have more widespread appeal, especially if it lived in the Barnes & Noble/mainstream bookshops. It could rest alongside books such as David Mazzuchelli's *Asterios Polyp*, Marjane Sartapi's *Persepolis,* or art spiegelman's *Maus*.

Of course, the comic is intended to appeal to viewers of *American Beauty*, offering those viewers a chance to go in depth with a character that had total depth yet was never fully explored (because for the needs of the film, she didn't need to be—her story was already complete. She was just "there").

How is the Comic Book an Irresistible Part of the Story Experience?

Screenwriter Alan Ball created memorable and deep characters to populate his world. Each had wants and needs—some for good, some for not. But the one character who had no needs whatsoever, no desire (or at least was never able to act on them) was Mrs. Fitts, as portrayed by Alison Janney. She was so intensely overshadowed by the dominance of her husband that there was no desire in her.

This comic would explore that—ten years after seeing the film, I still want to know what's going on inside her head. That's pretty irresistible.

* * *

The mixture of film and comics is a fascinating one. A two-hour runtime leaves plenty of room for stories in other media to be found and to deepen the world created by the film (like *The Matrix*).

Remember, though, most films and television series that have utilized comics have been sci-fi or action based; they don't need to be. Comics are more than a genre; they are a vibrant medium with an unlimited and often untapped (even in the industry) potential. Exploit it and use it to your maximum advantage.

You Must Remember This . . .

- ■ The trick with merging film with a comic is that film (usually) represents a self-contained narrative. You have to seek gaps in that narrative for the stories to be filled in.

- ■ Irresistibility in transmedia and storytelling comes from making it irresistible to absorbers to dig deeper. The way to do this? Engaging characters that they want to know more about.

- ■ Comics can expand the narrative of film in several ways: through exposition, thought and voiceover, and shifting perspectives.

- ■ Even if you have no intention of adding transmedia elements to your film, you still must create a deeply engaging storyworld that your audience wants to visit. This is the transportive power of film.

- ■ No amount of "transmedia-ifying" will save your film if it's crap.

Notes

1. Tyler Weaver, *Digging Deep: An Interview with Frank Rose,* Mastering Film. Available online at: http://masteringfilm.com/digging-deep-an-interview-with-frank-rose/.
2. Henry Jenkins, *Convergence Culture: Where Old and New Media Collide* (New York: New York University Press, 2006), p. 98.
3. Jeffrey Renaud, "Mike Johnson Beams Up 'Star Trek.'" Comic Book Resources, December 1, 2011. Available online at: ww.comicbookresources.com/?page=article&id=35683.
4. Darren Aronofsky, *The Fountain* (New York: DC Comics, 2005), p. 168.
5. Ibid.
6. Tyler Weaver, *Digging Deep: An Interview with Frank Rose,* Mastering Film. Available online at: http://masteringfilm.com/digging-deep-an-interview-with-frank-rose/.

Comics and Animation

Animation

From hand-drawn cell animation to flipbooks to claymation to the most advanced computer-generated 3-D models, animation is a medium with few limits. Here is a wonderful summation of the magic of animation (and of film in general):

> The power of animation lies in the fact that, like all film, it plays with an optical illusion known as "persistence of vision". The human eye retains an image for a fraction of a second after it has been seen. If, in that brief time-space, one image can be substituted for another, slightly different image, then the illusion of movement is created. What we are really seeing when we look at a cinema screen is not a "moving picture" at all, but a series of still pictures—24 every second—shown in such rapid succession that our eyes are deceived.[1]

"Perceived Vision." That is the magic trick of all visual storytelling styles, from comics to film to animation. We create the illusion of movement of sequential images through the language of the medium at hand. In the case of animation and film, that illusion of movement is accomplished mechanically. In comics, it is accomplished through panels, and the speed and pace set by the reader.

Any story is possible with animation. Serialized narratives work well (look at any number of animated television shows), as do feature-length films or short films (Pixar as the golden example). The limitations that beset live-action film to comic or television to comic such as the symbolic valley* are negated when going from animated project to comic.

Comics and animation also share a frustrating similarity. Both media are thought of as a "genre." The superhero in comics is considered the tent-pole by which all other are measured. Likewise, the "Kids" movie is regarded by the mainstream as the definition of animation—when nothing could be further from the truth. Like comics, absolutely any type of story is possible with animation (look, for example, as Marjane Satrapi's animated adaptation of her autobiographical comic *Persepolis*, or *The Triplets of Belleville*). Animation is

* The symbolic valley is my term for the "almost realistic" renderings of film and television shows when they move to comics, as discussed in Chapter 22.

much more than talking animals and toy tie-ins, just as comics is more than capes and underwear. As Brad Bird (director of *The Incredibles*, one of our case studies in this chapter) said in the DVD commentary for that film:

> People think of animation only doing things where people are dancing around and doing a lot of histrionics, but animation is not a genre. And people keep saying, "The animation genre." It's not a genre! A Western is a genre! Animation is an art form, and it can do any genre. You know, it can do a detective film, a cowboy film, a horror film, an R-rated film, or a kids' fairy tale. But it doesn't do one thing. And, next time I hear, "What's it like working in the animation genre?" I'm going to punch that person!

The power of both animation and comics lies in its utilization of imagination. Every single piece of the visual world must be constructed from scratch, enabling a tight control over the parameters of the story being told. Iconic imagery can be crafted in ways that live-action films cannot. Animation lives in the iconic whereas live action lives in the "real world," no matter how many or how fantastic the digital effects. For example, consider *Toy Story*. If that had been done in live action, you wouldn't see Woody the Cowboy and Buzz Lightyear. You would see Tom Hanks and Tim Allen looking really weird.

This is the transportive power of animation: a medium designed to transport you to a world constructed from scratch that is not your own. A world where the physical laws of appearance and reality are demolished, replaced with iconic personification, a world where absolutely anything is possible.

Comics do that too. Look at Superman. He is an iconic figure. When he is translated into live-action film, that actor "becomes" Superman, but it is still an actor playing Superman. When he is transformed into an animated figure, like the Fleischer cartoons, he retains that iconic form and scope. The animated Superman lives only in the world of animation. He doesn't have the tabloids following him around wondering about his love life.

Animation is an intensely immersive storytelling medium specifically because of that transportive power. It is a medium wonderfully ripe for transmedia applications with a world of the fantastic, creating unique and unforseen challenges to the content creator.

For instance, let me pose a question. How would you do a live-action version of *Gumby* that retains the same charm of the original vision?

Thought so.

Television

Great television holds one storytelling tenet sacred: character is everything. The depth which television allows storytellers to explore a character and offer a well-rounded and exciting character journey is unprecedented, rivaled perhaps only by the novel.

Like comics, television can handle three types of series well: serialized (soap operas, *The Wire, Lost, Twin Peaks*), serio-episodic (*ER, Castle* . . .), and episodic (*Seinfeld, The Simpsons*, any number of situational comedies [sitcoms]). The meat of television lies in the immersive qualities to it, as well as the ubiquity of the medium. It (along with film) is the mass-media equivalent of comic books. Whereas comics has a very limited, niche audience (now), television reaches a wide demographic each and every day. And when you add animation to the mix, with kids and adults (in the case of *The Simpsons* or *South Park*), the ubiquity and reach of the television medium is impossible to overstate.

One final strength of television comes from that serialization: the idea of "Seasons." The season-ender is (for the most part) a cliffhanger that leaves audiences gasping, filled with rage, and demanding the beginning of the next season over the innumerable months between seasons. The conclusion of seasons creates a gap in the narrative—a gap that can be exploited in other media to both deepen the story and sate the demands of the faithful audience.

No Rules

In fairy tales and fables, there are no complex rules. No one asks, "Well, how did the tortoise and the hare get to the starting line?" Likewise, with animation, no one asks, "What cataclysmic world event led to the extinction of the human race and the rise of the cars?" It just is. That removal from the "real world," where we seek to explain and rationalize everything, is where the marvelous simplicity of animated storytelling can come from—a simplicity that should be exploited when expanding a narrative to comics.

Realistic Problems Drawn

At the same time, by animating certain stories, it brings a level of charm and freedom to distinctly real-world problems. If *The Simpsons* weren't animated, it would be just another half-hour show about a dysfunctional small-town America family and would last maybe five episodes instead of 500. *King of the Hill* is the same deal. *Beavis and Butthead. South Park. Futurama.* That removal from reality is what allows shows and stories like that to explore realistic themes and settings with a new vantage point.

Expanding the Narrative

Depending on the format used (feature-length film, animated television series, short animated film, web-based animation), the limitations of animation align with the limitations of film (as seen in Chapter 31). However, with animation—especially mainstream animation—there are areas where comics can expand the narrative of an animated project.

Perception

I'm going to echo Brad Bird here for clarity: animation is *not* a genre! It is a medium! Unfortunately, thanks to this stigma, many mainstream animated films or television shows have to tone down the more dramatic and "adult" themes. Comic books can be a valuable place to explore those themes (if marketed correctly). The finest example of this, and one we will look at in depth, is the comic book extension of *Batman: The Animated Series*, *Mad Love*, a graphic novel written by series writer Paul Dini and drawn by lead brain Bruce Timm. It stayed within the style set forth by the series and added deep layers of dramatic complexity to the Monday through Friday 4:30pm show.

This may also help parents of kids who have to watch the same film over and over again. What if there were comics that were geared toward adults featuring more thematic and dramatic stories using the characters within the cartoon universe? Of course, this offers a challenge from a marketing

perspective (how do you avoid having kids pick these comics up?), but it is a worthwhile challenge to undertake, especially if it pushes deeper storytelling and more opportunities for expansion. Let's also not discount that even if the material isn't "adult" in the comics, simply a new story featuring characters that adults have grown to love through their children, that is a powerful means of expansion. Sometimes you just want to see new stories with the same characters.

Length

Like film, the animated story is chained by the time lengths dictated by the delivery system. This is a problem when an animated world can be so imaginative, vast, and vibrant. It is almost a wasted opportunity to only explore that world in one film or one television series. A comic book extension will allow for greater—and more cost-effective—exploration of the world and bring the fan base more stories within a world that they love.

* * *

In this chapter, we're going to look at two animated projects that have benefited from a comic book addition; from television, *Batman: The Animated Series;* from feature films, *The Incredibles*; and from a fantasy perspective, *The Triplets of Belleville.*

Case Study: *Batman: The Animated Series*

Led by the team of Bruce Timm, Alan Burnett, and Paul Dini, *Batman: The Animated Series (TAS* for short) premiered in September, 1992 and would go on to cement itself as the definitive animated version of Batman; perhaps *the* definitive version of Batman. Within the first months of its run, it set a gold standard for televised animation, the heir to the throne of the Max and Dave Fleischer *Superman* cartoons from the 1940s. Since its inception, the series has inspired films, a new *Superman* cartoon, and the animated version of almost every DC character in the *Justice League* series.

Batman: TAS (though during its first season, the show lacked a title) followed a very simple structure reminiscent of the great comic books of years previous. Often consisting of tight, taut "done in one" episodes that reduced core characters down to their simplest, most primal elements and adding a deep emotional subtext (such as the best of the series, the Paul Dini-scripted Mr. Freeze origin, "Heart of Ice"), the series would go on to introduce characters such as Harley Quinn and Renée Montoya to the Batman universe, characters that would eventually be incorporated into the comic book DC Universe.

In its second season, *Batman: TAS* became *The Adventures of Batman and Robin* when Robin became more prominently featured, and finally morphed into *The New Batman Adventures* after the success of Timm's *Superman* animated series and the moving of *Batman* to the WB network. In this new iteration of the series, the *TAS* universe has evolved—Dick Grayson is now Nightwing, a young Tim Drake is Robin, Batgirl is Batman's most consistent partner, and the entire look of the series is radically changed. The final iteration of the *TAS* world was *Batman Beyond*, a glimpse into the future with a younger Batman, Terry McGinnis (also integrated into the DC Universe in 2009), taking over the cowl from an aged Bruce Wayne who acted as his mentor and point man. Eventually, the tale of the animated *Batman* concluded in the final episode of the *Justice League Unlimited* series, when it was revealed that Terry McGinnis was actually Bruce Wayne's son, created in a lab to keep the Batman legacy alive.

How Do the Comics Deepen the World?

A month after the premiere of *TAS*, a comic book spin-off was launched, *The Batman Adventures*, written by Kelley Puckett and Ty Templeton. While set in the same world as *TAS*, it did not continue stories from the series (for instance, a television episode never ended with a "To Be Continued" tag and picked up in the comic book series). It did feature both the characters and the style from *TAS*, giving Batman fans tired of the endless events in the *Batman* continuity proper (at this point, the "Knightfall" epic was raging through the pages of every *Batman* title from DC, with the exception of *The Batman Adventures*, offering readers something different).

In 1994, Paul Dini and Bruce Timm finally came to comics with *Mad Love*, a one-shot story (hailed by many as the best *Batman* story of the 1990s), telling the origin of *TAS*'s most popular import to the Batman universe, Harley Quinn. A heartbreaking narrative of her descent into madness and a warped version of coupledom with the Joker, *Mad Love* deepened the psycho-sexual undertones only hinted at in *TAS* (the show aired on FOX Kids at 4:30pm Monday through Friday—the exploration of psycho-sexual relationships wasn't conducive to afternoon cartoons, in spite of being aimed at teenagers and young adults). *Mad Love* was eventually adapted into animated form as part of the *New Batman Adventures* version of the animated series.

Following the return of Batman in *The New Batman Adventures*, DC published a five-issue mini-series, *The Batman Adventures: The Lost Years*, that bridged the gap between *Batman: TAS* and *The New Batman Adventures*. It told the story of the evolution of the Bat-family, and of Dick Grayson's own evolution into the Nightwing persona. Subsequently, a new series was published, again set in the *TAS* universe, *Batman: Gotham Adventures*, which ran from 1998 to 2003.

A final *Batman Adventures* series was published between 2003 and 2004, with Issue #15 being especially of note: it bridges the gap between Mr. Freeze's final appearance in *TAS* and his appearance in *Batman Beyond*.

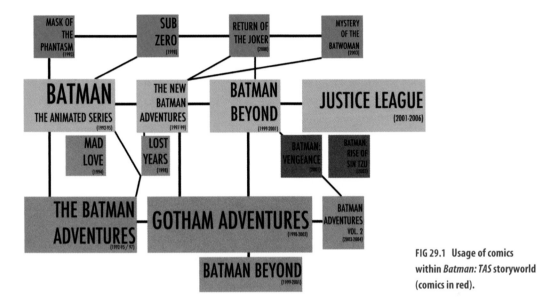

FIG 29.1 **Usage of comics within** *Batman: TAS* **storyworld (comics in red).**

Is the Comic Book Capable of Standing On Its Own?

Absolutely. *The Batman Adventures* series is a wonderful collection of Batman tales, free of 60 years of continuity. You can pick up any issue and enjoy a simple Batman tale (just like you can watch *TAS* and enjoy a Batman tale). *Mad Love* is a staggering achievement in comic book storytelling and works with either no knowledge of *TAS* or complete knowledge. Both series offer choice. You don't need to read the series or *Mad Love* to know what's going on, but you can certainly enjoy both. In the case of *Mad Love,* it deepens the world by telling a story that wouldn't fit into weekday afternoon cartoon programming.

How is the Comic an Irresistible Part of the Story Experience?

Unlike most properties, where the deepening of character creates irresistibility, the comics (with the exception of *Mad Love*) don't. The comics are irresistible because they are simple Batman stories in the vein of *TAS*. The very aesthetic and storytelling style of *TAS* makes them irresistible.

The Formats

Throughout this book, we've looked at a number of different formats: the anthology series, the ongoing, single-hero series, the finite series. In our look at case studies, we've discussed graphic novels, mini-series, and the occasional ongoing series (which seems to work especially well with television series like *Batman: The Animated Series*). But it begs a simple question: which one is best for your project?

The reason that ongoing series work for television series is the lengthy "shelf life" of a television series; a great television show can for last years (look at *The Simpsons*, still published by Bongo Comics), thus creating an opportunity for "continuing adventures" in comic book form. A mini-series works well when there are defined endpoints that must be hit, to fill in the gap, such as with the *Superman Returns* film or *Star Trek: Countdown*. A graphic novel works especially well when telling a story from another perspective, another contained narrative.

But ultimately, the choice of format is up to you and the needs of your project. When I say "needs" I mean story needs, not monetary ones. Utilize the format just as you would the medium: if it serves the story, go with it.

In the case of *Mad Love*, it is irresistible because of the Harley Quinn character. She is a character people want to learn more about, and again, thanks to the chains imposed by the airtime of the cartoon format, the comic book can provide a deeper, more adult look at her origin.

Case Study: *The Incredibles*

A family of former superheroes must return to their old lives to take down Buddy, a scorned wannabe sidekick turned super-villain.

The Incredibles is all about becoming the person you have always been. It's an affecting story (and my personal favorite Pixar film), written and directed by the incredible Brad Bird.

How Do Comic Books Interact with the Main Story to Deepen the World?

Set at points before and after the feature film, the various *Incredibles* mini-series—published first by BOOM studios and then Disney/Marvel (after Disney bought Marvel in 2009)—both expand and deepen the world of *The Incredibles*.

Writer Waid introduced several new characters to the world, including Doc Sunbright, who delivered Jack-Jack in the prologue of *The City of Incredibles* storyline (and is cousin to *The Incredibles*'s faithful fashionista, Edna Mode), villains like Mr. Pixel and Tronosaurus (as well as the entirety of the Confederacy of Crime).

Also providing a valuable lesson to creators moving their properties to comics is the art style utilized by Marcio Takara and Ramanda Kamarga. Said Waid in an interview with Comic Book Resources:

> Pixar specifically asked us not to do the 3-D CGI look, because they realized, and we realized it too, that's great for their movies but that's not necessarily comics at its rawest. If you're going to do comics, be unapologetic about it and do comics . . . it shouldn't look necessarily like it's all kid-ified, but certainly bring that energy to it.[2]

This is a key thing to keep in mind when translating from animation to comics. Just because the animation style works in the film or television version doesn't mean that it should be translated to the comics medium. Comics are comics—make comics, not still animation cells!

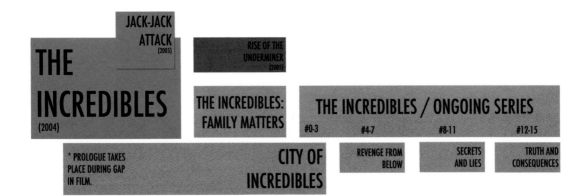

FIG 29.2 Usage of comics to extend the storyline in *The Incredibles* (comics in red).

Are the Comic Books Capable of Standing On Their Own?

Absolutely. Mark Waid (and eventual writer Landry Walker) and team crafted continuing (and past) adventures of *The Incredibles* with the same gusto and charm of Brad Bird's original screenplay. Each and every series was fully in the vein of the film and featured self-contained stories that required no knowledge of the film. If someone picked up the series without knowing a thing about *The Incredibles*, the comic book would provide fodder for the reader to dig deeper into *The Incredibles* world.

How is the Comic Book an Irresistible Part of the Story Experience?

Featuring characters that kids love and adults can identify with and empathize, *The Incredibles* is the most fun, vibrant, and exciting superhero universe that never originated in comics. The opportunity to dig deeper into that world led by a comics writer of Mark Waid's caliber and following Brad Bird's original vision?

Irresistible.

TRANSMEDIA TOOLS:
The Pitch

The most difficult thing when setting out to make a transmedia project is the money aspect. With transmedia being such a new and different thing (though now unfortunately a buzz word), offering a concise and well-rounded budget is difficult. That being said, here are five things you should be sure to include in your pitch:

1. **The Story**
 This should go without saying, but is unfortunately lost in most transmedia discussion. What is your story? What is the project about? This is the most important part of any project, be it mono-media, transmedia, or multimedia. If you don't have a story, you don't have a project. Transmedia is meant to enhance and deepen a story experience. It is not meant to wow with technology.

2. **Intent**
 Why is a transmedia approach the best one for this particular project? Is it because you want to immerse fans in a deep story experience or is it because transmedia is the flavor of the month and you want to cash in? The second most important question is: "What's the point?"

3. **The Experience Gap**
 Transmedia is very much a generational thing, though every audience will understand the concept of immersion. You have to be cognizant when pitching a project to donors that you bridge that experience gap and make it irresistible. Remember fine dining chefs from the Midwest that we

Thought Experiment: *The Triplets of Belleville*

Nominated for two Academy Awards in 2004, the musical/mystery/comedy genre-mash of *The Triplets of Belleville* is largely told through pantomime and music. Relatively free of dialog, it garnered worldwide acclaim because of that universality of silence coupled with motion and sound; it made the utmost use of the film and animation media.

After her grandson Champion enters the Tour de France and is kidnapped, Madame Souza must save her grandson from the Mafia in New York City with the help of the Triplets of Belleville, three elderly music hall singers turned improvisational musicians. Eventually, the team rescues Champion and escapes—though not without great difficulty and great comedy.

How Do Comic Books Interact with the Main to Deepen the World?

As the film contained very little dialog, so too would the comic. Comics, like film and animation, is a visual storytelling medium. We'll tell it through visuals. But what kind? Let's explore the Triplets of Belleville themselves. They obviously had quite an exciting life. So we'll do a simply drawn mini-series of their adventures in the 1930s music halls. Like *The Incredibles* comics, it will not merely bogart the style of the film, but will make the best use of the comics medium.

As *The Triplets of Belleville* is a genre mash-up of comedy, mystery, and music, so to will the comic craft a genre cocktail. On one hand it will be a crime comic. On the other, a comedic romp through the music halls of the 1930s with the Triplets of Belleville as a trio of song-and-dance private eyes. It will expand their story and add subtext to why the characters helped Madame Souza find her missing grandson.

How is the Comic Book an Irresistible Part of the Story Experience?

The Triplets of Belleville is an absolutely astonishing film with a wonderful supporting cast that begs for a deeper story. The comic book would offer depth for those who are already familiar with the film (the expanded adventures of the Triplets) and a fun comic series for those who just want a great alternative read along. If you haven't seen *The Triplets of Belleville*, you would simply be entertained by a whimsical tale set in the 1930s.

* * *

All of the films and series discussed here—*Batman: The Animated Series*, *The Incredibles*, and *The Triplets of Belleville*—share a common thread: they prove the vast possibilities of the animated medium. One is the televised adventures of a dark avenger of the night with stories that remain as vital and popular as the first time they aired at 4:30pm on Fox. *The Incredibles* is the best version of *The Fantastic Four*, though achieving a level of drama and humanity that only animators working at the top of their game can achieve. The other is a musical/comedy/mystery mash-up that is largely silent, relying instead on movement, action, and physicality to tell a story.

Both animation and comics offer the audience a world created entirely from scratch, birthed from the brains of writer and artist. Both are so much more than a genre; they are vibrant vehicles for world-building limited only by the imagination. If that doesn't convince you that animation is more than a genre, Brad Bird could always punch you.

You Must Remember This . . .

- The key strength that both animation and comics share is that each world is created purely from imagination. If it can be drawn, it can be done.

- The chief limitation that both comics and animation share is that they are regarded as "genres" by the mainstream. In fact, they are capable of nearly any type of story.

- Both comics and animation operate on perceived vision: in animation, the movement is created mechanically, in comics, by the pace of the reader

Notes

1. Peter Lord & Brian Sibley, *Creating 3-D Animation: The Aardman Book of Filmmaking* (New York, Abrams, 2004), p. 17.
2. Shaun Manning, "Mark Waid on The Incredibles." Comic Book Resources, January 21, 2009. Available online at: www.comicbookresources.com/?page=article&id=35683.

TRANSMEDIA TOOLS:
The Pitch—*continued*

discussed in Chapter 1? Meet an audience halfway: give them something they know and transform it into something they'll never forget.

4. **Money**
How much will this cost? Is it an experimental thing you're just going to try? Or is it half of the marketing budget (if the intent is to market a product?) Be very, very clear here, and be very, very clear as to why you are using the media you're using in order to fully immerse that audience.

5. **Be Open**
You have to be open to new ideas and things that come up during the pitch. You have to embrace that uncertainty.

6. **Bonus Round: You Cannot Guarantee Something Will Go VIRAL**
The only virus that is guaranteed is the flu. Make it crystal clear to potential backers that you cannot guarantee the virality of your project. If you have a great story, with clear intent and are open to change, you have more legs than most. You cannot make a "viral video." You can, however, utilize storytelling techniques that deeply immerse an audience in a storyworld. Virality is up to the audience, not you.

Comics and Video Games

Playing Video Games

You sit for hours in front of a television screen, pounding buttons and fully immersing yourself in a world that is not yours, one where you fight to save the world, make the best headshot, or rescue a princess.

You are playing video games, the most immersive form of entertainment available. With the best games, the players form a deep connection to the universe and the characters that populate the world. It is the closest we have gotten to *Star Trek: The Next Generation*'s holodeck; a virtual world where anything is possible (within defined parameters) and where the fate of the world lies on our shoulders.

With video games, we have control over pace and narrative outcome (though that control is deceptive—obviously games have a story running through them, although with MMORPGs [Massively Multiplayer Online Role Playing Games], the concept of an "unending game" is taking root). The values we insert into our avatar in the virtual world deepen our ties to the game. After all, Nico Bellic from *Grand Theft Auto IV* is a highly defined character in the linear gameplay. It's what we bring to him in the sandbox world of *GTA IV*'s Liberty City that makes him a merciless road-rage fueled killer of pixelated people.

It is that very choice and immersiveness that has made video games the comics of the new millennium. Like comics, they have been the subject of governmental and judicial outrage over their influence on the youth of America. They allegedly seduce the innocent. They also have the same niche audience that comic books have: highly dedicated fans who thrive on being rewarded both in gameplay and in expertise. That both media have inspired such debate and derision is, I believe, singularly tied to that niche and dedicated audience.

The Janet Murray quoted earlier from *Hamlet on the Holodeck* (reproduced in Frank Rose's *The Art of Immersion*) applies here too: "Every new medium that has been invented, from print to film to television, has increased the transporting power of narrative. And every new medium has aroused fear and hostility as a result."[1]

A World Not Our Own

The first ingredient in the success of video games comes from the exploitation of a deep, fully drawn world created from scratch. In that manner, games share a common bond with animation and comics: if it can be drawn, it can be created. If it can be programmed, it can be created. The potential for vibrant world-building and transmedia applications of that world cannot be understated. Couple that with the addition of "player as protagonist" (even with a deeply defined protagonist) and that completes the recipe of video-game immersion.

Player as Protagonist

The value of this unique phenomenon to video games is without comparison. It set the video-game medium apart from all other media, even the most immersive media of comics, prose, and radio that require the mind's eye to complete many of the pictures. By day, you may be a mild-mannered file clerk. By night, you are a cybernetically enhanced marine with the fate of the universe on his shoulders. By day, you may be a plumber. By night, a mushroom-eating plumber who stomps down freakish monsters and dragons all in the service of a beautiful princess. It appeals to our deep-rooted need to have a secret identity and be more than we believe we are.

The only historical precedent in media that may come close to this is the hard-boiled private eye of the pulps and crime fiction of Dashiell Hammett and Raymond Chandler. The very nature of these characters was that they were catalysts, unchanging avatars who revealed hidden secrets of the supporting cast, around which the mystery revolved. The characters were broadly defined, making the most use of the medium in which they were created. Very little character description was used—a little bit like a first-person shooter. Also like the iconic comics characters that have endured, everyone can bring their own twist. In video games, every player brings their own backstory to the game.

Reward System

Like the urge for an exciting fantasy life, video games also fulfill a deep-rooted desire for rewards. From elementary school, we are trained to earn gold stars for everyday tasks. An extra life for every 100 coins collected in *Super Mario Bros.* It rewards the player's expertise in a way that other media cannot . . .

Except for comics. Comics reward their readers through continuity, and the solving and dissection of continuity errors both online and off. By extending a game's continuity and mythology into a comic book, game designers can

Your Hero's Journey

Like comic books, video games make use of one of the most primal storytelling structures in existence: the Hero's Journey. However, it is how the Hero's Journey is utilized in games that is most fascinating.

Remember, games use a different storytelling form (reward-based) as opposed to narrative-based of linear stories and films. The character going through the "hero's journey" isn't the character you play, but you. You start off inexperienced, lost in this new world. You make the decision to embark on the challenge set forth by the game designers. As you overcome the obstacles and tests, you become more confident in your abilities until ultimately, you must save the world in the most spectacular fashion available. You have become the hero you needed to be to accomplish the game.

And what is the elixir that you return to your normal world with? The elixir of having risen to a challenge and overcome obstacles. The elixir of expertise.

further tap into that reward impulse by building connections between media and leaving the reader/player to find them.

Expanding the Narrative

For all of the unique storytelling opportunities offered by the video-game medium, it does have its limitations. Fortunately, those limitations can be overcome with a judicious and well-planned usage of comics.

Reward System

The reward system in games is its greatest asset and liability. Because one has to gear a story toward the needs of the medium, it may not always align with the stories the game creators want to tell. There may be side areas where rewards aren't needed, but a great story lurks. Comics offer a way to exploit that story.

The difference between game-based storytelling (stories that follow the conventions of games: rewards, bosses, levels, etc.) and narrative-based storytelling is based entirely on that necessity for a reward system. However, if we think of big blockbuster films, aren't there similar reward systems in place? A huge fight scene as the hero defeats the villain. Heroes rising up from defeat. Those are rewards. The difference is that in a game, the player is the one doing all of that.

Price

The cardinal issue with games is one that is similar to film: unless the game is a proven concept with a rabid fanbase, many will have a difficult time paying $60 for a new game. There are cases to be made for a distinct cross-pollination of fanbases between games and comics. We can use that cross-pollination to our advantage.

The trick in using a comic to expand the story of the game (and, by extension, reach more potential players) is that a game has many avenues of appeal: gameplay, community involvement by way of online services. With a comic, it's all about the story. If the game has a weak story, the comic won't help it. But if the game has a great story, and the comic places the same emphasis on character, story, and theme as the game, the comic will offer potential players a glimpse into the game, one that will only be augmented by the added capabilities of gameplay, interaction, and community.

Backstory

Because of the needs of the reward system and defining characteristics of the medium, games can be short on character development (with notable exceptions). While many protagonists are both well defined and ambiguous (so as to better allow the player to insert their own values and experience on top of that), many side-characters are not. Deeper subtext may be mined and a depth of experience from a story perspective (as opposed to a game and world-building perspective) exploited by the telling of several stories in comic book form.

* * *

In the next few sections, we are going to look at games that have come to define the video-game medium in the 21st century. First, we will look at the massively successful *Halo* franchise and the usage of comics to extend the narrative and fill in gaps in the story between games. Second, we will look at *Batman: Arkham City*, the semi-open world second entrant into the *Arkham Asylum* Batman video-game universe and its exemplary usage of comics. And finally, we will embark on another thought experiment (our final one in this book!): bringing the world of *Red Dead Redemption* to comics.

Case Study: *Halo*

Released as a launch title exclusively for the XBox in 2001, the first game in the trilogy, *Halo: Combat Evolved* spawned a massive following, cementing the *Halo* series as this generation's *Star Wars*. In 2004, its highly anticipated sequel, *Halo 2* was released, raking in $125 million within its first 24 hours of release.[2] In 2007, *Halo 3* concluded the first trilogy, amassing nearly $300 million in sales in its first week and $170 million in its first 24 hours of release.[3]

Halo's similarity to *Star Wars* doesn't lie just with the numbers. It lies with the absolute dedication of its fan base, creating a transmedia phenomenon that has reached in comics, novels, ARGs, and of course, revolutionary platform video games. It is a deeply drawn mythological battle between good and evil that tells its story across the most technologically advanced medium for storytelling available at the time. It blends influences as disparate as Virgil's *Aenid*[4] with Joss Whedon's *Firefly*, J.J. Abrams' *Lost*, Ridley Scott's *Blade Runner*, and William Gibson's *Neuromancer*[5] into a storytelling experience as immersive and enthralling as the greatest pulp stories of the 1920s and 1930s that birthed the science fiction genre and inspired Jerry Siegel and Joe Shuster to create Superman.

Alternate Reality Games

With the pervasiveness of the Internet, "Alternate Reality Games" or ARGs have exploded in popularity over the years, both as highly immersive and addictive community builders and essential parts of the story. *Why So Serious*, the campaign developed to promote 2008's *The Dark Knight* told the story of how the Joker put his bank robbery in motion prior to the beginning of the film.

Bungie's sequel to the massively popular *Halo* franchise, *Halo 2* begins with the protagonist, Master Chief, on Earth. To show how he got there, 42 Entertainment (also behind *Why So Serious*) created an ARG that unfolded across pay phones, piecing clues together that would only make sense when pieced together online.

It's worth noting that while I am strict in my belief that transmedia storytelling must be *irresistibly* transmedia, ARGs, while confused by many as transmedia, must be *expectantly* "transmedia" for them to function properly, thus making them the domain of deeply entrenched fans. Attempting to bring in new fans with an ARG is a lost cause.

In spite of its jaw-dropping graphics and much-deserved reputation as a bad-ass sci-fi extravaganza of mythological proportions, at its core are the relationships between characters as deeply drawn as Cortana, Sgt. Avery Johnson, and Miranda Keys and the mysterious protagonist Master Chief. It is a remarkable achievement in video-game storytelling: the combination of deeply drawn characters with a protagonist ambiguous enough that players can add their own values on top of him, but is also a vibrant character with his own backstory.

Those players control the Master Chief through the non-stop action and sci-fi insanity of the ongoing war between the United Nations Space Command (UNSC) and the Covenant, an alliance of aliens bent on exterminating humanity. The first trilogy concluded the war between human and Covenant, though left the Master Chief and Cortana drifting toward an unknown planet, setting the stage for *Halo 4* in 2013, which will launch the next trilogy, dubbed "The Reclaimer Trilogy."

How do Comic Books Interact with the Main to Deepen the World?

The first *Halo* comic book series (a graphic novel was released in 2005) *Halo: Uprising* (2007–2009), written by Brian Michael Bendis, fills in the gap between the conclusion of *Halo 2* and the beginning of *Halo 3*. According to *Halo: Uprising* writer Brian Michael Bendis:

> We stay in the human point of view for a lot of the comic. I think that is where the medium of the comic can really shine and show things the game can't show just by its nature and point of view.[6]

Uprising makes perfect use of the ability of comics to humanize a mythological sci-fi universe, a universe in which the player holds the fate of humanity in their hands by transporting the story to Cleveland (yep, Cleveland) and splitting the story between a hunt for "The Key of Osalanan" and bridging the gap between *Halo 2* and *Halo 3* with the Master Chief.

However, while *Uprising* does provide an intriguing side-story (and bridge), it wasn't met with accolades (in part due to an 18-month delay between Issues #3 and #4). A review of Issue #4 voices the disappointment:

> Unfortunately, the Master Chief segments continued to disappoint to some degree. If my long-term memory serves me, I complained in past reviews about how Master Chief felt like a guest star in what should be his own book. That doesn't necessarily change, even if the sheer amount of action and shooting have increased. Chief's tale never links with Ruwan's in any satisfactory way. Instead, his segment seems aimed to appease Halo fans

who require carnage and explosions. That's not to say they shouldn't expect as much from a Halo book, but the games tend to do a better job of linking story with action.[7]

This is a very fine line that creators must walk when crafting any transmedia application: give diehards what they want and give newbies something to chew on. *Uprising* was advertised as a bridge between *Halo 2* and *Halo* 3, and, for the most part, it functioned in that manner. However, it didn't quite deliver. How could it have worked better? The critical error here was in creating a subplot ("The Key of Osalanan") for the mini-series that had little to nothing to do with the events of *Halo 2* or *Halo 3*. If the Key had some bigger role to play in the *Halo* universe, one that wasn't integral to the mythology, but added an extra element of depth, and made an appearance in the video games, then it might have worked. Otherwise, it didn't.

Halo: Uprising was followed by *Halo: Helljumper* (written by Peter David) and *Halo: Bloodlines* and *Halo: Fall of Reach* (written by Fred Van Lente), both set in the pre-*Halo: Combat Evolved* era, both of which seemed to learn the lessons of *Halo: Uprising*.

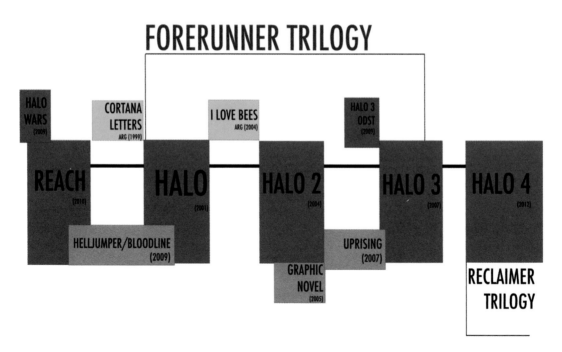

FIG 30.1 Usage of comics in the *Halo* storyworld (comics in red).

Open-World Games

The single most immersive video-game experience confined to one medium is the open-world video game. Both of the next games we discuss feature an open-world environment, a sandbox where anything is possible (though in the case of *Arkham City*, it's a limited open-world environment).

Open-world games rose to prominence (and infamy) thanks to Rockstar Studios and the *Grand Theft Auto* series. In *Grand Theft Auto*, anything goes in Liberty City. It is that "anything goes" feel that has so many up in arms. Remember Janet Murray's words: "Any medium that increases the transportive power of narrative is met with fear and hostility."

Who is the Intended Audience for the Comic Book?

Halo: Uprising writer Brian Michael Bendis said this prior to the release of *Uprising* in 2007:

> Writing for the Marvel icons, you learn quickly that every comic is someone's first or someone's last. It's my job to make sure every issue is completely satisfying so that they want to come back and they can enjoy what they are reading without needing anything else but the book in their hand. But at the same time it's important to honor the die-hard fans with references and nods to the games and novels.[8]

The *Halo* comics represent something fascinating: comics that are good reads for the non-*Halo* fans, but disappointing ones for the hardcore. Yes, they provided a fascinating human tale in the midst of the sci-fi insanity, but they failed to capture exactly what the players of the games wanted: Master Chief being a bad ass. The unfortunate thing is that they can never fully capture that; what makes Master Chief so bad ass isn't what he does, but what the *player* does.

How is the Comic Book an Irresistible Part of the Story Experience?

It isn't. But it also isn't expectantly transmedia. The comics will continue stories and create new ones, but they are not essential for the game player to have a complete vision of the *Halo* universe. That said, the human element of the comics, particularly *Halo: Uprising* under the stewardship of Bendis, does add a deepening element of pathos and a "man on the street" look at the insanity of the *Halo* universe. It's not something you *have* to know, but it is a nice wandering—except, of course, that it failed to satisfy hardcore players of the *Halo* game series.

The only essential parts to the *Halo* franchise are the games. Ultimately, they're the only irresistible part as well.

Case Study: *Batman: Arkham City*

For years, people said it couldn't be done. "You can't make a good Batman game." And for the most part, they were right. Through various iterations and adaptations (my personal favorite being the hand-held TIGER games version of Tim Burton's 1989 *Batman* film), designers and creators struggled to bring The Bat to the game screen, to put you into the boots and utility belts of The Batman.

Finally, in 2009, Rocksteady figured it out, unleashing *Batman: Arkham Asylum* on to the screens of gamers and comic book readers everywhere. For the first time, you *were* Batman, gliding over chasms, hurling batarangs, launching sneak attacks on armed Joker thugs, solving the Riddler's riddles, all in an effort to stop the Joker from succeeding in his attempt to overrun Gotham with Titan-powered creatures.

The key to *Arkham Asylum*'s success lay in three key areas: first, the game was written by *Batman: The Animated Series* veteran (and *Mad Love* writer) Paul Dini. Second, the game featured the voice talents of many of the *Animated Series* veterans, including Kevin Conroy as *The* Batman, Mark Hammill as The Joker, and Arleen Sorkin as Harley Quinn. And most importantly, *Arkham Asylum* created an entirely new *Batman* storyworld, one that blended the best of the comics with the best of the movies and the best of the animated incarnation into what I feel is the defining Batman experience of our generation.

Upon the release and success of *Arkham Asylum*, talk began of a sequel, one that would be even bigger in scope (which wasn't hard—while *Arkham Asylum* was a huge map and world, it had a wonderfully claustrophobic feel). What deeply immersed players discovered was a secret room in *Arkham Asylum*, a room held by then Warden Quincy Sharpe, that contained plans for something bigger, something called *Arkham City*.

A year after the events of the *Arkham Asylum* video game, now Mayor Quincy Sharpe has moved all of the prisoners of Arkham Asylum and Blackgate to a new, fortified prison in the heart of Gotham City, Arkham City. After leading a rally against the prison, Bruce Wayne is arrested and thrown into Arkham City where he must take down the warden, Dr. Hugo Strange, and stop his "Protocol 10" initiative. Standing between him and Strange is the Joker, terminally ill thanks to the Titan formula he used in *Arkham Asylum*, and an *Arkham*-ized set of his rogues, including The Mad Hatter, Catwoman, Two-Face, Mr. Freeze, Bane, and The Penguin.

How do Comic Books Interact with the Main to Deepen the World?

There are two series: *Arkham City*, which functions as a prologue to the game, bridging the events of *Arkham Asylum* and *City*, and a new, digital-exclusive series, *Arkham Unhinged*, that tells stories that take place inside the City while the game is going on.

Arkham City, scripted by game writer Paul Dini and featuring art by *Arkham City* game character designer Carlos D'Anda, is the story of the machinations that led to the creation of Arkham City in the year between *Arkham Asylum*

and *Arkham City*. We learn of the attack on City Hall, which gives Mayor Sharpe the power and political capital to construct Arkham City. The five-issue series also introduces readers to the *Arkham*-verse version of Robin, Two-Face, and Catwoman.

Running between each monthly issue of *Arkham City* are five digital-exclusive chapters, each telling a story of a different character, and all featuring a story by series and game writer Dini. Chapter 1 focuses on Hugo Strange. Chapter 2 is the story of criminals fleeing Gotham in the wake of Arkham City's guards, TYGER, arresting anyone and everyone. The third story focuses on The Riddler's entrance to Arkham City, while Chapter 4 is Robin-centric, and the final issue focuses on Bane. All five digital releases were written by eventual *Arkham Unhinged* writer Derek Fridolfs.

Arkham Unhinged was released as a digital exclusive to the DC Comixology store. The weekly series expands stories and perspectives as to what happens during the game. The Catwoman/Two-Face conflict is revealed in *Arkham Unhinged* (in the first section of *Arkham City*, you have to save Catwoman from a very pissed off Two-Face). Says series writer Fridolfs:

> "Arkham Unhinged" is complimentary to the Arkham City game. Now that the game is up and running, this is an ongoing, weekly, digital title that will have stories that are about what is going on in the game as well as backstories, motivations and further exploits in the Arkhamverse. It's a chance to flesh out things maybe hinted at or not covered in the game, as well as focus on brand new stories off the beaten path and follow these characters more closely.[9]

FIG 30.2 Usage of comics (in red) in the *Arkham*-verse.

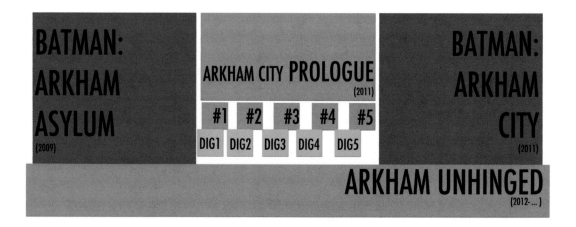

According to the same article, the series will also go back before *Arkham Asylum*, further deepening the *Arkham*-verse and revealing motivations and hidden secrets.

Are the Comic Books Capable of Standing On Their Own?

Yes and no. The prologue, written by Paul Dini, tells a rousing tale of the construction of *Arkham City* and introduces several characters that appear in the *Arkham City* game, as well as shows what happened in the fallout of *Arkham Asylum*. That said, the story feels very much like a prologue and doesn't have a clearly defined ending. There's definitely a beginning, lots of middle, and an ending that requires the reader to play *Arkham City* to figure out the whole story. *Arkham Unhinged* requires the reader to be familiar with the game.

How is the Comic Book an Irresistible Part of the Story Experience?

This is a 50/50 case again. It sort of is, and sort of isn't. The appeal here lies in the first game and wanting to know what comes after it. Again, it's tied to plot, not to character, and isn't an essential element to the story. It does, however, deepen the story of the game by filling in motivations.

Thought Experiment: *Red Dead Redemption*

What is the Main Story?

An epic set over a vast open-world Western landscape, *Red Dead Redemption* is the story of former outlaw turned farmer and family man John Marston. Blackmailed by government agents, Marston must track down and eliminate the former leaders of his old gang, Bill Williamson and Dutch van der Linde. After combing the countryside of New Austin, Mexico, and Blackwater, Marston succeeds in bringing his former compatriots to justice and is allowed to return to his family. However, van der Linde's final words to Marston, that "they'll just find another monster" ring true as the government agents betray Marston and attack him at his home. Marston sacrifices himself to save his family while his son, Jack, swears vengeance. Years later, Jack Marston tracks down and kills the government agent who betrayed his father, leaving his body in the Rio del Lobo and riding off to the next adventure.

TRANSMEDIA TOOLS: The Execution

Throughout this book, we've explored concepts and realities that you will face when you craft a transmedia project. Now, let's take a look at the final integral part of a transmedia project: the release.

If anything has been proven throughout this book it's that audiences have wanted to be immersed in the world of a story since the beginning of storytelling. With the proliferation of Internet communications technologies and the democratization of content creation, we can harness that power to create a deeply immersive world that our audience—or hopefully, absorbers—will want to explore. Here are a few things to bear in mind when releasing a transmedia project:

TRANSMEDIA TOOLS:
The Execution—
continued

1. **Serialization works**—but you have to keep the same thing that comic book creators have to keep in mind: any chunk of the story may be the audience member's first—or their last. It has to satisfy both deep divers and those testing the waters.

2. **Release pieces when the audience *craves* them**—don't feel you have to show all of your cards immediately. Let the audience sweat it out a bit.

3. **Sometimes the audience comes up with the best answers**—if you look at the ending of *The Sopranos*, it infuriated most people. But, creator David Chase did something that was pure genius: by ending it with a quick cut to black, he let the audience create their own ending, and said that all of the clues were in the show. He both left it to their imaginations and rewarded their expertise—if they could figure it out.

How Do Comic Books Interact with the Main to Deepen the World?

This one will take a slightly different route. There are two characters for whom books, adventure, and nostalgia are the driving forces: John Marston's son, Jack, and the one-time legend of the west, Landon Ricketts. During his father's lifetime, Jack is always reading books—dime novels—of adventure and intrigue. Let's make one of those books about Landon Ricketts.

I know I'm not exactly proposing a comic book here, but what I'm aiming for is immersion in a world, and a glossy, $3.99 comic book will only serve to pull an audience out of the immersiveness of the world, one that is so well defined that you forget you're playing a game. The "Landon Ricketts Rides Again" book will be one of Jack's favorites in the game, maybe one that he describes to his father in the expansion game, *Undead Nightmare*. It will feature era-authentic drawings and inserts throughout to fully replicate the dime novel aesthetic. Additionally, "Ricketts Rides Again" will expand the *Red Dead* world backwards, revealing what happened before the events of the game—maybe Ricketts even goes up against Marston's old gang, leaving Jack wondering who was really in this band of outlaws?

Then, moving forward, a comic book will be done in the old Timely style, *c.* 1939. It will tell the story of an outlaw in the last vestiges of the Old West, righting the wrongs of a government gone wild and corrupt. The figure will look familiar, in spite of the crude drawings and cheap quality—Jack Marston. The comic book will continue his adventures following the conclusion of *Red Dead Redemption*.

Finally, a third comic book, a graphic novel, done in a modern style. This one will retell the events of the game (truncated, of course) through the eyes of the final antagonist, Dutch Van Der Linde. It will show that he has been watching Marston throughout, and faces the inevitability of his crimes, knowing that his death will make him a legend.

Are the Comic Books Capable of Standing On Their Own?

Absolutely. All three tell a complete tale (though the comic may make use of perceived serialization) and can operate independently of the *Red Dead Redemption* game. However, to get the full experience, a reader must be familiar with the game itself, thus rewarding their expertise in *Red Dead* continuity.

Non-familiarity with the *Red Dead* world will leave those who have not played the game scratching their heads and wondering why someone made an old dime novel and a dusty comic book. But if they can get past it, it will offer a fun reading experience, one made that much more interesting should they decide to play the video game.

The Van Der Linde graphic novel will be more geared for non-players, a semi-familiar point of entry into the world that tells a ripping good story and presents the *Red Dead* world from another angle.

Who is the Intended Audience for the Comic Book?

Both the dime novel and comic book are for fans of the game who want to dig deeper into the already expansive world of *Red Dead Redemption*. However, if someone unfamiliar picks up the books, they'll get a complete story done in a style they're not used to.

How is the Comic Book an Irresistible Part of the Story Experience?

Both Jack Marston and Ricketts are fascinating characters, both with deeper stories to tell beyond the game; Ricketts before the events of the game, Jack after. The addition of a comic book told from Van Der Linde's perspective will add more depth to a character whose influence was felt throughout the game. With the comic, we will show exactly why it was felt: because he was there, watching and waiting.

* * *

Video games represent the next evolution in storytelling: the player as protagonist in a deeply immersive world filled with action, adventure, and drama that cannot be had in the real world, either by gravity, physicality, or morality. They are power fantasies of the highest order; mythological stories that transport and transform. Their fanbases are dedicated, willing to dive deeper into a fictional world and dissect and discuss their successes and failures with the community around the particular game . . .

Sounds a lot like comics.

You Must Remember This . . .

■ Video games can offer entire worlds of exploration, and comic books, already spectacularly deep world.

■ The defining characteristics of video game storytelling are a reward system and player as protagonist. The player is the hero.

■ The reward system, a defining characteristic of games, can also be a liability in the storytelling department. However, comic books can fill that hole by telling stories that don't require a reward.

Notes

1. Frank Rose, *The Art of Immersion: How the Digital Generation is Remaking Hollywood, Madison Avenue, and the Way We Tell Stories* (New York: Norton, 2011), p. 36.
2. Laura Parker, "The 300m Space Invader," *The Sydney Morning Herald*. Available online at: www.smh.com.au/articles/2007/09/22/1189881838207.html (accessed February 7, 2012).
3. "Microsoft Says 'Halo' First-Week Sales Were 300 Million," Reuters UK. Available online at: http://uk.reuters.com/article/2007/10/05/tech-microsoft- halo3-dc-idUKN0438777720071005 (accessed February 7, 2012).
4. Jennifer Valentino-DeVries, "How *Halo: Reach* is Like Classical Literature," Digits, *Wall Street Journal* Blog. Available online at: http://blogs.wsj.com/digits/2010/09/14/halo-reach-is-like-classical-literature-professor-says/ (accessed February 15, 2012).
5. Frank O'Connor, "The Bungie Guide to Sci-Fi." Available online at: www.bungie.net/News/content.aspx?type=topnews&link=bungiescifiguide (accessed February 15, 2012).
6. Richard George, "Exclusive Interview: *Halo: Uprising*," IGN. Available online at: http://comics.ign.com/articles/789/789811p2.html (accessed February 7, 2012).
7. Jesse Schedeen, "*Halo: Uprising* #4 Review," IGN. Available online at: http://comics.ign.com/articles/973/973325p1.html (accessed February 12, 2012).
8. Richard George, "Exclusive Interview: *Halo: Uprising*," IGN. Available online at: http://comics.ign.com/articles/789/789811p2.html (accessed February 7, 2012).
9. Steve Sunu, "The Bat-Signal: Fridolfs Crafts 'Arkham Unhinged.'" Comic Book Resources. Available online at: www.comicbookresources.com/?page=article&id=35450 (accessed February 1, 2012).

Collaboration

At its core, this book has been all about collaboration: the collaboration between media forms, the collaboration between comics and film, between comics and games, between comics and animation, between word and image. But it's also been about the collaboration between creatives in different creative disciplines. Transmedia especially is a new breed of collaboration; it is different from a film, where a director must work with writers, cinematographers and grips to create a great project. In transmedia, the producer/lead creative must work with multiple media forms created by multiple people with different skill sets.

The role of transmedia producer is like a mix of orchestra conductor (blending instruments to create tone color, or in this case, media color), television showrunner (writing the story bible, overseeing continuity), comic book editor (same as television showrunner, functioning, as Denny O'Neil called it, as "the keeper of post-industrial folklore"), CEO, audience, and manager.

In this short little chapter, I'm going to offer a few final, unorganized thoughts on collaboration among media and among creatives.

Work with the Best . . .

This should go without saying, but in the age of Twitter, social media, and the proliferation of people selling their sub-par wares, you have to be choosy with whom you work.

. . . and Let Them Do Their Job

Don't force people to work like you do. Everyone has their own method to the madness. It doesn't matter what those methods are, so long as it gets the job done. If things are moving along, let them move along. Your job is to be like the (good) boat captain: go with the currents, occasionally steering the boat back on course as needed.

Make Sure Your Skills Complement One Another

If someone is great at writing dialog, and you're great at writing dialog, but both of your skills in the description department are lacking, the partnership doesn't work.

Good Ideas Come from Anywhere—Be Open to Serendipity

The best moment in the entire five-year odyssey of making *Whiz!Bam!Pow!* was when I received the first thumbnail sketches of the comic book from Blair. We could see the script coming alive—it was awesome! In the script, we wrote in placeholders for ads. In one of those placeholders, Blair drew this little guy:

FIG 31.1 The Klein POWS! Guy (art by Blair Campbell, © 2012 Tyler Weaver; all rights reserved).

Paul (Klein, my writing partner) and I instantly fell in love with the little guy. So much so that he became the spokescharacter for our fictional cereal company, Klein POWS!—a whole new story extension—that "sponsored" the *Whiz!Bam!Pow!* radio show:

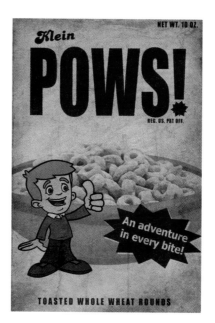

FIG 31.2 The Klein POWS! final (art by Blair Campbell, © 2012 Tyler Weaver; all rights reserved).

Good ideas come from anywhere. Always be aware, and always be willing to listen.

The Final Product Should Be Better Than You Evisioned

Akira Kurosawa once said that if the final product turns out just like he planned, he's unhappy. The entire point of collaboration is to bring new voices and new vision to your vision.

There Is Always Someone Who Knows More Than You Do

This should be the golden lesson here. The best collaborations are ones where you learn something new. If you've never written a comic script, work with an artist who is well versed with the needs of the medium and let them guide you towards creating a finished product that is "of" the medium. Always, *always*, be learning.

<p align="center">* * *</p>

The greatest joy in the creation of something new is the joy of discovery. That joy should spread from you to your collaborators, and ultimately from your collaborators to your audience—the audience that will make the choice to dig deep into your vibrant and exciting storyworld.

Conclusion

If there is one thing that I hope you take away from this book, it's that most great storytelling inventions were created *in service* of the story being told. Crossovers, team-ups, multiverses; they were all cool ways to tell a great story. They did not come from deep thought and pontificated upon ideas based around the technological fashions of the time. They came out of constants in storytelling: story, character, and the desire to be entertained.

This is the danger we face in this "wild west" media landscape: a loss of story, a loss of the joy of engaging with a character, replaced instead with a desire to "out-tech" or "out-cool" your transmedia competitors as you seek to "engage" your audience. Never focus on the fashion. Always focus on the unchanging: the audience's desire to be entertained by a great story that makes them *want* to be part of your world.

For me, the medium that has always done that has been comics.

Comic books are—and have been since their inception—the most vital and vibrant form of pop culture (and later, underground culture) ever conceived. They can tell stories of mythological battles between good and evil. They can tell stories of a hard life scraping by in Cleveland, or a series of vignettes about New York City tenements. They can tell harrowing stories of the Holocaust, or clichéd, idyllic overwrought teen romances and tales of forbidden love. Comics can tell stories in any genre; they transcend perceived limitation and act as a vehicle for the fantastic or realistic. Comic books are literature.

They are so much more than opportunities for cheap movie tie-ins or boring video-game expansions. They are more than a means to an end, more than a stepping stone to the Hollywood dreams of amateurs. Comics can help you construct one of the most vibrant storyworlds you've ever created, but only if you understand and love them. I hope this book has given you a start in doing so.

For more than 20 years, comics have been a part of my life, first as an escape, then a collection, then an escape (again), but always as a medium that has shaped my storytelling style—even if I didn't know it at the time. They transported me to other worlds and gave me a community within this one.

I hope you are inspired to dig deeper into this medium and see what you can create with it. I look forward to seeing your results and reading your adventures. If you have any questions, shoot me an email, or catch me on Twitter (@tylerweaver). Just do me one favor and always remember . . .

Comic books are more than storyboards.

Appendix
Recommended Reads

As with any book, there are things I wish I could have included. Almost every chapter here could be its own book. For those of you who wish to dig deeper (and I hope all of you do), here is a list of recommended reads—both comics and books on comics.

The Golden Age of Comics

Here is a list of books you should check out to get a full picture of the birth of the comic book:

Superman Chronicles, Vols 1–9 (Jerry Siegel & Joe Shuster/various).

Batman Chronicles, Vols 1–10 (Bob Kane/various).

Wonder Woman Chronicles, Vol. 1 (William Moulton Marston & Charles Paris).

The Shazam! Archives, *Vols 1–4.*

Captain America: The Classic Years, Vols 1 and 2 (Joe Simon & Jack Kirby).

The Best of the Spirit (Will Eisner).

Supermen! The First Wave of Comic Book Heroes, 1936–1941.

Superman: Sunday Classics, 1939–1943.

Marvel Comics Re-Presents: The First Ever MARVEL COMICS #1 (various, may be out of print, hardcover reproduction of *Marvel Comics* #1).

Any collection of Carl Barks' Donald Duck comics from the 1940s–1950s.

And even though they're not comics, here are three collections of pulps and newspaper strips that are fantastic reads that paint a better picture of the entertainments that converged into comic books:

The Black Lizard Big Book of Pulps, edited by Otto Penzler (Vintage Crime).

The Black Lizard Big Book of Black Mask Stories, edited by Otto Penzler (Vintage Crime).

The Complete Chester Gould's Dick Tracy: Dailies & Sundays, Vol. 1: 1931–1933 (IDW).

Frankenstein (Mary Shelley, illustrated by Lynd Ward), 1934 edition.

The Silver Age of Comics

The Silver Age was a time of great upheaval in comics, and the creation of one of the most vibrant shared universes in the media world. It was a time of rebirth, of renewed vigor, and a reflection of the times in which they were created. As the times changed, so did the comics. Here is a group of titles you should check out to get a better picture:

Showcase Presents: Superman (multiple volumes).

The Amazing Spider-Man #s 1–40 (multiple collections available) (Stan Lee, Steve Ditko, & John Romita).

The Essential Fantastic Four, Vol. 1 (Stan Lee & Jack Kirby).

Marvel Masterworks (any collection, particularly featuring the work of Stan Lee, Steve Ditko, & Jack Kirby).

Bat-Manga: The Secret History of Batman in Japan (Jiro Kuwata/Chip Kidd).

Showcase Presents: Batman (multiple volumes).

The Bronze Age of Comics

The age of transition and the age of a new generation:

Jack Kirby's Fourth World Omnibus (Jack Kirby).

Green Lantern/Green Arrow, Vols. 1–2 (Denny O'Neil & Neal Adams).

Crisis on Infinite Earths (Marv Wolfman & George Perez).

The Essential Tomb of Dracula, Vol. 1 (various).

A Contract With God (Will Eisner).

Maus (Vols 1–2) (art spiegelman). Note: Vol. 1 came out in 1985 during the Bronze Age, Vol. 2 in 1991 during the Modern.

American Splendor (Harvey Pekar, various).

The Private Files of The Shadow (Denny O'Neil & Mike Kaulta).

Superman: Whatever Happened to the Man of Tomorrow? (Alan Moore, various).

The Modern Age

The following is a list of the best examples of modern comic storytelling:

Batman: The Dark Knight Returns (Frank Miller).

Batman: Year One (Frank Miller & David Mazzuchelli).

Watchmen (Alan Moore & Dave Gibbons).

Marvels (Kurt Busiek & Alex Ross).

Kingdom Come (Mark Waid & Alex Ross).

Batwoman: Elegy (Greg Rucka & J.H. Williams III).

All-Star Superman (Grant Morrison & Frank Quitely).

The New Frontier (Darwyn Cooke).

The Fountain (Darren Aronofsky & Kent Williams).

Bone (Jeff Smith).

The Batman Adventures: Mad Love (Paul Dini & Bruce Timm).

Understanding Comics (Scott McCloud).

Sandman (Neil Gaiman, various).

100 Bullets (Brian Azzarello & Eduardo Risso).

Torso (Brian Michael Bendis & Marc Andreyko).

Tiny Titans (Art Balthazar & Franco).

Daredevil (Mark Waid, Paolo Rivera, & Marcos Martin).

Books About Comics and Storytelling

Men of Tomorrow: Geeks, Gangsters, and the Birth of the Comic Book (Gerard Jones).

The Ten Cent Plague: The Great Comic Book Scare and How It Changed America (David Hajdu).

Supergods: What Masked Vigilantes, Miraculous Mutants, and a Sun God Can Teach Us About Being Human (Grant Morrison).

Marvel: Five Fabulous Decades of the World's Greatest Comics (Les Daniels).

Batman: The Complete History (Les Daniels).

The Hero with a Thousand Faces (Joseph Campbell).

The Power of Myth (Joseph Campbell with Bill Moyers).

The Art of Immersion: How the Digital Generation is Remaking Hollywood, Madison Avenue, and the Way We Tell Stories (Frank Rose).

Convergence Culture: Where Old and New Media Collide (Henry Jenkins).

All Your Base Are Belong to Us: How Fifty Years of Videogames Conquered Pop Culture (Harold Goldberg).

Comics and Sequential Art (Will Eisner).

Hitchcock (Francois Truffaut).

Remix: Making Art and Commerce Thrive in the Hybrid Economy (Lawrence Lessig).

MetaMaus (art spiegelman).

As with any list, this is just a smattering of the books and pieces you should check out. This list will also be available at this book's companion website, comicstoryworld.com, where it will be constantly updated.

Index

Note: page numbers *italic* page numbers indicate figures.